CW01367928

GENDER IN HISTORY

Series editors:
Pam Sharpe, Patricia Skinner and Penny Summerfield

The expansion of research into the history of women and gender since the 1970s has changed the face of history. Using the insights of feminist theory and of historians of women, gender historians have explored the configuration in the past of gender identities and relations between the sexes. They have also investigated the history of sexuality and family relations, and analysed ideas and ideals of masculinity and femininity. Yet gender history has not abandoned the original, inspirational project of women's history: to recover and reveal the lived experience of women in the past and the present.

The series Gender in History provides a forum for these developments. Its historical coverage extends from the medieval to the modern periods, and its geographical scope encompasses not only Europe and North America but all corners of the globe. The series aims to investigate the social and cultural constructions of gender in historical sources, as well as the gendering of historical discourse itself. It embraces both detailed case studies of specific regions or periods, and broader treatments of major themes. Gender in History titles are designed to meet the needs of both scholars and students working in this dynamic area of historical research.

Women police

MANCHESTER
1824
Manchester University Press

ALSO AVAILABLE
IN THE SERIES

Gender, myth and materiality in an island community:
Shetland, 1800–2000
Lynn Abrams

'The truest form of patriotism':
pacifist feminism in Britain, 1870–1902
Heloise Brown

Masculinities in politics and war: gendering modern history
Stefan Dudink, Karen Hagemann and John Tosh (eds)

Noblewomen, aristocracy and power
in the twelfth-century Anglo-Norman realm
Susan Johns

The business of everyday life:
gender, practice and social politics in England, c. 1600–1700
Beverly Lemire

The independent man:
citizenship and gender politics in Georgian England
Matthew McCormack

WOMEN POLICE
GENDER, WELFARE AND SURVEILLANCE IN THE TWENTIETH CENTURY

Louise A. Jackson

Manchester University Press
Manchester and New York

distributed exclusively in the USA by Palgrave

Copyright © Louise A. Jackson 2006

The right of Louise A. Jackson to be identified as the author of this work has been asserted by her in accordance with the Copyright, Designs and Patents Act 1988.

Published by Manchester University Press
Oxford Road, Manchester M13 9NR, UK
and Room 400, 175 Fifth Avenue, New York, NY 10010, USA
www.manchesteruniversitypress.co.uk

Distributed exclusively in the USA by Palgrave
175 Fifth Avenue, New York,
NY 10010, USA

Distributed exclusively in Canada by UBC Press
University of British Columbia, 2029 West Mall,
Vancouver, BC, Canada V6 1Z2

British Library Cataloguing-in-Publication Data
A catalogue record for this book is available from the British Library

Library of Congress Cataloging-in-Publication Data applied for

ISBN 0 7190 7390 1 *hardback*
EAN 978 0 7190 7390 8

First published 2006

15 14 13 12 11 10 09 08 07 06 10 9 8 7 6 5 4 3 2 1

Typeset in Minion with Scala Sans display
by Northern Phototypesetting Co. Ltd, Bolton
Printed in Great Britain
by Bell & Bain Ltd, Glasgow

Contents

	LIST OF FIGURES	*page* vi
	LIST OF TABLES	vii
	ACKNOWLEDGEMENTS	viii
	LIST OF ABBREVIATIONS	ix
1	Introductions	1
2	Networks, structures and hierarchies	16
3	A respectable job for a woman?	47
4	Walking the beat	80
5	Going undercover	107
6	Policing the family: youth and welfare	138
7	Women, sexuality and the law	171
8	Beyond integration?	199
	SELECT BIBLIOGRAPHY	211
	INDEX	215

Figures

1. Senior policewomen at the national conference in Leeds, October 1964
 Courtesy of the Greater Manchester Police Museum *page* 35
2. Metropolitan Police Patrols led by Mrs Sofia Stanley, c. 1919
 Courtesy of the Greater Manchester Police Museum 51
3. Manchester City policewomen: allocation of duties after parade, c. 1948
 Courtesy of the Greater Manchester Police Museum 52
4. 'Today's Look', from *Keeping the Peace in London: A Career for Women in the Metropolitan Police* (London: Metropolitan Police, c. 1968)
 Reproduced with the kind permission of the Metropolitan Police Service 56
5. Manchester City policewomen in Bootle Street station canteen, c. 1962
 Courtesy of the Greater Manchester Police Museum 71
6. RUC women recruits drilling at Enniskillen, 1965
 Courtesy of the Police Service of Northern Ireland 85
7. Women's detective course, Wakefield, 1946
 Courtesy of the Greater Manchester Police Museum 128
8. Manchester City Police, promotional photograph, c. 1950
 Courtesy of the Greater Manchester Police Museum 139

Tables

4.1 Metropolitan Women Police: uniform duty in streets and open spaces *page* 94

4.2 Metropolitan Women Police: arrests (uniform) for street offences 95

Acknowledgements

This book would not have been possible without the co-operation of the Evergreens, the Metropolitan Women Police Association, members of the National Association of Retired Police Officers, Miss Jean Law and Miss Pauline Wren. It has been generously supported by Leeds Metropolitan University (where I completed the work) and by the Nuffield Foundation (Social Science Small Grants Scheme).

I acknowledge the substantial help of Ray Seale and Steve Earle of the Metropolitan Police Museum, Duncan Broady and David Tetlow of the Greater Manchester Police Museum, Alastair Dinsmoor of the Glasgow Police Heritage Society, Dave Cross of the West Midlands Police Museum, Hugh Forrester of the Police Service of Northern Ireland (Police Museum), John Endicott of the Kent Police Museum, the staff of the National Archives and curators at the West Yorkshire Archive Service. Margaret Cameron, Joan Lock and Maureen Scollan shared their vast knowledge of the history of women and policing. I wish to thank my colleagues in the School of Cultural Studies, Leeds Metropolitan University, for their support, suggestions, enthusiasm and encouragement – in particular, Gordon Johnston, Simon Gunn and Krista Cowman. The following individuals (amongst many others) shared their thoughts with me during the research: Shani D'Cruze, Clive Emsley, Lesley Hall, Matt Houlbrook, Heather Shore, Pat Starkey, Deborah Thom, Chris A. Williams and Alison Woodeson. Pat Cook and Sylvia Howard assisted with the transcription of tapes. Edith Sharples, (née Hoyle) 'My Life's Work' is quoted with permission of Bury Reference and Information Services, Bury Library. Documents from the Metropolitan Police Museum are quoted with kind permission of the Metropolitan Police Service.

Abbreviations

AMSH	Association for Moral and Social Hygiene
AR	Annual Report
BCL	Bury Central Library
BPP	British Parliamentary Papers
CID	Criminal Investigations Department
DORA	Defence of the Realm Act
GMPM	Greater Manchester Police Museum
HMI	His/Her Majesty's Inspector
IWM	Imperial War Museum
LCC	London County Council
MPM	Metropolitan Police Museum
MWPA	Metropolitan Women Police Association
NA	National Archives
NARPO	National Association of Retired Police Officers
NCW	National Council of Women
NIPP	Northern Ireland Parliamentary Papers
NSPCC	National Society for the Prevention of Cruelty to Children
NUWW	National Union of Women Workers
NVA	National Vigilance Association
PSNI	Police Service of Northern Ireland
RIC	Royal Irish Constabulary
RUC	Royal Ulster Constabulary
UK	United Kingdom of Great Britain and Northern Ireland
WAAF	Women's Auxiliary Air Force
WAPC	Women's Auxiliary Police Corps
WAS	Women's Auxiliary Service
WFL	Women's Freedom League
WMPM	West Midlands Police Museum
WPS	Women Police Service
WPT	Women Police Tapes
WPV	Women Police Volunteers
WRAC	Women's Royal Army Corps
WRAF	Women's Royal Air Force
WRNS	Women's Royal Naval Service
WSPU	Women's Social and Political Union
WYAS	West Yorkshire Archive Service

1

Introductions

I doubt if any country in the world has such a wonderful corps as our women police . . . I have never known one who was not calm, brave, and kindly in her work, and they need to be all of this . . . They are, indeed, a kind of Salvation Army, in a different uniform with no brass band . . . Some of the most moving scenes we ever witness are of very small children, who have been beaten and neglected by their parents, clinging to the women police and beaming at them lovingly through their tears . . . Perhaps their noblest work lies in befriending young girls before they have gone wrong and persuading them to go home, if they have one; or directing them to a hostel if there is one; or putting them in touch with a social agency such as the Moral Welfare Society, if one exists.[1]

Published in 1950, this eulogy to the work of women police officers was penned by high-profile magistrate Sir Basil Henriques, who had observed their work closely since he was appointed to the bench of the East London juvenile court in 1924. For much of the twentieth century women police often played a key role in the detection and prevention of child abuse, neglect and the 'policing of families', a role that has received scant attention in existing histories of welfare and the State. As 'specialists' working with women and children, they took statements from victims of violence and indecent assault. In the battle against juvenile delinquency, the 'befriending' and referral of girls who were deemed 'vulnerable' or 'in moral danger' was a significant aspect of their work.

Yet the assumptions informing Henriques's eulogy require interrogation. Firstly, although women officers were stereotyped through gender as 'the gentle arm of the law', the relationship between 'care' and 'control' was an ambivalent one. Women officers were required to work closely with social workers but their remit was ultimately one of crime prevention – the judicial – rather than the specific interests of a client

base. For several decades the hegemony of the concept of penal welfarism ensured that social work and policing were not totally disparate fields. By the early 1960s, however, tensions had become more apparent, leading to legislative interventions that sought to reduce the discretionary powers of the police in relation to the care or protection of children. Secondly, Henriques's account emphasised the 'welfare' and 'specialist' aspects of policewomen's work and (because he was concerned with the juvenile court) made no mention of the range of other duties in which they were involved. Women played an active role in plain-clothes observations, detective and decoy work, even in forces where they were not formally appointed to the Criminal Investigations Department (CID). In rural areas individual women often worked in country stations, carrying out similar duties to male officers and working solely with them. It is important, therefore, to uncover the diversity of women's policing work and to offer a comparative perspective across time and space.

This book examines the professional roles, identities, activities and experiences of women police in the United Kingdom of Great Britain and Northern Ireland (UK) from a historical perspective, using a range of oral testimonies, documentary and visual sources. In so doing, it also aims to comment more broadly on the gendering of modern surveillance technologies, on the relationship between justice and welfare, and on the changing situation of women in the twentieth century. It is a 'social history' in its concern with the 'everyday', in its focus on networks and interpersonal relationships, and in its evaluation of the role of structuring processes but also of agency in the shaping of events. It is also a 'cultural history', since it reflects an interest in the construction of meanings and values through the symbolic repertoires of language, image, gesture and appearance: in the processes that define people and objects in relation to time and space. Moreover, it participates in the creation of a 'cultural history' of 'the social' by viewing the 'social sphere' as a constructed field that was regulated through the activities of police officers as well as social workers and other professional groups.[2]

Most of the book focuses on the period 1915 to around 1975: from women's first official appointment as attested police officers until their formal integration within the police service on the same terms as men. Women were employed on different pay, conditions and promotional structures to men until the introduction of the Equal Pay Acts of 1970 and the Sex Discrimination Acts of 1975/6. In larger towns and cities their work was organised through a 'Women Police Branch' or 'Policewomen's Department', headed by a senior female officer who was usually answerable only to the Chief Constable.[3] Despite the visibility of 'voluntary

patrols' during the First World War, the number of attested women officers remained low across the period, increasing nationally from only 282 in 1940 to 418 in 1945, and to 4,000 in 1966. They formed a small yet significant group who, as mediators on behalf of the State, had considerable authority to intervene in the lives of ordinary people. This book argues that women police negotiated their own distinct occupational identity in relation to masculine police cultures, other professional groups, and the women and young people whom they encountered on a daily basis. By focusing on the parameters of police discretion and on the relationship between identities and social actions, I shall show that assumptions about class, status, gender and sexuality were both challenged and reinforced by women police in the first three-quarters of the twentieth century.

Finally, an understanding of the era before integration will be used to shed light on perceptions and experiences of gender and policing in the late twentieth century. In 1982 a BBC documentary about Thames Valley Police showed male detectives subjecting a rape victim to inappropriate and insensitive questioning. Women officers argued this would never have occurred in the days of the Women Police Branches. In 1990 Alison Halford, the first woman to reach the rank of Assistant Chief Constable in a UK police force, took the police authorities to court for sexual discrimination (the case, which lasted two years, was finally settled out of court). Other incidents, both of sexual harassment and discrimination, came to light. Despite the notion of 'equality' that had been introduced in the mid-1970s, it was apparent that the myths surrounding gender had resulted in a culture of sexism within policing, which, arguably, was exposed in a backlash against equal opportunities legislation. The creation of an ethos of feminine professionalism based on 'equality through difference' that was embodied in the Policewomen's Departments had served to protect both policewomen and to some extent women victims. However, it can also be argued that the confidence of the Policewomen's Departments was misplaced. The late twentieth century has seen a set of other crises that have impacted on the practice of policing and social policy. The discovery of the prevalence of child abuse within the family and, at the same time, within institutional children's homes has led to a loss of faith around the types of intervention in which Henriques so clearly believed. The conviction, confidence and belief in welfarism that shaped the work of the Policewomen's Departments needs to be offset against the climate of uncertainty clouding the practices of social work today.

Gender and policing

A growing interest in the history of crime and, more specifically, the gendering of the criminal justice system, has drawn attention to the role of women not only as victims and offenders but also as 'women in control'.[4] The argument for the necessity of women police was initially won on the grounds of gender difference: that it was appropriate, ethically, for women officers to deal with female victims or offenders and, moreover, that women possessed specific qualities and skills that made them 'experts' with children. Did women subsequently become 'bearers of alternative values'? Or did they duplicate the assumptions of male officers? Sommerlad and Sanderson have suggested that women lawyers, who were able to practise in Britain following the Sex Disqualification (Removal) Act of 1919, tended to reject an identity as 'women' and to accept the values of the male workplace.[5] In policing, however, women negotiated the masculine cultures of canteen, the CID and senior ranks as well as the women-oriented culture of the Policewomen's Department. Processes of partial separation/segregation resulted in an awareness of 'difference' and the cultivation of a police identity that was at times gender-specific.

While viewing 'gender' as a cultural construction – that is, as sets of symbols and meanings that are learned, contested and played out – I shall also consider the ways in which 'gender' intersects with other categories to create identities that are multiple, fluid and malleable rather than fixed.[6] The ways in which national, regional, ethnic, religious, sexual and class identities intersected with gendered 'police' identities will be an area of consideration. Identities are historically specific and contingent; they will be mapped here in relation to the wider social, cultural and political contexts of the twentieth century, including the impact of war and other forms of conflict. Women both absorbed the rhetoric and symbolic order of male policing and created their own styles and approaches that were partly concerned with occupational equality and partly concerned with gender difference, approaches that are not necessarily diametrically opposed.[7] The Second World War saw an emphasis both on women's duties as equal citizens and on women's distinct role as *women*, which meant that gender was maintained as a significant marker of one's role within the national community.[8] The notion of 'feminine duty', developed during wartime, continued as an important reference point in women's policing into the 1950s. While it would be incorrect to argue that 'policing' is a profession in structural terms (in that it fails to conform to the 'ideal type' that is associated with law and medicine), it is possible to

talk about the strategies of professionalism that shaped women's role within it.[9] As Daniel Walkowitz has argued, 'professionalism' is an 'ethos' and an 'ideology' that is informed by perceptions of gender, class and ethnicity.[10] I shall demonstrate that Women Police Departments sought to foster a distinctly 'feminine' professional identity in relation to male policing and to other occupational groups such as probation officers and social workers.

Recourse to the 'feminine' could be used as a bargaining tool for acceptance within police culture and, even, as a statement of moral superiority. It could also be deployed as a tactic within the repertoire of policing, as an examination of the technologies of uniform and covert/undercover surveillance will demonstrate. A particular style of 'feminine' authority was demarcated through the uniform, which put women on display to command respect. However, 'femininity' could be interpreted by others as a sign of vulnerability or lack of status. In plain-clothes observations, the 'mask of femininity' could render women invisible, since it was assumed that the 'gaze' of surveillance was bound to be male. Assumptions about gender were both exposed and subverted through undercover surveillance in which 'femininity' was most clearly a performance, designed to conceal the authority of policing which was masculine in derivation.

Previous studies of the history of policewomen in the UK are small in number and have tended to focus either on institutional politics or wartime regulation. Both Joan Lock and John Carrier have offered an institutional focus, examining the long battle for the appointment of women police in Britain, making careful use of the findings of parliamentary committees of enquiry.[11] The employment of women in the Royal Ulster Constabulary (RUC) has been the subject of a separate and unique study by Margaret Cameron – herself a former policewoman (like Lock) – which uses personal recollection as well as archive sources to chart developments within the Women Police Branch.[12] Where women's identities and work practices have been examined, this has been almost exclusively in the context of the First World War, which has received a great deal of attention from scholars of gender history such as Philippa Levine, Lucy Bland, Alison Woodeson and Angela Woollacott. The debate has centred on the significance of, on the one hand, feminism, and on the other, middle-class values, in the shaping of women's interventions in this period.[13] There has been little attempt so far to examine the everyday practices of women involved in policing after 1919.[14] The controversial figure of Mary Allen, former suffragette and self-styled 'commandant' of the Women Police Service (WPS), renamed the Women's Auxiliary

Service (WAS) in 1921, has been studied in depth from very different perspectives by Laura Doan and R. M. Douglas.[15] Doan has concentrated on Allen's image and dress in order to unpack the cultural codes surrounding lesbianism in the 1920s and 1930s. Douglas has focused on Allen's politics in the First World War and inter-war period, particularly her involvement with fascism in the early 1930s. It can be argued, however, that Allen was increasingly discredited from 1922 onwards and her influence on later debates about the employment and duties of policewomen was minimal. Allen courted controversy and it is difficult to see her as 'representative' of anyone other than herself.

The work of women police has also been explored from the perspectives of criminology and sociology from the 1980s onwards. Studies by Susan Martin, Sandra Jones and John Brewer have used oral interviews and anthropological fieldwork to position women officers in relation to two oppositional categories: one centring on a police orientation/identity and one centring on a gender orientation/identity.[16] Within this schema, women who had joined before formal integration tended to be typecast as gender-oriented and it was implied that they articulated 'traditional' or 'conservative' ideas about gender and women's place in policing. Although all three studies situated the categories of police and gender orientations at opposite ends of a linked continuum, there is little detailed discussion either of the aims, identities and work experiences of pre-integration women or of the complexities of their position. Nevertheless, Brewer, whose fieldwork was largely concerned with women in the RUC who had joined after integration, has usefully argued that 'gender identity in the police station is a managed accomplishment', suggesting that it is a performative device or tactic with particular uses at particular moments.[17]

Frances Heidensohn's comparative work, based on extensive interviews with women who joined British, American and other police forces in the 1980s and 1990s, has involved a move away from dichotomies and has provided a detailed examination of women's testimonies through the identification of common concepts and themes.[18] Her work has also offered a more historicised perspective, which includes an analysis of cartoons and other forms of representation. While Heidensohn has characterised the period 1922–45 as a 'latency' period in terms of the history of women and policing, because appointment numbers were low, I shall suggest that it was a crucial one in the delineation of an identity and an ethos. In the Metropolitan Police in particular, where the establishment remained buoyant, an important professional role in relation to child protection and the prevention of delinquency was developed by Dorothy

Peto, head of the Women Police Branch. She used the 1933 Children and Young Persons Act to carve out a sizeable 'specialist' role for women officers and to place them at the frontline in child abuse enquiries. This developmental work had a profound impact on the shaping of Policewomen's Departments in the period of numerical expansion after the end of the Second World War. Sociological studies have tended to characterise the work of the Policewomen's Departments as 'restricted'. In doing so, however, they unwittingly follow the logic of male policing that women's work was not really proper policing (it is rare, for example, that the 'specialist' work of the CID is labelled as 'restricted'). If child protection is viewed, instead, as a significant area of police and social work intervention, women's 'specialist work' then becomes an important area of study.

This book provides a comparative analysis of the day-to-day workings of Women Police Branches and Policewomen's Departments across the UK, exploring the intersections between policing and child welfare policy, gender and surveillance, as well as masculine and feminine police cultures. It is important to account for differences in policing across the regions of the UK. England and Wales have a separate legal system from Scotland and Northern Ireland. The decisions of individual chief constables and police authorities (previously watch committees in boroughs and joint committees in counties) are subject to the scrutiny of the Home Office (HO), although they also claim significant levels of autonomy. In Scotland, scrutiny is the concern of the Scottish Office, while in Northern Ireland it was exercised by Stormont until the imposition of direct rule in 1972 (when the RUC came under the watchful eye of Her Majesty's Inspectors of Constabularies). While the police conducted their own prosecutions in England and Wales until the setting up of the Crown Prosecution Service in 1985, Scottish police have always referred cases to the Procurator Fiscal for possible prosecution. There are also differences in terms of police powers, most noticeably in Northern Ireland, where conflict between nationalist and unionist groups has shaped the context of policing.[19] The RUC, set up to serve the newly formed province in 1922, was the only UK force in which police officers normally carried firearms. Under the 1922 Civil Authorities (Special Powers) Act, which imposed martial law, the Stormont government was given powers to intern without trial, to arrest people without warrant, to issue curfews and to prohibit inquests; this has led to descriptions of the RUC as 'paramilitary'.[20] The RUC performed both a 'political' or 'security' role, which became more intense with the outbreak of the Troubles in 1968, and a community policing role that 'approximated to the liberal model of policing in Great Britain', which had been dominant in the 1950s.[21] Histories of policing

have tended to focus either on the context of Great Britain or of Northern Ireland rather than the UK. My intention here is to acknowledge that both were part of a political relationship with aspects of shared government, although this relationship was recognised by some and contested by others. A discussion of the history of women in the RUC enables a detailed consideration of the ways in which the role of policewomen shifted within a divided society.

Despite apparent disparities, I shall demonstrate that there was common ground that drew policewomen together across the UK. Firstly, there was a certain amount of mobility between forces, particularly among the initial pioneering group and, later, among senior officers. In Northern Ireland, the RUC's Women Police Department was set up in 1946 following the appointment at its helm of Marion Macmillan, who had previously served as a sergeant in the Women's Branch of the Metropolitan Police (the Met). The RUC's Women Police Department was unarmed, its workload was developed along similar lines to the Met, and it concentrated (although not exclusively) on community policing until 1968. Secondly, the comparatively small number of women, the need to forge a new occupational identity, and the desire both to delineate and to expand the scope of their duties, drew policewomen together. Links were encouraged and assisted by the setting up of a series of national and regional policewomen's conferences from 1937 onwards, which often involved delegates from the RUC. The detailed minutes of these 'national' conferences provide a fascinating record of meetings in which policewomen compared and discussed their work. Despite significant regional and local differences (including strong identities within forces for both men and women), it is possible to speak meaningfully of policewomen 'in the UK'.

Detailed archival research, which has traced an extensive range of documents, will be interlaced with an evaluation of autobiographical testimony – both previously published and in the form of oral history interviews – in order to produce a multifaceted impression of women's role in policing. It is necessary, therefore, to say something about the forms and functions of autobiography, the construction of the oral history sample, and the ways in which personal testimony can be interpreted to shed light on 'identity' and 'experience'.

Identity and experience

The personal testimony of police officers has a substantial pedigree. The emergence of detective fiction in the nineteenth century was paralleled by

the development of the 'true crime' genre, central to which has been the publication of police memoirs. These have tended to take two forms: 'famous' police detectives recounting their 'great cases' in the form of short stories or memoirs, and the autobiographies of senior policemen describing their progression through the ranks from 'bobby on the beat' to chief constable.[22] Both are inflected by the construction of policeman as 'hero' and both invoke the narrative structure of the personal quest: the solving of a particularly puzzling or gruesome crime (in the 'great cases' format) and the single-handed pursuit of law, order and effective policing (in the life story). Autobiographical writing has also been produced by women officers in much smaller numbers and it can be argued that their writing takes slightly different forms because the 'heroic' position was less easy to occupy.

Certainly some aspects of the 'heroic' are apparent in the memoirs of early 'pioneer' women police officers, which focus on 'struggles and achievements' and the author's role in the delineation of a new and socially significant occupation for women. The emphasis on the 'hero' as law enforcer, however, was replaced with a focus on the social/welfare orientation of women's police work. The women's 'pioneer' narrative was forged in Mary Allen's three self-promotional memoirs (published in 1925, 1934 and 1936), which described her seemingly single-handed crusade to introduce women police to the world.[23] It was also invoked, although to a lesser extent, in Lilian Wyles's *A Woman at Scotland Yard*, published in 1952, where the 'pioneer' narrative is combined with detailed anecdote and observations of the daily work of the Met's Women Police.[24] Although not published in her lifetime, *The Memoirs of Miss Dorothy Olivia Georgiana Peto OBE* can also be classified loosely as 'pioneering', although there is a distinct shift in the narrative voice. There is more of an attempt to write a general history rather than a personal and heroic one and the resounding 'I' of Allen's account is replaced with a collective 'we'.[25] A further brief memoir, which tends to be self-effacing rather than 'pioneering' in tone, was written by Phyllis Lovell, who served as sergeant in the Birkenhead force from 1916 to 1917.[26] Edith Sharples, née Hoyle, described her employment as a 'lady police assistant' in Huddersfield from 1915 to 1918 in another unpublished typescript, written retrospectively.[27] Although her father had been a bank manager, he died when Hoyle was 11 and the text is resonant of working-class autobiographies in its charting of the battle for economic survival despite periods of adversity. Nevertheless, a spirit of adventure and the sense of carving out new work in an uncharted territory are also conveyed.

Among a different generation of policewomen, the focus on the everyday rather than the heroic is apparent in Stella Condor's *Woman on*

the Beat and Joan Lock's *Lady Policewoman*, which describe women's police work in the 1950s through a series of impressionistic sketches and encounters.[28] Jennifer Hilton's *The Gentle Arm of the Law*, published in 1967 as part of a series of career books for young people, provided a personal and practical account of the processes of recruitment, training and probationary life.[29] In all three accounts the voice is one of youth rather than the maturity of the 'pioneer', discussing anxieties, insecurities and mistakes as well as the potential for excitement and adventure on the London streets. The voice of experience became apparent once again in the 1990s, in Alison Halford's *No Way Up the Greasy Pole* and Carol Bristow's *Central 822*.[30] Both Halford and Bristow had joined the Metropolitan Women Police Branch in the early 1960s and went on to gain promotion in the years after formal integration. Both subverted the narratives of progression and quest, which were shown to be hollow, as they depicted the negative effects of a competitive and masculine occupational culture on health and personal life. Like the early 'pioneers', Halford and Bristow were engaged in a battle for acceptance.

The autobiographical writing of policewomen, while providing an extremely useful set of personal testimonies, is limited because of its rarity. In order to gain a wider picture of the work practices of women police officers before integration, I conducted interviews with 40 former women police officers who joined UK forces between 1938 and 1973.[31] Their length of service varied from 3 to 34 years and they finished their service in a variety of ranks. The women were contacted through existing networks of retired police officers: the National Association of Retired Police Officers in England and Wales (NARPO), the Metropolitan Women Police Association (MWPA), the Evergreens (the network for former RUC Women Police) and the Glasgow Police Heritage Society.[32] In addition to this anonymised sample of 40 women, interviews were conducted with two other named senior officers: Miss Jean Law OBE, QPM, who served as Assistant to Her Majesty's Inspectors of Constabularies from 1962 to 1976, and Miss Pauline Wren MBE, who was employed by the Home Office inspectorate from 1968 to 1974 and retired as a Divisional Commander of West Midlands Police in 1980. These 42 women had, together, served in a total of 26 different police forces across their careers.[33]

Historians have drawn attention to issues of factual inaccuracy and exaggeration in the autobiographical accounts produced by Mary Allen and Lilian Wyles.[34] Rather than seeing memoir and personal testimony as a transparent window on to an externally referential truth, I treat them here as forms of self-presentation that are located within a wider cultural

field. Personal testimony involves the reconstituting of events and the interpretation of their significance in order to make sense of them as 'experience'.[35] The process of telling, which may have taken place many times before, involves the selection (or rejection) of narrative structures and linguistic frameworks from an available repertoire of possibilities in order to create a new and unique account. Liz Stanley has convincingly argued that 'autobiographies, both written and spoken, are inter-textual, but within this there is the primacy of everyday life and its concrete material events, persons, conversations'.[36] The identities that women adopt within the autobiographical frame are a result of a series of personal encounters, dialogues and discussions, perhaps over many years.

While Allen's desire to write her memoirs could be linked cynically to her zeal for self-publicity, the reasons for writing are many and varied, from the desire to make a living as a professional writer (in Lock's case) to the defence of personal reputation (in Halford's). Similarly, it is important to point out that all of the women who were interviewed volunteered themselves because they wished to be involved. There may have been an array of personal reasons for doing this, although in many cases they spoke of a conviction that the history of women police officers was worth recording. The desire to be involved may mean that certain types of account are more prominent than others. Those with wholly negative views of policing were unlikely to join occupational associations or to volunteer for interview. Moreover, membership of an occupational organisation after retirement implies identification with other members and participation in a shared culture that may involve reminiscence, the comparison and pooling of memories, and the forging of a collective history. The Evergreens have already participated in the writing of a history of women in the RUC, and the MWPA maintains its own archive of members' donations.[37]

Rather than compressing individuals into 'types' and setting up dichotomies (between 'feminism' and class ideologies or between 'feminine' and 'police' identities), I shall show that women who joined the police service in the UK before integration drew on a more fluid set of complex and sometimes contradictory frameworks. These frameworks included constructions of gender, class, age, status, ethnicity, sexuality, community or family. 'Identity' will be viewed as a 'process' rather than a static object. Under constant construction, a sense of self is worked out through experience, which involves relationships and encounters with others (which are almost always unequal). I shall examine the hierarchical structures, classifications, repertoires and sets of dispositions that

shaped such encounters, and the ways in which they were negotiated by individuals.[38]

Furthermore, the interviews will be used alongside other textual sources to comment on the relationship between gender, physical surveillance and the implementation of welfare policies in the modern state. Sociological studies of the relationship between modernity and surveillance have tended to outline the broad strategic vision of policy-making and to focus on the net effect of policy implementation (the view from above).[39] This book takes a different approach, not only in its concern with the specifically gendered operation of surveillance but also in its focus on the tactical negotiations that took place at grassroots level. Chapters 2 and 3 will examine the ways in which policewomen's identities and work roles at the interface of policing and welfare were constituted through the cultural and structural formation of a 'feminine' professionalism. Chapters 4 and 5 examine women's operations within the technologies of physical surveillance, dealing with both uniform beat patrol and undercover observations. Chapters 6 and 7 deal with the regulation of specific groups through policewomen's 'specialist' role: firstly, the policing of family, youth and child welfare; and secondly, the regulation of sexuality in relation to adult women. A final chapter – 'Beyond integration?' – examines women's perceptions of the transformations of the 1970s and 1980s. It comments on the loss of women's distinct identity as a cultural group, comparing and contrasting the differing notions of 'equality' that have shaped the work of women in the police service across the twentieth century.

Notes

1 B. L. Q. Henriques, *The Indiscretions of a Magistrate: Thoughts on the Work of the Juvenile Court* (London: Non Fiction Book Club, 1950), pp. 48–9.
2 L. Hunt (ed.), *The New Cultural History* (Berkeley: University of California Press, 1991); W. H. Sewell, 'The concept(s) of culture', in V. E. Bonnell and L. Hunt (eds), *Beyond the Cultural Turn* (Berkeley: University of California Press, 1999); M. Poovey, *Making a Social Body: British Cultural Formations 1830–64* (Chicago: Chicago University Press, 1995).
3 The Metropolitan Police and the Royal Ulster Constabulary used the term 'Women Police'; women officers were titled WPC (Woman Police Constable) or WPS (Woman Police Sergeant), etc. The term 'policewomen' was used in Birmingham, Leeds, and in Scotland, where women were titled PW. I use the terms 'women police' and 'policewomen' interchangeably throughout.
4 Histories of gender and crime have tended to concentrate on the eighteenth and nineteenth centuries; see M. L. Arnot and C. Osborne (eds), *Gender and Crime in Modern Europe* (London: UCL Press, 1999). Recent work exploring the twentieth century

INTRODUCTIONS

includes: P. Cox, *Gender, Justice and Welfare: Bad Girls in Britain, 1900–1950* (Basingstoke: Palgrave, 2003); S. D'Cruze (ed.), *Everyday Violence in Britain, 1850–1950* (Harlow: Longman, 2000); S. D'Cruze, 'Crime', in I. Zweiniger-Bargielowska (ed.), *Women in Twentieth-Century Britain* (Harlow: Longman, 2001).

5 H. Sommerlad and P. Sanderson, *Gender, Choice and Commitment: Women Solicitors in England and Wales and the Struggle for Equal Status* (Aldershot: Ashgate, 1998), p. 19.

6 Judith Butler, *Gender Trouble: Feminism and the Subversion of Identity* (London: Routledge, 1990), has been instrumental in defining gender as a 'performative' process through which meanings are 'dramatically' and 'contingently' constructed (see p. 139).

7 J. W. Scott, *Only Paradoxes to Offer: French Feminists and the Rights of Man* (Cambridge, Mass: Harvard University Press, 1996).

8 S. O. Rose, *Which People's War? National Identity and Citizenship in Wartime Britain 1939–1945* (Oxford: Oxford University Press, 2003).

9 For the traits of the ideal-typical profession, see A. Etzioni (ed.), *The Semi-Professions and their Organization* (Toronto: Free Press, 1969); for professionalisation as a gendered strategy, see A. Witz, *Professions and Patriarchy* (London: Routledge, 1992).

10 D. Walkowitz, *Working with Class: Social Workers and the Politics of Middle-Class Identity* (Chapel Hill: University of North Carolina Press, 1999), p. 111.

11 J. Lock, *The British Policewoman* (London: Robert Hale, 1979); J. Carrier, *The Campaign for the Employment of Women as Police Officers* (Aldershot: Avebury, 1988).

12 M. Cameron, *The Women in Green: A History of the Royal Ulster Constabulary's Policewomen* (Belfast: RUC Historical Society, 1993).

13 L. Bland, 'In the name of protection: the policing of women in the First World War', in J. Brophy and C. Smart (eds), *Women in Law* (London: Routledge, 1985); P. Levine, 'Walking the streets in a way no decent woman should', *Journal of Modern History*, 66 (1994), 34–78; A. Woodeson, 'The first women police: a force for equality or infringement', *Women's History Review*, 2 (1993), 217–32; A. M. Woollacott, '"Khaki fever" and its control: gender, class, age and sexual morality on the British homefront in the First World War', *Journal of Contemporary History*, 29:2 (1994), 325–47.

14 For an important exception, see B. Weinberger, *The Best Police in the World: An Oral History of English Policing from the 1930s to the 1960s* (Aldershot: Scolar Press, 1995).

15 L. Doan, *Fashioning Sapphism: The Origins of Modern English Lesbian Culture* (New York: Columbia University Press, 2001); R. M. Douglas, *Feminist Freikorps. The British Voluntary Women Police 1914–1940* (Westport: Praeger, 1999).

16 S. E. Martin, *Breaking and Entering* (Berkeley: University of California Press, 1980); S. Jones, *Policewomen and Equality* (Basingstoke: Macmillan, 1986); J. D. Brewer, 'Hercules, Hippolyte and the Amazons – or policewomen in the RUC', *British Journal of Sociology*, 42 (1981), 231–47.

17 Brewer, 'Hercules, Hippolyte and the Amazons', p. 245.

18 F. Heidensohn, *Women in Control? The Role of Women in Law Enforcement* (Oxford: Oxford University Press, 1992); J. Brown and F. Heidensohn, *Gender and Policing: Comparative Perspectives* (Basingstoke: Macmillan, 2000).

19 P. Dixon, *Northern Ireland: The Politics of War and Peace* (Basingstoke: Palgrave, 2001), introduces these issues.

20 J. McGarry and B. O'Leary, *Policing Northern Ireland: Proposals for a New Start* (Belfast: Blackstaff, 1999), p. 28. Plans to reform the RUC, laid out in the Good Friday

Agreement of 10 April 1998, led to its replacement with a newly constituted Police Service of Northern Ireland.

21 J. Brewer with K. Magee, *Inside the RUC: Routine Policing in a Divided Society* (Oxford: Clarendon, 1991), p. 4. Brewer's study was specifically concerned with routine and public service policing, in order to offset the 'folk myth' that RUC officers were constantly involved in anti-sectarian combat.

22 Memoirs of 'great' detectives include R. Fabian, *Fabian of the Yard* (London: Naldrett Press, 1950), and P. Beveridge, *Inside the CID* (London: Evan Brothers, 1957). Autobiographies of high-ranking policemen include P. Sillitoe, *Cloak without Dagger* (London: Cassell, 1955), and R. Mark, *In the Office of Constable* (Glasgow: William Collins, 1978). See H. Daley, *This Small Cloud: A Personal Memoir* (London: Weidenfeld, 1986) for an atypical focus on the uniform beat constable.

23 M. S. Allen, *The Pioneer Policewoman* (London: Chatto and Windus, 1925); M. S. Allen and J. H. Heyneman, *Woman at the Cross Roads* (London: Unicorn, 1934); M. S. Allen, *Lady in Blue* (London: Stanley Paul, 1936).

24 L. Wyles, *A Woman at Scotland Yard* (London: Faber and Faber, 1952).

25 D. O. G., Peto, *The Memoirs of Miss Dorothy Olivia Georgiana Peto OBE* (Bramshill: Organising Committee for the European Conference on Equal Opportunities in the Police, 1992).

26 Metropolitan Police Museum, London (henceforth MPM), unpublished typescript, P. M. Lovell, 'The Call Stick', undated.

27 Bury Central Library (BCL), unpublished typescript, E. Sharples (née Hoyle), 'My Life's Work', 1968.

28 S. Condor, *Woman on the Beat* (London: Robert Hale, 1960); J. Lock, *Lady Policeman* (London: Michael Joseph, 1968).

29 J. Hilton, *The Gentle Arm of the Law* (Reading: Educational Explorers, 1967).

30 A. Halford, *No Way Up the Greasy Pole* (London: Constable, 1993); C. Bristow, *Central 822* (London: Bantam, 1998).

31 There were 187 individual forces in England and Wales in 1908. These were reduced, through amalgamation, to 125 in 1960, 117 in 1966 and 41 by 1974. See C. Emsley, *The English Police: A Political and Social History* (Harlow: Longman, 1991), pp. 116, 169–74.

32 Pseudonyms are used to refer to this group of 40 women in order to protect identity. Of these 40, 20 left the police service as constables, 7 as sergeants, 2 as chief inspectors, 3 as superintendents and 1 as a chief superintendent. Interview volunteers were identified through three processes – a) Advertisements were placed in the *MWPA Newsletter* and *London Police Pensioner* (NARPO); I attended social events in the four Metropolitan Police districts to talk informally to MWPA members and to make initial contacts; 15 women were identified for interview (the Met was the largest employer of policewomen across the century and the sample aimed to reflect that); b) The RUC was selected as a point of focus as the second largest force in the UK; information about the research and a request for former RUC volunteers was distributed at a social event organised by the Evergreens; six women were subsequently interviewed; c) A further set of interviews with 19 women was arranged as a result of 'snowballing' through key contacts in NARPO and the Glasgow Police Heritage Society; six of this final group had served in Bournemouth Borough Police (as well as other forces), which provided a useful example of a small town force.

All interviews took place between February 2001 and November 2003, either in the women's homes or the homes of former colleagues. The interview was semi-structured: I initially invited a chronological framework ('Tell me about your background and why you joined') as one with which most people would be familiar. Similar ground was covered in each interview, while women were allowed to follow their own routes if they wished. On four occasions women were interviewed in pairs, creating a dialogue between them and less input from the interviewer.

33 The 42 women served in a mean average of 1.5 forces (two of the women having served in four forces). The relationship of the 42 women to service in 26 forces is as follows: Bath (1 woman); Birmingham City (2); Bournemouth Borough (6); Coventry City (1); Dorset (5); Essex (2); City of Glasgow (2); Gwent (1); Hampshire (1); Hull City (2) Humberside (4); Kent (1); Leeds City (3); Lincolnshire (3); Manchester City (1); Met (15); Newcastle (1); Nottinghamshire County (1); Portsmouth City (1); RUC (6); Surrey (1); West Midlands (2); West Riding (1); West Sussex (1); West Yorkshire (1).
34 Douglas, *Feminist Freikorps*; Lock, *British Policewoman*.
35 J. W. Scott, 'The evidence of experience', *Critical Inquiry*, 17:3 (1991), 773–97.
36 L. Stanley, *The Autobiographical I* (Manchester: Manchester University Press, 1992), p. 246. For the analysis of oral testimony, see S. B. Gluck and D. Patai, *Women's Words: The Feminist Practice of Oral History* (London: Routledge, 1991); and, by P. Summerfield, *Reconstructing Women's Wartime Lives: Discourse and Subjectivity in Oral Histories of the Second World War* (Manchester: Manchester University Press, 1998).
37 Cameron, *Women in Green*. The *MWPA Newsletter* invites members to contribute old photographs and personal reminiscences.
38 P. Bourdieu, *The Logic of Practice* (Cambridge: Polity, 1990).
39 For example, D. Garland, *The Culture of Control: Crime and Social Order in Contemporary Society* (Oxford: Oxford University Press, 2001); J. Donzelot, *The Policing of Families* (Baltimore: Johns Hopkins University Press, 1997); M. Foucault, *Discipline and Punish* (London: Penguin, 1991).

2

Networks, structures and hierarchies

POLICE FORCES IN THE UK have emerged historically as semi-autonomous, bureaucratic organisations, structured in terms of a pyramidal hierarchy that creates a framework of authority and deference.[1] While much of this book is concerned with the everyday practices of policing, including encounters on the street and in other public places, it is important to discuss the institutional structures and hierarchies – including those of gender – that shaped professional experiences. Although women officers were appointed within police forces, they were often segregated into separate offices, branches or departments in the first half of the century. Yet their duties were never merely 'specialist': the balancing of 'women's' work and general 'policing' work was a subject of constant debate. This chapter will outline the tactics – including the cultivation of *influence* as much as authority – that were used by 'pioneers' to negotiate a growing role for women officers within existing structures. I shall demonstrate that senior women officers achieved considerable success in creating their own professional networks that cut across individual police forces. These networks were strengthened after 1945 with the appointment of the first woman as an Assistant to His Majesty's Inspectors (HMIs) of Constabulary. This appointment was to prove decisive in the expansion of women's work in policing and in the standardisation of their duties.

The figure of the chief police*man* – titled 'chief constable' in provincial forces, 'commissioner' in the Met, and 'inspector general' in the RUC (until replaced with the designation of chief constable in 1970) – looms large in this account.[2] Members of the UK's individual police forces took great pride in local autonomy and identity. Tensions were likely to arise when localism was challenged by centralising tendencies, either in the form of women's national networks or the Home Office desire to standardise procedure. Indeed the refusal of the Home Office and

Scottish Office to make the employment of women compulsory, relying instead on advice and persuasion, arose from concerns about stepping on the toes of police chiefs. Women officers were often caught up in the tensions between local and centralising agendas. The exact nature of their duties varied between forces and was a result of individual negotiations between policewomen, chiefs and other senior policemen. Because they were initially few in number, policewomen often had unique access to their chiefs compared to men of their rank, and in some forces they had considerable latitude in the shaping of their duties.

My discussion will be set against the ideological contexts of gender politics and in relation to the impact of total war in the first half of the twentieth century. The campaign for women police officers can be seen an integral part of the history of first-wave feminism in the UK.[3] In its earliest stages, it drew on what can be loosely characterised as both liberal and radical feminist arguments. Josephine Butler's opposition to the Contagious Diseases Acts in the 1870s – which had legislated for the arrest, detention and forced medical examination of women alleged to be prostitutes – had involved a critique of the brutality of a male-dominated criminal justice system.[4] Edith Watson and Nina Boyle of the suffrage organisation the Women's Freedom League (WFL) called for women magistrates, jurors, police and police surgeons in the pages of *The Vote* in 1912.[5] It was inappropriate, they said, for courts to be cleared of women observers when sexual assault cases were heard, leaving female victims alone to give their evidence in a courtroom full of men. They proposed that women police should be appointed to take statements from female victims of assault, to escort them in court, and to search women prisoners. From the 1880s onwards, child welfare organisations such as the NSPCC argued similarly that women police were needed to attend to child victims.[6] The argument centred on justice, dignity and legal rights for women and children. However, overtly 'feminist' arguments about women and policing were increasingly replaced with other agendas.

It has been argued that war tends to be a 'gendering activity', in which the participatory roles of combatants and non-combatants alike are marked in terms of masculinity and femininity.[7] During both the First and Second World Wars, women's increased involvement in the policing of the home population was positioned in terms of women's 'war work', undertaken for 'the duration' only and in relation to a feminine duty to serve the nation. Certainly wartime conditions and experiences facilitated women's move into policing, demonstrating their utility and creating precedents that could be drawn upon by 'pioneers'; to some degree, therefore, war was an accelerator of social change. As the Higonnets have

argued, however, the process of gender transformation during wartime was in part illusory; while women appeared to advance, gender lines were redrawn as war ended and attempts were made to restore women to a more conventional role.[8] A resolute and vociferous lobby had some success in consolidating women's involvement in the police service in the years after 1918 and, in particular, after 1945, evidencing a process of change. Yet the argument was often won on the grounds of gender difference rather than equal rights: that there was 'a special sphere of usefulness' for policewomen. The idea that policewomen could be 'specialists' in duties pertaining to women and children became a central focal point for attempts to consolidate their role and expand their numbers from the 1920s through to the 1950s. A final section of the chapter uses oral history interviews to examine women's day-to-day experience of structures and hierarchies, moving on to tackle the question of sexual harassment – a key concern of second-wave feminism – in the police service in the years before integration.

The politics of difference

During the First World War the highly visible involvement of over 6,000 women in the UK in activities loosely termed as 'policing' was coordinated through two separate organisations. Firstly, the National Union of Women Workers (NUWW, renamed the National Council of Women or NCW in 1919), an association with strong interests in philanthropy and moral welfare, organised the work of around 5,000 voluntary patrols, dressed in dark coats and armbands.[9] A small number of 'superpatrols', recruited through the NUWW/NCW Bristol Training School for Women Police, began to create professional roles. A second organisation, the Women Police Volunteers (WPV, renamed the Women Police Service or WPS in 1915), brought together an unusual combination of former suffragettes and social purity activists. The WPV/WPS trained a further 1,080 women between 1914 and 1920. Edith Smith was sworn in as a member of the Grantham Police Force in 1915 – as the first attested policewoman in the UK – and a further 148 WPS members were employed by 31 police forces, 9 local authorities and 24 voluntary committees/groups between 1915 and 1920.[10] The vast majority of WPS members (91 per cent) were employed by the Ministry of Munitions to supervise women workers in munitions factories. Historical debate has centred on the extent to which the initial goals of feminists were diluted, compromised and sublimated in relation to the war effort.[11] Those who supported women's involvement in patrolling and 'policing' during the First World War

sought to make the streets safe spaces for 'vulnerable' women and children, but they also exhibited a desire for moral and sexual regulation that threatened other women's freedom.

During the 1920s the number of women involved in policing in the UK fell to a few hundred (mostly employed within police forces), although a series of parliamentary committees made strong recommendations that policewomen should be employed for gender-related duties.[12] The inter-war campaign for their appointment drew together a broad coalition of viewpoints. Feminist arguments about the legal rights of women and children soon blurred with protective arguments about moral propriety (that it was indecent for a woman to be questioned by men about intimate matters) and traditionalist viewpoints, which demarcated the 'sphere' of social/welfare work as feminine. Although there were female opponents of the employment of policewomen in the inter-war period, the issue tended to unite women associated with mainstream political parties around a broadly liberal agenda.[13] The Sex Disqualification (Removal) Act of 1919 made it possible for women to be appointed as magistrates or lawyers and to stand for election to the House of Commons. Between 1919 and 1945, women MPs – Nancy Astor (Conservative), Margaret Wintringham (Liberal), Ellen Wilkinson (Labour), Eleanor Rathbone (Independent), Megan Lloyd George (Liberal) and Edith Picton-Turbervill (Labour) – joined a series of lobbies and deputations to the Home Secretary, arguing that every police force in the country should employ women to take statements from female and child victims, that conditions of service should be standardised, and that a woman should be appointed to work with HMIs of Constabulary.[14] These deputations were supported by a coalition of women's organisations, which included professional associations (such as the National Union of Women Teachers), former suffrage societies (the WFL and the National Union of Societies for Equal Citizenship), groups with religious affiliations (the Catholic Women's League), domestic associations (the Women's Institute) and former vigilance societies (the Association for Moral and Social Hygiene). The lobbying was frequently orchestrated by the NCW, whose countrywide branches organised regular petitions to both central government and local police committees.[15] While the NCW is frequently depicted as a middle-class organisation, demands for women officers were also made by branches of the Women's Co-operative Guild, which had a predominantly working-class base.[16]

It is often argued that the 1920s saw a splitting of feminist ideologies. 'Old' feminists such as Margaret Rhondda and Winifred Holtby continued to advocate equal rights for men and women, believing that gender

difference should be eradicated. The 'new' feminism associated with Eleanor Rathbone emphasised difference between the sexes and argued that women should be valued for their special role as citizens, which was located in relation to maternity.[17] As Susan Kingsley Kent has demonstrated, '"new" feminist demands arose from the conviction that sexual difference rather than a common humanity characterized the "natural" relationship between men and women'.[18] The aftermath of the First World War had seen a rejection of aggression and a desire to associate womanliness with peace and procreation. References to both 'equality' and 'difference' were apparent in campaigns for the employment of women police and were sometimes deployed together. However, an emphasis on women's 'duty' and special skills tended to dominate.

The argument about sexual difference was adopted by both those (such as Rathbone) who identified as 'feminist', as well as women MPs who rejected the label. In the Northern Ireland Parliament, the 1922 maiden speech of the unionist MP Julia McMordie highlighted the significance of the special relationship between women and children, as she called for an increase in policewomen in Belfast (from a current establishment of two): 'there are some cases where a woman's influence is superior to that of a man . . . there are many cases affecting women and children who can tell their story with much greater ease to a woman than to a man'.[19] Her reasoning was based on biological essentialism as well as awareness of processes of acculturation: children who were accustomed to female carers were more likely to relax in their presence, while women's maternal function made them more adept in dealing with children. In the UK Parliament, Labour MP Ellen Wilkinson rejected the 'equality' argument: 'I have always stood out against the extreme feminist attitude that women can necessarily perform the same duties as men'.[20] She maintained that women constables 'have a special job to do, work that it is undesirable that any man should be called upon to undertake . . . the many difficult cases arising out of offences committed by and on women and children'.[21]

Women had been accorded a public role during the nineteenth century by associating themselves with the sphere of the 'social', in which they were deemed to have a specialist expertise.[22] Strands within first-wave feminism had positioned women as morally superior to men in their quest to 'banish the beast' of male sexuality.[23] By maintaining the notion of sexual difference, inter-war women MPs appealed to a traditional antifeminist interest that had always valued the framework of 'separate spheres'. Tactically, the concept of 'a special sphere of usefulness for policewomen' was more likely to win arguments against vested male

interests, since women would not be viewed as a direct threat to male labour.[24] The campaign for women officers was positioned in terms of debates concerning liberal citizenship and the promotion of a 'specialist' role for women in the existing apparatus of the modern state.

Separate or integral?

The connection between suffrage militancy and women's activity in policing had been embodied in the 'masculine' figure of Mary Allen, who was regularly photographed for the inter-war British press in a uniform that included breeches, cropped hair and a monocle.[25] A former suffragette hunger-striker and member of the Women's Social and Political Union (WSPU), Allen had been involved in setting up the WPS with Margaret Damer Dawson, who had been formerly involved in rescue work with the National Vigilance Association (NVA).[26] When Sir Neville Macready, Metropolitan Police Commissioner, agreed to employ women patrols as part of the force at the end of the war, he rejected Allen and Damer Dawson in favour of members of the NCW patrols. In 1921 the WPS (now under Allen's sole leadership) was forced to change both its uniform and its name – to the Women's Auxiliary Service (WAS). It is highly likely that Allen's links with militant suffrage made her unpopular with the male establishment. Allen was also increasingly marginalised by other 'pioneer policewomen', because of anxieties surrounding her political viewpoints, transgressive image and separatist arguments, which were felt to undermine the campaign for women officers.

The WAS and the NCW clearly shared common ground. Both advocated the appointment of women police as attested officers and both recognised the need to train women to undertake this work. The NCW had been associated with the founding of three Federated Training Schools – in Bristol (1916), Liverpool (1917) and Glasgow (1918) – which had initially agreed to take members of both organisations. Yet there was a central point of contention. The WPS/WAS wanted an entirely separatist organisational structure, based on a nationally centralised Women Police Service with authority and ascendancy over chief constables, run by women and uncontaminated by male intervention. This separatist structure was similar to that pioneered for nursing by Florence Nightingale in the 1850s.[27] The NCW, however, argued that 'all policewomen should be an integral part of the police service, under the authority of chief constables, on the same footing as men'.[28] Women with links to both the WPS/WAS and the NCW found their loyalties split. In 1920, Iveigh More Nisbett wrote to Edith Tancred, Director of the NCW's

Glasgow Training School, to tell her that she had decided to transfer to the WPS: 'I have always felt my home was with the WPS as they are simply the WSPU and I always was one of them ... I am heart and soul with Miss Damer Dawson on the advisability of a state Service of Policewomen officered *by women* [sic]'.[29] The desire of the WPS/WAS to retain a hold over its women was not welcomed by chief constables, whose autonomy was threatened. In November 1918, Lily M. Allen was employed by Huddersfield Borough Police as one of two lady police assistants.[30] She had been trained by the WPS, who were keen to retain her membership. To her chief constable this was clearly undesirable: 'with regard to the question of you remaining in the WPS after taking up your duties here, I do not favour the idea at all'.[31] She agreed to sever her links.

Mary Allen's controversial political trajectory has led the historian R.M. Douglas to entitle his book on the history of the WPS/WAS *Feminist Freikorps*. In 1926, Allen formed a special WAS Emergency Corps to help break the General Strike. In 1934 she visited Germany, penning a laudatory account of Hitler's work in her autobiographical *Lady in Blue*. Finally, in 1939 she declared herself a supporter of Mosley's British Union of Fascists; she was made the subject of a detention order, her house was raided and fascist publications seized.[32] While there clearly were members of the WAS with fascist sympathies (including More Nisbett), it is problematic to project Allen's political sympathies on to the entire organisation. In 1921, the WAS had 110 members employed in 28 county and borough forces and a further 19 in the private sector.[33] Allen herself never served within an UK police force, although she was awarded expenses by the War Office between 1923 and 1925 to undertake duties in relation to the regulation of prostitution within the occupied zone of the Rhine.[34] Those employed within the service tended to distance themselves from her. It has been suggested that Barbara Denis de Vitré, later Assistant HMI, preferred not to have her WAS training stressed and did not approve of Mary Allen's methods, her desire for a separatist structure, nor her links with suffrage militancy.[35]

The model that was adopted within the UK police service in the 1920s, and that dominated for the next 30 years, was neither separatist nor fully integrated. While rejecting the notion of a separate 'national' service of policewomen, chief constables encouraged the development *within* forces of separate structures and hierarchies (which developed into 'Policewomen's Departments' in urban areas in the 1930s and 1940s). This not only protected women to some extent from the jealousy of rank-and-file policemen who, as members of the Police Federation, had opposed women's appointment in 1918.[36] It also positioned

women's work structurally and spatially in terms of gender difference, emphasising the rhetoric of women's 'special sphere of usefulness' as guiding rationale.

Working with the chiefs

Policewomen's roles and working conditions were carefully negotiated with their chief constables during the First World War and the inter-war period. When, for example, Edith Hoyle was appointed as Huddersfield's first lady police assistant in 1915, she took her orders 'from the Chief Constable or his deputy, and no other rank'. Her office was adjacent to his and she was given 'somewhat of a free-lance' in creating a specific body of work in relation to child protection and the shop acts.[37] Such close patronage could, however, lead to jealousy from those whose work she had usurped, as well as vulnerability when her patron left the force (and she felt obliged to resign). Without standardisation or formal recognition, the position of early policewomen was dependent on persuasion and personality.

The career of Dorothy Peto – who became the most senior policewoman in the country as head of the Metropolitan Women Police Branch from 1930 to 1946 – indicates the significance of negotiation skills in dealing with chiefs, the need for a careful balancing of the rhetoric of both equality and femininity, and the importance of personal determination and strength of will.[38] When the chief constable of Birmingham City Police was looking to appoint a lady enquiry officer in 1920, he requested 'a really good woman for the work and not a faddist who wants to air her own particular views'.[39] In 1922 the post was offered to Peto, former Director of the NCW's Bristol Training School, despite a slightly guarded recommendation from the city's chief constable: 'I have not the slightest doubt about her ability and general character which are both excellent, but I would have appreciated her interests in police work the better had she steered clear of those, who perhaps not out and out suffragists, have pronounced views on "Women's Rights".'[40] While she had no direct connections with the suffrage movement, she had campaigned for policewomen to be given powers of arrest at the end of the First World War. In Birmingham she appears to have built up a good working relationship with male colleagues, while continuing to argue that she should be given powers of arrest.[41] Her argument hinged on both her inferior legal status as a woman officer (which could be equated with a 'women's rights' position) and issues of professional effectiveness. For the most part, however, Peto avoided overtly feminist statements and her memoirs have

little to say about her personal motivations or aims. They are diplomatic about her dealings with the WPS, including only a brief reference to Allen.

Peto worked extremely effectively with the Met's commissioners and assistant commissioners, negotiating an increase in establishment from 51 to 152 in her 16 years of office, as women were gradually sent out to work in most of the Met's Divisions. She constructed her requests for increases in relation to women's specialist role with regard to child protection, which she had done much to develop (see Chapter 6). In 1943, she argued that more women police were needed to deal with the increase in juvenile delinquency and child neglect resulting from the broken homes and unsatisfactory parenting that she associated with war conditions. Elizabeth Bather, who succeeded her in 1946, made similar requests and the establishment was raised to 338 in 1948. Peto's influence was felt far wider than the Met. Not only was she regularly called upon to advise the Home Office on child welfare policy, but the women whom she trained took the Met's ethos to other forces. In 1943, Sergeant Marion Macmillan of the Met was appointed by the RUC to develop the work of policewomen in Northern Ireland (where two women officers had performed specialist plain-clothes duties in Belfast for the last 30 years).[42]

Outside of the UK's largest cities, there was a tendency to employ policewomen individually or in twos or threes during the 1930s. Hopes for the standardisation of duties, pay and conditions were not met, even when the Home Secretary issued the Police (Women) Regulations for England and Wales in 1931 (extended to Scotland in 1934). The regulations merely offered a list of duties that 'may be assigned to police women'. These included patrol duty, escorting women and children and taking statements from them in relation to sexual offences, watching and searching female prisoners or those who had attempted suicide, clerical work, plain-clothes duty and detective work. The Regulations also highlighted 'duties in connection with women and children reported missing, found ill, injured, destitute, or homeless, and those who have been the victims of sexual offences, or are in immoral surroundings', signposting their potential uses in relation to 'welfare' work.[43] The Regulations provided a framework that could be used for discussion within individual forces. Oldham's first policewoman, Clara Walkden (who had been appointed in 1921), commented on them in depth. In a report prepared for her chief constable she identified closely with essentialist arguments, stating that 'women are more qualified by nature than men to attend to women, girls and children' and that 'natural sympathy and understanding' could be claimed by 'any true woman'.[44] Not only had the argument regarding

women's 'special sphere of usefulness' gained women entry to the police service, but it also shaped discussions of their work internally. Although the testimony of early constables is rare, it is probable that the majority of women who were appointed in the 1930s and 1940s used it – to a greater or lesser degree – to justify and explain their capabilities and responsibilities. As Chapter 3 will show, any emphasis on 'femininity' increasingly framed recruitment campaigns and media representations.

The Second World War

The concept of the 'feminine' continued to be a point of reference during the Second World War, although some members of the newly created Women's Auxiliary Police Corps (WAPC) were deployed to undertake more 'masculine' activities. Women were appointed as auxiliaries from 1939 onwards, ostensibly to free up men for military duty and to allow remaining male officers to concentrate 'their full time and energy on tasks, which they alone can perform'.[45] Their numbers were originally pegged to a maximum of ten per cent of the overall establishment, but this cap was lifted in 1941. It was initially expected that women auxiliaries should carry out duties that did not specifically require police powers: driving, maintenance of vehicles and equipment, clerical or telephone work, and canteen work. These were tasks given to women 'for the duration' only, on the understanding that policemen would return to their posts when the war ended.[46] Yet it soon became apparent that the war was exposing specific social issues relating to the regulation of women, children and adolescents as well as a need to intensify covert surveillance relating to the licensing laws. It was agreed, therefore, that there was a need for an expansion of those involved in 'feminine' policing duties.

Women's gender-specific duties grew during the Second World War to include the patrolling of railway terminals to prevent prostitutes 'molesting servicemen', as well as the supervision of air-raid shelters to prevent undesirable sexual activity. Policewomen were also involved in the arrest and escort of enemy women 'aliens', enquiries (for the War Office) relating to servicewomen who had absconded, the evacuation of schoolchildren, and the provision of support for relatives who were involved in the identification of bodies.[47] In addition, 11 women officers from the Met were seconded to the Isle of Man from 1940 to 1945 to undertake escort and surveillance duties with women aliens accommodated at Rushen Internment Camp.[48] Conditions of service for the WAPC, introduced by the Home Office in 1944, distinguished between 'Class A' women auxiliaries, who were engaged 'on police duties proper' as attested

officers undertaking gender-specific work, and non-attested 'Class B' auxiliaries, who were 'otherwise employed' as clerics and drivers purely as a function of wartime.[49] The marriage bar was temporarily lifted.

Sonya Rose has highlighted the 'contradictory effects' of the Second World War on female citizenship.[50] Women MPs rigorously campaigned to put equal pay and equal opportunities for women workers firmly on the agenda, and wartime undoubtedly disrupted assumptions about gender roles. Yet the concept of 'feminine duty', based on gender difference, was a central theme in postwar reconstruction. These contradictions are apparent within the police service. Reshaping the Met's postwar Women Police Branch, Elizabeth Bather carefully emphasised the sphere of femininity. In 1951 she wrote: 'I feel it is important to bear in mind that the function of Women Police is *not* [*sic*] to substitute men but to have available in the Force trained women to carry out those Police duties for which a woman is more appropriate than a man, i.e. duties in connection with women and children'.[51] As head of the West Riding's policewomen, Inspector Mary Danby agreed with Bather's approach, arguing in 1947 that women should be used 'primarily for the work they can do by virtue of their sex'.[52] Yet this rhetoric was deceptive, masquerading policewomen's growing workload. The expansion of women in the West Riding – from three regular policewomen in 1946, to 102 in 1957 – involved women 'carrying out almost every form of police duty'.[53] As subsequent chapters will demonstrate, a 'specialist' role was certainly consolidated for policewomen; nevertheless, many of their everyday duties and responsibilities were similar to (rather than distinct from) those of their male colleagues. In the RUC, Marion Macmillan developed the specialism in child protection that Peto had orchestrated at the Met, but also sought to broaden the base of their duties, writing in 1949 that 'the duties of women police do not vary much from those of their male colleagues'.[54] Under Macmillan the size of the RUC's newly uniformed Women Police Branch grew from 9 in 1943, to 15 in 1946 and 38 in 1957.[55] In the aftermath of the Second World War, policewomen performed a dual role that combined specialist 'women's' work with standard 'police' work.

Women at the Home Office

In 1945, Barbara Mary Denis de Vitré was appointed as a Police Staff Officer to assist the HMIs with the inspection of all provincial women police in England, Wales and Scotland (the Met was directly answerable to the Home Secretary).[56] She was given the tasks of monitoring duties and conditions of service, as well as advising chief constables and Home

Office civil servants on training and deployment. She was given the title of Assistant HMI in 1948 and became responsible for all annual inspections of women. De Vitré had considerable experience of developmental work, having overseen the genesis of policewomen's branches in Sheffield, Leicester and Kent as well as recruiting and training Egyptian policewomen. Between 1945 and her sudden death in 1960, the number of women employed in English, Welsh and Scottish police forces increased from 445 to 2,500, testimony in itself to her commitment and success. By 1969, this number had swelled to 4,700 (417 in Scotland).[57]

It should not be assumed that women's involvement in policing was assured in 1945. A significant number of women had carried out police work as their war service as members of the WAPC. Undoubtedly, assumptions about women and work had shifted, yet few chief constables were anxious to expand their establishments of regular policewomen at the end of the war. In her new role as Assistant HMI, de Vitré carefully persuaded chief constables, watch committees (in boroughs) and standing joint committees (in counties) of the need for a regular establishment of women (reinforcing the campaigns of women's lobby groups). Her position as an 'assistant' rather than a fully titled 'inspector' can be seen as a disappointing hint at women's inferior professional status. The appointment, however, was to be an extremely significant one for the development of women's policing. De Vitré and her successors turned the position of Assistant HMI into a high-profile and extremely influential one, from which they were able to advise chief constables and to create professional networks of policewomen, facilitating the exchange of knowledge and information. They successfully encouraged expansions in establishment and the range of duties undertaken by women as well as promoting strategies of professionalism, bureaucratisation and the standardisation of best practice. Barbara de Vitré was succeeded by Kathleen M. Hill (having worked with her closely at the Home Office since 1945), who served as Assistant HMI from 1960 to 1968. Scotland was given its own Assistant HMI in 1961, with the appointment of Janet Gray, who had served in Glasgow City Police. In 1962, Jean Law, formerly Woman Superintendent of the West Riding Constabulary, was appointed alongside Hill to undertake inspections of all women in England and Wales. Her duties were extended to Northern Ireland as a result of the Police Act (Northern Ireland) 1970, visiting the RUC for the first time in June 1972.

In the first few years of her appointment de Vitré made an exhaustive tour of all constabularies in Britain, auditing and reviewing women's employment. Her detailed personal notes for the years 1945–48, preserved together in a ring binder, provide a remarkable snapshot of women's police

work throughout the country in the aftermath of the war.[58] As unpublished reflections, often highly critical in tone, they offer insights into de Vitré's character, personality and negotiating skills, her involvement as 'troubleshooter', and her opinions regarding women and policing. They are suggestive of relationships between senior male officers and policewomen, and of the effectiveness of networks, structures and hierarchies.

De Vitré's notes show that in terms of numbers women were overwhelmingly employed in urban areas in 1945 (in rural constabularies they were often based in market or county towns). They also show that two models had influenced the organisation of policewomen's work before 1945. The first was the patrol model, developed during the First World War to regulate streets and public places, with an agenda of 'rescue' or moral welfare. This model was still firmly in place in Liverpool, where the watch committee employed unattested patrols until 1947.[59] In a small number of forces – most notably Ayrshire (one attested policewoman) and Caernarvonshire (two) – the work of regular attested policewomen was similarly restricted to uniformed patrol. The second model was the statement-taker detective, in which women were employed in plain clothes rather than uniform, often within the CID (but in a separate office). Edith Tancred suggested this model was widespread in Scotland, a result of a 1925 Scottish Office circular, which urged chief constables to appoint women to take preconditions (statements).[60] De Vitré's notes reinforce this. Where women were employed as regular police officers in Glasgow (fourteen women), Aberdeen (two), Renfrewshire (two), Lanarkshire (seven), Motherwell (one), Paisley (two), Kirkcaldy (one), Ayrburgh (two) and Banff (one), they were concerned with plain-clothes duties. In Edinburgh, women had been employed in statement-taking until the Second World War and had recently begun uniform duties, undertaking a wide variety of work when the force was visited in 1945. Outside of Scotland the model of the policewoman as statement-taker was in place in the West Riding (three women), Halifax (two) Lancashire (fifteen) and Monmouthshire (three). In the majority of forces a third hybrid model had developed, in which policewomen undertook a mixed range of uniform and plain-clothes duties. Women were first appointed in Wales during the Second World War, and regulars were attested on the hybrid model in Carmarthenshire (one woman), Neath (one), Newport (one) and Swansea (four) in 1945. A fourth group of provincial forces had chosen not to employ regular attested policewomen; these included Anglesey, Glamorgan, Cardiff, Montgomeryshire, Pembrokeshire, Merthyr Tydfil, Cornwall, Buckinghamshire, the North Riding, Huddersfield (despite the early appointment of Hoyle and Lily Allen), Fifeshire, Midlothian and Perth City. This group

had, however, appointed members of the WAPC to undertake clerical, driving and patrol duties as part of the war initiative.

A further analysis of de Vitré's notes reveals more of the personal dynamics that sustained these models. She divided women officers whom she met into 'good' and 'bad' 'types'. She wrote approvingly of those who were motivated, independent and keen to expand the scope of their duties; Inspector Jessie Dean of Leeds was 'keen and go ahead and controlling her department very well'. Those who preferred to restrict their duties to office-based work were described as 'old-fashioned' and of the 'old type'. In some forces she felt women constables were held back by the conservatism of women inspectors recruited in the 1920s, often as police widows, who had received no formal police training (and who had clearly not been involved in the WAS or the NCW training schools). This was presented as a particular problem in the cities of Glasgow and Manchester. Although Glasgow City Police had employed women since 1918, she felt they had failed to develop the range of duties of women in Kent or the Met. In 1945, Glasgow's 14 regular policewomen were employed in plain clothes only, based in the CID either at Headquarters or on Divisions, and their work only involved statement-taking and related enquiries. De Vitré commented that 'many have long service and are dug in too deep in their division. All fiercely oppose any change and look upon uniform work as beneath them.'[61] Glasgow's 135 attested auxiliary policewomen, appointed as part of the war effort, performed much wider duties than the regulars in the city. De Vitré's solution lay in the disbanding of the auxiliaries and the recruitment of the best of them as regular uniformed constables with an expanded remit. Manchester employed 9 regular uniformed women police and 22 auxiliaries under the authority of Inspector Emma Jane Ball. They were not given warrant cards and full powers of arrest until 1940 and still performed very limited duties. When de Vitré visited in April 1945 she commented on the disinterest of the chief constable and the lack of effective leadership from the women inspector, who 'constantly putting the brakes on'. De Vitré identified training as priority and gradually persuaded the chief constable of Manchester to send women on the CID course at the Detective Training School, Wakefield. She also invested her hopes in Sergeant Nellie Bohanna, suggesting that she should be sent on the 'A' course (for inspectors) at the police training college at Ryton-on-Dunsmore in 1948. A year after her return, Bohanna took over the reins on Ball's retirement, and set about creating a very different ethos.

De Vitré's opinions of chief constables were recorded warts and all: 'very noisy and has been quite stupid over the women' (Hull); 'very

old-fashioned and pig-headed and will need shaking up pretty soon' (Huddersfield). She found others extremely amenable and charming: 'intelligent and co-operative' (Cardiff); 'most enthusiastic and giving full support' (Swansea); 'pleasant and open to suggestion' (Bradford).[62] In structural terms, the HMIs had no direct authority over chief constables or the police committees who appointed them. The County and Borough Police Act of 1856 had laid down the principle of annual inspection and certification of efficiency, upon which the award of Treasury grants was dependent. By the twentieth century, forces in England and Wales received half of their funding from central government and raised half from local rates.[63] It was extremely rare for the HMIs to recommend that a grant should not be made. All increases in the size of force establishments were subject to Home Office approval upon application from police committees, but the Home Office was unable to demand increases or reductions. HMIs could, however, attempt to exert pressure and influence. This was a strategy that de Vitré adopted with zeal and perseverance, identifying those who would be susceptible to intelligent discussion and those who required 'continuous prodding'.[64]

While it was clear that different forces had different needs, the desire for standardisation is apparent in de Vitré's notes. In all cases, auxiliaries and other non-regular policewomen were to be phased out and the establishment of regulars, with a mixed diet of plain-clothes and uniform duties, was precipitated. In Liverpool she finally persuaded the watch committee and chief constable to apply for the establishment of 20 regular policewomen in 1947 in place of the voluntary patrols that had been funded directly from watch committee grants since the First World War.[65] Cornwall was the last English force to appoint regular policewomen (also in 1947) after campaigning by local women's groups as well as Home Office pressure. Standardisation was accompanied by bureaucratisation – in particular, the development of indexing systems to record information about women and children coming to attention – and a strategy of professionalisation, which involved the selection of good-quality applicants and the use of a range of training packages that straddled local and regional policing boundaries. The Federated Training Schools run by the NCW had closed in 1921 after the Baird Committee had recommended that training should be organised by chief constables on a mixed rather than a segregated basis.[66] During the inter-war period, however, there had been no consistent policy across provincial forces on the training of policewomen; series of ad hoc arrangements were made and some women in small forces had received no formal training whatsoever. This was soon to change as a result of general developments in training

programmes, which were harnessed by the women. The year 1946 saw the opening of District Training Centres, and two of them – Ryton-on-Dunsmore (near Coventry) and Bruche (near Warrington) – offered joint training courses for men as well as women, to which de Vitré was firmly committed, and she advised chiefs accordingly. When Ryton became the Police Staff College for senior officers in 1948, Mill Meece in Staffordshire began to take women instead. In addition to the initial 13-week course undertaken by all new probationers, the postwar period saw the development of specialist courses for sergeants, inspectors and CID officers, which were also accessed by the RUC. In Northern Ireland, women probationers attended the Training Depot at Enniskillen since the launch of the Women Police Branch in 1943; and from 1948 onwards classes were mixed, a result of 'much persuasion' on Marion Macmillan's part.[67]

As a woman of middle-class birth with a university education as well as substantial police experience, de Vitré had the deportment and personality that conveyed gravitas through presence and demeanour. Women who remember meeting her at early stages of their careers describe her as a formidable figure: 'She was a very strong powerful woman' who 'knew she was the boss'.[68] Annual inspections by the HMIs were bound to be formal ceremonial occasions, yet oral history accounts suggest that de Vitré's disciplined and austere exterior in official situations was combined with a warmth on informal occasions. She attended the annual cricket match between the Metropolitan Women Police Branch and Leeds City Policewomen's Department, joining in if teams were short of numbers.[69] De Vitré's inspection notes similarly convey an impression of force of character and determination. They also suggest she was able to use discretion in personal dealings, exercising considerable charm over watch committees and chief constables in order to persuade rather than coerce those whom she considered to have 'old fashioned' views.[70]

Jean Law, who served as Assistant HMI from 1962 to 1976, has spoken of the even temperament, tact, patience and diplomacy that were required in her dealings with chief constables:

> They didn't all do what I wanted to do, but I didn't upset. I'd go back the next year and the following year . . . 'I tell you what I've done, Miss Law, I've now got two girls in the CID, and I've got one on the motor patrol' . . . and all the things that I had been preaching for years, but he was boasting to me that he had done it. And I was just pleased and thankful that it was being done . . . That was the kind of thing I was doing: advising chiefs, trying to steer them in the right direction of employing more women and employing them properly; and it sometimes succeeding.[71]

Inspections involved lengthy meetings with both senior officers and junior policewomen. In her 1972 report on the RUC's Women Police, Law advised that 'policewomen should be relieved of searching duties at Long Kesh [internment camp] as soon as possible because of the bad effect on their relations with women in the community'.[72] Oral testimony suggests this was a key issue for junior officers, although not identified as controversial in the notes submitted by the RUC's chief constable.[73] Law often acted as an intermediary between policewomen and their chiefs, in the case of one English force negotiating access to driving courses.[74]

While rank-and-file policewomen could use the inspector's visit to raise issues of concern, it was important to do so discreetly. One Leeds City policewoman, who was serving in the CID in 1957, was concerned because women were no longer being sent to the Detective Training School at Wakefield:

> I waited until Miss De Vitré ... came on an inspection visit and ... we were all in this room, and she said, 'Has anybody any complaints or anything they wish to say?' So I stood up and said, 'Could you tell me if it's now the policy in this force to stop sending women officers on CID courses?' And so, she turned round to the chief constable and he said, 'Oh no, no, no, it's not a policy,' and that was the end of that. Well, what happened was that all the other women were sent on a CID course, the other three, but I never went on a CID course.[75]

It is possible that this policewoman's behaviour was resented as disloyal to the force. If she was being 'punished' for her indiscretion, she felt it was nonetheless worthwhile: 'if I hadn't done it, others wouldn't have gone ... we had to battle quite a lot'.[76] De Vitré's influence on this occasion assisted the group but not the individual.

De Vitré, Hill and Law were driven by a total commitment to women's police work and a desire to protect and advance what they saw as the interests of women in policing. They saw this in terms of the greater good of the service as a whole. Within a male-dominated service, they developed the tactics and skills that generated influence and hence an element of agency. Pauline Wren, who worked with Law at the Home Office as her staff officer from 1968 to 1974, has commented: 'We spent our lives trying to get women into every department in the police.'[77] This was a considerable shift away from a belief in women's 'special sphere'. Interwar debates about women's involvement in policing had focused on women's duties as citizens in the modern State, conceived of in terms of 'femininity'. Although the mid-1950s and early 1960s have somewhat problematically been associated with affluence and a concomitant recognition of individualism, there was undoubtedly a transformation in the

ways that women's work was viewed. While certain duties were still seen as 'specialist' to women, it was argued that women had a wider utility. The desire to expand women's work within policing accorded with a new rhetoric of personal fulfilment through career development and, in terms of gender, a broad acceptance of a dual role for women in both home and the workplace.

A professional community?

One final aspect of the work of the Assistant HMIs involved the creation of a professional community for women police. As a sergeant in Leicester, Barbara de Vitré had set up the First Provincial Policewomen's Conference in the town in March 1937. The conference, which did not involve women from the Met, who already formed an establishment of 97 by this point, was attended by 36 women delegates from 26 forces – approximately half of all provincial policewomen. The conference had important educative, celebratory and social functions for women who were isolated as solitary individuals, twos or threes, working among large numbers of male officers. Lectures were presented on forensic medicine (Professor John Glaister of Glasgow University), the taking of statements from women and children (Inspector Mildred White of the Birmingham CID), and on 'Criminal Women and Girls' (Miss Lilian Barker, HMI Inspector of Prisons).[78] The conference sought to motivate, to develop solidarity between women, and to create an important space to compare duties and conditions. The ritual of the formal dinner was used to mark past achievements and future aspirations. If tensions existed between Mary Allen on the one hand and Barbara de Vitré and Edith Tancred on the other, they were carefully stage-managed. A toast was raised to 'the wartime women police' (12 of whom were present) by the chairman of Leicester's Watch Committee, which was responded to by Allen. A toast to 'the women police of today' was received by de Vitré. Allen was symbolically accorded her place in history, with de Vitré representing the modern policewoman.[79]

De Vitré brought the idea of policewomen's conferences with her to the Home Office. Chief constables agreed to the holding of regular conferences in each of the districts of England, Scotland and Wales, and the first meetings took place in the summer of 1947, organised by the Home Office. This time the Met was to be included and the Inspector General of the RUC requested that he should send a representative; Marion Macmillan attended the meetings of either the northwest or the Scottish women throughout her service. Conferences aimed to facilitate

the exchange of information and to enable women to form good working relationships with each other. While there had been some discussion of pay and conditions in 1937, it was made clear to delegates that this was outside their remit: 'if these meeting are abused by the discussions of these subjects ... [they] will in all probability be stopped'.[80] This was in part a legal requirement, since the Police Act of 1919 had made it unlawful for police officers to meet together to discuss pay and conditions other than through the Police Federation (which women in England and Wales were permitted to join in 1948).[81] It was probably also a response to the anxieties of chief constables, some of whom were ambivalent about structures and networks that attempted to undermine local autonomy.

The political tensions between the collectivity of policewomen's work, the Home Office's centralising influence and the particularities of individual forces came to the surface in 1950, when chief constables in the northwest of England requested that policewomen's conferences should cease. It was claimed that misinformation had been relayed at a policewomen's conference in Oldham. The claim was investigated and it emerged that the term 'Home Office rule' had been used in the minutes (which were copied to chief constables) instead of 'judges rule'.[82] The resentment of chief constables ran deep: 'It was stated that a member of the Home Office [de Vitré] attended these conferences and there was a real danger that anything she said may be taken as authoritative by the policewomen who would naturally look to the Home Office for guidance, rather than to their own chief constables.'[83] It was decided that policewomen's conferences should be reduced from four to two a year in each district, that chief constables should be asked for agenda items, and that minutes should be carefully checked before distribution. The District Policewomen's Conferences continued to meet biannually to discuss procedures and practices, interesting or difficult cases, liaison with other organisations and legislative changes, until the process of integration began in 1973. From 1963 to 1973, the senior policewomen in charge of Policewomen's Departments and Women Police Branches in the UK held their own annual conference, attended by Jean Law, to discuss a broad range of cognate issues (Figure 1). The conference structure provided professional support, discussion and training. It also provided the social and geographical space to enable the creation of a broad sense of community and identity among women police.

Figure 1 Senior policewomen at the national conference in Leeds, October 1964. Marion Macmillan is seated (far right) next to Jean Law

Working with the men

The memoirs of early women officers – including Lilian Wyles, Phyllis Lovell and Edith Hoyle – hinted at the resentment and animosity of male officers.[84] Discussing women's working relationship with the Metropolitan Police CID in the early 1920s, Wyles wrote '[we] had no illusions about our male colleagues' sentiments towards us . . . [and] were quite willing, eager in fact, to risk insults and humiliations, however mortifying' in order to continue in the work.[85] Their 'heroic' silence over detail suggests that the attempt to ignore insults and to deal with them stoically may have been a predominant coping mechanism. It can be argued, however, that women were slowly accepted because of their engagement with forms of specialist work (sexual assault, child welfare) that were not particularly favoured by male officers and because separate structures of rank meant

that men and women were not competing for appointment or promotion. The size of policewomen establishments was approved separately and the number of supervisory officers (sergeants, inspectors and superintendents) was allocated accordingly. Women who joined UK forces in the 1940s to 1960s tend to present their male colleagues as supportive. Helen, who joined Manchester City Police in 1962, has said that 'the men treated us as ladies, and, although we'd have a laugh and a joke, there was no "you shouldn't be in this job, it's not right for women"... nobody was rude to you then; you'd have a joke and that's as much as it would be'.[86] Christine, who joined the Met in 1958, felt that 'they did become good friends once they realised we weren't threatening them and we weren't looking to take their jobs away'.[87] The past was often remembered as happier and more chivalric, in which men respected women and were unwilling to swear in their presence. In most accounts misogyny was presented as a rarity: 'there's a black sheep in every family that has no time for women; I found nearly everyone that I worked with friendly, supportive, willing to help and I would hope that I was classed the same'.[88] Resentment was often associated with older 'traditional' policemen: 'some of the old, older men, didn't think we were any use at all'.[89]

Second-wave feminism has labelled and defined sexual harassment in terms of unwanted sexual remarks or advances and positioned it as part of a continuum of sexual violence.[90] The 1980s and 1990s have seen the subsequent use of legal frameworks and industrial tribunals to regulate sexual harassment within the police service. Concerns about the 'victims' of sexual assault were shared by both first- and second-wave feminism as well as defining an important area of women's 'specialist' police work. Yet the issue of what we now call 'sexual harassment' within the service was never recorded as an item for discussion in the minutes of national or regional conferences. Pioneer policewomen, like Wyles, seem to have seen 'insult' as one of many challenges against which they had to 'prove' themselves. As senior officers shaping the character of Policewomen's Departments they would have been instrumental in the creation of a stoical ethos, which intersected with the refusal to 'grass' on others that was part of rank-and-file police culture. The police hierarchy encouraged deference rather than complaint. Hence women who joined the police service in later years were socialised into a work-based culture in which harassment was to be ignored or resisted calmly.

Oral history interviews indicate that the majority of women officers probably experienced some form of unsolicited sexual attention and they developed their own individual tactics for resisting or coping with the situation:

We would deal with the men. Now the girls make allegations and try and make fortunes out of them, don't they? I mean if a man pinched your bottom you'd just slap him down and say, 'Behave yourself,' and it would be dealt with. You didn't get a lot of that sort of thing. But it did happen. I remember the first time I came back from training school a particular sergeant got me in the [police] box . . . and got me round the waist, squeezed me round the waist. I thought, 'What do I do here? Oh heck!' So I just pretended nothing had happened. And he stopped. But you can deal with things sometimes by not doing anything. And if they wanted to tell you a dirty joke or something, like some of them did, I used to say, 'Oh . . . yeah . . .' and they used to go, 'Bloody hell,' as if to say, 'She's thick, she can't get that one.' I knew what they meant but I didn't let them know. And you could deal with things like that . . . You'd just pretend you were thick. I did. They weren't all like that, there were some dear sweet people. There was the odd one, there always is, isn't there?[91]

As this account suggests, tactics for self-protection – fighting back, feigning ignorance, or simply pretending something was not happening – involved the performance of an accepted role or script.[92] This particular policewoman alternated between both a 'hard', more 'masculine' performance – 'slap him down' – and a 'soft' display of 'feminine' innocence and ignorance. The individualised response was seen as appropriate because it was in keeping with the culture and profession of policing, which required women to present themselves as capable, unemotional and non-complaining.[93] Ability to cope was a way of getting respect from male colleagues: 'It's no good going in and being the meek little woman and saying, "Poor me" . . . whereas you go in and lay down your ground rules, they might not like it and they might not like you but perhaps they're not going to pick on you.'[94] The military regime of the training school used austere accommodation, drill and rote learning to instil self-discipline at the beginning of a police career: 'people got yelled at and the drill sergeant was the caricature of the one person that everybody hated, but in the end he got everybody's respect'.[95] While many women, particularly those who had not served as servicewomen in the Second World War, viewed training school as a considerable shock, they nevertheless saw it as a formative experience: 'We certainly learned to work together and keep together and stay together and be loyal together, and we had a terrific sense of achievement having come out.'[96] Sexism within the context of training school was viewed as part of the hardening-up process: 'When we were at training school sexist remarks would abound, but you didn't think twice about it . . . They always said at training school, "If you can't put up with what we give you up here, how are you going to manage on the street?"'[97]

Self-reliance, a 'stiff upper lip', and an ability to walk and talk with authority were part and parcel of the ethos of policing for both men and women. Those who felt uncomfortable with it might question their own abilities rather than the institutional framework. During the Second World War, Alice was asked by a male inspector to act as a demonstrator for a training session on the wearing of protective clothing, which required her to undress to her underclothes and put on protective trousers, a jacket, bag, tin hat and gas mask: 'He said to the chaps, "Now, the girl" – you know, I – "wasn't embarrassed, so they didn't have to be". . . I got undressed, and there I was, terrified really you know. I hated undressing in front of other people and still do . . . I was too frightened to say anything. I thought I'd be out on my nose if I said anything.'[98] Alice asked another woman constable to accompany her on other occasions, but she felt unable to speak to her woman inspector about the matter. Because of her inferior rank, she felt bound to accept the directives of the male inspector. Hierarchal structures were obviously open to abuse.

Interviews indicate that an acceptance of the humour of 'canteen culture' was considered necessary in order to be accepted as a police officer: 'We always had our legs pulled, policewomen . . . wherever you served. But there's a certain line that they seemed to know they couldn't cross. And if they were starting to come up to that line, one of us would say, "You'd better watch this now" and that was it, they'd draw back. There was a lot of good-natured ribbing, on both sides – women gave as good as they got.'[99] As women became more involved in rank-and-file police culture during the course of the century, the rhetoric of male policing was inflected in their own language and self-presentation and women referred to themselves as 'coppers' rather than the more austere and formal 'Women Police' of the specialist department. Women acknowledged the sexual stereotyping of women that was dominant within male police cultures: 'The men's opinion really was that you were an old dyke, you were OK, or you were a raging nymphomaniac. There were three classifications broadly. I think most of us were in the middle and were tolerated, more than tolerated.'[100] To some extent policewomen also internalised the model and used it to comment on the behaviour of others: 'If you had a problem I honestly think you brought it on yourself'; 'The girls who got involved in dirty jokes and so on, they were the kind of people who in no time at all would find themselves being patted by a policeman'; 'there were "station bikes", if you know what I mean, a WPC who could be ridden by everybody, which did not make good news for those of us who didn't want anything to do with it.'[101] Forms of gossip about sexual reputations are powerful mechanisms in the maintenance of accepted norms of

virtuous heterosexuality for women.[102] Those who felt they were wrongly labelled – particularly with regard to allegations of lesbianism – felt particularly hurt and unable to challenge or to contradict.[103]

Sexual harassment was ritualised and normalised within the gendered concept of the 'initiation ceremony' for new recruits. While this might involve a range of pranks committed on male recruits, the practice of 'station-stamping' was a point of reference within the accounts of women who had served in the Met, Bournemouth Borough and the RUC. The ritual involved stamping bare flesh – either the chest or the thigh (above the stocking top) – with one of the rubber document stamps kept at the station. While some women felt it was more a 'threat' or a 'myth', a small number described it as happening to them or their friends:

> The sergeant said to me, 'You're new'. I said, 'Yes, serg, I've only just started a few weeks ago.' 'Have you been initiated into the job?' 'No.' So he looked at the chap who worked with him and shut the door . . . He said, 'Right, we shall initiate you'. And they lifted up my blouse and stamped me all over with a rubber stamp, saying, 'Verminous: to be destroyed' . . . I went back to my office and they said, 'Oh, you've been initiated' and I said, 'Well, why didn't you warn me?' 'Oh well, they do it to everybody, you know.'[104]

As an initiation ritual it was designed to humiliate, while also acting symbolically as a statement of male ownership over the female body. This particular policewoman was also struck by the element of complicity within her Policewomen's Department: it was assumed that sexual harassment, including 'station-stamping', was a test that must be dealt with individually to prove strength of character.

Policewomen were continually tested as they were sent out to 'new' stations where women had not previously served. The 1950s and 1960s saw the further expansion in size and workload of Policewomen's Departments and Women Police Branches. Policewomen continued to be managed through a central headquarters. However, they were increasingly distributed – numerically and spatially – across the police district. In urban areas, where 'specialist' work remained a strong focus, those who had completed probation were sent out to divisional stations to concentrate on 'specialist' duties. The model tended to be different within county constabularies (covering predominantly rural areas and market towns): women were posted in ones or twos to individual stations working with male shifts and responding to 'specialist' call-outs only when they arose. Women in rural areas were less likely to think of themselves as 'specialists' or as 'separate' by this period. Vera, who joined Lincolnshire Constabulary in 1960 and was regularly involved in traffic duty as part of

a relief, argued that she 'felt integrated from the word "go"'.[105] Jean Law described the women of the West Riding as 'bobbies' because 'they were just on the staff until they were needed as a woman'.[106] However, the experience of working with the male shift could involve frustration, as policewomen pioneered a role in each station:

> I found that when I first went to Abergavenny that they didn't really want to take me under their wing. The lad who had come at the same time as me, he was always being taken off on jobs and doing this and doing that, and I'd be manning the switchboard ... It wasn't until I started protesting that nobody had shown me how to use a breathalyser, and nobody had come with me on an accident, and nobody had done this, that and the other, and started to get in with the blokes ... [that] they'd say 'come here and do that'.[107]

Similar experiences – characterised in terms of lack of understanding – were described by RUC women who were sent out to work on rural divisions in the early 1960s (having been based predominantly in Belfast and Londonderry).[108]

The centralisation of women in Women Police Branches and large urban stations had offered protection from the possible resentment of male colleagues and perhaps also from some of the worst excesses of harassment. As women moved out into smaller stations in the 1950s and 1960s, they had to negotiate their own work patterns with male colleagues in much the same way as the early pioneers of the 1920s. Difficulties might also arise in situations where a woman constable was answerable to both a male duty inspector, who oversaw her work within the station, and a woman inspector, who was in charge of policewomen's work within the division.

No one account of policing can be seen as more authentic; rather, there was a range of possible 'experiences'. It is fair to say, however, that the majority of women officers experienced some form of unwanted attention within the workplace. There were no formal structures or mechanisms to guarantee protection and, up until the last 20 years or so, it was up to the individual to negotiate encounters with other officers. While it is possible that levels of sexual harassment in policing increased in real terms as a result of integration, and the competition, (for the first time), for promotion among men and women, it is extremely difficult to evidence this because of the dearth of comparable data. Clearly former women officers have constructed accounts of a more benign past, which can be seen as generational. Most women interviewed made reference to a distinctly different past culture: 'you had to accept that it was a man's world in those days, even in 1964'.[109] Almost all, however, spoke

unfavourably of what they saw as a present-day replacement of informal mechanisms with litigation, 'canteen culture' with political correctness, self-discipline with counselling, and camaraderie with impersonal structures. The rejection of these transformations indicates just how extensively the older frameworks were embedded and how central they were in the construction of mid-century police identities, both male and female.

This chapter has shown that the argument about sexual difference was crucial in winning debates about the usefulness of women police, and this led to an orientation of women's work as 'specialist' in the inter-war period. The emphasis on the 'feminine' aspect of their duties should not necessarily be seen as a lost 'feminist' cause. Rather, the creation of a 'specialist' – or gender-specific – portfolio for women officers turned them into 'experts' within policing, working closely with other emerging and equally feminised semi-professions such as social work and probation. Far from being a 'latency' period in the history of policewomen's work, the 1930s saw pioneer policewomen – such as de Vitré and Peto – build a solid foundation upon which to capitalise when war broke out. Their enthusiasm, determination and skills of persuasion were vital factors in the shaping of policing as a profession for women. The 'specialist' portfolio facilitated the growth of Women Police Branches (in the Met and the RUC) and Policewomen's Departments (Leeds, Birmingham and Glasgow) that were at their height in the mid-1950s. Attempts to standardise policewomen's work and to create a network of regional and national conferences meant there were elements of a shared culture; furthermore, women officers were involved in continual discussion about their roles and duties. There was undoubtedly considerable regional variation: women's work in urban areas was more likely to maintain its 'specialist' connotations, while women in county constabularies were more likely to be absorbed into the male shift. Nevertheless, separate ranks and structures for promotion meant that, even in rural areas, the concept of gender difference had some currency.

The rhetoric of 'specialism' concealed women's involvement in an increasingly wide range of general policing duties. As women demonstrated their capability and utility, their involvement in other departments – the CID, Special Branch, Flying Squad – increased. By the 1960s, senior policewomen were positioning their officers as both equal *and* different. The language that was used – and which won the support of chief constables – was not that of women's rights but the general interests of the police service. Throughout the period women also worked with male officers, traversing the twin cultures of the Policewomen's Department and the canteen, cultures that were brought more closely together as women's

work was increasingly acknowledged. Through informal mechanisms – such as gossip and insult – ideas about gender and sexuality were negotiated, debated, contested and sometimes resisted. To some extent, however, the notion of 'difference' mean that sexual harassment was not perceived to be a problem.

The cultural and the structural are complexly intertwined. Rather than seeing either as primary, I have suggested here that networks and hierarchies were shaped by contingent ideologies (including both liberal/patriarchal hegemonies and feminist or 'feminine' engagements and resistances) as well as themselves being constitutive of the spaces and differences that were then experienced culturally. Structures were cultural products, while work cultures were structurally organised. Chapter 3 will focus on cultures of gender, class and status in more depth, exploring the creation of an ethos of 'respectable' femininity within policing and the promotion of a consciously feminine image to a wider audience through public relations strategies.

Notes

1. M. Brogden, *The Police: Autonomy and Consent* (London: Academic Press, 1982). For the Home Office's strengthening of its supervisory role in the 1960s, see T. Jefferson and R. Grimshaw, *Controlling the Constable: Police Accountability in England and Wales* (London: Muller, 1984).
2. See Report of the Advisory Committee on Police in Northern Ireland (Hunt Report) (NIPP 1969) Cmnd 535. Changes were subsequently made to bring the RUC into line with other UK forces, including the introduction of British ranks and structures; an attempt to replace green with blue uniforms was unsuccessful.
3. 'Feminism' can be defined in broad terms as the promotion of women's issues, interests and freedoms within a framework of equality and fairness; clearly such a definition leads to a wide range of possible interpretations. To avoid ambiguity, I use the term 'feminist' here in a much narrower sense: to refer to the political identities of those women who specifically identified themselves as 'feminists' and to the movements in which they were involved ('first-' and 'second-wave' feminism).
4. J. Butler, 'An appeal to the people of England' (1870), in S. Jeffreys (ed.), *The Sexuality Debates* (London: Routledge, 1987).
5. S. Jeffreys, *The Spinster and Her Enemies: Feminism and Sexuality 1880–1930* (London: Pandora,1985).
6. L. A. Jackson, *Child Sexual Abuse in Victorian England* (London: Routledge, 2000).
7. M. R. Higonnet, J. Jenson, S. Michel and M. C. Weitz (eds), *Behind the Lines: Gender and the Two World Wars* (New Haven: Yale University Press, 1987), p. 4.
8. M. R. Higgonet and P. L. R. Higonnet, 'The double helix', in Higonnet *et al.* (eds), *Behind the Lines*.
9. The NUWW was founded in 1895 as an umbrella organisation for welfare groups concerned with women and children, with a predominantly middle-class membership. See Carrier, *Campaign for the Employment of Women*.

NETWORKS, STRUCTURES AND HIERARCHIES

10 Imperial War Museum, London (henceforth IWM), Women's Work Collection, Emp 43.83, WPS Annual Report (henceforth AR) 1920.
11 Bland, 'In the name of protection'; Levine, 'Walking the streets'; Woodeson, 'The first women police'.
12 Report of the Committee on the Employment of Women on Police Duties (Baird Committee) (BPP 1920) Cmd 877; Report of the Departmental Committee on the Employment of Policewomen (Bridgeman Committee) (BPP 1924) Cmd 2224; Report of the Departmental Committee on Sexual Offences Against Young Persons (BPP 1925) Cmd 2651; Report of the Committee on Street Offences (BPP 1928) Cmd 3231; Report of the Royal Commission on Police Powers and Procedures (Lee Commission) (BPP 1928–29) Cmd 3297.
13 The entry of women to policing was not a campaigning issue for women involved in socialist and (in Northern Ireland) nationalist parties, who opposed the existing state apparatus.
14 See National Archives, London (henceforth NA), HO 45/13433 Women police, 1928–29, and HO 45/14260 Women police, 1929–31.
15 For NCW lobbies/deputations, see Carrier, *Campaign for the Employment of Women*.
16 In 1934 a joint petition involving the National Association of Women's Institutes and the NCW yielded over 6,000 signatures. See E. Tancred, *Women Police 1914–1950* (London: NCW, 1951), p 20.
17 B. Harrison, 'Women in a men's house: the women MPs 1919–45', *Historical Journal*, 29:3 (1986), 623–54; J. Alberti, *Beyond Suffrage: Feminists in War and Peace 1914–28* (Basingstoke: Macmillan, 1989).
18 S. K. Kent, *Making Peace: The Reconstruction of Gender in Interwar Britain* (Princeton: Princeton University Press, 1993), p. 117.
19 *Northern Ireland House of Commons Debates*, vol. 2, cols 372–3, 5 April 1922, quoted in D. Urquhart, *Women in Ulster Politics 1890–1940: A History Not Yet Told* (Dublin: 2000), p. 178.
20 *Hansard*, House of Commons, col. 2313, 11 July 1928.
21 E. Wilkinson, 'Urgent need for women police', *Pearson's Weekly*, 13 October 1928.
22 D. Riley, *'Am I That Name?' Feminism and the Category 'Women' in History* (London: Macmillan, 1988).
23 L. Bland, *Banishing the Beast: English Feminism and Sexual Morality 1885–1914* (London: Penguin, 1995).
24 The quotation regarding women's 'special sphere of usefulness' was lifted directly from the Report of the 1928 Street Offences Committee and was used widely in speeches by Edith Tancred (see, for example, *Oldham Weekly Chronicle*, 25 February 1935).
25 Doan, *Fashioning Sapphism*.
26 Damer Dawson set up the Women Police Volunteers (WPV) in 1914 with Nina Boyle of the WFL. The organisation split as a result of disagreements over involvement in the enforcement of the Defence of the Realm Act (DORA), which involved the imposition of curfews on women. Allen and Dawson then formed the WPS. See Bland, 'In the name of protection'; Levine, 'Walking the streets'; and Woodeson, 'The first women police'.
27 A. Summers, *Angels and Citizens: British Women as Military Nurses 1854–1914* (London: Routledge, 1988).
28 Peto, *Memoirs*, p. 16.

29 West Yorkshire Archive Service (henceforth WYAS), Tancred Papers, WYL 258/12, letter from Iveigh More Nisbett to Edith Tancred, 24 February 1920.
30 WYAS, Huddersfield Borough Police, A147/8, correspondence regarding the application of Lily Allen for the post of lady police assistant. She does not appear to have been related to Mary S. Allen.
31 Ibid., letter from Chief Constable John Moore to Lily M. Allen, 31 August 1918.
32 Douglas, *Feminist Freikorps*.
33 Ibid., p. 81.
34 NA, WO 32/3562, Visit of Commandant Mary Allen (WAS) to the British Army of the Rhine.
35 MPM, papers of Miss K. M. Hill: letter from Hill to biographer Clifford Stanley, 20 April 1971.
36 Carrier, *Campaign for the Employment of Women*.
37 BCL, Sharples (née Hoyle), 'My Life's Work', p. 28. Involved with neither the NUWW nor the WPS, Hoyle indicates she was recommended to the Huddersfield Watch Committee by the chief constable of Blackpool for her involvement in rescue work.
38 Dorothy Olivia Georgiana Peto (1886–1974) was employed as a paid patrol in Bath, Southampton and London in the First World War before becoming Director of the NCW Bristol Training School (1916–20). She was a female enquiry officer in the City of Birmingham Police (1922–24), an organiser for the National Council for Combating Venereal Diseases (later the Social Hygiene Council) (1924–27) and Director of the Liverpool Patrols (1927–30). She was appointed as head of the Metropolitan Women Police in 1933 (first as staff officer and, from 1933 as superintendent, making her the highest-ranking woman in the UK at the time).
39 West Midlands Police Museum, Birmingham (henceforth WMPM), Birmingham City Police, personnel files, Dorothy Olivia Georgiana Peto: letter from Chief Constable C. H. Rafter to Sir Leonard Dunning, 6 November 1920.
40 Ibid., letter to Chief Constable of Birmingham, 29 October 1920.
41 Peto, *Memoirs*.
42 Cameron, *Women in Green*, p. 3.
43 Statutory Rules and Orders, 1931, no. 878, Police, England and Wales.
44 Greater Manchester Police Museum, Manchester (henceforth GMPM), Clara Walkden Papers. Walkden resigned in 1943 because of ill health.
45 WYAS, WYP1/A124/578 West Riding Police, use of women auxiliaries, 1941. Policing was a 'reserved' occupation in England and Wales until 1941, when young officers were permitted to volunteer for the RAF and Fleet Air Arm. In 1942, all regular officers under 25 were de-reserved. The RUC remained a reserved occupation throughout the war.
46 The WAPC were originally supplied with blue cotton overalls and an armlet for clerical work, and a gaberdine coat and peaked cap for external use in driving, etc., suggesting a separation from skilled police duties. By the end of the war, attested auxiliaries ('A') had adopted tailored uniforms similar to those worn by regular policewomen.
47 MPM, Women Police AR 1940.
48 NA, MEPO 2/6151, Women's Internment Camp, Isle of Man. Women police escorted 'aliens' to and from tribunals in Douglas, searched property, carried out patrol duty to prevent escape and enforced curfews. From 1942, women 'aliens' were paroled out to

farms for agricultural work; women police were required to escort them and to visit them on bicycles.
49 WYAS, WYP1/A136/38 Women's Auxiliary Police Committee 1943–46.
50 Rose, *Which People's War?*, p. 122.
51 NA, MEPO 2/6170, Postwar establishment A4.
52 GMPM, No. 3 District Policewomen's Conference, minutes, 3 December 1947.
53 NA, HO 287/317, West Riding of Yorkshire, Women Police 1955–65.
54 Quoted in Tancred, *Women Police*, p. 48.
55 Police Service of Northern Ireland (henceforth PSNI) Museum, Belfast, Women Police Branch, AR to Inspector General, 1957.
56 Tancred, *Women Police*, p. 48: the appointment of the Assistant HMI saw the achievement of the NCW's aims; Tancred passed the baton to Peto and de Vitré to shape future development.
57 C. R. Stanley, *The Purpose of a Lifetime: A Profile of Barbara Mary Denis de Vitré OBE, 1905–1960* (Chichester: Barry Rose, 1972). She had worked as a nursing assistant before completing a training course in social welfare at Manchester University. Trained by the WAS, she joined Sheffield City Police in October 1928. As Head Constable for women in Cairo City Police (1931–33), she organised the supervision of the city's brothels and register of prostitutes. In 1929, she succeeded Eileen Claire Sloane as Leicester's second policewoman, moving to Kent in 1944, where she expanded the Women Police Department from an establishment of 2 to one of 179 (including auxiliaries) in 1945. She was Police Staff Officer and then Assistant HMI from 1945 until her sudden death in 1960.
58 MPM, Hill papers, envelope 4, ring binder of inspection notes, 1946–47.
59 Gaynor D. Williams, 'Women in public life in Liverpool between the wars', Ph.D. thesis, Liverpool University, 2000.
60 Tancred, *Women Police*, p. 6.
61 MPM, Hill papers, envelope 4.
62 *Ibid.*
63 Emsley, *English Police*, pp. 91–2; the Scottish grant covered a third of costs.
64 MPM, Hill papers, envelope 4.
65 *Ibid.*
66 Tancred, *Women Police*, pp. 37–8. Women were trained in police schools in the Met (Peel House) and Birmingham.
67 *Ibid.*, p. 49.
68 Women Police Tapes, interviews conducted by the author with former women officers (referred to henceforth as WPT), Margaret; Peggy.
69 WPT, Cynthia.
70 MPM, Hill papers, envelope 4.
71 Interview with Miss Jean Law, OBE, QPM, and Miss Pauline Wren, OBE, 23 August 2001.
72 PSNI Museum, Women Police ARs, report of Miss J. S. Law, 1972.
73 WPT, Moira.
74 Interview with Jean Law.
75 WPT, May.
76 *Ibid.*
77 Interview with Pauline Wren.
78 *Leicester Mercury*, 6 March 1937; GMPM, Walkden Papers.

79 Ibid.
80 GMPM, No. 2 District Policewomen's Conference, minutes, 31 July 1947.
81 Women were permitted to attend the Scottish Police Federation in 1953 as advisers only; in 1964, they became full representatives with the right to vote. See I. C. Livingstone, 'History of Glasgow Policewomen', unpublished typescript, Glasgow Police Heritage Society, 1998.
82 NA, HO 45/25216 Policewomen, 1946–51: No. 1 District Conference of the Chief Constables' Association, minutes, 19 January 1950 and 24 July 1950; Response from Miss De Vitré, 31 August 1950.
83 NA, HO 45/25216 No. 1 District Conference of the Chief Constables' Association, minutes, 19 January 1950.
84 MPM, Lovell, 'The Call Stick', p. 25 described attempts to discredit her that forced her to leave Birkenhead Constabulary in around 1917: 'the chief's mind was being poisoned'.
85 Wyles, *Woman at Scotland Yard*, p. 51.
86 WPT, Helen.
87 WPT, Christine.
88 WPT, Irene.
89 WPT, Joan.
90 L. Kelly, *Surviving Sexual Violence* (Oxford: Polity, 1988), p. 81.
91 WPT, Zena.
92 Brewer, 'Hercules, Hippolyte and the Amazons'.
93 See Brown and Heidensohn, *Gender and Policing*, for coping strategies in contemporary policing.
94 WPT, Jill.
95 WPT, Carol.
96 WPT, Jennifer.
97 WPT, Carol.
98 WPT, Alice.
99 WPT, Edna.
100 WPT, Susan. See also Malcolm Young, *An Inside Job: Policing and Police Culture in Britain* (Oxford: Clarendon, 1991).
101 WPT, Susan; Joan; Joyce.
102 Melanie Tebbutt, *Women's Talk: A Social History of Gossip in Working-Class Neighbourhoods* (Aldershot: Scolar Press, 1995).
103 WPT, Zena; Kathleen.
104 WPT, Jennifer.
105 WPT, Vera.
106 Interview with Jean Law.
107 WPT, Sian.
108 See WPT, Laura; Amy; Joy; Pamela.
109 WPT, Jill.

3

A respectable job for a woman?

THIS CHAPTER IS CONCERNED with the status and 'respectability' associated with women's work in the police service. Explaining her decision to join Birmingham City Police in 1950, one senior policewoman commented: 'There was quite a bit of kudos attached to being accepted as a policewoman. Even then the average member of the public and average mother thought you had to have all sorts of educational qualifications . . . it was a challenge to see if I could get into the holy of holies'.[1] This chapter assesses this 'kudos'. Firstly, I shall explore a range of popular cultural representations in the media and film to demonstrate that senior policewomen played a key role in the refashioning of an image for women officers that accorded with notions of an attractive, efficient and modern 'femininity'. Secondly, I shall examine the 'type' of woman who was considered to be 'suitable' for policing – in terms of class, status, ethnicity, religious and educational background – by evaluating statistical evidence relating to recruitment as well as the recollections of those women who were involved in the process. Finally, I shall focus on personal testimony in order to discuss women's perceptions of themselves and the culture within which they were operating.

Policing was overwhelmingly related to a 'white' identity and, in the Northern Ireland context, a loyalist Protestant identity. In class terms, however, women recruits were more diverse and any discussion of their social background needs to be set against a broader history of attempts to shape new professions for women in the twentieth century.[2] Inter-war policing attracted a broad constituency of women, including graduates and those trained in nursing, teaching and social work, as well as policemen's widows and former domestic servants. While male officers were traditionally hostile to the university-educated, pioneers such as Dorothy Peto and Barbara de Vitré sought to transform their branch of policing into a feminine profession, based on a sense of duty and vocation as well

as careful recruitment and specialist training. In the long run policing was unable to compete with teaching and social work. Most of those who joined after the Second World War were drawn from lower-middle-class or upper-working-class backgrounds that were not significantly distinct from policemen. They did, nevertheless, retain a sense of themselves as an elite group as a result of their attempts to delineate an ethos of professionalism and respectability.

From Gracie Fields to Hattie Jacques

The political struggle for the appointment of women police was keenly reported in the press. Once women were admitted to policing, they continued to attract the interest of the media, whose personnel were keen to present them as a novelty in terms of gender and sexuality. As Brown and Heidensohn have pointed out, cartoons and comic representations of policewomen used discourses of sexuality to trivialise their work. In the pages of *Punch* and *Police Review*, cartoonists presented policewomen either as seductresses or as 'manly' and 'unnatural'. These images worked 'to deprofessionalize or defeminize' women officers and, by default, to lower their status.[3] However, if these stereotypes of women police were quick to emerge and were shaped by wider attitudes towards gender difference, they were also challenged. As well as seeing media representations as discursive effects, it is important to consider the processes of negotiation that shaped them. A press office was set up at the Met in 1919, and its publicity machine was further developed after 1945 by experienced journalist Percy H. Fearnley, who was appointed as public information officer by Commissioner Sir Harold Scott.[4] I shall demonstrate that senior women police sought to manipulate press coverage, to influence the image and profile of women officers, and to reshape cultural stereotypes. This they did with mixed success. The image was restyled in relation to notions of gender and occupational status between 1930 and 1950. Original perceptions of women officers as clumsy, unattractive and mannish were replaced with an emphasis on a respectability and professionalism that was distinctly feminine. Nevertheless, sexualised stereotypes retained a presence in media representations of women's work.

At the end of the First World War, pioneer policewomen were viewed by many as 'faddists' or militants. Representations of women police as severe, masculine and authoritarian were vividly displayed in music hall during the 1920s as well as in the 1931 film *Looking on the Bright Side*, a vehicle for the singing talent of the new Lancashire star, Gracie Fields.[5] Dismissed from her post as a manicurist in a West End beauty parlour for

rudeness to a customer, 'Gracie' joins the Met. The humour becomes slapstick as she appears in an ill-fitting uniform, is chased by police dogs, teased by children, and disciplined for playing skipping games and singing in the street. *Looking on the Bright Side* is a musical comedy that draws in places on fantasy (a desire for glamour and success) and surrealism (East End tenements become musical stage sets). Yet the film is also infused with realism and the caricatures and stereotypes that are deployed are drawn from a pre-existing cultural repertoire. The uniform of the women police is a carefully observed rendering of the austere model worn in the Met. It is significant that the women police are not distinguished from 'Gracie' in class terms and they inhabit the same East End spaces. In the depiction of their work role, however, differences are constructed around gender and age. All the policewomen except for 'Gracie' are depicted as mature, portly, unattractive, and 'manly' in deportment.

Considerable publicity was needed in order to counter the 'bad press' accorded women officers. In September 1936 the *Daily Express* ran a feature entitled 'Job that women do not want', which included quotations from interviews with women in the street.[6] It is possible that the 'mannish' appearance of women's police uniforms was associated with lesbianism, which had became a focus of public anxiety during the censorship trial of Radclyffe Hall's *The Well of Loneliness* in 1928.[7] While Mary Allen of the WAS promoted herself and her organisation through a series of regular photo opportunities, women officers employed by the Met distanced themselves from her masculine and military style. In the autumn of 1936, Dorothy Peto, head of the Metropolitan Women Police Branch contacted freelance journalist Joan Woollcombe for assistance 'to counteract the foolish but rather harmful paragraphs which appear from time to time about women police'.[8] This was the first move to repackage the work publicly as a modern professional but 'feminine' career and to counteract suggestions that it was either an anachronistic legacy of an authoritarian 'Victorian' moralism or a movement of 'unnatural' women who threatened the wider gender order. Peto and Woollcombe targeted the provincial press and popular nationals with a mixed response. Although there were some refusals, a press release issued in late summer of 1937 gained wide coverage. In contrast to the simple recruitment notice that had been previously used, the press release aimed to orchestrate a news story around recruitment, centring on Peto's personal views, which were quoted extensively:

> 'I want women who are interested in the lives and troubles of other women and children', she said. 'The first thing I ask is: has she done anything to show such an interest, and is she a good citizen? Then I want to

know if she is a good mixer. And lastly: can she smile when the joke goes against her ... there is a good chance for women of the right type to get away from humdrum surroundings and to do something worthwhile'.[9]

These comments clearly linked women police with social/welfare work and depicted it in terms of duty or vocation based on citizenship and a desire to 'do something worthwhile'. They also combated the prevalent and austere image of policewomen by stressing the need to 'smile at a joke' and the importance of sociability. Despite the careful choice of words in the press release, Peto and Woollcombe had little control over the way in which it was used. The *Evening News* titled its story 'Our girl PCs must have a sense of humour'.[10] While conveying elements of Peto's message, the reporter had transposed women into 'girls' and trivialised the message. This example shows some of the difficulty of conveying a serious message to the press when a reporter's agenda centred on 'newsworthiness', which stressed novelty and used dramatisation or titillation to 'entertain' the reader.

The restyling of the image also required a move away from 'flannel petticoats and thick stockings'.[11] The Metropolitan uniform – which, for all but senior women, combined the heavy skirts worn by the women police patrols in the First World War with a high-necked policeman's tunic (Figure 2) – was seen as out of kilter with a new modern womanhood. During the mid-1930s the long, straight serge skirt was replaced with a shorter one with single pleats at front and back, while the tunic was cut lower with lapels and worn with a collar and tie. Heeled shoes replaced boots and a seamless hard felt hat replaced the helmet. The illustrated magazine *Picture Post* profiled their activities in a full six-page photographic feature 'The life of a policewoman' in July 1939, which emphasised their 'intelligence, cool-headedness and sympathy'.[12] Yet the Metropolitan Women Police Branch was still criticised by the *Daily Mail* in 1944 for having 'one of the world's frumpiest uniforms'.[13] By the end of the Second World War, an increasing number of forces were recruiting women and their choice of uniform was very different from those in the Met. In 1943, the RUC rejected its dowdy image: 'We are not keen on the helmet type of headgear, as worn by women in the London Metro police and other forces'.[14] The style of uniforms worn by servicewomen in the Women's Royal Air Force (WRAF) and the Women's Royal Naval Service (WRNS), with soft peaked caps, shorter flared skirts and tailored jackets, was seen as a more modern sartorial symbol of attractive, efficient womanhood. The promotion of 'beauty as duty' during the Second World War led to an emphasis on the mixing of utility with grooming, correct

A RESPECTABLE JOB FOR A WOMAN?

Figure 2 The Metropolitan Police Patrols led by Mrs Sofia Stanley, c. 1919

deportment and smart femininity.[15] Much to the approval of the press, 'service-style' uniforms were introduced in a number of provincial forces at the end of the war (Figure 3). Chief Constable of Kent, Sir Percy Sillitoe, was alleged to have commented: 'I am having the uniforms made smarter and more stylish than those the average policewoman wears'.[16] In 1946, Peto's successor at the Met, Elizabeth Bather, who had served as a staff officer in the WRAF, followed the example of the provincial constabularies, introducing uniforms similar to those worn in the forces.

The 1949 film *The Blue Lamp*, shot on location on the streets of London and at Paddington Green police station, created an idealistic image of the reliable British copper in the paternal figure of George Dixon (played by Jack Warner). While the film centres on the masculine camaraderie of canteen culture, there is a brief vignette which features a solitary woman officer, Sergeant Millard, who briefly interviews the 17-year-old runaway Diana Lewis. Millard remains a cipher for respectable femininity in opposition to other female characters in the film, her cut-glass accent locating her as separate and aloof from the apparently working-class identity of male officers.

Figure 3 Manchester City policewomen: allocation of duties after parade, c. 1948. Sergeant Nellie Bohanna (later superintendent) is standing first left next to Inspector Emma Jane Ball

Yet *The Blue Lamp* must be positioned in relation to a second film, *Street Corner*, directed by Muriel Box and released in 1953, which sought to acquaint British cinema audiences with the work of the women at Chelsea police station.[17] While Box herself can be attributed a key authorial role, the production was collaborative and the film can be examined in relation to Elizabeth Bather's refashioning of the Met women.[18] Like the far more popular *The Blue Lamp*, *Street Corner* was scripted and produced in close consultation with the Met. Examples of cases involving women police were forwarded to scriptwriter Jan Read. Woman Police Sergeant Maude Lambourne was given the task of advising about production during the filming. Drafts of the script were sent to Bather, for comment. Files indicate that she was never happy with Read's work: 'I am still very disappointed and perturbed about the script . . . the stories are so completely improbable and in no way giving a true picture of our work'.[19] She also raised complaints that were never resolved about characterisation and demeanour: 'I still think the dialogue is "smart alec" and I don't think any of the policewomen have the manner and approach of real women.'[20] Nevertheless, Read intended to cast off the image of

women officers as 'bluestockings' and to promote an image of 'young women who . . . perhaps had some experience as hospital nurses, secretaries, or in teaching, but want an active life with social implications'.[21] Although one male officer (Angus) voices disapproval of the work of women police, the film effectively combats his misogyny. The film's women officers embark on their duties with efficiency and competence and they stand in striking contrast to the policewomen of *Looking on the Bright Side*. As Christine Geraghty has commented, 'the model is of distanced, compassionate concern that relies on professional skills and calm common sense'.[22]

The film's plot-line emphasises policewomen's specialist work with women and children (dealing with cases of bigamy, child neglect and female shoplifting) so that the nature of their work is clearly gendered as feminine. Gender and status are also delineated through dress. Woman Detective Joyce Sherrell (Sarah Lawson) sports a smartly tailored suit with a discreet brooch pinned to her lapel, which contrasts with the stolen and extremely showy costume jewellery given to Bridget (who has been arrested for shoplifting) by her boyfriend Ray. Woman Constable Lucy Lockett (Barbara Murray) is frequently dressed in the height of 'new look' fashion, whether in evening dress for plain-clothes observations in a club or in day attire, shopping on her afternoon off. A tasteful and sophisticated glamour is thereby associated with the women officers that marks them as respectably middle class and heterosexual.[23] Whereas the policemen of *The Blue Lamp* and *Street Corner* speak with regional or working-class London accents, policewomen in both films espouse received pronunciation. If *The Blue Lamp* creates the image of an intensely homosocial culture in inter-war policing, *Street Corner* depicts an elite but equally close-knit feminine community; as one slightly cynical review put it, 'the policewomen . . . seem to have the makings of a good hockey team'.[24]

A similar image of the young women who became involved in policing was depicted in the girls' career novel *Elizabeth: Young Policewoman*, published in 1955 and written with the assistance of the Met's Women Police Branch and the District Training School at Ryton.[25] The central character, Elizabeth, is depicted as 'hearty', 'blooming' with health and 'sturdy, sensible, level-headed'.[26] Her interest in people, particularly children, is set aside her sister Monica's vanity. As with other girls' career novels, the author is keen to emphasise Elizabeth's sensible heterosexuality.[27] Although she rejects her mother's plans for courtship, we are told she is not 'in any way averse to meeting young men'.[28] The book stresses the welfare aspects of police work: 'Being in the Metropolitan Police is just

about the most human job there is, I should imagine. You're dealing with people all the time, and in quite a number of cases you can do something which really is a help.'[29] As Elizabeth decides to join the police, her sister Monica refers to the image of women police as 'a frightful lot of flat-footed old battle-axes', an image that the text clearly sets out to refute.[30] The femininity of the uniform that Elizabeth is given – which makes her look 'young, well set-up and smart' – is contrasted with the 'perfectly hideous thing' that her sergeant remembers having to wear.[31]

The only problem that *Elizabeth: Young Policewoman* is never quite able to resolve is the balance between career and marriage. Stephanie Spencer has argued that careers novels aimed to 'negotiate the tension between the desire for independence and self-fulfilment on the one hand, and the inevitable domestic results of romance on the other'.[32] Although a 'dual role' was increasingly advocated for women in the 1950s, enabling them to combine work and marriage, this was hard to achieve in the case of police work.[33] The marriage bar that forced women to resign on marriage was retained in Scotland and Northern Ireland until 1968. Although it was removed in England and Wales in 1946 (and had been temporarily waived during the war years), it was clearly expected that women officers should leave on marriage, particularly if their husbands were policemen. In other career novels – on nursing and the electronics industry – it is indicated that the young women will continue to work in some capacity after marriage.[34] However, on the final pages of the novel, Elizabeth rejects marriage and asserts 'this is the job for me, and I'm going to stick to it'.[35] Marriage is almost totally sidestepped in *Street Corner*. Firstly, the suggestions of romance between Lucy and Angus that appeared in an earlier screenplay do not feature in the final film.[36] Secondly, Susan (Anne Crawford) reveals that her husband and child had been killed in the Blitz and we are left to presume that widowhood inspired her to join the Metropolitan Police. As Geraghty has pointed out, the 1950s saw 'the development of paid caring roles (teachers, nurses, childcare officers) within the welfare state', which led to increased recognition of the female expert who specialised in a social and educative roles.[37] Both *Street Corner* and *Elizabeth: Policewoman* offer a vision of the sensible, efficient and attractive young policewoman who is inspired by the 'duty, loyalty and stoicism' that was seen as desirable in women in the aftermath of war.[38]

By the early 1960s an image of women police as 'pretty but tough' had achieved prominence.[39] At their national conferences, senior policewomen regularly described the effective working relationships that they were building up through their public relations departments.[40] Police forces found that the popularity and continued novelty of women officers

meant they could be used extremely effectively to advertise the police service as a whole. In 1960, the Met bought a MGB sports car for a specially selected group of six women officers to undertake motor patrol. While there was clearly a practical policing role associated with this venture, it was also an ideal publicity opportunity and the Met actively engaged in the glamorisation of its women officers.[41] The Met's younger women were also profiled in a series of *Evening Standard* articles entitled 'Beauty in blue' and a film – *It's a Fair Cop* – shown in local cinemas.[42] The promotional appeal of women police was recognised by the RUC: between 1964 and 1968, members of the Women Police Branch travelled to towns and cities in England and Scotland to publicise 'Ulster' goods during 'Ulster Trade Week' each autumn.[43]

The 'novelty' value of policewomen also led to press coverage of the restyling of uniforms in the late 1960s. While the service style had been seen as symbolic of feminine confidence in the wake of the Second World War, it was the 'air hostess' style that was to influence uniforms 20 years later, invoking a form of occupational dress that was exclusively associated with women and a 'glamorous' lifestyle. Its introduction was tellingly described by Robert Mark, who had served as Chief Constable of Leicester City Police: 'I had boldly ignored all the various Home Office exhortations and equipped them with court shoes, short skirts, airhostess tunics and shoulder bags. The effect was electric. Even in a town like Leicester, where women earned exceptionally high wages, our recruitment rocketed.'[44] The new uniform for the Met, launched in 1968 after Mark had moved there as Commissioner, was designed by Norman Hartnell, couturier to the Queen (Figure 4). The Metropolitan Police press release announced that the 'fashionable' new uniform aimed to combine 'elegance with authority' and to maintain 'the necessary aspect of legal authority in a less military and more feminine style'. The 'kepi' cap, with small patent-leather peak, was described as 'elegant, feminine and thoroughly serviceable'. The uniform was to epitomise 'the fashionable picture of the modern, efficient woman of the Metropolitan Police'.[45] In Northern Ireland Janet Cameron, a graduate of the Ulster College of Art, tailored a new green serge jacket and shorter, straight skirt for the RUC women.[46] The adoption of the air-hostess image was orchestrated by a combination of male desire and women's pursuit of fashionability. Perhaps unsurprisingly, the straight skirt was found to be unpractical and was replaced with an A-line version.

The postwar image of women officers stressed a sensible and fresh-faced heterosexuality associated with middle-class respectability. *Carry on Constable*, the fourth in the popular British comedy series, was released in

Figure 4 'Today's Look'. From the Met's recruitment brochure *Keeping the Peace in London*, c. 1968

1960. The characters played by Hattie Jacques (Sergeant Laura Moon) and Joan Sims (Police Woman Gloria Passworthy) are models of well-spoken, respectable and highly efficient womanhood (in contrast to the ineptitude of the majority of their male colleagues). Unlike the treatment of women in later 'Carry On' films they are not overtly sexualised. Yet the argument that women's police work was successfully repackaged in terms of modern femininity should not be overstated. The Met's women were disappointed in the distribution of *Street Corner* and older stereotypes persisted, most obviously in the spinsterish policewoman played by Joyce Grenfell in the 'St Trinians' series of films (1954–70).[47] Susan Sydney Smith has argued that television police series, including *Dixon of Dock Green* (the spin-off from *The Blue Lamp*, broadcast from 1955) and *Z Cars* (1962) were constructed around masculine cultures in which women tended to feature only as

wives or mothers (Woman Sergeant Millard played a marginal role in *Dixon*). It was not until 1966 that the series *Softly Softly* included a credible female detective who can be viewed as an early prototype of DCI Jane Tennison (played by Helen Mirren in the *Prime Suspect* series of 1989).[48] The stereotypes of the 'bimbo' and the 'harridan' that dominated cartoons in *Police Review* in the 1970s perhaps reflect a sexism and misogyny in male canteen culture that became more visible when women were competing with men for the first time as integration took place.[49]

The 'right type' of woman

For senior policewomen the publicity machine was an important vehicle in the process of recruitment.[50] But who was the 'right type' of recruit? There had been some recognition among early pioneers that it was desirable to recruit from a variety of social backgrounds. Phyllis Lovell, herself from a wealthy Merseyside family, had selected 11 recruits in Birkenhead in 1917: 'I felt it would be wise to include among them women of good education and women of no education at all. A variety of capability and viewpoint would I felt be of advantage.'[51] Yet, the number of middle-class women engaged in policing and patrol work during the First World War – most driven by a sense of national duty – was disproportionately high.[52] In July 1939, *Picture Post* positioned the occupation of policewoman as comparable to that of a teacher or a doctor for women leaving 'schools, training colleges and universities all over the country'.[53] In doing so, it accorded police work professional status and expertise, suggesting it was suitable for middle-class women, including graduates. An examination of recruitment campaigns and of the backgrounds of women who joined police forces in Britain and Northern Ireland suggests a more complex picture.

In 1959 the Metropolitan Police asked universities to distribute careers information to women graduates: 'we can with confidence offer a really worthwhile career to young women leaving the universities who want to use their own initiative'.[54] Universities themselves were less convinced, reporting very little interest among female students.[55] The five Oxford women's colleges refused to back the recruitment campaign: 'the principals decided that they could not recommend graduates of this university to apply for entry on the salary and conditions laid down in the pamphlet'.[56] In 1963, senior policewomen expressed concerns at their national conference that 'teachers – especially careers masters and mistresses – were not very sympathetic towards the police as a profession for the better educated boy or girl'.[57] A career in policing did not have sufficient 'kudos' or salary to attract the university-educated (male or female).

Policemen were classified as non-manual skilled labour by the Registrar-General and it has been argued that the male force was drawn from a working-class base.[58] While sociological studies seek to measure the category of 'class' through occupation in terms of manual and non-manual trades, this reflects neither the complexities of women's involvement in war work, voluntary work and part-time labour, nor the ways in which the status attached to different occupations may fluctuate over time (through processes such as professionalisation). Rules of closure for police personnel files vary from force to force and the detail that is recorded varies across time and space. Many files do not give parental occupation, and data concerning policewomen's previous occupations became obsolete as the minimum age of recruitment was lowered.[59] Cadet recruitment schemes, introduced in the late 1960s to provide a specific post-16 vocational education and training, provided a different orientation to academic sixth forms that is not comparable. Nevertheless, sets of data have been abstracted for the City of Birmingham Police, the Metropolitan Police and the RUC that suggest trends in the relationship between social class and recruitment.

The City of Birmingham Police recruited a small number of uniformed policewomen from 1917 onwards, although women were not attested until 1931. In 1917, Mrs Rebecca Lipscombe and Mrs Evelyn Miles, who had worked as matrons in the police lock-up, were appointed as Birmingham's first policewomen. Miles became sergeant in charge of the Policewomen's Department, retiring in 1939 at the age of 72.[60] Lucy Charlton – who had worked as a prison officer and was the wife of a warder – was appointed in 1918 at the age of 35, retiring in 1942. Four other women were appointed in 1919: Ellen Vernon, age 53, widow of a music teacher, who retired in 1939; Sarah Hancock, then aged 50, who had served in the Women's Voluntary Reserve and whose husband was a commissionaire (she retired in 1937); Catherine Downey, aged 48, who had some nursing experience and retired in 1944; and Adelaide Pearce, aged 35, whose husband was a postman (she retired in 1947).[61] The first uniformed women in Birmingham can be characterised in terms of their maturity and length of service as well as their non-elite origins, drawn as they were from the skilled and semi-skilled labour force. While the Met only recruited unmarried women in this period, Birmingham did not introduce a marriage bar until 1931 (as a result, married women already in post remained as unattested officers).

In addition to its uniformed officers, however, Birmingham recruited a small number of lady enquiry officers during the inter-war period to work with the CID, taking statements from women and children and

assisting with investigations. In contrast to the uniform section, these women, who worked in plain clothes, can be characterised as a highly educated middle-class elite. Dorothy Peto (later superintendent of the Metropolitan Women Police) was employed as an enquiry officer from 1920 (aged 34) until 1924. The daughter of an architect, she was educated at home in the New Forest, Hampshire, by a governess. She was replaced by Mildred White, then aged 52, who had taught modern languages in a large girls' school before she became involved in policing in 1917 (previously employed in Bath and Salisbury). The work was deemed too much for one solitary officer and White was assisted by Joan Alexander (1930–33), a 24-year-old Oxford jurisprudence graduate who was training for the bar. In 1933, another graduate, 35-year-old Doris Bushnell (daughter of a lawyer), replaced Alexander and was called to the bar while in post (1934), continuing her duties until 1944. Norah Gray, who also became an enquiry officer in 1934 and went on to head Birmingham's policewomen between 1944 and 1962, came from a less academic background. She had left school for secretarial work and had studied business at night school before moving into policing, joining Sheffield City Police in 1931. After the war the separate recruitment to the CID of a graduate group was swiftly abandoned.

The inter-war use of both graduates and working-class women was also apparent in London. Between 1919 and 1936 the Met recruited 84 women, who had been previously involved in a broad range of activities.[62] A significant group (35 per cent) had been engaged in occupations that were in the process of acquiring semi-professional status (in the fields of education, social work and medicine) and which could be broadly characterised as middle class, while 7 per cent had been involved in domestic services, a further 14 per cent in rural and industrial production and 6 per cent in war work. Thus the Met's women were drawn from a variety of class backgrounds in the inter-war period, although middle-class backgrounds were probably over-represented.

After 1945 policing was unlikely to be seen as a graduate job for women, partly because other forms of graduate social work were expanding rapidly. This was reflected in recruits. A 10 per cent sample of the personnel records of the Policewomen's Department in Birmingham shows that, among women recruited in the 1940s and 1950s, a clerical/secretarial background was dominant (66 per cent), with women occasionally joining the force from teaching (14 per cent).[63] The sample included one woman who had failed to complete her university degree. Despite the lifting of the marriage bar in 1946, the majority of women who joined the Birmingham force felt compelled to leave when domestic

circumstances changed. During the 1940s and 1950s, the mean average age on joining was 23, while the average length of service within this sample was four years, with 21 per cent leaving because of marriage and 28 per cent because of pregnancy. During the 1960s and early 1970s, 60 per cent of women recruits were drawn from the Police Cadet Corps and a further 35 per cent from secretarial/clerical backgrounds. The average length of service was 2.9 years, with 35 per cent of women who resigned giving marriage as the reason. The average age on recruitment was 20, a considerable drop from that of new recruits in the early 1920s. Given the rapid turnover of officers, the women's department as a whole had an extremely young age profile, a problem that was regularly discussed at senior policewomen's conferences in the 1960s.[64] In 1970, a part-time employment scheme was introduced nationally to encourage women to return after maternity leave.[65]

Finally, an occupational profile of the 88 women who joined the RUC's Women Police Department between 1943 and 1959 shows that 46 per cent had been involved in clerical work before joining. A further 8 per cent had been engaged in shop work, 7 per cent had been involved in 'household duties', while 5 per cent had been employed in domestic service. Remaining miscellaneous occupations included a linen handpainter, a military policewoman, a prison officer, a machine operator, a lab assistant and a dairymaid. The marriage bar that was still in operation in Northern Ireland until 1968 produced a similarly 'young' Women Police Branch: the average age on joining was 24 and 62 per cent of women left within five years.[66]

It is difficult to draw conclusions about social class from sample data for the postwar period. Women of all social groups engaged in war work. Moreover, office work was a ubiquitous choice for working-class and lower-middle-class women in this period. For young women who had decided on a career in the police, it was also an obvious 'stop-gap' while they waited to reach the minimum age for recruitment. It is possible to suggest, however, that police work became a lower-middle-class/upper-working-class occupation for women as numbers increased at the end of the Second World War, and women's class position was not significantly different to the men.

The recruitment process

While not setting out to attract an academic or class elite, the recruitment process was a very competitive one, with only a small proportion of applicants succeeding. In 1952, for example, the Met (which recruited

nationally) received 2,008 initial enquiries from women and sent out 1,974 application forms (indicating that police work was considered by a substantial number of women). From the 703 returned forms, 325 women were summoned as suitable for examination. Of the 285 who attended, 75 were rejected by the chief surgeon as medically unfit (poor eyesight or flat feet might disqualify them) and 102 were rejected by the selection board. Only 108 women were offered posts, of which 74 accepted.[67] RUC recruitment took place approximately every two years from 1943 onwards and it has been suggested that only one woman in ten was selected who applied.[68] Those drawn to police work recognised it was a competitive process: 'I knew when I was about 13 that I wanted to join and it was just hope, hope, hope, that I'd be accepted because it was quite difficult to get in.'[69]

Senior policewomen were looking for women with particular characteristics and qualities in the 1950s and 1960s. Jean Law, who recruited women to the West Riding Constabulary before taking up her post as Assistant HMI of Constabularies, said, 'We were very choosy about the women we selected; they might have the qualifications but you could tell "I can't see her doing the job".'[70] While a benchmark of four 'O' levels was seen as desirable, those who did not have them were asked to sit a basic educational exam. Previous work experience or involvement in youth organisations was seen as vital in developing social skills and responsibilities. This was stressed by a former chief inspector in West Sussex:

> They'd got to have a good foundation, a good family, who would support them and keep a balance on everything ... They had quite a good education, not necessarily marvellous ... and they had nice personalities, an approachable attitude, and, principally, were there to help people, which gave them a right attitude. You'd try to get that, and a certain amount of, not worldly experience, but experience in either Guides or as a leader in a youth club. They were natural beings to help to lead, they liked people, they mixed with people, they had some staying power, some endurance, and they thought deeply about what the responsibilities would be.[71]

Other senior policewomen identified 'assertiveness', the ability to 'get on with people', 'basic common sense, logical thinking' and 'confidence' as key criteria.[72] Those considered to have potential but insufficient confidence or maturity might be advised to reapply later on.[73]

While educational attainment was not a focus, women recruits were often perceived to have superior ability to the men: 'they took the men because they needed the number but the girls had to be something special to get there to start with'.[74] In Leeds it was noted that 'the Women Police Service in those days drew a good class of women and it's true to

say that we had a better class of women constable than there was male constable' (the term 'class' seems to be used here to suggest 'calibre').[75] In Birmingham in the 1960s, girl recruits to the cadets were found to be of a consistently better standard than boys.[76] Because of the statistically small number of women students at the Metropolitan Police training school at Peel House, the Women Police Branch expected them to do well. The Annual Report of 1948 commented that they 'often held high places in their respective classes' in exams.[77] In some cases, therefore, empirical evidence of measured achievement reinforces the perceptions of recruits and recruiting officers that women officers possessed greater ability.

Personal appearance might also be considered important in recruitment. A former Chief Inspector in Leeds City Police commented: 'we tried to recruit slim people . . . we were going to put somebody in uniform and you wanted the public to look at that person and see them as somebody who had an air of authority, who was smart and well kept'.[78] If women officers were to command respect, they had to look 'the part', which might entail conformity to gender expectations. Metropolitan policewomen who were recruited by Bather in the 1950s often referred to her apparent desire to 'feminise the force' by recruiting 'young ladies'.[79] The 'Miss Bather model' was 'slim, quite good-looking, held themselves well and could speak reasonably well', according to one 1949 recruit.[80] The restyling of recruits was part of the intentional cultivation of a less 'butch' image. Women officers were expected to possess the bodily signifiers of respectability.

As for male officers, prospective policewomen were fully vetted and detailed enquiries were made into their backgrounds and previous employment. Metropolitan Police enrolment forms from the inter-war period show that referees were asked, 'Are her connections and associates respectable? Do you consider her character and habits satisfactory, especially as regards honesty and sobriety?'[81] The same questioning was used regarding both male and female candidates. Yet the meaning of 'respectability' was still gendered in an era when the sexual double standard was very much in existence and women's personal and sexual reputations were a significant area for scrutiny. In recruiting to the RUC, women's social status and moral standing was also equated with church attendance.

In Northern Ireland the religious background of candidates was meticulously recorded. When the RUC was set up in 1922, it had been recommended that a third of all police officers should be drawn from the Catholic community, to reflect the population profile. The two women who had been serving in Belfast under the Royal Irish Constabulary

(RIC) in 1922, Mary Fallon (Catholic) and Jane Bell (Protestant) transferred to the RUC and were for many years the only policewomen in the force.[82] In 1940, Mary Catherine Carton, another Catholic and the daughter of a former RIC policeman, was appointed to replace Fallon after the post had been advertised in the *Irish News* and *Belfast Morning News*. Out of the 35 applicants, 7 were short-listed and detailed enquiries were made. Favourable information was worded in a similar way for all Protestant women: 'She is a respectable person of good character, trustworthy and loyal'. The recommendation was qualified in the case of Catholics: 'She is a very respectable girl, steady, trustworthy, reliable, and so far as the police are aware, loyal'.[83] While the word 'loyalty' simply implied 'duty', 'responsibility' and 'trustworthiness' in England and Wales, it was a rhetoric that was politically charged in the context of Northern Ireland, where the authorities were looking for those who would support the union. While the RUC was keen to recruit unionist Catholics, it was also recognised that Catholics were more likely to be associated with nationalism. Religion served as a marker of identity. The RUC was never able to achieve the target of a Catholic third, partly because nationalists were unlikely to apply or to be accepted but also because Catholics might face intimidation and ostracism within their community. The RUC was clearly royalist in name, flew the Union Jack flag and required new recruits to swear an oath of loyalty to the Queen.[84] Women who joined the RUC felt great pride in the 'royal' designation that positioned them as unique among forces in the UK. In 1927 the percentage of Catholics in the RUC had fallen from 21 per cent to 17 per cent, with a further drop to 10 per cent by 1969.[85] Of the first 100 women who were appointed to the RUC between 1922 and 1963, 11 per cent are identified as Catholic on record cards (where extant), a slightly lower profile to the overall figure for RUC recruitment at this time.[86]

While recent discussions of policing in Northern Ireland have centred on the creation of a force that is denominationally and politically representative of the province, the issue of 'race' has been paramount in England and Wales, where the police service has been described as 'institutionally racist'.[87] The invisibility of police officers from non-white backgrounds is obvious for much of the twentieth century, and the injunction that officers must be of 'British parentage' made it impossible for second-generation immigrants from non-commonwealth countries to apply. Where non-white faces appear on training school photographs of the 1950s, they belong to police officers from Commonwealth countries visiting the UK for training purposes only. The first 'coloured policeman' in the UK was appointed in Coventry in 1966, while the first non-white

policewoman, Sislin Fay Allen, served in the Met from 1968 to 1972. Home Office figures indicate that only 19 'coloured officers' had been recruited nationally on regular contracts by July 1969 (three of them women), despite campaigning attempts to broaden the ethnic background of the British police service.[88] As John Lambert pointed out in 1970, recruitment drives were unlikely to succeed if immigrant communities felt threatened by 'a hostile discriminatory white society' or were unresponsive to 'white definitions of status'.[89] Despite producing community liaison literature which stressed that 'the police are there to help all law-abiding citizens regardless of race and religion',[90] recruitment brochures for women's branches contained a series of images of young white policewomen, reflecting but also reinforcing the notion of policing as a white occupation. While recognising the cultural diversity of London, the Met's 1968 brochure for women police inadvertently linked migrant and transient populations with criminality:

> London is a magnet for all kinds of people. There is a big shifting population of all races, with different customs and ways of living – and a constant flow of visitors from the provinces and abroad. There are always the problems of crime and accidents and their impact on people. As a London policewoman you'll always be dealing with people. People are your concern.[91]

Interspaced with the text are photographs of policewoman who look remarkably similar, dealing with a variety of situations on the streets of London. If the backdrop is difference, diversity and 'otherness', the woman officer represents stability. While this is a stability that derives from the uniformity and authority of police dress, which seeks to draw attention away from the identity of its wearer, it also comes across as a stability that is coded as white. All samples constructed for the purposes of this study have, unsurprisingly, emerged as white.

As Jones has argued, selection criteria for policing – as for other occupations – 'are highly subjective in nature' and dependant on the 'discretion' of the selection board.[92] In some cases senior policewomen sought to recruit women in their own image. In other cases, the net was cast a little wider but the notion of core personal characteristics remained the same. The 'right' qualities for the job were 'character, common sense and readiness to make your own decisions'.[93] By the 1960s, however, 'common sense' tended to be contrasted with university education, which was seen as an inadequate training for life, and graduates were extremely unlikely to apply. A graduate entry scheme, administered nationally, was in operation by 1966 but very few women recruits came through this path. In 1969, two out of only five women applicants were successful: one joined

the Met and one joined Sussex but left shortly afterwards.[94] If women officers had acquired public 'kudos', it was through an image that was sensible, practical, reliable, resourceful, and 'pretty but tough';[95] its status for women was most closely aligned with the semi-professionalism of nursing.

'Do you really want to do that?'

Perceptions of the suitability of police work for women were shaped by class and community attitudes towards the police service as a whole. Interviews with women who joined police forces in Britain between 1938 and 1973 indicate that the police were viewed with ambivalence or as oppressive in some poorer working-class areas. Maureen, who joined her local force in 1959, commented, 'Well, my father was dead by then and I'm not sure he would have approved . . . Being brought up in a hard-working area of Newcastle he'd probably had his ears boxed or been kicked in the pants by a local bobby'.[96] Sian, who joined Gwent Police in 1970, recollected of her father: 'He went loopy; he was so upset. He said, "You'll never have any friends again, nobody speaks to police officers."'[97] Yet, in other unskilled or semi-skilled working-class homes, recruitment to the police was associated with social mobility. Zena, who joined Bournemouth Borough Police in 1960, said: 'In my walk of life, girls where I lived didn't take up jobs like that. The people in the neighbourhood said, "Oh, she'll never get in," and I did, and I was very pleased with myself.'[98] Among lower-middle-class families there was often a clear note of approval. Katherine had wanted to go to art school in 1967 but her father, an ex-brigadier and bank manager, would not consent because he saw it as too unstructured. Police work enabled her to leave home but to 'do something that was thought upon by them as being a profession'.[99] The 'respect' that they felt their work brought them in the public eye was not necessarily compatible with a private identity. When courting or socialising, women officers were unlikely to disclose their occupation in the first instance and the majority selected police partners.[100]

Within their own lifetimes women experienced what they saw as changing attitudes, which affected their own sense of identity and their relationships with others. Interviewed in 1940, Evelyn Miles recounted that 'in her early days she had to put up with a great deal of jeering from men and women alike, but she continued her work long enough to see virtually all prejudice against women police vanish from Birmingham'.[101] *The Blue Lamp* and *Dixon of Dock Green* helped to shape an image of British policing in the 1950s and 1960s as benign, community-based and

consensual. A nostalgia for this era shaped many of the accounts that women presented of their work. Helen, who joined Manchester City Police in 1962, described her decision to join and her friends' reactions:

> They didn't know any policewomen. And they said, 'Wow, do you really want to do that?' They were quite proud and liked the idea of me becoming a policewoman. They didn't mind telling people, 'My friend's a policewoman'. I was quite proud of it. But I think these days I don't like telling people I was in the police any more because they're not as fond of the police as they used to be.[102]

Policewomen in Britain referred to a perceived decline in community 'respect' for police officers in the 1970s and 1980s that had clouded their own sense of personal status. This apparent deterioration in police/community relations has been associated with a general 'decline in deference', the replacement of foot patrol with panda cars, a series of scandals involving alleged police corruption, and the more visible use of police in the regulation of 'political' disputes.[103] In Northern Ireland, former women officers referred to a similar previous golden age of community policing, which was disturbed by the eruption of violence in 1968. The disclosure of police identities became a security issue and the experience of being a 'force under fire' impacted severely on RUC families, forcing them to become introspective.[104] Rosemary Sales has argued that the Troubles created a sense of loss and alienation for the Protestant community: 'British identity is extremely important but they feel that Britain has let them down.'[105] For former RUC women this was intensified by the loss of their name and badge (the crown and harp) with the creation of the PSNI in 2001: 'it hit me personally very badly when they took our name away... we didn't do anything to deserve that'.[106] For the UK as a whole, memories of early careers are inflected by a desire for a happier past that is seen as long gone and unrecoverable.

While policing might be seen as an appropriate line of work for a son, there were mixed feelings where daughters were concerned. This was partly because of a desire to protect daughters: 'Mother was delighted and supported me all the way; father was very worried and concerned because he thought I would see the worst of the male sex, because 90 per cent of crime thereabouts is committed by men'.[107] Given the small number of women who entered policing, it was still considered an unusual choice: 'I think my dad was very proud and my mother when I told her, I'll never forget... said, "That's a strange thing to do."'[108] In some cases mothers had professional aspirations for their daughters that they themselves had been unable to fulfil: 'I think she thought that girls should have

opportunities. But dad wasn't so keen. His idea was you were a girl and that was it.'[109]

The reasons that women gave for joining must be seen as part of a wider personal narrative in which they reconstructed and remembered younger versions of their (present) selves. The question 'Why did you join?' presumes a logical answer based on a weighing up of choices, yet decisions made in life are not always organised in this way. Six of the women found it difficult to recollect or to specify why, initially, they had been attracted to police work. Personal connections − either having relatives who were police or having friends/family suggest it as a line of work − were identified as significant factors in the decision-making process by a sizeable proportion of those interviewed (42.5 per cent); yet they do not indicate women's expectations of police work. 'Reasons for joining' tended to fall into categories, suggesting shared sets of experiences and assumptions that were articulated in relation to a common cultural repertoire. These categories overlap to some extent with those used by serving (male) officers interviewed by sociologist Rob Reiner in 1973, although there are significant inflections that can be linked to gender ideologies of the period.[110] Clearly the attraction to policing as a 'man's job', labeled the 'machismo syndrome' by Reiner, does not apply. Of the women, 15 per cent of the women (compared to 28 per cent of Reiner's men) stated they were attracted to the uniform, discipline and structure of the police. An older generation of women served in the forces during the Second World War and depicted police work as part of a continuum. Kathleen, who had been in the Auxiliary Territorial Service (ATS), said: 'I liked the discipline, it's a comfortable sort of life, providing you do as you're told, that you're not in trouble, but you're allowed to use your imagination and your own initiative.'[111] They found themselves disappointed by the variety of work on offer when war ended: 'when the men came back there wasn't a lot of employment for women, not decent jobs, not at that stage.'[112] Among younger women the interest in a disciplined regime was generated either because they came from 'army' families where it was prized, or (in a few cases) because they portrayed themselves as 'rebellious' or 'tearaway' adolescents and thought 'it was perhaps a good way of getting a bit of structure back'.[113] Some women (25 per cent) were attracted to the police because they said they had wanted to 'help people', 'work with people', or saw it as a social or public service. Reiner similarly identified 22 per cent of men as seeing the police as a 'public service'. Yet the meanings of this are gendered. In male accounts there seems to have been more of an emphasis on the policeman's law enforcement role, whereas the notion of 'helping people' seems to be a

more specifically feminine construct. Pat, who had joined Coventry City Police in 1957, commented: 'I think it was really the variety of the work and performing a service really . . . it was really a help to the community, or doing something worthwhile.'[114] The emphasis on 'helping people' echoes the rhetoric of 'duty, loyalty and stoicism' associated with postwar femininity that was evident in media representations and recruitment brochures.

All of the women had worked in other occupations (often in clerical work) before they joined and all saw police work as preferable to the monotony of the office routine. Police work was seen as exciting, unusual and unconventional for women (in a way it could never be for men). Three of the women saw recruitment to the Met (which provided accommodation in section houses) as a good way to get away from home and from parents who were felt to be too strict or too controlling (a factor that is not mentioned by Reiner). Police work in the 1940s to 1960s clearly offered an escape for women and an interesting and challenging alternative to the mundane routine of office and home. 'Instrumental reasons', including the security of regular pay and a pension, were only mentioned by two of the women whom I interviewed, although they featured in a third of Reiner's sample. This is partly, again, because policing was seen as unusual and an escape for women. The lack of interest in 'security' is probably also a function of gendered expectations of marriage and a still-dominant assumption that married women should not work.

Assumptions about marriage also meant that many women who were interviewed found it difficult to answer the question as to whether they had seen their work as a 'job', a 'career' or a 'profession'. Marion spent five years in the Met, leaving to have her first child in 1966: 'I suppose that my parents expected me to get married and have a family . . . I knew that was expected of me, so therefore I didn't look at it as a profession.'[115] Even some women who became senior officers were surprised at what they had achieved. Maureen, who retired as a chief superintendent, said:

> Someone once said to me, 'A career woman like you'. I said, 'I don't know what you mean.' I don't know what a career woman is, other than somebody who follows, or pursues, a career. I never pursued anything, I just did something I really enjoyed doing. Promotions came, opportunities came, I never was bored . . . I don't think it was a job, because it absorbed my whole life really, which sounds a bit corny. I just loved it ... I didn't plan it, it just happened.[116]

For many women the concept of 'career' was non-existent in the 1950s. The meaning of the term was also contested. Some who were reluctant to use the term 'career' saw it as suggesting an individualistic pursuit of

personal advancement or a deliberate rising up through the ranks, both aspects which they had rejected. For others the term 'career' suggested a 'commitment' to helping others, with which they were happy to associate.[117] A number of women preferred to classify police work as 'a way of life', identifying themselves with a wider police culture and using a term that also featured in Reiner's study.[118] As an active Christian, Joyce saw her work as 'a vocation' that arose from her spiritual beliefs.[119]

A women's work culture?

Women's experiences and occupational identities were shaped by their encounters with both male police cultures and the women-oriented environment of the specialist women's departments. A shared identity as 'women' was cultivated though central Women Police Branches and Policewomen's Departments in larger towns and cities, which had considerable organisational autonomy and were also spatially separate. Glasgow City's policewomen were allocated a whole ground-floor flat in 1959:

> We had a front office and there was always a policewoman behind it. The superintendent had a room, the inspectors had a room, the chief inspector had the next one down, and there was one where the sergeants were. We had a dining room, we had a proper kitchen with a cooker, washing facilities in it. On the other side of the corridor the two CID girls had a room, there was a little interview room for privacy and there was a drying room where they could take their wet coats and things . . . We had our own car and our own driver, we were completely independent.[120]

In Leeds the Policewomen's Department was situated in a separate building, underneath the City Library on the Headrow; there was a separate suite of offices, a reception and waiting area, and a separate sign over the entrance. While the male establishment might, historically, have influenced this segregation, many of the women interviewed enjoyed the dynamics of working in a women's department. The close-knit community could be extremely supportive: 'It was just a lovely atmosphere because you belonged; if you took any stick from the men, you'd chat about it.'[121] Within the Met, women were based at different stations but there was almost always a separate women police office: 'That was lovely, you had your own office, your own telephone . . . that was nice to shut your door and that was your inner sanctum'.[122] In some of the smaller stations, women developed their own set of daily rituals. At Commercial Street in the early 1960s, where a small group of policewomen were

quartered in a small flat, the routine revolved around the preparation of a communal lunch: 'We'd go out to the butcher's [for meat] ... and [someone would] stuff it down their mac' pockets or their tunic pockets ... and someone else would buy the potatoes, and somebody else would buy the carrots or greens'.[123] The notion of solidarity was built around the sharing of the mildly illicit: they were not supposed to shop on duty and food preparation could only take place in snatched minutes between police duties. Although women worked closely with the men, sometimes patrolling with them or working on observations, station routine was often based on the maintenance of separate spaces. At West End Central in the 1960s, women did not eat in the canteen. Older women accepted that this was the best way to do things: 'I think they liked to let their hair down and they didn't necessarily want the girls there, quite honestly.'[124]

For a younger generation of women coming into the force, the segregation seemed anachronistic. Carol, who was stationed at West End Central in 1969, thought it strange that all refreshments including meals had to be collected from the canteen and eaten in the Women Police office. 'It was very strictly controlled for the women ... you were expected to sit with women police and not fraternise too much, it was frowned upon.'[125] This was not always the case either in the Met or nationally, and there was considerable variation from station to station. While women officers ate in the canteen in Manchester (Figure 5), head of the Women Police Branch from 1949, Nellie Bohanna, cultivated an ethos of difference and distinction, based on rigorous discipline. She sought to label her 'women' as an elite group: 'She was straight and to the point, what she would like and what she wouldn't like. And all her "Women Police"... not policewomen ... "My Women Police are very special". You sort of set yourself aside from the men, you did everything, you were smart.'[126]

The concept of 'respectability' was seen as crucial to image and a sexual double standard informed disciplinary procedures; women were more likely than men to be asked to resign because of sexual improprieties. In 1930 a Metropolitan policewoman was requested to resign for 'improperly associating' with a married male constable.[127] By 1969 women who were found to be involved in relationships with married men were most likely to be transferred swiftly to another station.[128] Senior officers tended to distinguish between 'the promiscuous young women and the one who became genuinely attached to one particular man where the marriage had already broken down'. Single women who found themselves pregnant were asked to leave, while male officers who were involved remained within the force. As Assistant HMI, Jean Law argued that she expected a '*higher* [sic] standard of conduct from women'.[129]

Figure 5 Manchester City policewomen in Bootle Street canteen, c. 1962

Some women preferred to escape the Women Police Branches. This could most easily be done in rural areas. Vera was posted to Boston in Lincolnshire in 1960 as one of only two policewomen, each covering alternate shifts: 'If we'd been in Scunthorpe, you had a separate office, a separate supervisor, a separate everything, you were completely isolated from the men. Whereas in a smaller place like that you were in with them from to start with, and you got treated very much the same.'[130] She saw this as beneficial because she got a wider experience of police work. She much preferred to see herself as 'a police officer' to a 'policewoman', although she also commented that 'I never forgot that I was a woman'.

Gender difference, inculcated by the Women Police Branch, was for many women an important aspect of personal identity, although its exact meaning was a result of personal negotiation. Katherine, who joined the Met in 1967, said: 'I saw myself as a woman officer, purely probably because I was quite feminine anyway. I would not have seen myself in a male role. I always strove to keep my femininity, even in uniform I never had my hair cut.'[131] Reflecting on her teenage 'self', however, she said she had been 'a bit of a tomboy', which had inspired her to do something

'interesting' and 'challenging' as a career. A desire to identify as 'feminine' did not mean that women saw themselves as 'unequal'. In many cases they argued that they were superior to male officers because they felt they were better trained and more experienced because of the wide variety in their work. At another point in the interview, Katherine commented that 'We had our own little niche that was elitist really at the time, and we had access to anything else that was happening.' An identity as 'specialists' with regards to women and children often led to an increased sense of professional status. Women also felt that their femininity, because of its rarity in policing, made them special: 'I enjoyed being treated as a woman in the job, there's no doubt about it; to all intents and purposes I believe I was treated as a woman, which was lovely, the niceties.'[132]

Police identities were also based on age, as women compared themselves to those who were already in the force and depicted themselves as more 'modern'. Each generation positioned older women inspectors as belonging to an 'old type'. Edna, who joined Lincolnshire Police in 1949, made reference to women 'of the old type' who 'put the fear of God in you'. She added, 'I think those early women had to be . . . because they had to put up with a terrific lot of backlash and prejudice, particularly from the senior male officers.'[133] For Joan, who joined the Met in 1949, the older inspectors could be categorised into two types: 'society women who went in with the idea of welfare, and the rougher, tougher women.'[134] Both were seen as austere in different ways. Katherine was extremely critical of her women inspectors: 'The women who governed the women were really quite tyrants, they were really old-fashioned, old-school people; most of them were single, they didn't put up with any nonsense from the women police, so if anything did ever happen you were severely reprimanded.'[135] On rare occasions women also experienced bullying by their female superiors.[136] Women from several different generations similarly characterised previous ones as 'butch', emphasising their own femininity and heterosexuality and disassociating themselves from lesbianism.[137] Dorothy Peto had herself cultivated an androgynous personal image, and when she first joined the Met in 1920 she was photographed with cropped hair, a tie and a trilby.[138] Those who joined in the 1960s pinpointed an apparent hypocrisy that did not question living arrangements involving two women cohabiting.[139] While, for cultural reasons, close relationships between women were less subject to formal scrutiny, the mechanisms of gossip sought to censure lesbianism. It is important to avoid drawing conclusions about women's sexualities from circumstantial detail. Given that the marriage bar positioned career and marriage as discrete entities for older women, companionship and emotional support were often

sought from female colleagues; close personal friendships were forged as a result of working together; and these friendships were not necessarily sexual ones.

Women who joined from the 1960s onwards felt that a gulf separated them from those who had joined just after the war with backgrounds in the forces: 'We were seen as a softer touch really, men as well.'[140] This later generation were clearly shocked by the military discipline and its clear difference from other forms of professional training. Sian, who was sent to Ryton in 1970, said that she had expected police college to be like a teacher training college: 'Nobody had told you or certainly hadn't told me that it was a semi-military-run establishment where everybody marched everywhere and did drill.'[141] While a certain 'professional' image of policewomen had been developed in the press and recruitment brochures, some younger women felt this did not accord with the military model.

In addition to age and sexuality, difference was constructed around marital status. The few married women who joined the force in England and Wales in the 1950s found they were consulted because of their knowledge and expertise by younger colleagues who had received little in the way of sex education.[142] However, this difference could also constitute division. In Scotland the removal of the marriage bar was hotly debated in 1968. Elsie, who had joined Glasgow City Police in 1944, believed that police work and marriage were incompatible: 'When it was brought up at the Federation I fought it tooth and nail. It's not a job for a married woman.'[143] She argued that the first duty of a married woman was to her husband and family; the first duty of a police officer was to policing. Peggy, who joined Leeds City Police in 1954, felt it had been difficult to balance the interests of single women and married women, who might require specific shifts to fit with child-care and domestic responsibilities. Resentment could arise, she argued, if pregnant women had 'to be given a cushy job which deprived somebody else of a day or two inside'.[144] The dominant model of policing as a full-time male occupation, in which policemen had traditionally counted on the unswerving support of police wives, made it very difficult for women officers to negotiate the demands of work and home. Divisions were undoubtedly created (although not always felt) between married and single policewomen as a result of the occupational ethos and culture of policing.

While there were processes of segregation and separation at play in the delineation of Women Police Branches and Policewomen's Departments, women also participated in a wider police culture, which included police balls, seasonal events, and parties or drinks after work. Over a quarter of interviewed women married police officers – while not encouraged

on duty, the workplace nevertheless provided opportunities for courtship – and retained their links with the police service even when they left to have a family. The prevalence of police/police marriages was explained in terms of the complexities of shift work, which made it difficult to socialise with other occupational groups. By the 1950s, in most forces women worked very closely with male officers on a wider variety of duties: 'we built up this great bond ... it was this tremendous loyalty for each other'.[145] In Northern Ireland the RUC socialised together for security reasons and the sense of being a 'family' was felt to be of crucial importance. The majority of the women interviewed identified closely with police culture and canteen culture (as well as seeing themselves as 'women officers'), which they linked to a wider comradeship and camaraderie in which they felt they had participated.

Women's perceptions of themselves and their working lives are delineated in relation to a dense web of reference points – gender, class, status, age, sexuality, religion – that have been, and continue to be, negotiated through interpersonal relationships (both familial and occupational). Identities and self-perceptions are fluid and at times contradictory. Women who criticised their own inspectors as 'sticklers' about smartness also spoke of personal pride in their uniform in opposition to a present generation of police officers who wear 'anoraks and trousers'. An occupational identity as 'police' shaped all accounts but so, too, did an identity as 'women', which contained aspects of what could be defined as both 'femininity' and 'feminism' (although women never used that term). If the 'new feminism' of Eleanor Rathbone had emphasised equality through difference in the inter-war period, it was the notion of women's distinct contribution that often shaped the accounts of former women officers. It was argued that the 'integration' or 'equality' that was proposed in the 1970s was undesirable because 'we're not coming down to your level'.[146] A notion of women as both superior (*more* than equal) and different was used to counter the sexism of male officers, which was accepted as a social norm rather than viewed as problematic. The sense of a women's culture has been cultivated since the closing of the Women Police Branches through the setting up of separate networks – in particular, the MWPA and the Evergreens (RUC) – to act as a social forum for former policewomen. The networks have themselves fostered a collective memorialisation of the work of Women Police Branches through the collation of histories and the sharing of stories, which has further inculcated feelings of solidarity among members as well as a sense of pride and status in their 'lost' work.

This chapter has shown that the image of policewomen was restyled during the course of the century, although there were constant tensions

between the agenda of senior women officers, who were concerned with the creation of a serious professional reputation, and the agenda of the media in displaying a desirable femininity. However, the 'feminine' and the 'feminist' are not necessarily polarities. 'Femininity' could be used as tool to gain professional status and respect when associated with efficiency and expertise. An increasingly feminised image of policewomen emerged, which was negotiated but generally accepted by women recruits, at the same time that women were expanding their field of activities and embarking on duties previously considered a masculine preserve. Arguably, the performance of femininity rendered this intrusion permissible. Policing was positioned as a 'respectable job' for upper-working-class and lower-middle-class women from the 1940s to the 1970s and it was perceived to have more status attached to it than was accorded male police culture. As I shall demonstrate, the complexities of women's police identity makes it inadequate to analyse their work simply in terms of the imposition of middle-class values. The ways in which ideas about gender, class, status, occupation, sexuality and ethnicity shaped the practice of policing will be the subject of the next four chapters.

Notes

1. Interview with Jean Law and Pauline Wren.
2. A. Oram, *Women Teachers and Feminist Politics 1900–1939* (Manchester: Manchester University Press, 1996); J. Lewis, *The Voluntary Sector, the State and Social Work in Britain* (Aldershot: Edward Elgar, 1995).
3. Brown and Heidensohn, *Gender and Policing*, pp. 42–76. For examples of cartoons, see *Punch*, 16 October 1933; *Police*, October 1968; and *Police Review*, 2 July 1971.
4. Sir H. Scott, *Scotland Yard* (London: Andre Deutsch, 1954).
5. British Film Institute, London: *Looking on the Bright Side* (1932), directed by Graham Cutts and Basil Dean, scripted by Basil Dean and Archie Pitts.
6. *Daily Express*, 25 September 1936.
7. Doan, *Fashioning Sapphism*.
8. NA, MEPO 2/7443 recruitment publicity: letter from Peto to Woollcombe, 15 September 1936.
9. NA, MEPO 2/7443: press release summer 1937.
10. *Evening News*, 19 August 1937.
11. *Daily Express*, 25 September 1936.
12. *Picture Post*, 22 July 1939; see also *Picture Post*, 7 October 1944.
13. *Daily Mail*, 14 October 1944.
14. PSNI Museum, Women Police, early files, letter from the Inspector General's Office to uniform manufacturers, 13 August 1943.
15. P. Kirkham, 'Fashioning the feminine: dress, appearance and femininity in wartime Britain', in C. Gledhill and G. Swanson, *Nationalising Femininity: Culture, Sexuality*

and *British Cinema in the Second World War* (Manchester: Manchester University Press, 1996).
16 *Star*, 25 April 1944.
17 British Film Institute, London: *Street Corner* (1953), directed by Muriel Box, scripted by Jan Read.
18 For a reading of *Street Corner* in terms of Muriel Box's sole authorship as an explicitly feminist film, see Justine Ashby, 'Odd Women Out: Betty and Muriel Box', Ph.D. thesis, University of East Anglia, 2001.
19 NA, MEPO 2/9040: 'Street Corner' film: memo, 5 August 1952.
20 *Ibid.*
21 NA, MEPO 2/9040: first rough treatment.
22 C. Geraghty, *British Cinema in the Fifties: Gender, Genre and the 'New Look'* (London: Routledge, 2000), p. 147.
23 For the rejection of the excessive glamour of Hollywood in the aftermath of the Second World War in favour of a British emphasis on 'natural beauty', see J. Stacey, *Star Gazing: Hollywood Cinema and Female Spectatorship* (London: Routledge, 1994).
24 *Monthly Film Bulletin*, 20:231 (1953), 56.
25 V. Baxter, *Elizabeth: Young Policewoman* (London: Bodley Head, 1955).
26 Baxter, *Elizabeth*, pp. 10, 35.
27 S. Spencer, 'Women's dilemmas in postwar Britain: career stories for adolescent girls in the 1950s', *History of Education*, 29:4 (2000), p. 337.
28 Baxter, *Elizabeth*, p. 19.
29 *Ibid.*, p. 47.
30 *Ibid.*, p. 53.
31 *Ibid.*, p. 79.
32 Spencer, 'Women's dilemmas', p. 330.
33 A. Myrdal and V. Klein, *Women's Two Roles: Home and Work* (London: Routledge, 1956).
34 Spencer, 'Women's dilemmas', p. 340.
35 Baxter, *Elizabeth*, p. 190.
36 NA, MEPO 2/9040: first rough treatment.
37 Geraghty, *British Cinema*, p. 31.
38 Spencer, 'Women's dilemmas', p 342.
39 Lock, *British Policewoman*, p 187.
40 GMPM, National Conference of Senior Policewomen, minutes, October 1963.
41 WPT, Christine.
42 MPM, women police newspaper cuttings 1964–66.
43 Cameron, *Women in Green*, p. 62; WPT, Laura.
44 Mark, *In the Office of Constable*, p 95.
45 MPM, donations from MWPA: press release: 'New uniform for London policewomen: elegance with authority'.
46 Cameron, *Women in Green*, p. 30.
47 MPM, Women Police AR 1953, p. 8.
48 S. Sydney Smith, *Beyond Dixon of Dock Green: Early British Police Series* (London: I. B. Tauris, 2002).
49 See also Young, *Inside Job*.
50 Recruitment was based on local initiatives until 1967, when a national recruitment campaign for policewomen was planned.

51 MPM, Lovell, 'The Call Stick', p. 15.
52 See Levine, 'Walking the streets', p 46. Of WPS-trained women, 38 per cent were of 'private means', while a further 20 per cent had worked as teachers or nurses (suggesting that over half could be defined as middle class). The 1911 census had categorised a quarter of the working population as being engaged in non-manual occupations; see S. Gunn and R. Bell, *Middle Classes: Their Rise and Sprawl* (London: Phoenix, 2003), p. 22.
53 *Picture Post*, 22 July 1939.
54 NA,, MEPO 2/7950: women police recruiting campaign: letter from Bather to various universities, February 1959.
55 NA, MEPO 2/7950: March 1959, letters from the Appointment Boards of the University of Wales (Cardiff) and Durham. More positive responses were received from Manchester and Bristol.
56 NA, MEPO 2/7950: May 1959, letter from Oxford University Appointments Committee. The pamphlet indicated a salary of £670 p.a. plus rent allowances and a period of four to five years before promotion.
57 GMPM, National Conference of Senior Policewomen, minutes, October 1963.
58 R. Reiner, *The Blue-Coated Worker* (Cambridge: Cambridge University Press, 1978), p. 150; Emsley, *English Police*, pp. 191–7.
59 In 1946, the Met reduced the recruitment age from 24 to 22. The age of recruitment was further reduced to 20 in 1948 and 19 in 1962. See MPM, women police ARs 1946, 1948 and 1962.
60 Similarly in Manchester, police widow Emma Jane Ball, who had originally joined the force in 1922, was in charge of women police until 1949. Her replacement Nellie Bohanna had worked as a mail-order clerk in a shipping warehouse before joining the WAPC in 1940 as her war work
61 WMPM, City of Birmingham, personnel files, Policewomen's Department.
62 MPM, Women Police AR 1936.
63 WMPM, Personnel files.
64 Pressures to leave because of marriage and maternity were acute in policing. National statistics for Britain suggest that 52 per cent of all married women were in work by 1961: J. Bourke, *Working-Class Cultures in Britain 1890–1960* (London: Routledge, 1994), p. 100. Significantly less than half of all policewomen stayed in post after marriage.
65 GMPM, National conference of Senior Policewomen, minutes, 17–28 September 1967.
66 PSNI Museum, personnel records, Women Police.
67 MPM, Women Police AR 1952.
68 *Daily Mail*, 3 March 1965.
69 WPT, Irene.
70 Interview with Jean Law and Pauline Wren.
71 WPT, Margaret.
72 WPT, Kathleen; Edna; Maureen.
73 WPT, Elsie, who said she was sent away by an 'old harridan of an inspector' in 1937 with the words 'away home and grow up'; she joined Glasgow City Police seven years later at the age of 27. Moira described Marion Macmillan's initial comments: 'I think you should just go home and grow up.'
74 WPT, Jennifer.

75 WPT, Kathleen.
76 J. Reilly, *Policing Birmingham* (Birmingham, 1989), p. 190.
77 MPM, Women Police AR 1948.
78 WPT, Kathleen.
79 WPT, Joy.
80 WPT, Joan.
81 MPM, Metropolitan (Women Patrol) enrolment forms.
82 Cameron, *Women in Green*, p. 2.
83 PSNI Museum, Old Women Police Papers: candidates for position of policewomen in Belfast, 3 April 1940.
84 McGarry and O'Leary, *Policing Northern Ireland*, p. 65.
85 *Ibid.*, p. 30; C. Ryder, *The RUC: A Force Under Fire* (London: Methuen, 1989).
86 PSNI, personnel records, Women Police. A further 28 per cent were identified as Presbyterian, 13 per cent as Church of Ireland, 6 per cent as Methodist, 2 per cent as Baptist, 2 per cent as Church of Scotland and 1 per cent as Brethren.
87 D. Mann-Kler, 'Emerging Irish identities', in A. Bourke *et al.* (ed.), *The Field Day Anthology of Irish Writing*, vol 5, *Irish Women's Writing and Traditions* (Cork: Field Day, 2002), pp. 166–7, argues that the focus on political and religious divisions conceals the discrimination faced by ethnic minorities in the province; Report of the Stephen Lawrence Inquiry (Macpherson Report) (BPP 1999) Cmd 4262.
88 NA, HO 287/1453 Police and Colour: recruitment. See also HO 287/1459 Police and Colour Recruitment: reports. Two of the three non-white policewomen served in the Met; both had moved to London from Jamaica in the early 1960s and were already trained nurses. The third had been born in Shrewsbury and joined West Mercia Constabulary in June 1969. The first non-white policewoman in Greater Manchester was appointed in 1972.
89 J. Lambert, 'The police and the community', *Race Today*, November 1970.
90 HO 287/1455, Police and Colour Training: Leeds City Police leaflet, 'The police and you', 1971.
91 MPM, Metropolitan Police, *Keeping the Peace in London. A Career for Women in the Metropolitan Police* (London: Metropolitan Police Force, 1968).
92 Jones, *Policewomen and Equality*, p. 44.
93 MPM, Home Office and Scottish Home Office, *The Police as a Career for Women* (London: HMSO, 1967).
94 GMPM, National Conference of Senior Policewomen, minutes, 1–2 October 1969.
95 Lock, *British Policewoman*, p. 187.
96 WPT, Maureen.
97 WPT, Sian.
98 WPT, Zena.
99 WPT, Katherine.
100 Condor, *Woman on the Beat*, p. 18.
101 *Birmingham Post and Journal*, 2 January 1940.
102 WPT, Helen.
103 Emsley, *English Police*, pp. 171–91.
104 Brewer with Magee, *Inside the RUC*.
105 R. Sales, 'Women divided: gender, religion and politics', in Bourke, *Field Day*, vol. 5, p. 417.

106 WPT, Laura.
107 WPT, Margaret.
108 WPT, Peggy.
109 WPT, Jennifer.
110 Reiner, *Blue-Coated Worker*, p. 12.
111 WPT, Kathleen.
112 WPT, Edna.
113 WPT, Carol.
114 WPT, Pat.
115 WPT, Marion.
116 WPT, Maureen.
117 WPT, Helen; Jennifer.
118 Reiner, *Blue-Coated Workers*, p. 88. WPT, Maureen; Zena; Ivy.
119 WPT, Joyce.
120 WPT, Elsie.
121 WPT, Maureen.
122 WPT, Joyce.
123 WPT, Mary.
124 *Ibid.*
125 WPT, Carol.
126 WPT, Helen.
127 MPM, Women Police AR 1930.
128 WPT, Carol.
129 GMPM, National Conference of Senior Policewomen, minutes, 1–2 October 1969.
130 WPT, Vera.
131 WPT, Katherine.
132 WPT, Joyce.
133 WPT, Edna.
134 WPT, Joan.
135 WPT, Katherine.
136 Bristow, *Central 822*, p. 44.
137 WPT, Susan; Joan; Joy.
138 Peto, *Memoirs*, p. 63.
139 WPT, Carol.
140 WPT, Susan.
141 WPT, Sian.
142 WPT, May.
143 WPT, Elsie; National Archives of Scotland, HHSS/776 Policewomen.
144 WPT, Peggy.
145 WPT, Elizabeth.
146 WPT, Susan; Gina.

4

Walking the beat

THE METROPOLITAN WOMEN POLICE of the inter-war period, easily identifiable in their blue serge uniforms, were official observers of city life who also formed part of the urban spectacle: they were there both to see and be seen. For commanding officer Dorothy Peto, women police were participants, as well as viewers, in what she called the 'kaleidoscope of the streets'. The image is a suggestive one. As they turned each corner, passed through major thoroughfares or entered dimly lit alleys, new vistas of buildings, people and objects emerged, which had to be observed, analysed and also intercepted: 'not despite of one's uniform but because of it, one becomes a part of the accepted background to the ebb and flow of the human tide'.[1]

The experience of policing in the metropolis and, in particular, the West End – which was often represented as a microcosm of society and a 'melting pot' of the social – was in many ways unique. 'Specialist' patrol duties formed a central feature of the work of the Metropolitan Women Police from their origins in 1919 until integration, and the extensive records that they left enable comparisons across time. Yet there are also striking similarities between the function and experience of foot patrol in London and the UK's other towns and cities as Policewomen's Departments expanded after 1945.[2] In her study of the patrols of the First World War, Levine has argued that women's highly visible presence on the streets 'challenged significant and symbolic boundaries . . . [by] claiming female authority in the public arena'.[3] Women patrols had not been unusual in their uniformed presence in 1915: they joined female bus and tram conductors, railway guards and auxiliary servicewomen. Rather, the particularity of women police lay in their official status as female spectators. As women's role in the police service developed in the inter-war period, so too did a particular style of patrolling, described in detail by Peto. They stopped and stared; they 'parked up' against a shop front

looking for tell-tale signs on the faces and bodies of passers-by; they lingered on street corners rather than hurrying through.[4]

Modern police forces in the UK were engaged in physical surveillance as a preventative strategy – exemplified by the uniformed bobby patrolling his fixed beat – from their origins in the early Victorian era. As Edward Higgs has argued, this strategy became outmoded as new electronic technologies began to impact in the 1960s, transforming information and communications systems.[5] It was replaced by the unit beat system of vehicle patrol, in which teams of uniformed policemen provided rapid responses across broad geographical areas.[6] Such technological change, however, was slow to impact upon Women Police branches. The following two chapters are concerned with the methods, strategies and tactics that were used in relation to traditional methods of physical surveillance by women in the UK's police forces before integration. The overt and highly visible surveillance of foot patrol was counter-balanced (despite initial objections from the press and public) by the covert surveillance of undercover or plain-clothes observations, which tended to be used for the regulation of 'vice' and the detection of crime (especially crime of a 'political' nature).[7] A great deal has been written on the policing of the modern State: firstly by social and political theorists concerned with the origins and effects of a broad range of regulatory practices; and, secondly, by historians and sociologists of the police service who have charted transformations in the duties, perceptions and experiences of police officers over time. These studies have not, however, dealt with the involvement of women in policing or with the impact of 'femininity' and its negotiation on surveillance techniques. I shall, therefore, consider the differing symbolic effects of uniform dress and of plain clothes in relation to the dynamics of gender and space. I shall also examine the ways in which participation within 'the gaze' of 'authority' was experienced and negotiated by women officers. As well as observing, police officers were themselves subject to disciplinary mechanisms – in relation to time, space and the body – within the bureaucratic structure of policing. How were these mechanisms felt, and how were they accepted, subverted or resisted? Finally, I shall examine the ways in which identities – of gender, class, occupation and status – were constituted and negotiated on a daily basis as a result of surveillance duties. While Chapter 5 will focus in depth on undercover work, this chapter will use women's personal testimony – memoirs and oral history interviews – to explore their involvement in uniform beat patrol.

The 'gaze' of authority

Recent academic study has tended to rely on two frameworks – Foucauldian and feminist – to consider the 'gaze' (the relationship between the spectator and the spectacle).[8] The work of Michel Foucault has stressed the significance of the principle of visibility as a modern regulatory strategy.[9] Drawing on Jeremy Bentham's design for 'the Pantopticon' – a prison incorporating a central control tower surrounded by a ring of illuminated cells – Foucault has argued that the threat of violence as a technology of surveillance was in part replaced by an 'immediate, collective and anonymous gaze' from the end of the eighteenth century.[10] While the control tower of the Panopticon was visible to all, blinds placed over the windows concealed both who was watching and, indeed, whether they were watching: the 'gaze' was assumed to be constant and prisoners learned to regulate their own behaviour accordingly. Within Foucault's work, 'Panopticism' – the anonymous gaze and its interiorisation – moved beyond the prison walls and came to operate as a general principle through which an increased population could be disciplined in relation to time and space in order to become docile but industrious bodies.

Influenced by Foucault, Michel de Certeau uses the term 'strategy' to refer to a calculation that is made by a subject or institution 'with will and power' in order to appropriate a particular place as 'one's own'.[11] The strategic vision is wielded from above in an attempt to delineate and regulate spaces by making them visible and by de-marcating what is proper or permissible. In contrast, however, de Certeau uses the term 'tactic' to refer to the intervention or resistance of those who are objects (or 'other') within the field of vision: 'the art of the weak'. 'Tactics' are based on the utilisation of time rather than space; on the ability to make use of critical moments to intercede. They are based on surprise and the immediacy of opportunity. It might, initially, seem illogical to use the term 'tactics' to describe the daily interventions of police officers. However, while uniformed police officers were part of the 'eye of power' and were holders of 'delegated authority', they were also, and equally, objects that were surveyed. The term 'tactic', with its stress on timing, reflects the interplay between strategy and everyday practice; I use it here to indicate moments of discrepancy and resistance. The use of 'tactic' in police surveillance is most apparent in relation to undercover work (Chapter 5), in which officers aimed to infiltrate the space that had been colonised by 'the other'.

Feminist scholars have argued that the dominant gaze tends to be male within patriarchal cultures.[12] Women are continually evaluated in terms of feminine beauty and attractiveness. They are objects (sexual or aesthetic) to be looked at and possessed rather than subjects who can watch with immunity. Drawing on discussions of 'the male gaze' and on insights suggested by Foucault, cultural historians have begun to chart the relationship between gender and urban spectatorship within the specific contexts of the late nineteenth and early twentieth centuries, paying particular attention to issues of time and space.[13] While the Victorian gentleman could casually observe others without scrutiny as he passed through different social spaces – from opera to public house – the movements of 'respectable' womanhood were curtailed, since female status (which was also a sexual status) was ostensibly compromised by the dirt and bustle of the streets. The *flâneur* – the casual observer/explorer of everyday city life – could only be male. Similarly, the professional observer – the policeman – who was engaged in the deliberate act of watching was also, by definition, male. Middle-class women were, of course, involved in daily activities in nineteenth-century public space.[14] Nevertheless, the act of loitering or lingering on the streets was associated with women of ill repute. Although the significance of the First World War in transforming gender attitudes has been debated, the high visibility of women in uniform (undertaking male occupations) undoubtedly challenged previous assumptions about gender, authority and city space. The practice of chaperoning was discontinued at the end of the First World War and cafés and tearooms provided new social arenas for a predominantly female clientele in the inter-war period.[15] Nevertheless, women's perambulations within city and suburb were still negotiated in relation to perceptions of respectability and sexual danger. In summary, women were constantly watching themselves being watched, although the presentation of appearance and the meanings attached to it were historically specific.[16]

As women entered policing, they were not simply concerned with the creation of a feminine space within a masculine occupational culture. They were also involved in a re-negotiation of women's relationship to the 'gaze' within the culture of physical surveillance, defining a strategic role for women as official uniformed spectators. In the first half of the twentieth century women police officers were appropriating the gaze and creating a role for themselves within the 'kaleidescope of the streets': by using and sometimes subverting predominant assumptions about gender difference.

Women in uniform

In her memoirs, *Central 822*, Carol Bristow described the moment when she first put on her uniform in 1965: 'Catching sight of myself in the mirror, I gasped. Wearing my police uniform for the first time I felt intoxicated. With its shiny silver buttons and inky material, it made me look like someone important, someone with confidence. This wasn't the Carol Bristow I used to know. All this prestige and influence was new to me.'[17] The process of dressing for the first time was a transformative one, which involved the exchange of a civilian identity for a police one. The 'uniform', so named, functioned to accord anonymity to its wearer ('This wasn't the Carol Bristow I used to know'). In its military smartness, it invoked 'authority', which for Bristow was a combination of official status and confidence. It might also create initial feelings of anxiety. Those who wore the uniform on the street for the first time saw it as symbolising certain forms of knowledge and skill, which they felt they did not yet possess:

> I remember the first day I walked out on the streets in it; I felt terrible, absolutely petrified. You're worried if you hear feet behind you running: 'My God, what's going to happen, what are they going to ask me?'... You feel as though everybody's looking at you when you first put on your uniform and you're on the street, and yet they're not.[18]

> The first time they sent me out alone I had to walk to the Lansdowne, which is not very far from the police station in Madeira Road, and I remember trying to remember my judge's rules and my powers of arrest, and was going over them in my head, just in case something awful happened. I was terrified.[19]

The sense of 'being watched' might not have been particular to women's experience, but it tends not to feature in policemen's memoirs. For women who had been brought up to scrutinise their own appearance attentively, the move to uniform was a significant step: 'the first day that you go out on patrol, all you keep doing is keep looking at yourself in reflections in the window'.[20] The sense of transformation was most acutely felt by generations who had not undertaken uniformed war work. They were also most likely to experience training school as a culture shock as well as a pivotal experience. At training school new recruits learned how to dress and to care for their uniforms, which involved an expert precision:

> It was a while before I got used to the shirts, because they were cotton, long-sleeved, with a detached collar. You had to have a collar stud at the back and a collar stud at the front. And it hurt as well. I had a mark on my neck for a long time, where the collar stud pressed in. The

policewoman sergeant . . . said, 'You'll have to put your shirts on girls, and I'll have to show you how to put the collars on, because you'll never do it on your own.' And she's walking along, inspecting us, and she said, 'Mark on your collar, take it off and put a clean one on.'[21]

Other women recalled being shown how to 'bull' their shoes with spit and polish by male trainees who had undertaken national service. Training school – with its emphasis on military drill – sought to discipline the body to create order and uniformity in deportment (Figure 6). A carefully controlled outer appearance – in which police officers learned to take pride – would instil inner self-control and a disciplined character. As Brogden has argued, training was as much about 'a transformation of identities' as about the acquisition of knowledge and skills.[22]

As women became more experienced in their work they became less self-conscious and more confident. Extremely uncomfortable in both hot and rainy weather, it was never possible to forget that you were wearing the uniform or to discount its effect on others:

Figure 6 RUC women recruits drilling at Enniskillen, 1965

> A uniform and height gave you authority. And I would like to think that one exercised that authority reasonably and responsibly. You used to gauge, when you went in, 'Am I here on official business?', 'Nasty official business? In which case I will remain standing and keep my cap on', 'Am I here as a helper? Do I want to be a friend with these people? In which case I'll take my cap off and I'll ask if I can sit down.'[23]

The uniform came to function as 'armour', a 'shield' and as 'security'.[24] Women officers all spoke of feeling 'safe' on the streets of Belfast, Glasgow, London, Leeds and Manchester in the 1950s and early 1960s: 'I walked the Bogside in Derry and up in the Craven . . . the boys did the same.'[25] Referring to an assumed 'golden age' of policing, they argued that the majority of people with whom they came into contact treated both the police uniform and their status as women with a respect and deference that had since been lost. Those who joined in the late 1960s were aware of other currents as young officers. Bristow, for example, has written:

> For the first time in years angry young people were challenging the previously unquestioned respect for their elders and those in authority. Despite my age and uncertain political stance, my uniform classified me as one of the latter, and it frightened me to realize that certain members of my own generation saw me as the enemy.[26]

Training school, textbooks such as Moriarty's *Police Procedure*, and police culture offered a justification and analysis of the role of the police officer in terms of social contract and the rule of law, which countered Marxist critiques.[27] It was argued that police authority was based on consent, that officers' status was based on their position as citizens representing the interests of the community, and that the police service was simply a 'reflection' of a wider society.[28] Officers found by experience that attitudes towards the police and the law were often ambivalent: those who critiqued the police or viewed them as oppressive on some occasions might turn to them for assistance on others. At the scene of a road accident people might step back and wait for them to assume leadership: 'People look at you: "You're in uniform; you must know what to do".'[29]

The transformation in experience over time was most noticeable in the RUC after 1968, when many areas became 'no-go' as far as the police were concerned. Laura became aware of the difference between working in Coleraine and Glenravel Street station in east Belfast when she was transferred in 1970:

> I had come from a county area where, you know, you could go anywhere, walk anywhere at any time of the day or night and you'd have got help . . . and I thought, 'Now I'll go out as I have done, with various

transfers, and have a wee walk around, just to get to know the area.' And I never thought. I walked out and I walked up the Antrim Road, and up around that way and back, in uniform. And it was only when I came in there was 'Where was I? What was I doing? Had I no sense?' And it hadn't dawned on me that it was no longer safe for me to go out like that on my own and walk the streets. And then for a good wee while I used to put on a civvy coat and go . . . I thought, 'Oh this is ridiculous.' I went into Unity [flats] one day. One day this woman asked for help and I went over . . . and I was being watched right round. And it was only when I was up rapping on the woman's door that I realised, they were watching me. So then I realised, 'I can't go and do that any more.'[30]

The confidence of walking the beat from a position of authority was replaced with profound feelings of insecurity resulting from the sense of becoming an object or target of surveillance – the spectacle – for others.

The original uniform of the Metropolitan Women Police, modeled on male police dress, arose from assumptions about the masculine derivation of the authority of law and of citizenship; indeed, women gained police powers of arrest in some forces before entitlement to vote. As previous chapters have shown, women had had to prove that they could act as sensible and stoical officers rather than feminine hysterics and the donning of the 'masculine' uniform could be seen, metaphorically, as part of the test. In comparison to Carol Bristow, who dressed herself in a far more feminine version of the uniform nearly 50 years later, Lilian Wyles experienced considerable anxiety and displeasure when she saw herself in a man's tunic and tall boots: 'When, at last, I stood before the mirror clad from head to feet in police-provided clothing, I shuddered, and for the first time regretted my choice of career'. She rashly contemplated methods of feminising the austerity of the dress: 'I thought, if only I could wear a pair of earrings, and run a piece of white frilling along the top of the hard stand-up collar of my tunic, how much better I would feel.'[31] The public pointed and stared at the strange hybrid of policeman and woman. Daunted at first, Wyles became accustomed to her visibility as another London sight 'along with the Tower and Westminster Abbey'. People stopped and commented within earshot: '"How queer." "How unwomanly", "Not quite nice, do you think?"'[32]

By the 1950s policewomen were still photographed regularly by tourists, but their uniforms, restyled several times to reflect changing fashions, might be viewed as both smart and flattering: 'He was well into his eighties, his name was Valentine; he said, "Excuse me, I hope you don't mind, I just want to say how nice you look in your uniform".'[33] Cultural assumptions about femininity – including the adage that 'You don't hit a

woman' – meant that policewomen might be viewed differently from policemen. It also meant that women's interventions – as much a product of acculturation as training – might have a diffusive rather than a confrontational effect. Women who were interviewed described perceptions of gender difference:

> I think women can get away with more than men can – with the public. You can often talk people out of it, whereas the men just put their backs up sometimes, because they go in quite aggressively. I was only hit once ... but the men get them all the time. I think women can talk their way out of things.[34]

> He must have been at least six foot four and Norwegian, drunk as a lord, frightened everybody. But he thought I was lovely and as long as he put his arm around me he'd go anywhere I wanted, so I arrested him when he wrapped round me and walked him back to the police station. And it took seven policemen to put him in the cell, because he didn't like them.[35]

> They used to use the expression 'the gentle arm of the law'. You didn't get involved in as many confrontational situations as the men did.[36]

The existence of a chivalrous and protective attitude towards women across a range of social classes was referred to by Margaret, who worked in Nottinghamshire Constabulary in the 1950s and was based in Mansfield:

> You'd go into these pubs to see who was there, you'd walk in. One or two horrible types, strangers coming from Nottingham or Chesterfield thought they'd try it on ... they start saying all sorts of things. Very often it was people you'd arrested and dealt with for crime, and so on, they'd say, 'You leave her alone, she's ours.'[37]

The idea of 'the gentle arm of the law' served to position women officers as distinctly non-violent in comparison to policemen. Unlike male officers, women were not equipped with truncheons in British forces in the years before integration. Similarly, in Northern Ireland the RUC's Women Police Branch was unarmed: 'We weren't armed then. That was well known ... and I always felt that was our greatest strength.'[38] Their association in the public eye with the 'soft' policing of welfare work arguably led to greater acceptability and to an association of their role with community policing. Women officers in the RUC certainly felt that their femininity positioned them as less threatening in nationalist areas before the troubles of the late 1960s: 'Because you were there to do something with the kids, there was a great rapport ... and I always felt that the women had a lot to offer in terms of keeping the rapport going.'[39]

Hence 'femininity' itself could provide an important element in a delineation of women's authority as persuasive and non-aggressive. It was also a useful tool in the attempt to achieve coercion by consent, or to diffuse potentially violent situations. Ultimately, of course, policewomen relied on the threat of male back-up when consent was refused: 'We used to say to people, "There's two ways we can do this. We can do it our way and do it all nice and neat and tidy, or if you want to struggle I'll just get some assistance and we'll drag you screaming and kicking to the station." And they'd go, "Oh, alright then." Rarely did we have any problems.'[40] This did not mean that policewomen escaped assault or lacked physical force (although their perceived weakness compared to male colleagues was commented on by critics). The disciplined and efficient body that emerged from training school was one that was able to defend itself; ju-jitsu and other forms of self-defence formed a central component of the programme. Most women interviewed argued that female drunks were most likely to be violent towards them, presumably because the concept of chivalry did not hold. Respectable femininity was instilled in officers through a range of cultural and more obviously regulatory mechanisms, and it was specifically used as a strategy within the repertoire of policing. An effective combatant against the disorderly male, it was of little use against other women who refused to recognise its currency.

The discipline of the beat

In his study of beat policing in Merseyside between the wars, Mike Brogden has argued that 'time, distance and social isolation ensured that each patrolling constable carried a mobile Panopticon within'.[41] Police districts were divided into Divisions, then into stations and then into beats, each with their own distinctive architectural features, local landmarks and social geography. The development of the beat system in the nineteenth century was one feature in the intensification of the 'eye of power'; cities were mapped and their populations regulated through processes of spatial organisation. The beat system also involved the intensive regulation of the constable's every move as he was embroiled in the mechanism of surveillance. Each constable patrolled a specific beat (or group of streets), reaching fixed points at 15–minute intervals (where he might be met by a sergeant): 'the ultimate in disciplined, supervised, time-tabled work'.[42] This form of regulation also, of course, acted as a safety valve in case a constable went missing. The introduction of blue police boxes in many forces in the inter-war period (firstly in Manchester and the Met) reduced the labour-intensivity of the sergeant's work.

Constables now had to phone in routinely from police boxes or contact the station if the blue light on the top was flashing. The introduction of radios in the 1960s, in theory at least, made constant communication possible.

Women officers were subject to similar mechanisms as they undertook foot patrol in towns and cities, but their movements were less prescribed and there was considerable variation within forces as well as across them. The Metropolitan Police and a number of other city forces had specific routes for women police to follow by the 1950s, which covered larger areas than the policeman's beat. They were used extensively at West End Central, Caledonian Road and Norbury stations within the Metropolitan Police District, as well as in Manchester.[43] Women were encouraged to enter shops, cafés or clubs, and were not required to stick meticulously to the route. Gina was patrolling London's West End at night during the 1960s:

> You had a lot of flexibility, and you weren't expected to spend [time] if you were on late turn in the evenings, walking the streets of Mayfair . . . because there wasn't much to do. You were expected to be in the clubs, and on the areas and the streets where the clubs were and the kids were going to congregate . . . We had a loose beat system.[44]

She was expected to use police boxes to phone in twice: 'once in the first half and once in the second half of duty'. Helen, who served in Manchester in the same period, was allocated one of three beats for her morning shift. She took a folder containing details about missing persons with her on patrol. She had to wait at a set of points at a fixed time: 'if they had a job to give you, they'd be there; so you'd wait for several minutes, and if nobody came, you'd move off'.[45] Where a policewomen's beat system was not in place or was not regularly used, women would plan their own routes in relation to their enquiries. Susan, who served at Rochester Row in the Met, was usually sent out with a handful of 'alien inquiries' regarding work/residency licences for 'foreign immigrants'.[46] Because officers usually walked to an enquiry (bicycles were in use at some stations and, briefly in the early 1960s, one or two motor scooters), they were expected to keep vigilant and to make use of the journey for surveillance purposes. When they were not dealing with specific business, they might target parts of the Division where they knew that women, children or young people tended to congregate.[47] Women who worked in Newcastle and Coventry in these decades had considerable free range to plan their own routes, provided that they reported in by phone.[48] On outer divisions in Leeds, women were required to use police boxes to phone in every hour;

while they had no fixed beats, they had to write their planned route in a book kept in the box.[49] When the Met's women officers had first started patrolling in pairs in 1919, they had been followed by two policemen 'at a distance of six to ten yards' but this form of chaperoning was dispensed with quickly by 1921.[50] With the exception of Scotland, where, it was argued, women had to patrol in pairs because of the law of corroboration,[51] women often patrolled on their own once they had been 'puppy walked' by a more experienced officer. At night-time, women were more likely to patrol in pairs or with another male constable but in some areas they went alone.

While women experienced foot patrol as less restricted than for male constables, they were nevertheless aware of the watchful eye of sergeants and inspectors, maintained through the routine of phoning or reaching fixed points. This gaze was also resisted and subverted. May joined Leeds City Police in 1954, serving under Chief Inspector Jessie Dean, who expected all her women to be out on patrol when she arrived in the morning:

> You saluted the police inspectors and we called Miss Dean 'ma'am', and it was no smoking in the office. I didn't smoke but we used to have an open coal fire and they all used to stand there and blow smoke up the chimney. And one of the women sergeants used to ring Miss Dean at home ostensibly to tell her what had happened over night. But of course they knew that if she was at home they would have time for a cigarette before we went out on patrol.[52]

In this case, 'deference' was used as a resource to convert work time into leisure time. The diversionary tactic itself also brought pleasure since it 'succeed[ed] in "putting one over" on the established order on its home ground'.[53] Officers who were phoning in from police boxes could attempt to give misinformation about their location, although older switchboards indicated the box number when the call came through.[54] As radios were introduced, other methods were found of asserting individual control: 'If you didn't want to answer, you just had to press your "squelch" button a few times as if it was breaking up . . . "Sorry, I can't quite hear you . . . I'm not coming back to do matron duty at Gerald Row."'[55] The tactic enabled Gina to stay on patrol, which she considered preferable. While many of those interviewed saw beat patrol as exciting and interesting, those who disliked it knew where to 'get a cup of tea': another tactic that blurred the boundary between work and leisure.[56] Workplace jokes were also commonplace. Helen recalled playing a prank on her inspector in Manchester City Police, which involved a fake mouse: 'I said, 'Oh, isn't that a mouse in

the corner?" The poor woman got up and shot out.'[57] Pranks, jokes and diversionary tactics momentarily subverted the axes of authority but they were only effective because of the acknowledgement of the importance of discipline in the culture of policing. Pranks were, significantly, reserved for the middle ranks of inspector and sergeant. Women at the top tended to inspire a combination of fear, awe and respect. Marion Macmillan of the RUC was 'somebody to look up to', while Elizabeth Bather of the Met was 'extremely pleasant, distant, very much in control, very authoritative, and extremely nice'.[58]

The difference in the organisation of women's beat patrol can be accounted for in terms of their 'specialist' function. It was not necessary to repeat the basic observation that was already being conducted by the 'bobby on the beat'. Across the period, policewomen were looking for women and children who were out of place: prostitutes, truants, absconders from institutions such as industrial and approved schools, and those who had run away from home or had been reported missing. In the interwar period, particular emphasis was placed on the need for women officers to patrol parks and other open spaces where children played to prevent the activities of 'park perverts': exhibitionists and those who sexually assaulted children. Their remit was quite clearly concerned with the protection of women and children from forms of sexual danger but this protection was also 'regulatory': to prevent young women, who had escaped the watchful eye of parents, guardians or schoolteachers, from engaging in inappropriate sexual relationships. In the 1920s, Lilian Wyles's officers searched the cafés of London's Limehouse district, to 'rescue' young women who were consorting with Lascar seamen.[59] In Manchester in the early 1960s women officers visited beat clubs – such as the Twisted Wheel – to track down girls who where involved in under-age drinking and who might be sleeping rough.[60] In most cases their aim was to send them back to their families or to have them committed to appropriate institutional care.

Forms of delinquency were also geographically specific. One Gloucestershire policewoman was almost disappointed that the quiet thoroughfares of Cheltenham were not awash with 'amateur prostitutes' in 1928: 'Looking out for and picking up girls in the street is considered one of the chief duties of the Police-women, but having only four months' experience I have not yet met with one of these cases.'[61] The city centres of Manchester, Birmingham and London were assumed to be magnets for runaways because of the excitement offered by their leisure industries but also because of the possibility of concealment that the intense concentration of population presented: 'in a large city, women police patrol at

night; this was when you might find juveniles sleeping out and things like that'.[62] Beat patrol in suburbia was more likely to lead to the discovery of cases of truancy and perhaps child neglect. Docks and port areas – in Scunthorpe, Hull, Chatham, Liverpool and Belfast – were associated with prostitution and related offences.

While the specialist aspect of policewomen's work served to organise their routes, it is important to point out that women (who had received the same training as men) were also expected to respond to any incident or request for help as a police presence on the streets, dealing with accidents, assaults and burglaries as they took place: 'if they had a crisis and you were in uniform, it didn't matter if you were male or female, they would come to you'.[63] Dealing with drunks and the homeless was also routine.

Statistics presented in the annual reports of the Metropolitan Women Police indicate the scope of women's work 'on the beat' in the postwar period. The number of woman hours spent on patrol duty peaked in the mid-1950s – suggesting this was the optimum moment in the capital for women's visibility on the streets – and began to fall in the 1960s as women were diverted into other duties.[64] Beats were clearly planned in relation to specialist work as well as general policing strategies: 'a number of divisions have revised their women beats, firstly to ensure that all parts of the division where the women as such are required and where children and missing persons may be in danger are adequately covered and, secondly, to make the best use of women in general policing'.[65] Tables 4.1 and 4.2 show that a significant component of general policing was carried out: dealing with traffic offences and accidents or using the 1839 Metropolitan Police Act 'to stop, search and detain a person reasonably suspected of having stolen property' (Table 4.1)[66]; making arrests for drink-related and vagrancy offences, gaming and betting, for failing to have an identity card (under DORA) and (from the late 1960s) for possession of drugs (Table 4.2). There was also a great deal of work that was gender-related. Enquiries relating to missing persons (many of whom were found in public places) were almost always detailed to women officers. Policewomen also had special responsibility in relation to the Children and Young Persons Acts which allowed them to stop juveniles whom they suspected were runaways – from their own homes or from probation officers and approved schools. Children found on the streets might be taken before magistrates as in need of 'care or protection' if their parents were considered 'unfit' and they were 'falling into bad associations or exposed to moral danger or beyond control'. Under the Education Acts, action could also be taken against children and parents

over truancy. While policemen also dealt with prostitution, it was considered to be an area in which women had a 'special sphere of usefulness' in the Met and they made arrests for soliciting before the introduction of the 1959 Street Offences Act (see Chapter 7).

Table 4.1 Metropolitan Women Police: uniform duty in streets and open spaces

	1948	1949	1950	1951	1952	1953
Cautions	664	1,029	1,742	3,862	5,083	6,842
Arrests	930	1,076	1,115	1,918	2,246	2,273
Reports for summons (mostly traffic offences)	79	155	260	354	722	1,003
Witness for arrest or summons	438	662	565	896	870	948
Care or protection cases	80	73	81	118	195	182
Missing persons found	318	377	366	316	509	617
Shelter found for stranded persons	1,126	1,280	1,229	1,472	1,735	1,733
Persons advised on beat	1,433	1,803	2,634	3,677	3,576	4,890
Person ill or of unsound mind	328	405	450	577	736	873
Accidents or collisions	119	204	322	458	649	782
Reports to information room	29	30	29	55	47	74
Persons stopped (Sec. 66 of Met. Police Act 1839)	235	519	256	285	352	375
Persons advised re young persons stopped	473	544	615	879	1,131	1,066
Special attention to complaints	867	1,105	1,446	2,154	2,693	2,847

Source: MPM, Women Police ARs 1948–53.

If policewomen experienced greater 'freedom' in their patrol work than policemen, this did not necessarily signify a lack of discipline. Women's work was not merely 'shaking hands with doorknobs', as the 'bobby's work' was often characterised, but was more exploratory. The acquisition of local knowledge – by talking to café proprietors, toilet attendants or even older prostitutes – was part of the remit. The regula-

Table 4.2 Metropolitan Women Police: arrests (uniform) for street offences

	1948	1949	1950	1951	1952	1953	1954	1955	1956	1957	1958	1959	1960	1961	1962	1963	1964	1965	1966	1967
Drunk and disorderly	39	53	62	104	111	70	106	124	127	110	88	47	58	60	49	58	50	24	37	39
Drunk and incapable	113	158	184	320	295	357	437	521	608	524	451	289	214	250	244	239	255	182	206	302
Prostitute soliciting	126	174	148	591	782	717	583	550	695	812	441	213	19	24	20	8	7	3	8	9
Insulting behaviour	13	17	17	26	24	24	38	25	48	49	40	41	18	8	13	17	11	5	11	20
Indecency	1	22	12	5	9	19	15	13	5	11	7	2								
Indecent exposure	2	1	4	1	3	4	3	4	2	2	5	4	4	5	4	4	2	3	20	30
Wandering abroad	26	20	25	17	18	16	11	13	10	8	9	4	4	2	3	1	6	4		7
Begging	9	3	2	7	5	8	7	5	4	10	7	6	6	4	1	2			2	
Obstructing footway	5	5	8	8	17	42	28	37	35	55	31	27	23	24	4	27	28	42	32	46
Street betting	5	25	9	6	25	11	56	46	22				18	7						
Parks regulations offences	1	2	4								4									
Obstructing police		2	4	2	4		3	9	8	3	7	11	7	8	2	2			2	
Defence of realm	2	4	2	5	3	8	6	3	2	8	7	10								
Gaming	3	10	13	16	16	21	7	26	27	75	76	17	21	1	3	8	9	7	4	13
Beyond control	17	25	15	20	7	17	29	9	22	27	65	91								
Education act	14	9	10	24	5	17	8	23	26	17	23	19								
Possessing drugs													1			7	3	21	42	31

Note: a new form for classification seems to have been introduced in 1960, which did not include entries for 'indecency', 'beyond control' and 'education act'.

Source: MPM, Women Police ARs 1948–67

tion of feminine respectability was clearly exercised through the Women Police Departments, as they monitored women's romantic liaisons with male officers. Notions of trust and loyalty were enforced through the fallback of disciplinary proceedings. Nevertheless, women officers were given considerable licence to build and make use of their relationships within a locale.

Personal discretion and local knowledge

The regulation of the policeman's beat patrol through the fixed points system neatly equates with the Panoptical vision. The trend towards bureaucratisation in policing, reflected in the appointment of the first woman HMI and moves to standardise procedures, also suggests uniformity and anonymity. Yet these features should not be overstated. Discretion and charisma continued to operate as central components of uniform foot patrol, resisting the pull of modernisation arguments.[67] It was not until the development of the unit beat system in the 1960s, based on patrol cars, that foot patrol was considered outmoded technologically and insufficiently cost-effective. The concept of discretion was highlighted in successive parliamentary reports:

> A constable is, as a general rule, placed alone, to perform his duty on one or more general beats or patrols ... However difficult and novel may be the circumstances which confront him in the course of this ordinary duties, he has, unless the matter brooks delay, to decide instantly and on his own responsibility, whether they call or not for his interference. It follows that a great deal of the most difficult work of the Force is left to the initiative and capacity of the humblest unit in each Division.[68]

This statement is worth quoting at length because it highlights the recognition that was given to initiative, responsibility and discretion in the conduct of daily duties. Dorothy Peto indicated the highly individualised and personal nature of beat patrol when she wrote: 'You get to know yourself and your own capacities, and, above all, you get to be known and trusted.'[69] 'Personality policing', which involved the individual negotiation of relationships with shopkeepers, publicans, café owners or toilet attendants, was of vital importance in the acquisition of information. The police constable was guided by a strategic vision that was imparted through legislative frameworks, Home Office directives and the General Orders of the force (which laid out local policy on the implementation of laws and guidelines). Yet the daily practice of policing was shaped by the ways in which this strategic vision was informally and tactically

negotiated both between officers and in relation to those whom they policed. Policing has never involved the arrest of all law-breakers and foot patrol was concerned as much with prevention and containment as with detection and conviction. While some policemen might have been intent on a 'macho-style' of policing, aiming to secure a maximum number of arrests, others preferred to avoid the extraneous paperwork that resulted.[70] The strategies of the Home Office or local authorities might also compete with the agendas of the police officer. Agreement and consensus with 'the other' – the policed – were sometimes important tactics within the repertoire of beat policing.

Brogden has argued that a great deal of beat duty in Merseyside was 'prophylactic' or 'social cleansing': drunks, vagrants or mischievous children were moved on so that the constable could 'keep his beat clean'.[71] Similarly, a central function of the work of the women police patrols of the First World War had involved cleansing the streets of 'amateur prostitutes' – young women with 'khaki fever' who flocked to military bases, leisure sites and railways stations where there was a military presence – amidst concerns about the growth of venereal disease.[72] The 'moving on' involved a clear reorientation: young women away from home were directed to hostels and girls' clubs in an exercise aimed at rescue and reform. As Levine and Woodeson have shown, a sense of moral obligation, as well as a superiority that was in some cases class-based, shaped the experiences of these early patrols, who were clearly culturally distinct from a parallel male police culture.[73]

Thus the 'misplaced' were to be relocated. In 1928, Evelyn Miles, sergeant in charge of Birmingham's policewomen, described their activities over the previous year: 'the women have patrolled daily the streets, visited the public libraries and lavatories, railway stations, women's lodging houses and coffee houses'. A total of 74 women and girls were taken to the police hostel at Dale End (funded by the Watch Committee), a further 35 described as 'destitute' or 'immoral' were taken to the night shelter in Tennant Street or to the YWCA, and 48 girls who had been reported missing were returned to homes and friends. The physically ill were transferred to hospitals, those with venereal disease were escorted to specialist wards, those who were pregnant were moved to maternity clinics, and 'mentally deficient cases [were] taken to Dr Potts and certified by him'. Deprived, depraved or orphaned children were found places in training homes, Salvation Army homes, Summer Hill Home or Doctor Barnardo's.[74]

The work of Birmingham's women police in 1928 was very much a continuation, albeit an expanded one, of work initiated during the First

World War (Miles had been appointed as a patrol in 1917), and it accords with the accounts of women's police work in London described in Lilian Wyles's memoirs. While committal to industrial schools required a magistrate's order, the majority of these arrangements were informal ones involving networks of charitable and voluntary bodies. The police remit was ostensibly based on the maintenance of 'public order', but patrol work in the 1920s also reflected a concern about welfare that was not merely predicated on crime prevention. Evelyn Miles's reports show that she was aware of the hardship faced by many women in Birmingham as a result of unemployment: women officers helped to find them domestic or catering jobs and provided boots and clothing for young women 'in very great need'. As Chapter 2 demonstrated, the background of Miles and her fellow uniform officers was far from lofty and she certainly had disagreements with the ladies of the Watch Committee over appointments; it also took her some time to persuade them of the need for a shelter in Dale Street.[75] Her approach can be seen as matronly or maternalistic – it was clearly informed by notions of working-class respectability – but it was not based on middle-class prejudice. While some measures – in particular, the treatment of the mentally ill – sound unremittingly austere, in many cases her officers were attempting to provide more acceptable alternatives for women when the workhouse beckoned. Notions of caring and befriending, while maintaining a certain distance, were conveyed in her reports. Lucy Bland has similarly drawn attention to attempts by First World War patrols to rescue women from 'aggressive and violent men' and to advise about separation orders, practices that cannot be reduced to 'oppressive surveillance' or class politics.[76] This argument can be extended across the period. The practice of policing was informed by pre-existing assumptions about an individual's positions within the social order; but these assumptions were sometimes challenged as a result of everyday encounters.

While the responsibilities of beat duty were taught at training school, the practical skills of observation, interpretation and interception were acquired from one's peers. Edna joined Kent Constabulary in 1950:

> When I first started out on the streets in Chatham as a young constable, I remember the male sergeant there, he met me on the corner of one of the streets; I'd only got a few weeks in. He said, 'I'll tell you this . . . you stands and you looks, and you looks at the ordinary and eventually you then see the extraordinary.' And he was absolutely right. On your patrols you'd be looking at things you'd seen for weeks and then one day something wouldn't be quite right, and it would attract your attention enough to take it further.[77]

Effective policing was also seen as instinctual as well as rational: 'You do have a feeling for things. You do have a feeling "there's something not right about this person".'[78] The body itself was read in relation to codes associated with order and disorder. Women officers, in particular, learned to identify runaways and those in 'moral danger' in order to carry out 'stops' under the 1933 Children and Young Persons Act:

> We spent our time [in 1948] combing the toilets, and if you saw a kid go in there washing their hair, which they did occasionally, you realised that she was on the run from somewhere. When the girls went to approved schools, the first thing they did was to cut their hair very short. They used to give them an Eton crop, a very short haircut, and of course these kids would try to get themselves hats to cover this. So if you saw a youngster walking along with a hat on, you immediately knew she was on the run from somewhere.[79]

> What did we look for? Firstly youthful appearance if the hour was late. Then a grubby and unkempt look – the feet and legs were a good guide. Scuffed and dirty shoes, laddered stockings or none at all often indicated that a girl had been sleeping rough. Sometimes at close quarters the smell too was indicative. Attitude was important. A girl who didn't want to be noticed either tried to get out of our sight quickly or brazened it out by approaching us and asking the way.[80]

If women officers were taught to maintain high standards of appearance in terms of personal cleanliness and neatness (down to their highly polished shoes) as markers of respectability, they also recognised its opposite: the dirt and slovenliness of the 'down-at-heel'. 'Dirt' also had particular meanings in relation to femininity: if cleanliness was associated with sexual purity, the unwashed were also the sexually deviant or corruptible.

Women officers had their own distinct 'hunting grounds', based on local knowledge of the social geography of delinquency, on which they concentrated their attentions:[81]

> There was a particular café on Oxford Street [Manchester]. I can't remember the name of it. It was like a magnet. I was passing by one night, and I was looking for an absconder. And I looked in the window and she's sitting looking out at me. I went in to her and she came, she was all right. She didn't put up a struggle, fortunately, because she was a hefty girl.[82]

Knowledges were also clearly shaped by perceptions of race and ethnicity that led to the focusing of police attentions on particular groups. The targeting of cafés associated with both the Chinese community and with

Lascar seamen in London's East End during the 1920s were replaced with concerns about refreshment houses run by the Cypriot community in the 1930s.[83] The 1950s saw targeted searches of lodging houses and bedsits that were used by black workers from the Caribbean as Leeds policewomen attempted to track down adolescent girls who were absconders from approved schools.[84]

Particular concerns about invisibility and the impossibility of effective surveillance resulted from blackout conditions in wartime. The darkness made it difficult to gain or rely on 'local knowledge'. As a young policewoman in Birmingham in 1941, Jean Law had to study her street map meticulously before she embarked on a routine enquiry. She would memorise the grid of streets that she would have to negotiate with her dim torch: 'Get off the bus and count four streets up, and then two streets that way.'[85] Policewomen voiced their frustration in the First World War because 'the darkness partly destroys our usefulness': 'Men of unpleasant character have appeared in the crowded better streets and speak to women freely, a very large number of giddy girls find the novelty exciting and gather in dark corners giggling and shrieking.'[86] On the one hand, women officers were concerned to protect civilians from insult, injury and assault. Yet there were also anxieties that places were being used inappropriately; that thoroughfares had become leisure spots and, in the Second World War, that air-raid shelters had become dens of ill repute, used by both courting couples and 'amateur prostitutes'.[87]

If modern urban surveillance was concerned with the demarcation of place – restricting specific spaces and objects to specific functions – this was also resisted through the *bricolage* of the marginal: by runaways and 'vagrants' (the homeless) who slept in public toilets or used their facilities for other purposes. In Birmingham by the 1950s, as in other major cities, the large public lavatories of the main thoroughfares – spaces that were liminal in terms of public and private – were important places to patrol for women police:

> We all wore a whistle in uniform, never blew mine but you had it to summon help if you wanted it. And we soon found out, we women constables, that you could take the loop that looped round your button before it went into your breast pocket and with that you could open a toilet. So nothing was sacred to us. If we found a locked door – said 'engaged' on it – we just opened it and we'd find a vagrant who'd been there all night.[88]

> [She used to] make lavender bags. She took rolls and rolls and rolls of lavatory paper and she sat there in the lavatory quite happily – it was providing a seat and it was quite warm. I don't know where she got the

lavender, maybe she paid for it. And she made up little bags of lavender and then she sold them the next day.[89]

Despite this rigorous application of the strategic gaze, vagrancy itself continued. Whether subject to a fine or a brief prison sentence, homeless women would reappear in their usual haunts and they were viewed with familiarity. Many officers made tactical decisions to turn a blind eye to their presence and to prioritise other work. Helen patrolled central Manchester at night in the early 1960s:

> I think there were three or four sets [of toilets], and you went round them each night, if you were quiet. You nearly always found somebody on one of the toilets asleep who had no home to go to, or maybe sometimes the missing from homes would go down there: you'd take them in and deal with them. But if you found homeless women, which you often did in Piccadilly toilets, nearly every night, all you could do really was advise them to go to Mayfield House, which was on Great Ancoats Street, or Ashton House for women, which would take in homeless people overnight. Well, you gave them that advice, and you knew full well that when you'd gone they'd go back down in the toilets again and stay there. And you thought, 'Well, what can you do? They're out of harm's way down there.' So each night if they were there you just gave them the same advice and they'd go and they'd come back after you'd left.[90]

By this point in time the welfare of children and young people – in the battle against juvenile delinquency – had most cogency. Those who were new to the streets, 'the missing from homes', would be dealt with, while the old guard would be left in peace.

While they socialised with their peers at the station, patrol duty involved regular encounters with the 'other' people of the streets, and the relationships that were formed were valued and remembered:

> People can be very dismissive of real down-and-outs, but obviously I've met quite a few in the job, meths drinkers and such, but when they'd sobered up the next day, you'd find that in general basically they were decent people. But their marriages had broken down, they'd lost their homes, and they got so low down there wasn't a way up for them. But basically, initially they'd been just the same as everybody else, things had just got out of hand. So you do learn not to be quite so dismissive of people, look a bit further. It is really 'There but for the grace of . . .' We could all end up in that way.[91]

The figure of the London policewoman was an interesting and attractive one for journalists seeking a magazine feature. Gina, who was based at

West End Central in the late 1960s, remembers being shadowed on the beat as she spoke to the homeless:

> They were people that were almost natives, inhabitants of the area, except they didn't have a roof over their heads. They were filthy, they were lousy and sometimes they were a lot of trouble but they were almost yours ... When you do these interviews [with journalists], they're with you for hours and hours, and then a little quote comes out, and it was so twee, and it was along the lines of 'Oh, these are our people.' Just to see it in writing was awful! But they *were* our people. You couldn't do much for them. Sometimes if you had any change in your pocket you'd give them a couple of bob, or get them some bread rolls, or something.[92]

The relationship involved empathy and the recognition of a shared humanity developed through social proximity, familiarity and a shared knowledge of the street and its culture. Yet it was mediated by other processes of distancing – they were clearly not the same ('*almost* ours') – as a police identity was maintained and perpetuated through a culture of police camaraderie and discipline. 'Canteen culture' worked with stereotypes and labels – learned by both male and then female officers – which served to categorise those whom they policed as members of an alternative social order: the 'absconder', the 'down-and-out', the 'nutter', and the 'tom' or 'tart'. The 'tom' and the 'down-and-out' were frequently cast in terms of generosity and an element of mutual respect. Initial preconceptions were challenged as a result of everyday beat duties as relationships, albeit unequal ones, were forged on the streets. The negotiation of these relationships was both strategical (shaped by wider policy frameworks regarding the use of public space) and tactical (individually negotiated through temporal encounters).

While women felt self-conscious the first time they stepped into uniform because it transformed a 'mere' woman into a symbol of official authority, they soon experienced its effects. The uniform enabled women to traverse city space with confidence and immunity. While 'respectable' women were unlikely to linger on the street corners of thoroughfares without feeling compromised, conspicuous or attracting unwanted attention, the uniform enabled women to step into the shadows; it facilitated female spectatorship. A particular style of feminine authority drew on women's positioning as 'the gentle arm of the law': women were expected to act as diffusers of violence and to acquire knowledge, where appropriate, through charm, tact and understanding. At the same time they were also police officers and there was considerable overlap between their roles and functions and those of male constables. There were, of course, oper-

ations where the advertisement of police identity was not desirable; these moments will be considered in the next chapter, which deals with the tactics of covert surveillance.

Notes

1. D. O. G. Peto, 'Kaleidoscope', *Criminal Law Review* (1958), 793–8.
2. In county constabularies, patrol was restricted to market towns. Cars, vans or bicycles were vital to rural work (See WPT, Sian).
3. Levine, 'Walking the streets'.
4. Peto, *Memoirs*, p. 95.
5. E. Higgs, *The Information State* (Basingstoke: Palgrave, 2004), pp. 177–87.
6. The unit beat system based on patrol cars – which was represented in the television drama series *Z-Cars* – was initiated by the Lancashire Constabulary in 1958 to police the new town development of Kirkby. By 1968, two-thirds of the population of England and Wales were subject to the system. See Emsley, *English Police*, pp. 174–9.
7. 'Vice' here includes prostitution-related offences, homosexuality, illegal betting and gambling, licensing contraventions, and the use of illicit drugs.
8. G. Pollock, 'The visual', in M. Eagleton (ed.), *A Concise Companion to Feminist Theory* (Oxford: Blackwell, 2003).
9. Foucault, *Discipline and Punish*; M. Foucault, 'The eye of power', in C. Gordon (ed.), *Power/Knowledge: Selected Interviews and Other Writings* (New York: Pantheon, 1980).
10. Foucault, 'The eye of power', p. 154.
11. M. de Certeau, *The Practice of Everyday Life* (Berkeley: University of California Press, 1984), pp. 36–9.
12. The problem of the 'male gaze', first advanced by L. Mulvey, 'Visual pleasure and narrative cinema', *Screen*, 16:3 (1976), 6–18, has generated considerable debate and criticism. For useful overviews, which also allow for a 'female gaze', see A. Kuhn, *Women's Pictures: Feminism and Cinema* (London: Verso, 1982), and Stacey, *Star Gazing*.
13. For example, J. Wolff, 'The invisible *flâneuse*: women and the literature of modernity', *Theory, Culture and Society*, 3 (1985): 37–46; G. Pollock, 'Modernity and the spaces of femininity', in *Vision and Difference: Femininity, Feminism and the Histories of Art* (London: Routledge, 1988), pp. 50–90; J. Walkowitz, *City of Dreadful Delight. Narratives of Sexual Danger in Late-Victorian London* (London: Virago, 1992); D. E. Nord, *Walking the Victorian Streets: Women, Representation and the City* (New York: Cornell University Press, 1995); D. L. Parsons, *Streetwalking the Metropolis: Women, the City and Modernity* (Oxford: Oxford University Press, 2000).
14. L. Nead, *Victorian Babylon* (New Haven: Yale University Press, 2000).
15. Parsons, *Streetwalking the Metropolis*, p. 131.
16. J. Berger, *Ways of Seeing* (London: BBC, 1972).
17. Bristow, *Central 822*, p. 40.
18. WPT, Elaine.
19. WPT, Zena.
20. WPT, Katherine.
21. WPT, Helen.

22 M. Brogden, *On the Mersey Beat: Policing Liverpool Between the Wars* (Oxford: Oxford University Press, 1991), p. 19.
23 WPT, Joy.
24 WPT, Anne; Jill; Sian; June.
25 WPT, Laura.
26 Bristow, *Central 922*, p. 56.
27 C. C. H. Moriarty, *Police Procedure and Administration* (London: Butterworth, 5th edn, 1950), 46: 'the organisation and duties of the Service . . . ensures the freedom and orderliness of the country'.
28 WPT, Joan; Susan; Gina; June; Laura. The argument that the police are simply a 'mirror' of society was used to explain sexism and racism in the service, arguing that it was not particular to police culture.
29 WPT, Jill.
30 WPT, Laura.
31 Wyles, *Woman at Scotland Yard*, p. 44.
32 *Ibid.*, p 43.
33 WPT, Carol.
34 WPT, Vera.
35 WPT, Ivy.
36 WPT, Joy.
37 WPT, Margaret.
38 WPT, Laura. A group of 53 policewomen from 34 UK forces was sent to Cyprus May 1957 to May 1958; they were similarly unarmed (unlike their male counterparts). A state of emergency had been declared in November 1955 after EOKA began an armed campaign to bring Cyprus under Greek rule. Policewomen were required to search women and young girls thought to be involved in the transport of guns and messages to mountain gangs and to assist in the training of Greek and Turkish Cypriot policewomen (although Greek Cypriots, like Catholic nationalists in Northern Ireland, were unlikely to join the police). The policewomen also had a clear 'public relations role' that was linked to the novelty of their gender. NA, CO 1037/58: Secondment to Cyprus of UK women police.
39 WPT, Moira. For a critique of the positioning of women as caring, non-aggressive and peaceful, see A. Crilley *et al.* (eds), 'Women in the north of Ireland 1969–2000', in Bourke *et al.* (eds), *Field Day*, vol. 5, pp. 1476–515. They argue that such a focus detracts from women's agency and support of political positions.
40 WPT, Christine.
41 Brogden, *On the Mersey Beat*, p. 36.
42 *Ibid.*, p. 2.
43 WPT, Gina; Christine; Helen.
44 WPT, Gina.
45 WPT, Helen.
46 WPT, Susan.
47 WPT, Susan; Katherine.
48 WPT, Maureen; Pat.
49 WPT, May.
50 Wyles, *Woman at Scotland Yard*, p. 31.

51 WPT, Elsie.
52 WPT, May.
53 De Certeau, *Practice of Everyday Life*, p. 26. De Certeau adopts the French term 'la perruque' (literally, 'the wig') to refer to 'the worker's own work disguised as work for his employer' (writing a love letter in office time or borrowing tools for personal purposes). The secretive creation of leisure from work functioned similarly.
54 WPT, Gina.
55 *Ibid.*
56 WPT, Marion.
57 WPT, Helen.
58 WPT, Audrey; Elizabeth.
59 Wyles, *Woman at Scotland Yard*, pp. 63–70.
60 GMPM, Women Police Department, box file on clubs.
61 NA, HO 45/13433 Women Police 1928–29, Gloucestershire Constabulary, Cheltenham, 24 June 1928, report of WPC Annie Josephine Fay.
62 Interview with Pauline Wren.
63 WPT, Maureen.
64 MPM, Women Police ARs 1936–65. In 1936, 10,766 woman hours were spent on patrol. With the significant increase in establishment over time, patrol duty had risen nearly thirty-fold to 286,413 hours in 1953. It fell to 197,982 in 1961 and 67,908 in 1965 as women's work expanded into other areas.
65 MPM, Women Police AR 1954.
66 Lock, *Lady Policeman*, p. 21.
67 D. P. Griffiths, 'Policing in England and Wales between the two wars', Ph.D. thesis, Exeter University, 2000, uses the work of modernisation theorists such as C. Dandeker, *Surveillance, Power and Modernity – Bureaucracy and Discipline from 1700 to the Present Day* (Cambridge: Polity, 1990).
68 1906–08 Report of the Royal Commission Upon the Duties of the Metropolitan Police, quoted in Lee Commission (1928–29) Cmd 3297, pp. 7–8.
69 Peto, *Memoirs*, p. 95.
70 See, for example, Daley, *This Small Cloud*.
71 Brogden, *On the Mersey Beat*, p. 99.
72 Wollacott, '"Khaki fever" and its control'.
73 Levine, 'Walking the streets'; Woodeson, 'The first women police'.
74 NA, HO 45/13433 Women Police 1928–29: Evelyn Miles to Chief Constable Charles Rafter, 29 January 1928.
75 NA, HO 45/13433 Miles to Rafter, 3 August 1919.
76 Bland, 'In the name of protection'.
77 WPT, Edna.
78 WPT, Christine.
79 WPT, Mary.
80 Lock, *Lady Policeman*, p. 22.
81 *Ibid.*, p. 31.
82 WPT, Helen.
83 Wyles, *Woman at Scotland Yard*, describes the vigilance of women police in relation to cafés run by Lascar seamen and Chinese opium dealers in the East End. MPM,

Metropolitan Women Police AR, 1937 reported 'outstanding good work . . . amongst young girls frequenting Cypriot cafés', resulting in a series of care or protection cases involving girls 'in moral danger'.

84 WPT, Kathleen.
85 Interview with Jean Law.
86 IWM, Women and Work Collection, Emp 42.2: NUWW, May 1916, extracts from organisers' reports.
87 *Daily Herald*, 5 November 1940.
88 Interview with Pauline Wren.
89 Interview with Jean Law.
90 WPT, Helen.
91 WPT, Carol.
92 WPT, Gina.

5

Going undercover

THE WORK OF BRITAIN'S first women detectives was glamorised, sexualised and sensationalised in print as tabloid reporters wrote of 'lipstick and powder at Scotland Yard', 'pretty girl detectives' and the wartime bravery of the smart and attractive 'decoy Dora'.[1] Such a trope has had considerable endurance within popular journalism.[2] Given the 'secret' nature of 'undercover' work, there is an obvious paucity of archival sources and a complex process is involved if the narrative of sensation is to be replaced with an alternative framework. I shall begin by interrogating popular representations. Why were women detectives so newsworthy? Why were they deemed a sensation? This chapter aims to examine the moment of surprise or denouement – when the 'glamorous' young woman was unveiled as a police constable – and to suggest that it was indicative of a wider anxiety within mainstream culture. This moment also tells us a great deal about the significance of gender within the technology of covert surveillance. I shall move on to consider the tactics and strategies that shaped women's practices in undercover work. How did women manipulate their personal appearance? How did they subvert aesthetic codes associated with gender, class and status? Was plain-clothes work exciting and dangerous, or dull and monotonous? Personal testimonies will be examined in order to consider women's individual experiences of plain-clothes observations, the narratives they themselves constructed, and the ways in which they negotiated the concealment of a police identity.

London PC Harry Daley outlined the perceptions of rank-and-file male officers when he wrote that 'broadly speaking, the uniform branch tries to prevent crime and the CID detects and arrests the criminal if the crime has been committed'.[3] The Met's CID was set up in 1878 to complement the preventative function of uniform patrol, and undercover work 'became a routine strategy of the new police'.[4] There was an

occasional overlapping of the two camps: the Met's 'Clubs and Vice Branch' was positioned outside of the CID but worked in plain clothes (a model that was adopted elsewhere).[5] Nevertheless, for Daley and his colleagues there was a clear sense of the segregation of uniform and plain-clothes CID officers in terms of duties, dress and work culture. The experience of women officers was somewhat different in the era before integration. Both plain-clothes observations and statement-taking from women and child victims (all central aspects of criminal investigation) featured as an important component of their workloads[6]; all women interviewed had some experience of them. This chapter will, therefore, take into account women's ability to step from uniform into plain clothes on a daily basis. A final section, however, will consider the roles of women who were actually based in CIDs, considering their interaction within one particular police culture.

Looking the part

The ability to disguise police identity and to pass as 'other' was a central component of undercover work. During the 1920s there was considerable debate within the police service as to whether women officers, often of middle-class background, could successfully imitate the demeanour of the nightclub socialite or the woman of the streets. Much of this debate was reflected in the evidence submitted to the 1928–29 Royal Commission on Police Powers and Procedures (the Lee Commission). Metropolitan Police Commissioner, Brigadier General Sir William Horwood, was disparaging about the use of attested women officers. He said, 'the women who are employed – and we do employ women to help us in the investigation of night club offences in London – are hardly the stamp of women that you would enlist as Policewomen'.[7] Head of the Met's CID, Major General Sir Wyndham Childs, concurred: 'We use other women who not only look the part, but are the part.'[8] If Horwood was making a reference to respectability and social status, Childs was explicitly perpetuating the stereotyping of women officers as mannish, unattractive 'spinsters'. Chief Constable of Birmingham, Charles Rafter, also stated that his force used 'other women' who were not permanent members of the force 'for the purpose of keeping observation on premises'.[9]

The identity of these 'other women' remains nebulous, although Childs' comments suggests that it included women outside of the boundaries of middle-class respectability. Witness statements and court reports relating to the prosecutions of London nightclub hostess Kate Meyrick for contravening the licensing laws in the 1920s detail the plain-clothes

observations that were made on the Cecil Club at 43 Gerrard Street, Soho. Male detectives described visiting the club to buy drinks accompanied by 'a woman friend', who did not give evidence in court.[10] These 'women friends', it can be assumed, were selected purely for their look, hence Childs' comments that 'they are the part'. It is also likely that police detectives used wives and girlfriends for licensing investigations where appropriate.

In investigating 'vice', the police were also given information by a very different group of women. Rescue workers, involved in the social purity mission to save 'fallen' women, saw surveillance as part of their remit.[11] A striking account of undercover work is presented in Edith Hoyle's recollections of her rescue, police and probation work in the early twentieth century. In 1912, Hoyle was appointed as matron of St Margaret's Home for Friendless Girls in Blackpool (which accommodated girls who were perceived to be 'in moral danger'). She appears to have built up a close working relationship with local police detectives, who would pass on information when they found girls on the streets. She also describes an undercover mission, for which she adopted disguise since she 'was anxious to know how prostitutes lived'.[12] She presented information on the keeping of disorderly houses to the Chief Constable of Blackpool, which formed the basis of a series of police raids. Similarly, when former Metropolitan Police Sergeant George Goddard was tried for corruption in 1928 (having made vast sums of money out of London's nightclub owners by offering 'protection' from licensing prosecutions) alongside Kate Meyrick herself (for bribery), Isabel Charlotte Napier of the London Council of Public Morality was called to give evidence.[13] She said that she had been employed as an 'outside worker' for the Charing Cross Vigilance Association between 1918 and 1923 and had kept observations many times on Meyrick's 'Comfort Restaurant' in Greek Street, which she believed was operating as a brothel. She had watched the restaurant, seen prostitutes enter with different men, and had on one occasion ordered a meal, which she thought had been brought in from elsewhere. Napier told the court that she had worked for the Chief Constable of Shropshire during the war. Women's involvement in moral welfare work attracted them to policing; these links are most obvious in relation to patrol work during the First World War. Yet the activities of Hoyle and Napier suggest that forms of covert surveillance, including undercover and plain-clothes observations, had already been developed within the woman welfare worker's repertoire. The detection of vice in the early part of the century was undertaken by a range of official institutions and voluntary societies.

Nevertheless, the Met's women officers were establishing a reputation in this area, particularly amidst concerns about the sale of cocaine to the bright young 'flappers' of the West End nightclub set.[14] Dorothy Peto's memoirs state that Violet Butcher and Lilian Dawes were used for plain-clothes work to detect drug trafficking while serving as women patrols in 1918.[15] Dawes's working-class 'cockney' background, which made her distinct from other women officers, might have facilitated her involvement. Lilian Wyles described the activities of a young WPC who disguised herself as a prostitute in the early 1920s in order to infiltrate a cocaine racket that was based around the large subterranean lavatories in the West End.[16] While Wyles does not name her, Annie Pomeroy and Annie Matthews are recorded as receiving a commendation in 1920 for assisting detectives to arrest three cocaine traffickers.[17] The investigation into the deaths of dancers Billie Carlton and Freda Kempton – which led to the prosecution of drug trafficker 'the Brilliant Chang' in 1924 – may also have involved Metropolitan policewomen.[18] The very nature of undercover work makes it hard to identify women's role, since not all of those involved gave evidence in court; it is highly likely that women were not encouraged to expose their methods to public knowledge.

In 1928, when the Lee Commission met, women were most actively involved in detective and plain-clothes work in Lancashire where, in addition to carrying out a large amount of clerical work for the CID, they routinely kept observations on race meetings or betting houses (gaming laws) and cafes (licensing laws). They kept watch at a public swimming pool after items had gone missing from women's cubicles and had been involved in a case of murder and one of illegal abortion.[19] In Sheffield the plain-clothes work of the city's three policewomen (sworn in since November 1925) was commented on with enthusiasm by Chief Constable Percy Sillitoe, who said they had worked with the CID in special cases 'particularly in regard to searching houses for stolen property, and to accompany Police Officers in raids on betting houses, brothels, etc. where it is likely that women will be involved'.[20]

Despite the statements of Childs and Horwood, the Lee Commission argued for the usefulness of women in undercover and detective work. This was couched, firstly, in terms of an essential womanliness: 'Certain feminine qualities of quickness and intuition would seem to us of such value in some phases of this work.' Secondly, the Commission argued that women, in fact, could 'look the part' much more easily than men: 'women, we are credibly informed, have an advantage over men in the ease with which they can disguise their appearance'.[21] Thus notions of gender difference were pre-eminent in shaping women's entry into the

detection of crime. This was not simply because of an anti-feminist reluctance to recognise women's equality with men. Rather, it was an acknowledgement that the performance that was necessitated in 'disguising appearance' was always a gendered one, whether it involved male or female officers.[22] Women's appearance, it was suggested, was less easy to locate within the symbolic order.

The tactics of watching

In his memoirs, *What Price Crime?*, published in 1945, former Detective Inspector Jack Henry wrote with enthusiasm of the work of a small number of women detectives attached to the Met's CID. He described Sergeant 'C' (who had worked with him on the 'Lovers' Lane Murder') as a specialist at 'shadowing': 'Pretty and petite, she was adept at disguising herself. She would hang on to the track of a criminal night and day relentlessly ... Nobody seeing that pretty brunette in evening dress and wrap would have dreamt that they were watching one of the ablest detectives at New Scotland Yard.'[23] Even higher praise was reserved for Detective Sergeant 'E': 'when I was troubled with a poison-pen writer, Miss 'E' was called in and secured a job as a charwoman. I saw her at work, and at first failed to realize that the grey-haired old lady who was cleaning the step was in fact the very agile and youthful Miss "E".'[24] Jack Henry's representation of women police as 'pretty but tough' fits with the common stereotype that was becoming established in the postwar period (see Chapter 3). He glamorised their work roles, making feminine appearance and demeanour the focal point of enquiry. Miss 'E' and Sergeant 'C' were both conventional objects of the male gaze; their prettiness and their youthfulness drew Henry's eye. At the same time, however, their success as detectives was based on techniques of subversion. Sergeant 'C''s very prettiness concealed her own role as the watcher rather than the watched. Miss 'E' disguised her youth, beauty and status, and in doing so moved outside of the male gaze altogether.

For both male and female officers, undercover observations involved a performance in which both class position and police identity were masked.[25] The male officer trying to pass as a navvy in the early 1920s had to replace the neat, clean and ordered appearance of the policeman (a combination of genteel and military masculinities) with the rough shabbiness of the poorly paid labouring man. Peter Beveridge described this moment with pride:

> I remember once walking into the station canteen in Arbour Square, Stepney, dressed in a seaman's jersey, a muffler and a cap, stained

> trousers and filthy, down at heel shoes. I had not shaved for a week... I noticed [a] visitor looking at me rather closely but I thought it was pure inquisitiveness. A week later, my father wrote to say that an uncle of mine had heard from a friend... that I was looking very rough and untidy and he was concerned for my prospects in the police force.[26]

Beveridge's account can be compared to a very similar extract from the memoirs of Stella Condor, describing observations on street bookmakers in the 1950s:

> We disguised ourselves in the filthiest raincoats, overalls, down-at-heel shoes and tied our hair in turbans, from which peeped one or two curlers. Once I even smeared my legs with coal to make me look still more authentic and, on that occasion, my shoes were so worn that I could scarcely walk... Once an Inspector greeted us in the canteen with the accusation, 'I saw you two shopping on duty'. It had apparently never occurred to him that we did not usually walk around in such a filthy condition.[27]

Both accounts describe the attempt to disguise class and status – their stories are similarly structured, using an ironical misunderstanding to stress the intentional disparity between inner police self (the signified) and outer form (the signifier). The tactics of disguise were based on a recognition of the operation of popular symbolic frameworks: the belief that identity was inscribed on and through the body. Physiognomy, grooming, clothing and deportment (which together constitute appearance), as well as behaviour, demeanour, etiquette and speech (manners), located individuals within the social order.[28] The individual body was analysed, interpreted and classified by others in relation to pre-existing categories, the most pertinent in these two cases being those of class, status (or respectability) and their intersection with gender.[29] Condor and Beveridge both refer to the apparent 'otherness' of the labouring poor. The respectability/propriety of a police identity is signified through cleanliness, smoothness and a disciplined body.[30] The 'disguises' that are adopted here are those of abjection: a dirty, rough, disorderly body. The repeated references to 'filthiness' and 'down-at-heel shoes' (as symbols of disorderliness) indicate their currency within the lexicon of police culture. The police themselves used these markers to determine character and status. However, through the act of 'dressing down', they were also attempting to subvert the symbolic framework, disrupting the mechanics of the sign by separating outer and inner forms for the purpose of verisimilitude.

Yet it was not necessarily easy to effect a successful performance. Newspaper accounts and popular fiction made reference to the public

recognition of male police 'bodies'. It was assumed that police*men* were instantly detectable because of their height (a requirement), gait (a result of military drill), white hands (pen-pushing rather than hard labour) and short haircuts: 'the man on the pavement is a plainclothes policeman trying to hunch his normally broad shoulders into the authentic spiv stoop'.[31] The popular belief that male officers could be recognised was repeated by Colin MacInnes in his 1960 novel *Mr Love and Justice*:

> Edward drained his cup. 'So we're easy to spot', he said. 'Stick out a mile, you'd say.'
> The nark was quite unabashed. 'Most of you do, yes. That is, except for women coppers. Maybe it's just because they're fewer, or maybe we're all not quite used even now to the idea of them, but – well: even I quite often fail to spot them'.[32]

Why was it that women were considered more elusive? It is important to distinguish between the 'plain-clothes' CID man, dressed in a dark-striped three-piece suit with a black Homburg hat – seen as the model of acceptable dress – and the very different sartorial rhetoric of 'disguise'.[33] As Dick Hobbs has pointed out, the 'plainclothes' dress-code of the CID functioned more as 'battle-dress' than 'camouflage'.[34] Certainly women officers had their equivalent, which in the 1940s consisted of the tweed skirt suit, worn for any form of duty when uniform was deemed inappropriate (which often included home enquiries in cases involving children). Nevertheless, this image of smart, ordered, efficient femininity did not obviously denote police identity since it could just as easily be associated with genteel housewifery. Good tailoring gave women respectability and status, but it was not 'read' in relation to occupational position.

When it came to attempts to specifically conceal police identity, women had the edge because the public remained unsure as to what a policewoman looked like. The early assumption that policewomen had 'stern features, mannish hairstyles, big feet ...' were scuppered by newspaper reports that stressed the recruitment of 'attractive women' specifically for observation work.[35] Moreover, within the culture of physical surveillance, the most perfect disguise was, in fact, femininity itself. If women, unlike men, were constantly being evaluated 'in terms of socially predefined visible criteria of beauty and attractiveness', they were clearly positioned as the object of male scrutiny rather than as a 'knowing' subject[36]: 'a crook in a hurry might be tempted to say, "oh it's only a woman" – and get on with his job'.[37] In her 1929 essay 'Womanliness as a

masquerade', psychoanalyst Joan Riviere argued that what we would now call 'femininity' could be worn 'as a mask' to hide the possession of authority (deemed 'masculine' in derivation).[38] The 'mask' of womanliness enabled the female detective to conceal her police identity and relationship to authority.

Newspaper accounts of the work of 'decoy Doras' and 'pretty-girl' detectives did not, therefore, merely objectify. Rather, the very sensation to which they referred was one of transgression as the masquerade was used to subvert the male gaze. The news stories were 'sensational' in journalistic terms because they attempted to induce surprise, excitement and comment by the unveiling of a secret. In doing so, they also revealed that femininity was merely 'a form of acting', involving 'duplicity' and 'deception'.[39] Concerns about modernity, criminality and shifting gender roles in the aftermath of the First World War pervaded the popular press throughout the 1920s.[40] A trio of women characters – 'the flapper', the 'female fraudster' and the 'girl detective' – provided topical subject matter since they were symptomatic of these wider anxieties, exposing gender roles as constructed and 'femininity' as artifice. The press argued, for example, that 'the most successful of trade swindlers are women' because men tended 'to extend towards the "gentle sex" that deference which serves to stupify his common sense and dull his eye-sight'.[41] There were concerns about 'Flappers "on the make"'- girl 'crooks' who had drifted to London hoping to seduce men out of their money – who were presented as a response to 'the shortage of marrying manhood caused by the war'.[42] The *Sunday Dispatch* also bemoaned the activities of 'idle gold-diggers' who, as nightclub hostesses used their glamour to 'fleece' soldiers and tourists out of excessive amounts of money in payment for champagne and chocolates. The dissimulation that connected the girl detective and the female fraudster was highlighted. As clubs were closed as a result of police raids, one hostess allegedly told the reporter: '"It is strange that none of us seems to have been engaged by Scotland Yard as detectives . . . the night club dancing girl is placed in unique position to aid the police in tracking down some of the worst types of criminals"'.[43] In the nineteenth century the use of covert surveillance by the police had been viewed with suspicion as tantamount to espionage.[44] Anxieties about duplicity came to the fore once more in the publicity surrounding the girl detective: 'the woman officer is dreaded by the proprietors of illegally run night-clubs because she is very nearly undetectable'.[45] If the 'flapper' and the 'female fraudster' represented a feminine threat to social order, the 'girl detective' was, at the same time, both a similar point of destabilisation and the truly 'modern' solution. Undoubtedly a shocking figure for

more conservative reader, others would have viewed her with admiration; 'sensation' clearly speaks to both audiences.

Gender and plain-clothes surveillance

Women's actual involvement in covert surveillance involved a display of 'femininity' and, sometimes, the ability to 'dress' up' to become a spectacle or 'dress down' to guarantee obscurity. Women were used for decoy work from the 1920s to 1960s, predominantly as feminine 'bait' to trap exhibitionists and sex offenders. They were also consistently employed, together with male colleagues, in the observation of pubs and clubs, a form of work that required a performance of youthful heterosexuality. This was predominantly to detect the contravention of licensing regulations but it might also involve investigations into gambling and brothel-keeping.

Despite these continuities, different forms of crime, criminality, and their association with social and geographical space, were investigated at different moments in time. In the largest cities – such as London and Manchester – the arrival of troops (in both the First and Second World Wars) led to a sharp increase in the number of drinking establishments, an intensification of regulation through the Defence of the Realm Acts, and a concomitant increase in police vigilance. Concern about recreational drug abuse shifted in relation to racial anxieties. A public panic about opium and cocaine trafficking involving London's Chinese immigrant community led to the passage of the Dangerous Drugs Act, 1920, which resulted in a high level of undercover police activity over the next few years.[46] Concerns about recreational drugs re-emerged in the 1950s, associated this time with 'reefer-cigarettes' and 'hot music' in pubs that catered for black immigrants.[47] By the early 1960s, nightclub observations centred on youth and drug culture as women officers were involved in plain-clothes observations on 'beat clubs' and 'all-nighters', partly as a result of their specialist remit to protect 'vulnerable' young women and partly to assist male detectives in a clamp-down on amphetamines.[48]

In some situations, women were selected to infiltrate spaces that were constituted as specifically feminine. This was most obviously the case in relation to cocaine-running in women's lavatories but it was also a factor in the observation of spiritualist seances and fortune-tellers during the First World War and its aftermath.[49] Soldiers preparing themselves for the trenches turned to clairvoyants for reassurance and there are incidents in which male police detectives posed as soldiers to obtain evidence for prosecution.[50] Traditionally, however, fortune-telling and spiritualism

were associated with a female client base, and the observation of seances and clairvoyancy formed a notable element in the work of some women police in the First World War.

As covert surveillance became an integral part of women's general workload in a number of forces during the 1930s, concerns were expressed that it was damaging to both police and gender identities. In 1934 the Metropolitan Women Police undertook 275 observations on suspected brothels, 98 on clubs and cafés and 50 on gaming and betting houses. Nevertheless, Dorothy Peto warned of its ill-effects: 'this work is thoroughly unwholesome for women as it is for men; it entails long periods without discipline, encouragement to drink, gamble and make undesirable acquaintances'.[51] Peto was echoing some of the warnings made by the Lee Commission in 1929. Although 'entrapment' was not permissible within policing strategies, the Commission had acknowledged that police officers should be permitted to buy alcoholic drinks in clubs; otherwise 'they might just as well ring the bell and say who they were'.[52] This, however, created considerable anxiety. It was felt that the club scene exposed men and women to temptation since they were encouraged to live the lifestyle as well as observe it. Male constables were often 'chosen for their youth', and 'dressed in clothes to which they were unaccustomed' with 'money to spend freely'. This could lead to both the 'danger of corruption' and an overall 'demoralising effect'.[53]

The impact of plain-clothes work on 'reputation' was also gendered. Although the range of social spaces into which 'respectable' women could venture was clearly opening up in the inter-war period, there was still a suggestion that women's virtue could be compromised through association with the rough and the disorderly. Clara Walkden, Oldham's only policewoman, made it clear that it was a line of work that she would refuse, since it was detrimental to the exemplary moral position that was required if she was to advise and warn young women. She protested that frequenting busy wine bars and public houses would 'cause her to lose caste' and 'reflect on her reputation as a woman'.[54] One's sense of propriety would be damaged by imitating the 'improper' or 'disreputable' woman.

Despite these commentaries, women continued to move in and out of uniform in the postwar period. In all forces, the number of women appointed permanently to the CID or plain-clothes departments were either proportionately few (10 per cent of the Met's actual establishment of women) or non-existent.[55] Instead, officers from Women Police Branches worked very closely with plain-clothes men, mostly on a case-by-case basis. Women, it was felt, provided 'a smoke-screen'; plain-clothes

men used them as a prop in order to pose as part of an unassuming courting couple.[56] This role was gradually expanded as women developed key roles – for example, in the collation of information about brothels, illegal abortions and nightclubs. Although women in the RUC were not employed in the CID until 1972, they were used regularly for observations on suspected brothels, as decoys in indecent exposure cases and on plain-clothes duty to catch shoplifters in Belfast in the weeks leading up to Christmas.[57] One former RUC woman also described her involvement in observations in relation to the investigation of cattle rustling.[58] Increasingly, too, in some forces, women were placed on short-term secondments. Although Bournemouth Borough Police employed only one woman permanently in CID in 1962, probationers served a seven-week attachment while 'uniform' women were seconded for periods of six months.[59] By the 1960s, women in the Met were often seconded to the Vice Squad at West End Central for six months at a time to undertake undercover work. How did women perceive undercover work and how did this change across time? How did they negotiate and interact with the people and places they encountered? How did undercover work impact on their identities as policewomen?

The experience of watching

Personal testimonies indicate an awareness of the performative aspects of undercover work, as well as underlying tensions between a 'police' identity and a 'feminine' identity, revealed in the act of stepping out of uniform. If one's lack of confidence as a woman could be bolstered by a uniform and badge that signalled 'authority', the return to a position of 'lacking' was beset with anxieties. Furthermore, through the act of infiltration, which required passing as 'other', policewomen gained an understanding of how other women thought, felt and behaved, which might challenge previous perceptions. Memoirs and personal interviews are suggestive of the psychological and physical processes that were involved in the act of dissimulation, conveying a clear sense of a possible fear that might have to be hidden beneath a calm exterior. They hint at an awareness of the discrepancy between the sensationalism of the popular press and the practicalities of undercover work. There are also notable generational shifts in women's personal testimonies of undercover work – shifts that have been shaped by changing dress codes and by the rise and eclipse of the concept of 'glamour' within the formation of twentieth-century femininities.

The accounts of 'pioneers' Edith Hoyle and Phyllis Lovell, describing plain-clothes observations during the First World War, are far from the

narratives of 'cunning detection' that are presented by former CID men Robert Fabian and Peter Beveridge. As part of her investigation into prostitution in Blackpool, Hoyle made elaborate arrangements to dress as one of them, acquiring 'a golden wig... coloured stockings... and a golden tooth'.[60] Revelling in the transformation of 'disguise', which is depicted with something of the theatricality of a pantomime performance, she tested it on local notables – the vicar, a police superintendent and the Chief Constable – all of whom failed to recognise her until prompted. The joke – at which they all laughed – concerned her ability to pass from an appearance of moral rectitude and authority (as 'matron') to that of the dissolute woman. Her previous work with young women had provided her with an appropriate script with which to respond to their questioning: '... What was to be my plea? Of course, the old, old story of wanting to get home but had no money.' The second task required Hoyle to use her familiarity with street women to become one of them: 'Being familiar with a few regulars and knowing their names, I joined them at various places, chatted and sometimes went into a public house to see who was about, and maybe have a drink and sit down for a while.' The role was a precarious one, since she had to protect both her identity and her virtue. The information was forwarded to the Chief Constable of Blackpool and, according to Hoyle, a number of brothels were subsequently raided. While her 'journey' into this alternative social milieu was partly a fact-finding mission, there were clearly other forms of knowledge involved. The journey was an emotive one, involving the forging of personal relationships: 'not very long after this episode one of the girls I went out with was arrested. I pleaded in court for her and saw her return to her parents in the Isle of Man'. The model of 'befriending' was a significant one in philanthropic work (which would also develop as a reference point in women's police work), but there was clearly a recasting of this role during Hoyle's 'journey 'as she 'met' prostitute women as a supposed equal rather than as 'matron'. What she names as a 'journey' and an 'experience' was as much about self-discovery as about the observation of others.

Before working in Birkenhead, Phyllis Lovell was involved in a Police Aid Attachment (approved by Liverpool's Chief Constable in 1914), which worked closely with the CID in the detection of fortune-telling and spiritualist seances. Lovell describes how she and her colleague prepared for an operation. She posed as a young married woman, who had dreamt about her soldier husband:

> I did not proceed immediately to the case, preferring to work myself into a mental attitude sufficiently clear to handle the matter intelligently... I invented such a plausible story that I went near to believing

it myself. A man – lost somewhere in the desert, a place of much sand. I wore his wedding ring for days and I was terribly anxious. I wanted news. I was willing to pay for it. I was so very, so terribly anxious. So terribly distressed. With this story firmly held, Mabel and I proceeded to the given address and all went so well that in the middle of the appropriate diagnosis to which I listened, I saw suddenly how stupid the whole thing was. It was only the interruption of a moment but in that moment the fortune teller who I now saw was a mind reader wavered. She felt a shattering in my thinking and in her own and stopped her discourse abruptly. To my credit I was able to collect my thought sufficiently to terminate the interview in orderly fashion, and it was to Mabel's credit that she was able to witness the illegal exchange of money and to hand over eventually a tolerably accurate account of what had occurred.[61]

Lovell indicates the precariousness of assuming another identity and an awareness that the operation required more than just a performance. To succeed, one had to 'become' the other; in doing so, however, one's existing police identity might be challenged or compromised. This is suggested most clearly in the second operation that she describes: observations on a spiritualist seance group, which the CID had been unable to gain admittance to:

It was a challenge and I persuaded my sister to accompany me. Not immediately of course. Such a mission demanded more than a casual request to join the illegal gathering. It demanded, we realised this, an ability not only to look the part but also to speak the dialect which only a true Lancastrian can master. And we were not Lancastrians ... Dorothy, with a natural ability to mimic anything she heard, mastered the essential elements fairly easily and I, less gifted, practiced typical sounds and went on practising.[62]

They successfully observed a seance, although their fear of 'discovery' was present throughout. However, as for Hoyle, the moment of intimacy that had been created as they entered another's personal space disrupted their confidence in the regulatory framework: 'Neither I nor the women who helped me were very happy. Dorothy and I admitted to each other that any satisfaction found in facing the eyes of a delinquent placed in the dock as a result of what we had done was entirely wiped out by a strange sense of compassion which seemed inescapable. We decided to abandon work with the CID.'[63] A broad theme of Hoyle's memoirs is the ability to cope in adversity, and this similarly drives her account of 'disguise'; she presents herself as resourceful, determined and able to use her wits. Lovell's account is significantly more nervous. Both, however, felt that the

'undercover' experience had brought them closer to those whom they were attempting to 'police', and this had the effect of challenging their belief in formal institutional mechanisms.

For Hoyle and Lovell, who became young women against the backdrop of the First World War, 'duty' and 'industry' were key organising principles. Lovell, who came from a wealthy family, had been involved in suffrage campaigns; although privileged, she was driven by a clear sense of purpose. Hoyle's sense of duty was to her family, whom she helped to maintain financially, but her attraction to moral welfare work suggests a wider notion of public 'duty' through what she considered to be socially useful paid work. Notions of feminine respectability and propriety influence their memoirs (although they were, in fact, written far later). In contrast, the accounts of plain-clothes work produced by Joan Lock and Stella Condor, which describe policing during the 1950s, show the impact of American 'glamour' – evident in Hollywood movies, but also the popular press – on women's self-perceptions.[64] Lock and Condor are far more aware than Hoyle and Lovell of women's potential to be attractive objects who give visual pleasure to others, recognising themselves as 'unglamorous'. Condor described her disappointment that 'there was no call for me to wear low-cut evening dresses and sip martinis' because her 'face did not fit'. She also felt that 'not being particularly glamorous' might well have its advantages for plain-clothes work since, 'there is nothing at all outstanding about my looks, and no-one would be likely to recognise me again'.[65]

Lock demonstrates an awareness that feminine beauty is positioned in terms of the taste that is associated with class. Called on to undertake observations (in relation to licensing laws) in an exclusive club in London's West End, she is made to feel inferior by the informant, herself an elegant and wealthy restaurateur, who was to accompany the police contingency: 'Looking coldly at my simple, grey, Swedish mac, which I thought rather smart, she said, "What will you be wearing? I am used to taking nicely dressed people you understand".'[66] Lock and Condor invoke the terms of a visual literacy that can be associated with the delineation of cosmopolitanism/suburbanism in 1950s London and which served to locate individuals within the city's social spaces in terms of their gender, class and status. Lock's disdain for the pretensions of the élite circle also demonstrates, at this moment, a sense of assuredness about her lower-middle-class position. Her description of nightclub observations in London's West End during the 1950s involves both a rejection of popular perceptions that it must be 'glamorous' or exciting and any suggestions that it could be seductive or corrupting: 'I usually found the job utterly

boring. This was mainly because I was neither able to choose my company nor leave when I became fed-up or tired.'[67] Other accounts stressed the monotony of sitting in rooms or vehicles for hours on end.[68]

Like Hoyle and Lovell, Lock found her position as law-enforcer to be problematic when it involved those whom she perceived to be less fortunate: 'The big disadvantage of clubs work was that if we got to know and like the proprietor and/or customers we felt absolute heels sneaking around telling lies and later "shopping" them. Especially when the licensing laws often seemed as trivial to us as they did to them.'[69] Her chapter describing observations and raids on drinking and dancing clubs ends with the question, 'Whose side am I on anyway?'[70] Oral interviews revealed similar dilemmas. Violet was sent out with a male CID aide to observe street betting:

> I used to think that was awful really. There'd be a man taking bets, and these poor people would come up and put 'threepence each way' or something like that on a horse'. . . We used to stand in doorways and cuddle each other . . . and then we'd follow them home and they'd have a betting shop in the house and the poor old things used to be taken back to the station . . . I used to get upset about that, I didn't like that at all.[71]

As Jerry White has argued, the gaming laws were overtly class-biased: 'with all off-course betting forbidden, only those with time and resources to attend the race meeting could have a lawful flutter'.[72] Violet and Joan Lock were simply recognising the hypocrisy of the law, which they had not themselves made. If the accounts of the 'big chiefs' – the CID men of the 1940s and 1950s – created the image of a criminal underworld of vice and corruption, accounts of day-to-day policing such as Lock's resisted a clear black-and-white typology. Also absent from her account is Walkden's sense of the policewoman as a beacon of morality to provide a shining example to the 'fallen'. This rhetoric, present in many inter-war accounts of policing (although, in the case of Hoyle and Lovell, challenged by personal experience), had disappeared by the postwar period.

The cover of 'glamour', sensationalised in the popular press, was a useful ploy in decoy work and nightclub observations in the 1950s: 'A girl called Sheila . . . very, very attractive, lovely black shiny hair and beautifully made-up, well-spoken. She used to go into the clubs in the West End with a similar nice-looking PC in plain clothes, and they did ever so many clubs . . . We used to call her "flash eyes", she was very successful.'[73] On this occasion a distinct and decadent look was considered appropriate. For decoy work in relation to sexual offences, the ideal woman had to look

conventionally attractive or glamorous: 'We had one girl in Southsea, a blonde, very blonde, and she could just go out into the street and [catch them].'[74] To succeed in decoy work necessitated an ability to cast off the physical confidence instilled by drill, in order to convey the vulnerability and attainability of conventional femininity: 'I was a dead loss; I'm too big, they're going to pick somebody who looks smaller and more frail, and more impressionable.'[75] These accounts show the weighing-up of self and others in relation to conventional categories of beauty and glamour, a self-conscious appraisal of femininity that does not figure in the work of 'pioneer' policewoman.

The importance of dress was recognised by policewomen at the Met. Joan, who served at Paddington Green Station in the early 1950s, stated that 'For all sorts of reasons, we'd have plainclothes at the station; sometimes several sets of clothes, sometimes quite provocative clothes.'[76] For observations on street gambling, it was important not to look distinct: the adoption of overall, curlers and headscarf helped policewomen to blend in anonymously. Joan argued that 'often the best disguise of all is a dirty old raincoat; you merged into the background, dirty old raincoat, dirty old pair of shoes, headscarf'.[77] While smaller forces made use of plain-clothes work, they were possibly less aware of its potential as a strategy. Jill, who served in Portsmouth City Police in the mid-1960s, felt that male detectives lacked understanding of the tactics of appearance. In the following story, she describes an operation to detect under-age drinking:

> Sometimes they were stupid with the way they wanted you to dress. I had to do observations one night and [I said], 'What is it I'm doing?' They said, 'Well, what does it matter?' I said, 'Because how am I going to dress?' 'Well, you put a suit on.' I said, 'Oh no I don't'. Because that was it, CID officers put on suits. I said, 'Where are we going?' It was a pub and it was a youngsters' pub. I said, 'We're going to stick out like sore thumbs if we're dressed up' ... I put on just a blouse and skirt which is what the girls were wearing. Because we had to mix in with these kids and we did it on several weeks, going in. And the night they did the actual raid, I'm sat next to a girl at the bar, who I knew was 16, and she ordered a drink. And as she'd done it, the PC's helmet we could just see in the mirror as they came in the door, because it was packed. And she just pushed this drink away from her and I just pushed it back and said, 'I'm sorry love, but you're nicked.' ... And one of the lads said, 'I was beginning to wonder about you two,' so we knew that they would start getting suspicious ... If you'd gone in dressed very smartly the first week, you would have been sussed out as a social worker or somebody, you know, you just wouldn't have fitted in.[78]

Unlike Lock (who questioned the licensing laws), Jill reveals a moment of satisfaction in making the arrest as the culmination of the operation. By the 1960s, dress codes were far less formal (although CID men persisted in wearing the suit) and observations on pubs and clubs rarely required 'dressing up'. If 'style' was intrinsic to the formation of youth subculture, the demeanour of maturity or professionalism – the appearance of the social worker – was to be avoided.[79]

While a cosmopolitan appearance and received pronunciation had helped 'Sheila' infiltrate the upper-crust West End establishments of the early 1950s, a different manner, mode of speech and etiquette was required for other venues as a less formal nightclub scene developed. Elaine, who joined the Met in 1958, found herself selected early on for undercover observations:

> I did a lot of plain-clothes work while I was at Caledonian Road because I was short and I didn't particularly look the build of a police officer... We used to do plain-clothes in coloured clubs... after hours, selling drinks and that. I'd perhaps go in with a plain-clothes male officer. We'd go in there and we'd get chatting to people, seeing what was going on and then arrange for a raid or something for drinking out of hours... They tried to get you fitted in, so you fitted in with the sort of people there. And of course I've got a London accent which helps as well, 'cause of course it was very 'London' in that area. I've got a common accent, I'm a Cockney. I can't help the way I speak.[80]

The need for disguise and transformation became less of an issue as women were selected for their authenticity. Although less than ten years separated their service, Elaine's description of observations contrasts with Condor's elaborate account of smearing coal dust on her legs. Nevertheless, the act of concealment and the sense of performance were still present: 'You have to fit in, or you have to become somebody else. Up here you have to think "Lor', I've got to be careful what I say, I've got to be somebody else now... People can tumble police pretty quickly, I think, I think, but it's up to you to make sure they don't.'[81] Metropolitan policewomen involved in undercover work by the 1960s and 1970s convey both a sense of excitement for the job and a confidence about themselves and their appearance as the marker of 'glamour' disappeared from view. Katherine was seconded to the Vice Squad for six months in 1971 to carry out observations in the strip clubs and night spots of Mayfair and Soho, which she described as 'a very interesting, exciting time': ' I didn't look like a police officer, I was sort of – not hippie – but a seventies young woman, so it was a very good cover, I just blended in really.'[82]

Throughout the period, women were involved in a process of both simulation and separation; gaining knowledge of 'the policed' by obscuring but retaining their 'police' identity. The memoirs of Hoyle, Lovell and Lock position this process in terms of anxiety, resulting in the questioning of legal and regulatory frameworks. Undoubtedly some women may have crossed sides, either permanently or temporarily, as a result of plainclothes work. While histories of the Metropolitan Police indicate that various corrupt practices – including 'tipping' and the taking of bribes – continued to be widespread (despite the prosecution of Goddard), only one reference has been found to corrupt activities among policewomen.[83] In May 1943 Detective Sergeant Jean Stratton and Detective Constable Margaretta Low were sentenced to 12 months' imprisonment at West London Police Court for 'systematically stealing from unoccupied houses', evacuated because of wartime bombing.[84] The goods, assembled over a two-year period, were found in the home that they shared in Camberwell.[85] The prosecution of these two CID women was clearly a blow for the Women Police Branch of the Met, which prided itself on moral rectitude. Yet this prosecution appears to be unique. Women's relative marginality from male police culture, the intensive disciplinary regime of the Women Police Branch, plus women's sense of being different/superior to male colleagues, are all possible factors in explaining their apparent lack of involvement in other incidents of bribery and corruption. It is also possible that women who 'crossed sides' did so in different ways, possibly through marriage, which meant they had to leave the force. One woman interviewed had to leave the police because of her marriage to an illegal bookmaker.[86]

Incidents of 'crossing' are unusual in memoirs and interviews, precisely because they have been produced by those who have chosen to identify as 'policewomen'. Assumptions about other people's lives were challenged as a result of undercover work, but gender and occupational identities were also preserved. For women who masqueraded as 'prostitutes', anxieties focused on the protection of their own sexual identity and respectability. For Condor, who (like many policewomen) was proud of the neatness of her uniform, the adoption of dirt and disorderliness as disguise could only ever be a temporary process; she is very quick to comment that 'we did not usually walk around in such a filthy state'.[87] The association of dirt with disorder was negotiated and questioned, although ultimately reinstated as a result of women's surveillance work.

Coping with danger

Women were required to use their femininity – and, indeed, their sexual attractiveness – to persuade, attract and obtain information. Yet they were most certainly not expected to indulge in sexual activity and had to protect their virtue as well as their police identity. This fine balancing was manifest in 1947, when two women constables in the RUC investigated a man from Newry, County Down, who had placed an advert in a local paper for a 'clerical worker'. Women who had responded to the advert claimed he had attempted to molest them and to procure them as a mistress. Posing as secretaries, the two women constables developed an elaborate range of excuses in order to both prolong and postpone his sexual advances.[88] There were clearly moments when women felt vulnerable because they lacked the authority associated with the uniform. Joan was required to join a tennis club in the early 1950s and to drink in its bar as part of a licensing enquiry: 'There was a chap, a German, who took a great fancy to me. I couldn't get rid of him, I couldn't get rid of that man at all. And he wanted to take me home, that kind of thing. And in the end, I had to be withdrawn from the case, because he was proving a hindrance.'[89] Decoy work to trap sex offenders – both exhibitionists and rapists – brought women into a range of encounters that were potentially physically dangerous. They relied on a backup team of male officers to track their movements and to intervene before an assailant could attack, but there were moments when this was not possible. In 1955, WPS Ethel Bush and WPC Kathleen Parrott of the Met were awarded the George Medal after sustaining serious injuries in an operation to catch a man who had been attacking women in Croydon; police cover had been unable to intervene in time.[90] Decoy work was based on a working relationship of absolute trust and, for the most part, former women officers record feelings of complete support, although fears were rarely totally suppressed. Women experienced intense concern and anxiety when they lost their cover or realised that they were not being properly protected.[91]

Police culture, with its use of slang terminology and crude stereotyping, served to reinforce the boundaries between 'police' and 'policed'. Black humour that centred on these distinctions might also divert attention away from potential danger as a coping strategy. Police officers who were involved in plain-clothes observations might be subject to the humiliation of arrest in order not to blow cover; this was treated with irony, sometimes by both parties. Ivy had to pose as a prostitute in order to undertake observations on a country club near Southend in the 1950s; the raiding party was late and she had had to lock herself in the lavatory,

fearful of the attentions of a prospective 'client'. Yet the punch-line to the narrative – injected with humour throughout – comes in the form of a joke, which concerns the double meaning of police slang: 'I get arrested with all the others and taken to the police station and, as we're going in, one of the raiding party says to his mate, "I've seen this tart somewhere before."'[92] The derogatory term was used to maintain Ivy's cover, so that other women who had been arrested might think she was 'known' to the police for illicit activities. The 'hidden' meaning for both Ivy and the officer was the recognition of her police identity, and the solidarity that was reinforced through the sharing of the joke. For other policewomen such a joke was not appreciated: Carol Bristow was 'mortified' when other women colleagues strip-searched her following a drugs raid, although later acknowledging that 'if I couldn't take a joke then I should never have joined'.[93]

Women were involved in undercover work relating to 'political crime' or alleged terrorist activity throughout the period, both as detectives and as uniform constables. If femininity was the ultimate disguise in relation to nightclub observations, it was equally successful in relation to political activity, which had traditionally been associated with the 'masculine'. Robert Fabian's memoirs recall an attempt to infiltrate an alleged IRA bombing campaign in 1939: 'The meeting place was a café. We needed to follow them from this café to their new hide-out, which would not be easy, as they could suspect even a disguised detective. "Let me go, they won't suspect me", said a pretty, intelligent-eyed policewoman.'[94] While Fabian's account is constructed around a glamorous heroism, women's personal testimonies reveal a different aspect: the sense of danger conveyed is acute, as is the mismatch between the actuality of undercover work and popular perceptions of glamour. In 1971, Carol Bristow was required to pose as a secretary who was to deliver ransom money 'to a foreign terrorist who was threatening to blow up part of London's Mayfair':

> There have been several times in my police career when I have felt really frightened. The fear starts low in my stomach like butterflies but gradually rises to my chest, getting higher and stronger as I start to lose my bottle. By the time I heard the terrorist's threat, it had knotted in my larynx.[95]

> Standing in front of a mirror in the ladies' lavatory threading a piece of wire up the centre of my cleavage, I felt more like Mata Hari than a woman detective sergeant in the Metropolitan Police . . . I was given a green polo neck jumper to wear which would cover up the mike, and – what with my own nervousness and the boiling hot day – I was soon sweating like a pig and in danger of passing out.[96]

The reference to Mata Hari – which conjures up a glamorous image of exotic femininity – is juxtaposed with the indelicacy of 'sweating like a pig'. Despite attempts to discipline or disguise the body, it could betray through animal instincts: the knotting of the larynx and the feelings of faintness. The frailty of the body without its armour of uniform – and its ability to articulate that which is beyond the spoken word – is a dominant feature in Bristow's narrative.

Irene, who was later selected for the RUC's Special Branch, was called in to act as a decoy to infiltrate gun-running in the context of the Troubles around 1970:

> It is very frightening, very frightening ... I was asked to go to Springfield Road Station. I went, I was told to turn up in brown. I phoned a girl and asked her – I knew that she'd got a new brown coat, I didn't have a brown coat and it had to be fur-lined. And I got her coat and I went to the lost property office and I got a red handbag, and there was no umbrella mentioned but thankfully it was raining that night and I took an umbrella with me. I thought, 'Well at least I'll have some protection,' and I was going to be on my own. And I was to meet a gunman. And I went along, was dropped off quite a distance away. Don't forget this was quite a hostile territory, at this stage, to police. I walked along to the front of the shops and this man was to approach me. And my signal to the other police hidden in the area was to pull out a white hanky and wipe my nose and drop it and pick it up again. And I was approached by the gunman and I went through the procedure and stayed and talked to him and he was arrested ... He had previously fell in with this girl who had a brown coat and red handbag and had given her arms to keep for him and I was to bring them back to him. And I was unarmed and I thought I was meeting up with him again. The first part of the conversation was that he had more guns and he wanted me to keep them for him. And I said my handbag, this handbag I had, wasn't big enough, wasn't large enough to take them but I would see if I could get a plastic bag and put them into it. So he said, 'Will you do it for me?' So ... I didn't really want to talk very much because I didn't want him to realise that I wasn't the girl he had met the previous week ... It was very difficult. And of course don't forget I had a very country accent compared to the Belfast accent. So I really didn't want to say very many [things].[97]

The precision involved in getting appearances right (the coat, the handbag) is an important element in this narrative – as, again, is the fear of one's body leading to betrayal (the lack of a Belfast accent). The concentration on detail and procedure are suggestive of a coping mechanism and the telling of the story itself is controlled and focused. The sense of danger, however, underpins the whole narrative. The accounts of both

Figure 7 Women's detective course, West Riding Training School, Wakefield, 1946. Male training school lecturers are seated in the front row

Bristow and Irene highlight the importance of trust within undercover operations and the absolute necessity of having a reliable backup team: 'Oh yes, you have to be very, very confident in your cover. You have to have one or two people that you can really latch on to and know that they are your lifeline and they have to be your lifeline.'[98] The sense of police loyalty and police identity cut across gender boundaries on occasions like these and acted as a crucial support mechanism.

Women in CID

The first women to work with CIDs in the early 1920s – Lilian Wyles at the Met, Dorothy Peto in Birmingham and Emily Miller in Glasgow – were given the specific task of taking statements from women and child victims of sexual assault. Their role was gender-specific and their duties were viewed as separate from the male CID. As women's skills in observations became noticed, the range of duties in which CID women were involved began to expand during the 1930s. Amy Ettridge's work in collecting information in relation to murder investigations – in particular, her skills of feminine 'masquerade' – was commented on by Jack Henry, Arthur Thorpe and Robert Fabian in their recollections of their 'great cases'.[99] In Glasgow and Lancashire, all women officers were attached to the CID in

the inter-war period (see also Chapter 2).[100] Nevertheless, the number of women in UK CIDs remained small throughout the period before integration and, as I shall show, their work continued to be gender-related if not gender-specific. This section is concerned with women's experiences of CID work and CID culture. The specific work of statement-taking and approaches towards rape and sexual abuse will be explored later in this book. Subsequent chapters will also make it clear that 'uniform' policewomen, to a much greater degree than their male colleagues, undertook a great deal of criminal investigation and prosecution work – particularly in relation to child protection – although not formally part of the CID. Women in the RUC, for example, were routinely sent to the Detective Training School at Wakefield, West Yorkshire (Figure 7), although not formally 'detectives'. At Wakefield they found that they had considerably more investigative experience of casework involving illegal abortions, incest, rape and bigamy than many women who had served for a number of years in CIDs elsewhere.[101]

Oral history accounts relating to the 1950s indicate the prevalence of a pigeonholing of women's work as 'specialist' within the context of the CID. They also suggest that, when not occupied with matters involving women and children, women detectives tended to be given 'soft cases' of little interest to their male colleagues. Leeds City Police employed four women in the CID (two on each shift), who were accommodated in a separate room off the main CID office. Kathleen, who served in the CID from 1952 to 1956, and May, who served in the CID from 1956 to 1960, described similar caseloads:

> Women [officers] were treated very differently from men. You dealt with rape statements, you dealt with shoplifters by the dozen, that sort of offence. You spent hours and hours on observations, pickpockets... and then if there was any help that a man needed, on abortion observations, you would be part of that. But nobody booked off to you a house break-in.[102]

> They would sometimes book offences to us to deal with but they usually gave us things that there wasn't any chance of catching anyone, what we call, you know it was all dead stuff... washing gone off the washing line, and it was all very difficult, you know. But we didn't get any straight races. If there was a good chance of catching somebody, one of the men would do that.[103]

The emphasis on shoplifters was shared across forces. In 1965, approximately half of all arrests, summons and statements dealt with by Metropolitan women CID officers or women aides to CID were for

shoplifting.[104] While the memoirs of male detectives convey a chivalrous respect for female colleagues, traditional ideas about gender roles were often reinforced within the CID.

Maureen, who was appointed to Newcastle City Police CID in 1960, has described her battle to expand the remit of her duties:

> After about three [months], I went to see [the boss] and said, 'I'm coming out, I don't want it.' He said, 'Why?' I said, 'Because I'm a woman in CID, I'm not a detective. What I'm doing in CID I could do in uniform. I'm sitting beside the men while they interview the women, I'm taking statements, I'm doing all these things that I could do quite easily in uniform.' So he said, 'Well, if I said you could have a section and work it like the men. . .?' I said, 'Yeah, fine, but that's the only way I'm staying. I want to learn'. . . I had a section, I had a team of detectives and, although I was used throughout the city for rapes, sexual offences and abortions, stuff like that, basically I had my section. And I dealt with housebreakings . . . and crime, assaults, thefts, the whole gamut.[105]

She then stayed for three years, moving back to uniform to be promoted to sergeant. Maureen's narrative, which describes the battle to 'pioneer' an equal role for women in the CID, is echoed in other accounts. Carol Bristow, who went on to become the first Metropolitan Police woman on the Flying Squad and the first female detective inspector in the Drugs Squad, was sent to work in the CID at Notting Hill as a junior in 1968. Although she found male colleagues welcoming outside of work, there had been little consideration as to how she should be absorbed into the team as the only woman:

> Although they welcomed me warmly into their drinking circle (where I quickly proved my worth), I felt very much alone when it came to the work side of things. It was a rough area to police and when the fellas went out on inquiries they generally preferred to pair up with one of the other male TDCs [Temporary Detective Constables] – it was just human nature, I suppose. But at times this made me feel my new career was being overlooked. Time and again when a call came in they grabbed their coats and went flying out of the door. Time and again I was left in the office, answering the phones or waiting for further instructions.[106]

If formal structures and processes – the tried-and-tested formula that women dealt with 'women's work' – had shaped Maureen's early experience, cultural awareness of gender difference – qualified acceptance, but preference for a male colleague – had affected Bristow's. There were clearly two battles to be won; success in the first (changing ideas about the work that women were technically allowed to do) might lead to the

second (cultural shifts). The success of these two women in overcoming obstacles to their advancement in the CID is testimony to the changing role of women detectives in some forces by the later 1960s.

There was certainly regional variation and some county constabularies were noticeably more flexible. Vera, who joined Lincolnshire Constabulary in 1960, worked for three years as Scenes of Crime Officer in Scunthorpe CID, having been given special permission to apply for the post along with male candidates. Her earlier experience as a laboratory assistant and her interest in photography were seen as eminently suitable for the post.[107] In contrast, within some small borough forces, women's work continued to be gender-related and expectations remained low until integration. Jennifer, who served in Bournemouth CID as a probationer in 1972, recalled: 'I was a token woman, because if there was a job on and there was a woman involved, it was, "Well, we're going to search a house, and there'll be a woman there, come along".'[108] Unlike male detectives, she was not required to undertake a three-month trial period and was selected with very little police experience, which may have fuelled resentments.

Ethnographic studies have argued that CIDs tended to see themselves as 'a closed and somewhat élite family group' within individual forces, distinct from the uniform branch because of their more 'masculine' pursuit of hard 'crime' rather than minor offences. This 'fractured rivalry' was acknowledged by some women officers: '[In the CID] you used to think of yourself as a cut above the rest.'[109] The rituals of CID life often included an after-work drinking culture, in which Carol Bristow was clearly included.[110] Despite the apparent 'machismo' of the CID culture, none of the women interviewed reported concerns about harassment: 'I never had any problems at all working with the men . . . I always thought if you did your job and pulled your weight, you wouldn't get any problems.'[111]

However, 'doing the job' was premised on a lifestyle that was unattainable for most women. The social demands of CID and the long hours associated with the work were problematic for married women and those with domestic commitments as carers. May, who had unusually joined Leeds City as a married woman in 1954, went back into uniform after a four-year stint in CID: 'It was coming to the point where I could see my marriage or work coming first . . . and I decided my marriage was more important.'[112] Similarly Elaine found it extremely difficulty juggling work and family commitments when she was involved in the enquiry, headed by Leonard 'Nipper' Read, into allegations of murder and racketeering involving Ronnie and Reggie Kray in 1967. Elaine was given

the task of protecting a female witness (Liza) who had been witness to a murder:

> I was living with her for six months, 24 hours on, 24 hours off, with another girl, living with her. It was awful. I had my mother in hospital as well, so I was backwards and forwards on my day off going home, doing washing at home, ironing for my brothers and sisters, going back to work. It was hard graft. Living with her was a nightmare. She wasn't particularly fond of police officers, but we had to protect her. She did a marvellous job in the end. She was the best witness they ever had on the Krays, but she was a nightmare to live with ... We had to go to the doctors, to get sleeping tablets for her ... but we couldn't let the doctor know who she was, so I had to go in to get them.[113]

Her comments indicate something of the stress of caring for both family and witnesses. Although she found a lot of the work extremely satisfying, she eventually went back into uniform: 'I thought, "I can't take this. I'd rather go back into uniform and know what hours I'm doing".' Other women noticed the strain much sooner. Irene went for four weeks training in the RUC's Drugs Squad, which involved a lot of night work: 'I couldn't hack it, I couldn't, it wasn't my scene ... it was either Drugs Squad and no marriage or marriage and no Drugs Squad'.[114]

In Northern Ireland the pressures of working within investigative sections of the RUC were particularly acute, both because of the extreme sense of danger that was involved during the Troubles and the anger that was felt when police officers themselves became targets. Because of her previous experience of decoy work, Irene was selected for Special Branch with the intention of grooming her for undercover investigations. The task of calmly assuming another identity was too much:

> I just couldn't mix with the crowd that were throwing stones at the police station and throwing stones at the police, and pretending that I was one of them without doing anything ... I was going to be further on in, but I phoned the superintendent in the district I had left and I just says, "Get me out of here, please," and I was out that evening.[115]

This was an experience that was unlikely to be particular to women (indeed, some women chose to stay in the RUC Special Branch and pursue successful careers). However, Irene's identity as a wife with a RUC husband, whom she felt a duty to support, was a factor in the equation. She left a few years afterwards to raise a family. Her loyalty to the RUC and her identity as a police wife made it impossible for her to engage in acts of infiltration.

Women were involved in work that was sometimes exciting and on other occasions frightening. Yet their personal testimonies of undercover and detective work offer alternative narratives to the sensational accounts of newspaper reporters and to the memoirs of high-profile male detectives. Any sense of heightened adventure is counterbalanced by an acknowledgement of the difficulty of coping: the detailing of personal insecurities, the unglamorous nature of fear, and of the difficulties of juggling work and home commitments in an era in which it was assumed women were largely responsible for domestic duties. It is clear, too, that many operations were monotonous and mundane both within the CID and outside of it. Yet there are also resonances between women's narratives and more popular and sensational accounts. The concept of 'glamour' as a marker of femininity is present in testimonies of women serving in the postwar era, who often perceived themselves to be 'unglamorous'. Successful surveillance was based both on the ability to pass as 'other' through the manipulation of appearance as well as a central identification as 'police', which involved a sense of loyalty and belonging. For both male and female officers, plain-clothes observations required a performance that was gendered. However, according to both the popular press and accounts of former police officers, 'femininity' was the ultimate 'cover' since the public were less knowledgeable of the activities and bodily demeanour of women officers. If it is accepted that the 'Panopticon' – the generation of an all-seeing but anonymous regulatory mechanism – is a central metaphor for the process of surveillance in the modern Western state, it can be argued that the obscurity of 'woman' created the ultimate cypher for covert observation in the form of the female detective. The use of women was symptomatic of the strategic increase in levels of surveillance during the course of the twentieth century.

This chapter has also suggested that the identities of women officers were fluid and complex and that that they cannot be reduced to the dominance of *either* middle-class values *or* gender *or* occupational culture. Rather, women officers were involved in a constant negotiation of the relationship between 'self' and 'other' as perceptions were challenged, negotiated and adapted as well as reinforced. By considering the mechanics of physical surveillance, the last two chapters have begun to outline the ways in which identities and relationships were negotiated as a result of daily encounters. The next two chapters will continue this approach by focusing on the specialist content of policewomen's work in relation to, firstly, child welfare and, secondly, sexual offences involving adult women.

Notes

1 *Tit-Bits*, 27 June 1931; *Sunday Dispatch*, 4 November 1928; *Tit-Bits*, 31 August 1940.
2 N. Lucas, *Heroines in Blue* (London: Weidenfeld & Nicolson, 1985) and *WPC Courage* (London: Weidenfeld and Nicolson, 1986).
3 Daley, *This Small Cloud*, p. 111.
4 C. Fijnaut and Gary T. Marx, 'The normalization of undercover policing in the west: historical and contemporary perspectives', in Fijnaut and Marx (eds), *Undercover: Police Surveillance in Comparative Perspective* (The Hague: Kluwer, 1995), p. 9.
5 The Clubs and Vice Branch was charged with the investigation of brothel-keeping, pornography, gaming and licensing from 1930 to 1985. See K. Skinner and M. Fido, *The Official Encyclopedia of Scotland Yard* (London: Virgin, 2000), p. 75.
6 See 1931 Police (Women) Regulations (in Chapter 2).
7 WYAS, Acc no. 1187, Tancred Papers Box 6: Lee Commission, minutes of evidence, Q. 593.
8 *Ibid.*, Q. 1801.
9 NA, HO 45/13433: women police 1928–29: letter from Rafter to A. L. Dixon, 19 June 1928.
10 NA, HO 144/17667: File on Kate Meyrick with press clippings. For London nightclubs, see J. White, *London in the Twentieth Century* (London: Penguin, 2002), pp. 333–4.
11 E. Bristow, *Vice and Vigilance: Purity Movements in Britain Since 1700* (Dublin: Gill and Macmillan, 1977).
12 BCL, Sharples (née Hoyle), 'My Life's Work', p. 24.
13 *The Times*, 19 December 1928. Social purity groups were not always encouraged by police, who were likely to label them as 'do-gooders'. For Goddard, see White, *London*, pp. 290–1.
14 M. Kohn, *Dope Girls: The Birth of the British Drug Underground* (London: Lawrence Wishart, 1992).
15 Peto, *Memoirs*, p. 27.
16 Wyles, *Woman at Scotland Yard*, p. 77.
17 Fido and Skinner, *Encylopedia*, p. 264.
18 L. A. Jackson, 'The unusual case of "Mrs Sherlock": memoir, identity and the "real" woman private detective in twentieth-century Britain', *Gender & History*, 15:1 (2003).
19 Lee Report, Appendix II.
20 HO 45/13433: letter from Sillitoe to A. L. Dixon, 26 June 1928.
21 Lee Report, s. 253.
22 For the unstable sexual and gender identities of policemen involved in plain-clothes observations on 'cottaging' (homosexual activity in public lavatories), see F. Mort, 'Mapping sexual London: the Wolfenden Committee on Sexual Offences and Prostitution 1954–57', *New Formations*, 37 (1999), and M. Houlbrook, 'The private world of public urinals: London 1918–57', *London Journal*, 25 (2000).
23 J. Henry, *What Price Crime?* (London: Hutchinson, 1945), pp. 71–2.
24 *Ibid.* It is likely that Henry was referring to Woman Detective Sergeant Amy Ettridge (see note 99).
25 For the use of cross-class dressing by social investigators to 'observe' the urban poor from close quarters, see S. Koven, *Slumming: Sexual and Social Politics in Victorian London* (Princeton: Princeton University Press, 2004).

26 Beveridge, *Inside the CID*, p. 39.
27 Condor, *Woman on the Beat*, p. 19.
28 P. Bourdieu, *Distinctions: A Social Critique of the Judgment of Taste* (London: Routledge, 1984)
29 Butler, *Gender Trouble*.
30 Young, *Inside Job*, p. 83. Young uses the anthropological framework provided by M. Douglas, *Purity and Danger* (London: Routledge, 1966), to consider the metaphorical association of physical dirt with social contamination.
31 *Star*, 3 June 1947.
32 MacInnes, *Mr Love and Justice* (London: MacGibbon & Kee, 1960), p. 58.
33 Young, *Inside Job*, p. 319
34 D. Hobbs, *Doing the Business: Entrepreneurship, the Working Class and Detectives in the East End of London* (Oxford: Oxford University Press, 1988), p. 207.
35 *Tit-Bits*, 31 August 1940.
36 Kuhn, *Women's Pictures*, p. 6.
37 *Tit-Bits*, 31 August 1940.
38 J. Riviere, 'Womanliness as a masquerade', *International Journal of Psychoanalyis*, 10 (1929).
39 L. Pykett, *The Improper Feminine: The Women's Sensation Novel and the New Woman Writing* (London: Routledge, 1992), p. 90.
40 Kingsley Kent, *Making Peace*.
41 *Pearson's Weekly*, 25 October 1919.
42 *Liverpool Weekly Post*, 13 April 1929.
43 *Sunday Dispatch*, 9 December 1928.
44 Fijnaut and Marx, 'The normalization of undercover policing', pp. 7–10.
45 *Daily Mail*, 25 September 1936.
46 V. Berridge, *Opium and the People: Opiate Use and Drug Control Policy in Nineteenth and Early Twentieth-Century England* (London: Allen Lane, 1981).
47 *Daily Herald*, 28 December 1951: 'Two women detectives have been spending the past few weeks posing as customers at Soho public-houses frequented by coloured men.'
48 Bristow, *Central 822*, p. 49.
49 Fortune-telling and spiritualism were outlawed in England and Wales under the Witchcraft Statute of 1736, which made punishable the use of arts and powers to 'delude' and 'defraud' 'ignorant persons'. This act was repealed in 1951. See O. Davies, *Witchcraft, Magic and Culture 1736–1951* (Manchester: Manchester University Press, 1999). It continued to be outlawed in Northern Ireland under the Vagrancy Acts.
50 *Ibid.*, p. 268.
51 MPM, Women Police AR 1934.
52 Lee Report, pp. 40–42.
53 *Ibid.*, s. 115.
54 GMPM, Walkden Papers, Report on the First Provincial Policewomen's Conference, 5–6 March 1937.
55 MPM, Women Police ARs.
56 Interview with Jean Law and Pauline Wren.
57 WPT, Laura.
58 WPT, Irene.
59 WPT, June.

60 BCL, Sharples (née Hoyle), 'My Life's Work'.
61 MPM, Lovell, 'The Call Stick', p. 10.
62 *Ibid*, p. 11.
63 *Ibid.*, p. 12.
64 Stacey, *Star Gazing*.
65 Condor, *Woman on the Beat*, p. 19.
66 Lock, *Lady Policeman*, p. 96.
67 *Ibid*, p. 95.
68 J. Slipper, *Slipper of the Yard* (London: Sidgwick and Jackson, 1981), p. 51.
69 Lock, *Lady Policeman*, p 98. She also wrote of 'the feeling of being trapped inside the identity of a "police officer" so that anything I did reflected not on me but on "the job"' (p. 173).
70 *Ibid.*, p. 102.
71 WPT, Violet.
72 White, *London*, p. 288.
73 WPT, Joan.
74 WPT, Jill.
75 WPT, Joy.
76 WPT, Joan.
77 *Ibid.*
78 WPT, Jill.
79 D. Hebdige, *Subculture: The Meaning of Style* (London: Methuen, 1979).
80 WPT, Elaine.
81 *Ibid.*
82 WPT, Katherine.
83 See White, *London*, pp. 285–307, for the argument that corruption was endemic within the Met. See E. W. Clay (ed.), *The Leeds Police 1836–1974* (Leeds: Leeds City Police, 1974), p.102, for serious allegations of corruption relating to the Vice Squad in Leeds in 1954; resultant measures to decentralise the CID were introduced in 1955.
84 On the opportunities created by bombing, the blackout and rationing, see D. Thomas, *Underworld at War: Spivs, Deserters, Racketeers and Civilians in the Second World War* (London: John Murray, 2003). Evidence suggests that Lilian Wyles lied to protect her male colleagues during the Savidge Enquiry (regarding the treatment of female witnesses); see Lock, *British Policewoman*, pp. 157–72. While Wyles was at times deceitful, it would be inappropriate to suggest that she was 'corrupt'.
85 *Daily Mirror*, 5 May 1943.
86 WPT, Jean.
87 Condor, *Woman on the Beat*, p. 19.
88 PSNI Museum, Women Police, Miscellaneous items from ex-W/DI Macmillan's files: statements re undercover work, December 1947.
89 WPT, Joan.
90 Fido and Skinner, *Encyclopedia*, pp. 50, 314.
91 Interview with Jean Law.
92 WPT, Ivy.
93 Bristow, *Central 822*, p. 49. This brusqueness towards the unclothed body was also apparent in the brief, undignified and, for many women, embarrassing, medical examination that was used during recruitment to the Met. Interviewees were asked to

remove their dressing gown, stand naked in front of a doctor and woman officer, and bend over to touch their toes. Bristow, suggests it was a test for haemorrhoids (p. 29).

94 Fabian, *Fabian of the Yard*, p. 67.
95 Bristow, *Central 822*, p. 13.
96 *Ibid.*, p. 16.
97 WPT, Irene.
98 *Ibid.*
99 Ettridge joined the Met CID in 1935. Arthur Thorpe, *Calling Scotland Yard* (London: Wingate, 1954), p. 69, describes an incident in which she accompanied a male detective constable on plain-clothes observations in a pub. Fabian, *Fabian of the Yard*, p. 66, mentions Ettridge in the context of a kidnapping investigation. In 1938 she was commended in a case of abortion, and in 1949 she became the senior CID woman in the force, on the retirement of Lilian Wyles.
100 It was not until 1962 that Glasgow's policewomen were referred to as 'detective constables' rather than 'aides'. See Livingstone, 'Glasgow policewomen'.
101 WPT, Laura.
102 WPT, Kathleen.
103 WPT, May.
104 MPM, Women Police AR 1965.
105 WPT, Maureen.
106 Bristow, *Central 822*, p. 64.
107 WPT, Vera.
108 WPT, Jennifer.
109 WPT, Elaine.
110 See also WPT, Kathleen.
111 WPT, Elaine.
112 WPT, May.
113 WPT, Elaine.
114 WPT, Irene.
115 *Ibid.*

6

Policing the family: youth and welfare

IN 1950 JUVENILE COURT MAGISTRATE Basil Henriques described the Met's women police as 'kindly' and 'noble' as they 'befriended' neglected children and adolescent girls 'in moral danger'.[1] A great deal of their work, he suggested, involved advice and referral rather than recourse to the law. Women police were often described as performing a 'welfare' or 'social' role explained in terms of a 'preventive' function: the rescue of young people who might become either offenders or victims if left untreated (Figure 8). Such a role was considered 'women's work' and their involvement was accepted because it could be positioned as 'soft' policing as opposed to the 'hard' or macho policing of thief-taking.[2] Yet the retention of a police identity was also important if women's work was to be justified as distinct from that of, firstly, welfare workers in the voluntary sector and, secondly, a growing body of local authority social workers and probation officers. As a result of their role as law enforcement officers, policewomen had authority to arrest parents who were suspected of committing acts of cruelty and to remove child victims to 'a place of safety' without a warrant. Yet the relationship between the law enforcement function (the judicial) and the welfare function of their work (which referred to a social/educative framework) was also a source of debate as Policewomen's Departments expanded and women developed relationships with other child-care professionals (in both state and voluntary sectors). It was a relationship that was at times seen as complementary and at other moments was identified as a point of dispute. To a large degree the activities of Policewomen's Departments were sustained by the hegemony of what David Garland has called a culture of 'penal welfarism': a belief in the ability of treatment and rehabilitation to reduce crime and restore social order. This belief formed the basis for a whole set of normative and regulatory practices that bound 'care' and 'control' firmly together.[3]

POLICING THE FAMILY: YOUTH AND WELFARE

Figure 8 Manchester City Police, c. 1950. Publicity photographs highlighted policewomen's work with children

This chapter will argue that policewomen in many parts of the UK played a central role at the frontline of child protection and family surveillance in the mid-twentieth century. This role, carved out in relation to the Children and Young Persons Acts of 1933 (England and Wales), 1937 (Scotland) and 1950 (Northern Ireland), was not usurped by local welfare authorities until the late 1960s, a result of both new legislation and an

erosion of trust between police and social workers. The creation of a police identity in relation to child welfare and the negotiation of a working relationship with other professionals will be my first point of focus. While 'penal welfarism' may be seen as a dominant frame of reference, tensions between interest groups involved in its field of operation can be charted across the twentieth century. I shall consider policewomen's individual negotiation of the care/control nexus by examining their personal experiences of involvement in welfare intervention. There was considerable space for the exercise of discretion while working within legislatory frameworks. The distinctions associated with categories of class, ethnicity, status and gender informed interventions, although original perceptions were sometimes challenged: both on a day-to-day basis and as a result of reassessment over time. For some women, the process of 'looking back' – in the wake of the 'rediscovery' of child sexual abuse – has led to moments of reflection, recollection and personal insight that challenge an idealistic faith in a previous 'golden age' of both policing and welfarism.

Legislative frameworks

The notion that deprived children could easily become depraved children – which informed child welfare legislation in the first half of the twentieth century – created a significant space within the 'social' sphere that policewomen developed as their own.[4] Since 1889, a police officer could remove a child from its home to 'a place of safety' (in the first instance, a police station) if acts of cruelty had been committed, without the need for a magistrate's warrant.[5] The 'beyond control' clause, also introduced in 1889, entitled parents to seek assistance from the courts if they felt they could no longer cope with their children. The 1908 Children's Act, which applied to the whole of the UK, added 'neglect' – the lack of 'adequate food, clothing, medical aid or lodging' – to the initial category of cruelty.[6] Juvenile courts (special sittings of magistrates) were created to deal with both child offenders and those 'in need of care protection': children found begging, wandering or destitute, those with 'unfit' parents who had 'criminal or drunken habits', and those who were frequenting the company of thieves or prostitutes. It was possible for both child offenders and those rescued from dangerous surroundings to be committed to industrial schools, where they would be disciplined and trained. As Harry Hendrick has persuasively argued, a dualistic blurring of children's status – so that they were seen at the same time as *both* victims *and* threats – underscored the 1908 Act as well as subsequent

legislation.[7] Children of 'unfit parents' were increasingly positioned as a specific social/educative target; a 'tutelary complex', which sought to train and rehabilitate, was built around the deprived or neglected child.[8]

Civil proceedings for 'care or protection' as well as criminal proceedings for cruelty/neglect could be brought before the juvenile courts by three separate bodies: the police; local authorities; and the National Society for the Prevention of Cruelty to Children (NSPCC) or Royal Scottish Society for the Prevention of Cruelty to Children.[9] The precise relationship between these three bodies with regard to investigation, prosecution and the initiation of civil proceedings was worked out locally. In the early part of the century it is likely that the police were more than happy to hand cases over to the NSPCC, particularly those that involved the sexual assault of children.[10] When women first became involved in policing they were associated with statement-taking from child and adolescent victims of sexual assault. In 1907 Eilladh Macdougall was appointed as a lady assistant by the Met, to take statements and to run a refuge in Lambeth, which acted as a pre-trial 'safe-house' for witnesses.[11] Her appointment meant the CID, who need not engage in the embarrassing task of questioning adolescent girls, could concentrate on investigation and prosecution, claiming these cases back from the NSPCC. In Glasgow, Emily Miller performed a similar function from 1917 onwards. Dundee's pioneer policewoman, Jean Forsyth Wright, began to expand her remit beyond statement-taking, commenting in 1920 that, 'in cases of child neglect, as anything of that kind, I like to be present, because I know so many of the women [mothers] and do a great deal of work in conjunction with the officer of the Prevention of Cruelty to Children'.[12]

The Children and Young Persons Acts of 1933, 1937 and 1950 did not make the appointment of attested policewomen compulsory.[13] However, the legislation could be interpreted in such a way as to assure a specialist role for women officers. Most significantly, all children who were 'detained, being conveyed or waiting' at a police station were to be placed under the care of a woman (whether a matron or policewoman). Once again the legislation accorded police officers a vital role because of their powers of arrest and ability to remove a child or young person to a place of safety in emergency cases.[14] It also vastly expanded the range of child protection cases that could be dealt with through legal proceedings, creating a significant body of work that could be claimed by women police with relative ease. There were clear differences across the regions. In Scotland, juvenile courts had not been fully constituted as they had elsewhere.[15] Prosecutions of juvenile offenders or of adults for neglect and cruelty were handled by the Procurator Fiscal, while the police prosecuted

their own cases in England, Wales and Northern Ireland.[16] Nevertheless, the wording of all three acts was very similar, further broadening the categories of children who could be deemed 'in need of care or protection' to include those with an 'unfit parent or guardian' who were 'falling into bad associations, or exposed to moral danger or beyond control'.

The clause regarding 'moral danger' was targeted specifically at adolescent girls who were deemed sexually precocious: 'you had to prove the parents weren't exercising proper care and guardianship *and* their child was in moral danger; and moral danger in those days usually meant illegal sex, that the girl was sleeping around'.[17] In many forces, girls under the age of consent who were found in the company of an older man would be taken for a medical examination to ascertain whether they were *virgo intacto*.[18] The gender specificity of this clause clearly required the services of female rather than male officers. Practical concerns about under-age pregnancy, venereal disease and possible involvement in prostitution were accompanied by normative judgements about female sexuality and moral status. Sexual danger was associated with specific places – young women were not supposed to roam the streets, to stay out all night, or to visit cafés of ill repute – and policewomen's regulation of space/place through beat patrol involved restoring those who were out of place to a 'proper' private sphere. Both wars saw increased anxieties about the number of 'amateur' prostitutes attracted to military camps, railway stations and other public places to meet soldiers. During the Second World War it was argued that these 'amateurs' were largely girls under the age of consent: those in the 13–15 age category.[19] Regular patrols of the areas in which they congregated aimed to disperse young women and send them home as a preventive measure. Emma Jane Ball of Manchester City Police labelled them as 'naughty' and 'foolish' rather than 'fallen', rejecting older social purity frameworks.[20] Nevertheless, as Pamela Cox has argued, protective legislation tended to construct children and adolescents 'as objects of social action rather than as subjects with choices'.[21] 'Precocious' girls were, ultimately, denied sexual agency: they were to be protected against themselves and prevented from corrupting others. In 1951 a researcher for the Social Biology Council voiced concerns that the juvenile courts were 'being used with an excess of zeal to deal with mature, well-developed girls of 16 who stayed out all night with their boyfriends'.[22] In some cases this might mean that girls who had experience of under-age sexual intercourse were removed from their homes and sent to 'specialist' approved schools or, if their precocity was interpreted in terms of 'mental deficiency' to other types of institution.[23] This was increasingly replaced with other forms of supervision, advice and

warning. Nevertheless, the regulation of adolescent sexuality remained a key element both within the legislation and within the workload of policewomen. The sexual propriety and reputation of women officers was meticulously monitored within Policewomen's Departments and these behavioural frameworks also informed their 'welfare' work with others: women and girls were judged in terms of personal responsibility and respectability.

Overall, the legislation of 1933, 1937 and 1950 strengthened the powers of law enforcement officers, local authorities, and the NSPCC to 'police' the family, expanding the locus of social intervention. Jacques Donzelot has used the term 'policing' to refer not to a specific bureaucratic institution (the police service) but to the wide mesh of regulatory practices in the modern liberal State, which aimed to ensure 'that all things contribute to the welfare of the members that compose it', and which aimed to 'civilise' by inculcating values that were ultimately bourgeois in derivation.[24] Social workers, probation officers, educationalists, psychologists, health visitors and medical experts can all be positioned within this regulatory system in which 'welfare' is ultimately dependent on the power of the law: 'there is an initial model, the judicial one, of which all the others are only enveloping copies'.[25] Children or adolescents who were brought before the courts as 'in need of care or protection' could be committed to an approved school (the term 'training home' was used in Northern Ireland), to the care of a 'fit person' (a 'fit person order') or made the subject of a supervision order (involving a probation officer); the child's parent could also be made the subject of a recognizance, binding her or him to 'exercise proper care and guardianship'. Donzelot had a great deal to say about the involvement of social workers in the 'policing of families' through the juvenile courts, but he did not discuss the involvement of police officers in social work. In the UK it was often claimed that women police were in closer contact with children 'in danger' than other professionals: 'unlike any other social worker, they are out in uniform, at all hours of the day and night and they can therefore find the boys and girls in the danger spots. They too are often the first people able to get into some of the terrible homes in which children are living'.[26] My aim, here, is to uncover policewomen's daily work roles at the frontline, to shed light on their encounters and experiences and to discuss the assumptions that informed their interventions.[27]

Working with the law

The twentieth century can be characterised in terms of a 'mixed economy of welfare': voluntary bodies have continued to operate as significant wel-

fare providers although they have been joined by an expansion of state-funded provision. In the first half of the twentieth century the voluntary sector itself underwent processes of professionalisation, as it increasingly employed paid and highly trained experts rather than relying on the bounty of unpaid 'amateurs'.[28] As policewomen moved into child rescue in the 1920s, they developed collaborative working relationships with voluntary providers, but they were also involved in the delineation of a distinct sphere for women police. At the Met, Lilian Wyles, who was employed as part of the CID to take statements from women and children, had to carve out a role that differed from that of Eilladh Macdougall, whose background lay in moral rescue work and who insisted on seeing herself as a civil servant employed by the police in a welfare capacity rather than as a policewoman. Wyles was clear that 'welfare work is an integral part of all police work but only up to a certain point'.[29] It was police work to identify those in danger, but the strategy should then be one of referral (not welfare provision itself). Those who had been rescued from dangerous surroundings were to be taken to 'places of safety' run by religious organisations (such as the Salvation Army, Jewish, Catholic or Anglican societies) while legal proceedings were pending. Child victims of sexual assault might be referred to moral welfare workers for rehabilitation if their parents were in agreement. Elements within a masculine police culture were sometimes critical of moral welfare workers; Wyles had to remind her CID bosses that they were not 'female busy bodies' but trained women who worked closely with the local authority.[30] Despite Wyles's conviction concerning the difference between 'police' and 'welfare' work, the line was by no means clear-cut and the distinction between the two areas was a constant point of negotiation.

Given that both policing and welfare responsibilities were devolved to local authorities and individual police forces by central government, there was inevitably considerable variation in the way that the Children and Young Persons Acts were interpreted within the regions of the UK. With the introduction of the 1933 Act, the head of the Met's Women Police, Dorothy Peto, met with senior male officers, the Home Office and the London County Council's (LCC) Education Department, to argue for the development of a specialist child protection role for women police. It was agreed that in 'urgent' cases requiring some form of judicial action, legal proceedings would be undertaken by the Met rather than the LCC. Police officers were to inform the local authority and the probation service – who were responsible for preparing reports on the child's background – of the dates of the initial hearing. Although the later Children's

Act of 1948 introduced specially constituted local authority Children's Departments, each run by a Children's Officer to whom all police interventions must be reported, the Met continued to play a primary role in child protection proceedings. From 1934 until 1973, its Women Police Branch kept centralised indexes, which detailed missing girls and children who had come to attention; by 1950 there was also a central index of 'problem families'.[31] A brief 'social study' course was introduced for women police in 1930, featuring lectures by the LCC psychologist Cyril Burt (author of *The Young Delinquent*) and Miss Rosalind Chambers (tutor in social studies at the London School of Economics) as well as representatives of the Charity Organisation Society and the British Social Hygiene Council. This was quickly extended into a three-week training programme with exams at the end (on top of the basic training shared with male recruits).[32] The Met's women were encouraged to develop a professional expertise that was of equivalence to that of the new practitioners of probation and social work; the domain of child welfare was established as a key component of their remit.

When Marion Macmillan arrived in Belfast in 1943 to head the RUC Women Police Branch, she brought a working knowledge of English child welfare legislation acquired as a result of working under Peto at the Met. She adapted this to suit Northern Ireland, where the 1908 Act was still in place. A deputation to the Northern Ireland Minister for Home Affairs – involving the Belfast Council of Social Welfare and the Church of Ireland Moral Welfare League – had already argued that women officers could 'do extremely good work in connection with juvenile delinquency' and Macmillan was keen to develop this role.[33] In 1948, she prepared a detailed report on the causes of delinquency in Belfast, which was forwarded by the RUC to the committee appointed by the Northern Ireland Parliament to consider the introduction of new legislation on child welfare and the young offender. Her own report (unacknowledged) appeared in an abridged form as Appendices II and III of the committee's final report, which recommended the introduction of a similar body of measures to those in operation in Great Britain, although it warned against the 'slavish adoption' of the English system.[34] The Children and Young Persons Act (Northern Ireland) 1950 duplicated almost word for word the definitions of neglect, cruelty, and children 'in need of care or protection' contained in the Acts of 1933 and 1937. 'Welfare Authorities', set up to replace Poor Law Boards of Guardians, were given similar responsibilities to Children's Departments in England and Wales. RUC women worked closely with the NSPCC in the investigation of cases, passing on information to the 'Welfare' in relation to court hearings. The only major point of departure

from the 1933 Act was the raising of the age of consent in Northern Ireland from 16 to 17 years of age for females, as part of an extended attempt both to protect and to regulate the sexuality of young women.

As policewomen from different forces met to discuss methods and practices at their district conferences in 1947, discrepancies were exposed. At the Home Office, Barbara Denis de Vitré was anxious not to oppose local autonomy but she desired some form of standardisation. She encouraged all policewomen to set up indexes in their forces – similar to the Met – and to distribute information about missing women, children and adolescents to other Policewomen's Departments. The implementation of child protection legislation was an important topic for conference discussion. It was alleged, for example, that a probation officer in Durham had illegally brought a case involving 'a girl who was in moral danger' before the juvenile court as 'in need of care or protection'. Durham's Woman Inspector told the conference that she had instructed her women to deal with these cases in the future since it was they who were empowered to do so under the 1933 Act.[35]

Conferences also included discussions about the role of the NSPCC. There were two issues: the use of civil 'care or protection' proceedings in the juvenile courts and the prosecution of adults for criminal offences. When the small group of 36 provincial policewomen had first met together in 1937, they had been advised that cases of neglect or cruelty should be handed over to the NSPCC, who might initiate prosecutions.[36] In the postwar period women officers began to take more initiative, although regional differences remained. In January 1948 Inspector Lilian Dawes of the Met chaired a conference of representatives from central/southern forces:

> Miss Dawes felt that, in some forces, action in cases of cruelty to children was initiated by the police, while in others it was a noticeable feature that prosecutions were launched by the NSPCC. She suggested that when the police knew of acts of cruelty, it was best if they carried them forward to prosecution.
>
> The meeting agreed with this view and felt strongly that where criminal offences of the nature of carnal knowledge, incest, cruelty, and the like, were disclosed, the police should be brought in at once and appropriate statements taken and enquiries made. There was the danger that other organisations might, by initial action, do harm to the subsequent criminal prosecution, although reasonable collaboration was essential.[37]

Delegates expressed their strong feeling 'that it was a prime duty of policewomen, by vigilance, to prevent cruelty to children, and to take

every opportunity of preventing children becoming tainted by crime'.[38] At the Midlands District Conference Norah Gray, head of Birmingham's policewomen, asserted that, 'where a policewoman comes across evidence of criminal neglect or cruelty she should make fullest enquiries and reports with a view to police proceedings being instituted'.[39] Superintendent Bather of the Met made similar comments to the Southeast District Conference.[40] During the 1950s, prosecutions for neglect and cruelty tended to be shared between the police and the NSPCC, although there was still considerable regional variation. In the Met they were brought by either party[41] while in Kent, between 1946 and 1954 policewomen tended to pass neglect cases over to the local NSPCC inspector, with whom they liaised closely.[42] The police increasingly took responsibility for criminal prosecutions for sexual offences (indecent assault and unlawful carnal knowledge).

As their numbers expanded in the aftermath of the Second World War, policewomen were being given a strong steer to make child welfare proceedings – and the enforcement of the Children and Young Persons Acts – a central component of their work. This was also true of civil proceedings. In the 1920s, as Pamela Cox has shown, 'care or protection' cases tended to be pursued by local authority education departments or other bodies such as the NSPCC.[43] By 1950, women officers in the majority of the UK's towns and cities played a key role at the frontline of child welfare enquiries (although this side of work was far less significant in rural areas). Rather than handing over 'care or protection' proceedings to other agencies, women officers were expected to investigate those that came to their attention. In 1950, Henriques commented that the Met's women police tended to bring the majority of cases for 'falling into bad associations, or exposed to moral danger or beyond control' to the East End Juvenile Court; very few were brought by the NSPCC and almost none by the local authority.[44] The number of 'care or protection proceedings' brought by the Metropolitan Women Police Branch expanded from 62 in 1937, to 285 in 1949, and to 360 in 1950.[45] By 1960, Manchester's Women Police were dealing with more than a third of all care or protection cases in the city.[46]

Yet legal proceedings were not pursued in the majority of cases involving children or young persons that came to police attention. In 1950, Elizabeth Bather argued that 'much of the work of women police' simply could not be quantified: 'hundreds of cases of children and young persons were during the year helped and advised or referred'.[47] Most work involved the logging of information about children, adolescents and 'problem families', repeated visits, advice or warnings, and referral to

other social welfare bodies. Care or protection proceedings were increasingly unlikely in situations where girls approaching 16 were involved in sexual relationships with partners of a similar age.[48] Pregnant girls were given information about maternity provision and adolescent lovers were lectured on the dangers of under-age sex.[49] Women's work in 'policing' was largely invisible in terms of the courts.

In relation to child neglect, women officers followed the practice adopted by the NSPCC of distinguishing between the 'emergency case' requiring direct intervention or prosecution, and the more minor case, where advice could be offered and a warning administered.[50] Ivy served in Essex in the early 1950s:

> I had to go in one house one day and on the fire there was a saucepan, and in it there was a nappy being boiled, the same saucepan the woman used to cook the food in. There were five children, and the husband was unemployed and he didn't believe in work: no money and the place was filthy. We took the children away and, as we took the little girl away, the lice were walking up my sleeve as we went away in the car ... We had another one where the wife had left and the husband was looking after the kids and he hadn't got a clue. And actually I felt sorry for him and I didn't take the kids away ... I told him his fortune and I said, 'I'm coming back in a fortnight.' When I went back in a fortnight the house was clean from top to bottom; he'd painted it if it didn't move; everything was fine and I used to go back once a fortnight and check up on him and we got him through ... What would have been the point of putting five children into a home? If you could deal with it and get it on an even keel, then you did.[51]

Ivy was the initial point of contact and was able to exercise considerable discretion, making snap decisions that were based on her assessment of overall welfare. Recourse to the judicial was rarely chosen as a first resort, although it might be used as a threat.

In Britain and Northern Ireland policewomen built up close working relationships with the NSPCC, who were often instrumental in finding 'a place of safety'. Where home conditions did not warrant removal, RUC women would keep an eye on the family as well as reporting concerns to 'the Welfare': 'we would have called frequently then ... or I'd have done the beat in that area just to see what was happening'.[52] Only in a small number of areas, most noticeably in Leeds, was the NSPCC viewed unfavourably by women who served in the 1950s and early 1960s, according to oral history accounts.[53] While there was considerable overlap with police in terms of their work, this was not experienced as competitive, because of similarities in terms of a disciplinary culture and ethos: 'the

old-style NSPCC officers were very welcome because they were action men, they did things'.[54] NSPCC inspectors were similarly uniformed and in some cases were former policemen. The 'Cruelty', as the Society was popularly known, was viewed with considerable awe and fear in working-class communities, where their role was associated with law enforcement. The NSPCC continually stressed that it was not a prosecuting society and that the majority of its work was preventative. Policewomen, similarly, argued that cases were only prosecuted where absolutely necessary as part of their protective function. The NSPCC and women police shared a preference for 'care or protections' proceedings – which effected the removal or supervision of a child – over the criminal prosecution of parents.[55] Both parties viewed legal action – and the frameworks provided by the juvenile courts – as fundamentally useful in the business of child protection: the relationship between 'welfare' and the judicial was handled in similar ways.

Tensions occasionally surfaced between policewomen and probation officers in the 1950s and early 1960s in relation to court proceedings. In the Met a series of disputes emerged concerning the disclosure of children's statements, which were taken in advance for 'care or protection' proceedings and handed by the policewoman to the magistrate. Probation officers were allowed to read the statement in order to prepare their reports but not to retain a copy. The police argued that statements were *sub judice*, since they could lead to criminal proceedings against parents. Probation officers clearly felt, on the other hand, that the police were being obstructive by prioritizing legal frameworks over child welfare.[56] There was, however, occupational movement from the police to the probation service that guaranteed shared frameworks in some areas of the country.[57] The policewomen of Birmingham reported in 1948 that they were 'quite friendly with probation officers but the work of the two departments was never allowed to overlap', while in Dudley policewomen and probation officers often paid joint visits to girls who had come to police attention.[58]

Police criticisms of local authorities were more likely to be practical and procedural rather than ethical. Policewomen who served in the 1950s felt that Children's Departments, which worked on the basis of a nine-to-five office day, were unable to fulfil their responsibilities – such as arranging a place of safety for a child – at key times, such as weekends and evenings.[59] For the most part, however, a relationship of trust quickly emerged between the new Children's Departments and the women police: 'We had a lovely man in charge of the Children's Department in Leeds at that time ... who would help, or you could talk to him and

discuss things . . . it was great.'[60] RUC policewomen were involved in the establishment of a similar dynamic in Northern Ireland, where arrangements were made for out-of-hours communication: 'I've seen me ringing my counterpart in Welfare or in the NSPCC at three o'clock in the morning and there was never any fuss about it because we had that sort of relationship.'[61] The liaison that developed in the inter-war period was to a large degree dependent on individual initiative and personality – which worked where common ground was agreed locally – rather than on formal procedural frameworks.

In England and Wales, the 1963 Children and Young Persons Act legislated for more systematic communication, making it compulsory for police officers to consult child care officers before they began care or protection proceedings. The 1948 Act had made Children's Departments responsible for children committed to their care by order. The 1963 Act now added a duty to undertake social work while a child was still at home in order to prevent family breakdown. The new Act was welcomed by policewomen as they assembled for district conferences: 'it was felt generally that it was a good act, giving a wide scope to the police'.[62] The police were incorporated into regular monthly meetings with Children's Departments and other voluntary agencies to discuss 'problem families' that had come to notice, while consultation did not rule out subsequent police action.[63] Police sources suggest the Act was experienced as a mutual recognition of the symbiotic relationship between police and other welfare agencies. Regional policewomen's conferences in 1964 reported continued 'excellent co-operation' with Children's Departments.[64] The Children and Young Persons (Northern Ireland) Act of 1968 introduced a similar duty to consult with the welfare authority, which was broadly welcomed by the Inspector General as an opportunity to benefit from 'the advice and guidance of skilled and professionally trained social workers'.[65]

Women as experts

Women in a significant number of forces felt they had considerable expertise over and above supervising male officers.[66] This sense of professionalism in child welfare work was the product of the acquisition of knowledge through training ('specialist' courses) as well as continual practical experience ('on the job'). The professional identity was also a result of the policewoman's discretionary role, which required the ability to make informed decisions as to whether situations were life-threatening. Finally, it was a result of close liaison with a range of other bodies who were involved in similar processes of acquiring professional status. In this

section I shall profile the work of Marion Macmillan and Nellie Bohanna, who – as heads of large Women Police Departments – developed positions as regional experts in juvenile delinquency. I shall then consider the ways in which women constables – those who were involved in the everyday practice of child protection – negotiated the welfare/justice framework, balancing the 'expert' knowledge acquired as a result of training with their own personal experiences.

Marion Macmillan's 1948 report on the causes of juvenile delinquency in Belfast was influenced by Burt's *The Young Delinquent*, first published in 1925, which had argued that juvenile offending was caused by a multiplicity of factors rather than originating in either hereditary defects or the 'unnatural' environment of city slums. The significance of Burt's findings – based on a scientifically presented examination of 100 sample cases – lay in his conclusion that delinquency could be treated through a holistic social-educative approach uniting all those involved in child welfare. Macmillan's analysis of the cases of 163 juveniles – while extremely brief in comparison – was grounded in a simplified version of Burt's methodology. Like Burt, she categorised cases in terms of home conditions, parental history, medical and psychological health, educational attainment and histories of drunkenness or immorality in the family. She identified 'lack of parental control' as a causal factor in 40 per cent of cases, while home conditions were defined as 'bad' in a third of all cases. Poverty itself was not singled out as an issue (and, indeed, it is unclear whether the unemployment of fathers identified in 8 per cent of cases was presented as an economic or a moral issue). Similarly low mentality (8 per cent of cases) and physical or mental defects in parents (13 per cent of cases) were seen as contributory but not dominant factors. Macmillan did not connect delinquency to sectarianism or religious belief, and none of the 163 juveniles was linked to political crime (although 3 were identified as coming from families with IRA connections).[67] Macmillan followed Burt in concluding that delinquency was 'more a social problem than one in which the police can normally deal'. The solution lay in an extensive programme of social work provision, for which highly trained probation officers were needed. Quoting directly from *The Young Delinquent*, she argued that 'mere surveillance is not probation: probation is an intimate and active relation, which deals with all the factors of the child's life'.[68] The argument that this was not 'normally' the terrain of the police is interesting. It indicates that juvenile offending could not be solved by arrest, prosecution or caution, but it is suggestive of the possibility that police work, too, could accommodate an element of the 'befriending' that was constitutive of the welfare approach.

In Northern Ireland a probation service had only been introduced at the end of the Second World War and Macmillan was critical of its inadequacies. Although the 1950 Children and Young Persons Act introduced supervision orders for juveniles, there were still only 18 probation officers in the whole of Northern Ireland in 1959.[69] David Fowler has argued that policies and approaches regarding young offending were developed not within government but within the RUC and, in particular, within the Women Police Branch, which promoted the introduction of cautioning schemes in the 1960s.[70] Marion Macmillan's role in the regulation of delinquency and child welfare was recognised by Queen's University, Belfast, which employed her to lecture to social science students from 1948 onwards. University dean Professor George Seth described her as 'one of the most indefatigable social workers in the Province' when she was awarded an honorary Master's degree in 1964.[71] There were clearly differences of opinion between the Women Police Branch and welfare authorities, but it is clear that 'policing' and 'welfare' were not seen as discrete activities in the minds of Macmillan and her successors.[72]

In Northern Ireland, as in the rest of the UK, the incidence of actual offending by girls was significantly lower than for boys. Of a total of 356 juveniles who appeared before the Belfast courts in 1947, only six per cent were females, although the kind of offences in which they were engaged – mainly larceny or breaking and entering – were not distinctly different from that of juvenile boys.[73] Cox has similarly found that girls formed approximately five per cent of all cases coming before the juvenile courts in Britain in the period 1910 to 1950.[74] While Macmillan retained her interest in all forms of juvenile crime as a prosecuting officer in the juvenile court from 1956 onwards, most policewomen, both in the RUC and other forces, tended to work with comparatively small numbers of girl offenders and to concentrate instead on preventative measures with those who were potentially delinquent. Concerns focused on the sexually precocious adolescent who was in danger of falling into prostitution or single motherhood and would, ultimately, become an irresponsible parent and a breeder of future delinquency.

Nellie Bohanna, head of Manchester's Women Police Department from 1949 to 1968, was also employed to lecture on university social work courses from 1955 and, like Macmillan, developed a particular interest in young offending, which she closely linked to preventative work with 'problem families'.[75] In 1948, as a woman sergeant, she had attended the 'A' course for senior officers at Ryton and had chosen to write a detailed essay, based on secondary research, entitled 'Psychology in the service of the court'. Her essay, like Macmillan's report, shows the influence of Burt:

'What lies behind the unhappy and restless figure of the problem child? There stretches a miserable panorama of, perhaps, illegitimacy, disunited parents, an overcrowded home, defective physical or psychological heredity, lack of parental affection during childhood, imperfect education and lack of knowledge as to how to use leisure hours, and material or spiritual poverty.'[76] In her essay Bohanna combined frameworks of analysis, producing a panoply of causes and solutions (including psychoanalysis), in contrast to Macmillan's disciplined focus on the 'social'. The late Victorian concept of a 'residuum' – a 'vicious' and 'criminal' underclass that weakened the social order – had been recast in eugenics terms as a 'social problem group' during the 1930s. The postwar formulation of the 'problem family' tended to downplay hereditary factors, yet a causal link between deprivation and depravation was established through what was essentially a class stereotype.[77] Bohanna continued to be attracted by eugenics arguments – 'the criminal classes are irresponsible in their sexual relations and prolific breeders of children of low intelligence' – although she believed in a social-educative strategy since 'good environment ... may counteract bad hereditary gifts if they are not extreme'. There are references, too, to notions of 'maternal deprivation' (non-attentive mothering) discussed in the work of Winnicott and Bowlby that was just emerging in this period. 'Psychology in the service of the court' was not simply an essay that was designed to pass an exam or to stimulate classroom discussion at training school. It was a blueprint for subsequent training talks to women police and other groups. Bohanna's essentially conservative notes for a talk on delinquency in the early 1960s refer to broken homes, separated parents and a decline in moral standards as causes. While making it clear that delinquency could occur among those with a 'high living standard' who were too tired or aloof to demonstrate an interest in their children, Bohanna repeats her phrase of 12 years earlier: 'experience shows the criminal classes prolific breeders'.[78]

Within police training – including women's 'specialist' courses – it was commonly pointed out that it was children from 'lower socioeconomic groups' who tended to appear before the juvenile court in relation to both offending and care or protection proceedings.[79] The stereotype of the 'problem family' tended to be mapped on to an inefficient underclass that was distinct from the 'respectable' working class and associated with particular residential areas. These included urban slums during the 1940s and, by the 1960s, certain new council estates: '[they were] not necessarily poor in the money coming in but poor in the fact of the bad use of money. You'd go into a council house and it would be dreadful ... and there in the middle was this huge colour

television set'.[80] Irene was serving at Brown's Square station in Belfast in 1965:

> A lot of those girls [who were interviewed for care or protection or indecent assault] would have come from very deprived homes or areas. Seldom would you have been in a home for care or protection in a really good classy area . . . Wee small houses, two up, one down, neighbours know everything and that's possibly how a lot of the things came to light.[81]

Women officers were more likely to discover cases of concern in areas that they regularly frequented and where there was little opportunity for privacy. Moira similarly referred to a highly deferential society in Northern Ireland in the 1950s and early 1960s, in which incest and neglect were hard to imagine among the well-to-do: 'We had a thing in our heads that, well you know, if this did happen, it would only happen among the very lower classes because, "Well, there's a very rough lot"'.[82] The work of women officers can be construed in class terms: as a *petite bourgeoisie* or 'respectable' working class regulating the families of the poor. Nevertheless, a level of consensus is also apparent, as neighbours and relatives reported each other when they had genuine concerns. Similarly, nationalist families sought assistance from the RUC Women Police Branch when their children had been assaulted or were missing from home. As Jennifer Davies has argued in another context, those who experienced the law as oppressive on some occasions also chose to use it as a resource when informal strategies were unsuccessful.[83] Women officers were more likely to be seen as the acceptable face of policing because of their association with child welfare work.[84]

Sexual danger was viewed in terms of racial stereotyping as well as class. Concerns were repeatedly voiced about white adolescent girls consorting with Asian seamen (the 1920s), black American GIs (Second World War), Maltese and Cypriot café owners (1940s to 1950s), Caribbean immigrants (1950s to 1960s) and immigrants from the Indian subcontinent (1960s). Descriptions of adolescent girls who were 'wanted' by Policewomen's Departments were submitted to other regional forces in the early 1960s: 'frequents low class cafes and associates with Arabs and Pakistanis'; 'good-looking and attractive, not of common appearance . . . will almost certainly earn her living by prostitution and with Pakistanis'; 'known to frequent low-class cafes and the houses of coloured men'.[85] These young women were listed as either approved-school absconders or missing from home. As Wendy Webster has demonstrated, the concept of 'miscegenation' – the mixing of 'races' through sexuality and, hence,

reproduction – had been depicted as biologically problematic in both 'expert' and popular discourse during the inter-war period and into the 1950s.[86] Sociobiological studies depicted women who had relationships with black and Asian men as 'mentally weak' or morally impaired.[87] In these quotations from the reports concerning 'wanted' females, racial identities are linked with hierarchies of class and status; particular racial identities – Caribbean and Pakistani – are associated with the criminal underclass that Bohanna had identified. This was not necessarily the stereotype for all immigrant groups: Jewish communities in the East End of London had been presented in terms of 'courtesy and co-operation' by Lilian Wyles.[88]

The experiences of policewomen, as for their male counterparts, were undoubtedly shaped by cultural perceptions of 'self' and 'other'. These were identities that were located in terms of taste and the ordering of material objects and personal possessions. The desire for cleanliness, neatness and order – a central element within both the occupational culture of policing and within the rhetoric of 'respectability' – was challenged when officers stepped into places that were chaotically untidy, smelly and caked with dirt and/or effluent. Women officers who had joined in the 1940s and 1950s spoke of the 'culture shock' that they experienced when they encountered the homes of the less fortunate:

> I remember the first place I went into, I thought, 'My God, now I know what a slum looks like.' I hadn't even started; it was a perfectly respectable home. Yes, it was a culture shock and I think the majority of girls I worked with, it was the same for them, too. You had to adjust.[89]

> I had lived in a small village in Scotland, Birmingham was the first big city that I knew, and I never knew such poverty and neglect, nothing like it in my life . . . I had never seen poor dwellings to that extent in my life. I was absolutely terrified.[90]

> It was a real eye-opener for me, coming from Blackpool, where really there were no slum houses as far as I knew. I thought, 'Golly, how can people be living like this?'[91]

> I remember lecturing, as I often used to, at the police school and I said, 'Just because your kids are sleeping in a carpeted room with a duvet over them, and you go to a house at three o'clock in the morning and find a kid sleeping with a coat over it in a urine mattress, that doesn't mean to say that child is in need of care or protection; that child is probably loved to death by mum and dad.[92]

A poor environment was insufficient in itself to warrant removal. In exercising discretion, women officers had to consider whether a child's

life was in actual danger; previous assumptions were challenged and, as a result of this process, were renegotiated. Specialist training taught women to put their legal assessment of a situation before personal reaction. Nevertheless, perceptions of the parent–child relationship – influenced by popular psychology and normative assessments of industry, idleness, mental and moral incapacity – informed the decision-making process. The evaluation of whether a parent or guardian was 'unfit' was in part a value judgement.

Former women officers tended to see the frameworks of justice and care as symbiotic. Many policewomen made reference to occasions when they had 'befriended' women and children as part of a duty of care that was, nevertheless, located within a disciplinary framework. Marion, who joined the Met in 1961, was approached by a mother who requested that her daughter, who was continually running away from home, should be dealt with under the 'beyond control' clause: '[She] came in and sat and just said, "Please go and arrest my daughter", which is what happened, and ... I heard from her until the day she died a year ago last January. She was just beyond ... she couldn't cope with her daughter any more. There were cases where you were just helping the family.'[93] Alice, who served in London during the Second World War, received requests from parents concerned about a daughter: 'we'd have a cup of tea and a chat and we'd tell her that it was better that she joined a club, not to roam the streets because it was dangerous'.[94] The policewoman's authority was requested as a prop for parental discipline and the Women Police Branch was identified as a possible resource by some parents who were allies in the development of the 'tutelary complex'.[95]

There were, however, tensions between 'care' and 'control', most obviously in the balancing of the emotional work associated with befriending and the impersonal bureaucratic approach that was associated with adherence to the letter of the law.[96] These tensions were handled in different ways, both by different women and by individual women across the span of their careers. Although some element of 'befriending' helped them to do their job – relationships were built with families and neighbourhoods through 'community' policing – they also felt that too intense a relationship compromised professionalism. Carol befriended a 14-year-old girl, reported as missing from home, whom she found in a central London squat and who was subsequently placed under a supervision order: 'She wrote to me for quite a while after, and her parents wrote to me and thanked me. I mean what happened to her eventually ... it got, you know, I shouldn't be carrying on with ... So I just didn't reply eventually, not something I wanted to continue with.'[97] Cases of child cruelty

could be particularly disturbing and the circumstances of discovery were ingrained in women's minds. Christine had been involved in the removal of a severely beaten and neglected child who had been kept in a dog kennel: 'I used to go up to the hospital and see it a few times, but I realised I was getting emotionally involved and I had to stop doing it.'[98] 'Emotional work' received little recognition within the police service and little was offered in the way of support for officers other than the camaraderie of police culture. Joyce referred to a particularly poignant neglect case: 'I needed to be counselled, but I just came home and cried my eyes out, and I had nightmares for a week. I'd wake up and see this baby in my mind's eye.'[99] Aware of the problems of emotional investment, Joan also emphasised the need for the dispassionate detachment of law enforcement: 'We were very much more detached, you know – "You've broken the law, children can't be treated in this way, this is what we'll have to do, we're sorry, but . . ." – and get on with it.'[100]

Judgements might be made in relation to sense of personal ethical responsibility as well as professional guidelines. Maureen joined Newcastle City Police in 1959:

> As a young policewoman I was always worried about when I had to remove kids or when I had to leave them. The advice I got from an older policewoman was that if you leave them and you think to yourself that you couldn't go home to your bed and sleep peacefully knowing these children were still there, then remove them. If I was happy the mother was a bit silly and she'd gone out and there was no evidence the kids were neglected . . . I would just ring up the NSPCC the next day. But if I went in and saw a little kid cowering in a corner, bruised, that would be something. I would have to say, 'No, I'm not happy'. You had to take it seriously, because it was a big responsibility to remove a child from its home.[101]

Gina found it difficult to accept this responsibility, particularly in relation to care or protection proceedings in which children might be viewed as 'in moral danger or beyond control': 'it was sometimes said that I was lazy doing them and I wasn't. It was because I actually felt we weren't always putting people in the right places.'[102] Probationary policewomen experienced moments of anxiety regarding the authority they could wield. However, for the most part, women officers serving in the 1950s and early 1960s referred to an implicit faith in disciplinary and judicial frameworks to cater for welfare needs, describing their approach as 'no nonsense' and 'no messing'.[103] Joan, who joined the Met in 1949, had to use a judo hold to stop an adolescent girl from attacking the juvenile court magistrates who had committed her to institutional care:

I just grabbed her and marched her outside. I felt sorry for the girl, she didn't want to go into an institutional home, but it was the only way to deal with her. Half that family were mentally deficient, had some kind of illness . . . Ineffectual mothers, very little money, so they come into the hands of the police. You can't enjoy what you have to do with them, but you know it's the best thing for them, really, and for the public.[104]

Despite moments of tension – between personal emotion and the rationality of legal frameworks – the penal-welfare complex was enmeshed in the work of the Women Police Branches and in the professional identities and working practices of policewomen. 'Befriending' involved the creation of a relationship with parents, children and adolescent girls that was ultimately hierarchical rather than equal, and which involved a negotiation of moral imperatives.

The erosion of trust in England and Wales

Although points of disagreement occurred, a belief in the care/control nexus was broadly shared by the police, NSPCC and Children's Departments in the 1940s and 1950s at the levels both of institutional rhetoric and daily interface. By the mid-1960s, however, cracks were detectable within its fabric. As social workers carved out their own niche as practitioners within both voluntary and local authority agencies, police involvement in 'welfare' work was increasingly labelled as amateurish and inappropriate within a progressive State. Police discretion was felt to be too influential and it was argued that child protection should be more closely co-ordinated as a local authority responsibility. Through their professional associations, social workers influenced the agendas and debates of the Ingleby Committee (1958–60), the Kilbrandon Committee (1963–64) and the Seebohm Committee (1968).[105] The reports of all three committees argued that responsibility for child welfare was shared too broadly and that preventive work should be co-ordinated by a single-family- or community-oriented agency.

In England and Wales police initiatives – such as Juvenile Liaison Schemes – also came under attack. Juvenile Liaison Schemes had been gradually introduced in British police forces in the 1950s and 1960s, following a model that had been pioneered in Liverpool in 1949, involving policemen as well as women in the business of 'welfare'. Juvenile Liaison Officers aimed to carry out preventive work by liaising with a wide variety of welfare organisations, including education authorities, headteachers, probation officers and youth club workers. The schemes included an emphasis on cautioning rather than arrest/conviction when

offences were committed.[106] In 1960, however, the Ingleby Committee argued: 'while the police Juvenile Liaison Officers did much good work, it was work which required special training and should be done by other agencies'.[107] 'Justice' and 'welfare' were increasingly seen as irreconcilable frameworks: 'criminal responsibility is focused on an allegation about some particular act isolated from the character and needs of the defendant, whereas welfare depends on a complex of personal, family and social considerations'.[108] Social workers were attempting to separate themselves from law enforcement frameworks and agencies in order to develop client-focused relationships. In Scotland, the Kilbrandon Committee was much more supportive of 'social work' by the police, praising the work of Juvenile Liaison Officers.[109] It did, however, criticise the centrality of court procedures, proposing the introduction of Child Welfare Panels to deal with offenders as well as victims (similar to the model that had been adopted in Scandinavia), a measure that was introduced as a result of the Social Work (Scotland) Act 1968. In England and Wales the 1965 government white paper *The Child, the Family and the Young Offender* endorsed the Kilbrandon proposals and suggested the setting up of 'family councils' and the replacement of juvenile courts with 'family courts' (to deal with cases that could not be resolved by family councils).

While policewomen in England and Wales had fully supported the 1963 Children and Young Persons Act, they became increasingly defensive of the importance of court procedures. Some officers expressed concern about the 'present permissive attitude to moral laxity', reasserting the need for a balance between 'punishment' and 'welfare': 'it must be acknowledged that many children need correct punishment'.[110] The importance of the police role at the 'frontline' in emergency cases was reasserted and social workers were increasingly criticised as inadequate both in number and in calibre. In October 1966, the National Conference of Senior Policewomen passed a motion in favour of the continuance both of the juvenile courts and of the treatment of young offenders in relation to the 'existing judicial framework'.[111]

Moves to separate 'care' and 'control' not only exposed existing tensions between police and case-workers but created new ones, which were increasingly politicised. Policewomen perceived their role as under threat from what they believed to be a coalition of leftist and libertarian sympathisers. Their own statements, which stressed the role of the juridical, probably antagonised other welfare workers. These positions were most clearly demonstrated in a series of rows over the diagnosis and treatment of the 'battered baby' in 1970, which are suggestive of a nadir in relationships between police, the NSPCC and other welfare agencies. The term

'battered child syndrome' was first used in 1961 by American welfare adviser Dr Henry Kempe to describe a 'clinical condition' in which a child exhibited lesions, fractures, swelling or bruising that had not adequately been explained.[112] 'Battered child syndrome' presented child abuse within a socio-medical model, and paediatricians played a key role in both discovery and diagnosis. The term gradually appeared in the UK from 1963 onwards and, in 1966, doctors were advised that all suspect cases should be referred to Children's Departments (rather than the police) for action. In 1968 the NSPCC (which increasingly positioned itself as a research/lobby group as its casework was usurped by local authorities) set up a battered child research unit. The unit published a string of articles arguing for treatment that was based on prevention (a socio-educative role) rather than punishment (the judicial), associating the syndrome with family breakdown and an inability to mother. In 1970 the Home Office sent a circular to all local authority children's officers and medical officers of health instructing them to call inter-agency meetings to discuss procedures for dealing with the syndrome. Policewomen who attended these meetings often felt alienated. Superintendent Bond of Sussex Police told the Senior Policewomen's Conference:

> Almost without exception, meetings seemed to develop into two points of view – the police on one side and everyone else on the other. The social workers' attitude was [that] 'battering parents' are not usually suffering from a definable mental illness, but from a variety of emotional conflicts and character disorders ... It was not only the role of the police that was being challenged but the role of law itself. A whole body of social work opinion is against police involvement.[113]

Policewomen, who had worked closely with NSPCC inspectors in the 1950s and early 1960s, were shocked to find the battered child research unit describing them as 'an adverse agency' that was 'more concerned with getting convictions than with social work'.[114] In Manchester it was felt that 'the word police is regarded as a "dirty word" by other agencies dealing with the problem'.[115] Only children's officers, who had the ultimate responsibility for child welfare, were identified as sympathetic to police opinion in the debate surrounding the battered child. However, policewomen soon lost these final allies.

The potential for conflict was exacerbated in England and Wales when individual welfare departments, including Children's Departments, were collapsed into one umbrella department – Social Services – in 1971. Having built up relationships with children's officers and the child care officers who worked with them, policewomen now encountered a

different group of social workers who were unsure in their new roles: 'You had somebody who had specialised in mental illness dealing with children; and it just wasn't fair, not at that time, because they were like a fish out of water.'[116] Police anxieties had also been intensified by the Children and Young Persons Act of 1969, which aimed to channel youth offending through social workers rather than the police, replacing criminal proceedings with civil care proceedings in many cases.[117] The Act had essentially phased out NSPCC work in family intervention, making Social Services the central co-ordinator of all decision-making. The new group of social workers were often characterised by police as young university graduates who were immature, inexperienced and out of their depth in their new role as linchpins in child welfare policy.[118] Their desire to keep families together was seen as a reluctance to intervene: 'sometimes we had to fight for these children'.[119]

In Northern Ireland, as in England and Wales, women officers perceived the exchange of information as one-way, involving referral by the police but little in the way of consultation in return; there were also concerns about a new generation of social workers, who were seen as too sympathetic towards parental interests.[120] During the early 1970s the 'specialist' work of women officers had partially disappeared from view in Belfast and Londonderry as women were moved on to security work, as certain nationalist enclaves became 'no-go' areas, and as police/community relations deteriorated. In other country districts specialist work continued as a central focus. 'G' Division, which covered Bangor, Newtownards and Downpatrick, was described as 'one of the few divisions in which police work can be performed in the manner prior to the year 1969'. It was reported that 'most people come to us readily. Women bring along their young daughters who appear to come reasonably willingly. Our advice is sought on erring husbands as well as wayward children.' The nine women on the division dealt with 42 cases of young people 'missing from home', 7 cases of 'unlawful carnal knowledge' (under-age sex) and 5 'care or protection' cases in 1972.[121] The breakdown of relationships between police and social workers in England and Wales was observed and commented on by practitioners in Northern Ireland, who were concerned that they should not be involved in its duplication. In 1975 the RUC Women Police Branch was involved in the introduction of a Juvenile Liaison Scheme. The scheme was welcomed by probation officers and social workers: 'this should generate a mutual awareness of our respective roles and, if expanded upon, prevent much of the uniformed criticism of social workers that has developed lately from spreading to this part of the United Kingdom'.[122]

As Terry Thomas has argued, the mid-1970s saw the 'high-point of police–social work hostility' in England and Wales in terms of public rhetoric.[123] The collapsing of separate Women Police Departments as a result of integration undoubtedly led to further antagonisms. The expertise of women officers – and the close relationships they had forged with other practitioners – was lost as they were removed from 'specialist' duties and absorbed into other sections of the service. Their indexes of 'problem families' were discontinued and lost. While some specialist initiatives – such as Juvenile Bureaux in the Met – continued to work with juvenile offenders and to carry out some elements of preventive work, expertise in relation to child abuse, cruelty and neglect was no longer prioritised as police (women's) work. Arguably, however, the deterioration in police/social work relations was already in place by 1970. The creation of a unified Social Services department, with full responsibility for child welfare (both protection and prevention), meant that Women Police Departments lost their justification for existence. Policewomen continued to argue for a continued role for judicial structures in relation to child welfare and to defend their specialist duties, but the argument had already been lost.

The spectre of abuse

Women Police Departments in Britain had already been dismantled by the time that social workers were confronted by a series of new crises concerning the physically and sexually abused child in the mid-1980s. The deaths of Jasmine Beckford (1985) and Tyra Henry (1987), as well as the Cleveland sexual abuse cases of 1987–88, led to a questioning of the methods of intervention that were used by Social Services. Issues of interagency collaboration were placed firmly on the agenda and a new Children's Act (1989) in England and Wales led to a focus on children's rights which required a social work approach that was 'justice-oriented'.[124] Both female and male police officers were involved in attempts to rebuild the police/social worker relationship; women officers with previous specialist experience often played a central role.

While child abuse is a brutal physical phenomenon that is inflicted on the body (perhaps also involving psychological harm), it is also 'culturally constructed' in the sense that different forms of abuse are highlighted at different historical moments. The labelling and definition of forms of abuse positions them in relation to specific causes, diagnoses and treatments.[125] In the early 1920s, the Met's women police were predominantly concerned with child and adolescent victims of sexual

assault; incest was acknowledged as a rarity and it was assumed that sexual danger was located outside the family.[126] The neglected child – as a product of the 'problem family' – emerged as the new focus of anxiety and social action at the end of the Second World War. In the late 1960s the 'battered baby' became a socio-medical target. While the discovery of different forms of abuse leads to the generation of new forms of intervention, it may also involve the reappraisal of past lives and actions. The need for reappraisal – and the complex web of emotional feelings this may trigger – has been most intensely felt in relation to the widespread public exposure in the 1980s and 1990s of the prevalence of child sexual abuse.

As a result of their specialist work, policewomen were aware of the impact of incest and sexual assault on children. In 1949, Lilian Wyles gave the following justification for publishing her memoirs: 'I think the stress and anguish of the mind caused to the child and young girl by assaults upon it and her should be brought before the public who have no knowledge for the most part of what is happening around them.'[127] Yet police intervention was only triggered as a result of explicit disclosure. Assumptions about the relationship between social class and respectability, the idealisation of the family as a social unit and a faith in religious and educative institutions meant that cases easily remained undiscovered.[128]

Women officers who had joined in the early 1960s, and were involved in the setting up of specialist child protection teams in the 1980s and 1990s, spoke of the 'lack of knowledge' that had framed earlier welfare interventions: 'It was such revelation how much we didn't know, how much we'd missed.'[129] They felt that circumstances had been inadequately investigated (in relation to current practices) when adolescent girls ran away from home: 'We didn't know the signs because, well, it hadn't become acceptable, you know, to talk about it in society.'[130] Girls may have been returned to potentially abusive parents or placed in an institution to correct their incorrigibility: 'What you really dreaded was that some day somebody would stop you on the street and say, "You interviewed me 20 years ago and . . . I tried to tell you and you didn't listen".'[131] In Northern Ireland the sense of sorrow that surrounded the discovery of sexual abuse has been magnified by the physical and emotional legacies of the Troubles. Women's confidence in the children's home as an institution was rocked by the scandal surrounding Kincora boys' home in East Belfast, which involved the trial and conviction in 1981 of three men for a series of homosexual assaults over a previous 20-year period. The RUC was also shaken by unproven allegations that it had covered up earlier complaints, along with Belfast Welfare Authority.[132] In 1994, the priest

Brendan Smyth was convicted of charges of child sexual abuse dating back to the 1960s.[133] The notion of a safe haven for children and adolescents was no longer clear-cut: 'When I put a child in there I thought I was putting them in safety; now you wouldn't be so sure.'[134] The exposure of abuse led to a questioning of the ties of deference that were perceived to have informed earlier policing: 'an incest in my early days would have been the talk of the station ... "Oh my goodness, that would never happen, a man, a pillar of society and his church".'[135]

Women officers across the UK continued to offer an evaluation of their earlier work within Women Police Branches in terms of welfare professionalism: 'We did the best we could at the time.'[136] They identified clear cases where they felt they had without doubt made some positive impact: 'When she had the baby she came down to the station with a piece of cake ... She said she'd call the baby after me.'[137] Some also viewed their work as more successful in saving lives than the lighter touch that they associated with the new cohort of local authority social workers: 'children at risk only started dying when all that had been handed over to the Social Services'.[138] Yet for a number of women the older confidence in penal welfarism was replaced with increasing uncertainty. Their own sense of possessing authority was challenged as more was revealed and they were left in a position of 'not knowing'. Gina had been involved in the discovery of what seemed to be ever-widening circles of sexual abuse centring on the Playland Amusement Arcade in London's West End in 1970:

> At the time, you thought it was a good job you were doing, but looking back with hindsight, you thought, 'That was very traumatic, very stressful really'... It was like the bucket of water: while your hand was in the water you thought you were making an awful lot of difference. When you take your hand out of the water and the ripples settle, you just think to yourself, 'Why did I bother?' You just think to yourself, 'Did we have any impact?'[139]

The spectre of child sexual abuse possibly destabilised policewomen's identities as it challenged the ontological completeness of the care/control framework on which their work was built. Those who stayed in the service and were involved in the development of initiatives in the 1990s felt that they gained new knowledges as a result of retraining, enabling them to retain their professional confidence.

All welfare policies have to recognise that children are initially born into the world in a position of total physical dependency on adults. Children can never be truly 'empowered' because of this essential inequality.

They cannot necessarily claim their rights; rather, adults exercise them in their name. As a result of socialisation their position becomes more equal but they remain unequal players in relation to adults in the negotiation of power. Hendrick has argued that the 'trade-off' between the 'care' of children and the 'control' of families is a political decision that is shaped by perceptions of the significance of the institution of the family in the modern liberal State.[140] As law enforcers and welfare practitioners working within a state apparatus, policewomen tended to reflect dominant ideas about class, gender and ethnicity rather than to challenge them. It can also be argued their approach was based on a pragmatic realism. The 'trade-off' between 'protecting' a 15–year-old girl from sexual abuse or prostitution and restricting her sexual autonomy was grounded in an economic and social assessment of the gendered significance of sexual danger. Policewomen warned adolescents against the 'dangers' of pregnancy in the 1950s because they were aware of the social stigma attached to promiscuity and illegitimacy in this pre-permissive society. At the same time, however, they reinforced the social stigma by utilising the category of 'moral danger'.

This chapter has demonstrated that tensions between 'control' and 'care' have shaped the negotiation of both a social work ethic in policing and working relationships between police officers and other emerging practitioners in the first half of the twentieth century. For the most part, a broad consensus was achieved that was based on a confidence in the penal-welfare complex although tensions were present throughout. Between 1945 and 1965 policewomen played a key role in the detection of cruelty, neglect and the prevention of delinquency; it was a role that was also crucial to their identities as experts in relation to both policing and child welfare. The collapse of consensus led, ultimately, to the erosion of women's specialist policing role while the 'rediscovery' of child sexual abuse challenged their initial feelings of confidence in this expertise. This 'rediscovery' has not made it any easier to separate 'care' from 'control'. Rather, there is still a tendency to view the sexually abused adolescent as victim *or* threat rather than as a person in their own right. The problem of the overlapping of mechanisms of protection and regulation will also be discussed in Chapter 7, which focuses on policewomen's work with other adult women.

Notes

1 Henriques, *Indiscretions*, pp. 48–9.
2 Young, *Inside Job*, p. 191.
3 Garland, *Culture of Control*.

4 Donzelot, *Policing of Families*, defines the 'social' as the point of intersection between 'public' and 'private' domains.
5 H. Hendrick, *Child Welfare: England 1872–1989* (London: Routledge, 1994), p. 55.
6 1908 Children and Young Persons Act, 8 Edw 7, ch. 67.
7 Hendrick, *Child Welfare*, p. 128.
8 Donzelot, *Policing of Families*.
9 The 'Royal' prefix was added to the name of the Scottish National Society in 1922.
10 Jackson, *Child Sexual Abuse*, p. 62.
11 NA, MEPO 2/5562: Metropolitan Police Home for Women and Children.
12 Baird Report, Q. 2078, evidence of Jean Forsyth Wright.
13 The 1933 Act was technically a consolidating act, which brought together legislation dealing with child protection and young offending, including the 1932 act of the same title (which never actually came into effect in England and Wales). See V. Bailey, *Delinquency and Citizenship: Reclaiming the Young Offender* (Oxford: Clarendon, 1987).
14 The NSPCC or local authorities had to apply for a magistrate's warrant, which ordered a constable to undertake these duties.
15 F. M. Martin and K. Murray (eds), *The Scottish Juvenile Justice System* (Edinburgh: Scottish Academic Press, 1982); L. Mahood, *Policing Gender, Class and Family: Britain 1850–1940* (London: UCL Press, 1995); and L. Abrams, *The Orphan Country: Children of Scotland's Broken Homes from 1845 to the Present Day* (Edinburgh: John Donald, 1998).
16 Met policewomen took all their own cases to court, preparing court papers and briefing solicitors. In Scotland all criminal cases were referred to the Procurator Fiscal, who was responsible for final prosecution. Scottish policewomen did bring their own cases in 'care or protection' proceedings. In most other forces, such as the RUC, Coventry, Devon, Durham, Hampshire, Hull, Leeds, Newcastle, Somerset and the West Riding, papers were passed on to specially appointed Prosecuting Officers (the general procedure before the creation of the Crown Prosecution Service in 1986). Marion Macmillan was Prosecuting Officer in the Belfast Juvenile Court from 1956.
17 WPT, Marion.
18 WPT, May. This examination was not critiqued within the women police, although objections were raised by a woman doctor in 1945; see Cox, *Gender, Justice and Welfare*, p. 64.
19 *Liverpool Post*, 16 March 1945.
20 *Manchester Evening News*, 17 March 1945.
21 Cox, *Gender, Justice and Welfare*, p. 15.
22 C. H. Rolph (ed.), *Women of the Streets: A Sociological Study of the Common Prostitute* (London: Secker and Warburg, 1955), p. 106.
23 P. Cox, 'Girls, deficiency and delinquency', in D. Wright and A. Digby (eds), *From Idiocy to Mental Deficiency: Historical Perspectives on People with Learning Difficulties* (London: Routledge, 1996). See also the testimony of Edna Higginbottom (born Manchester, 1923) in Steve Humphries/Testimony Films, *A Secret World of Sex: Forbidden Fruit* (broadcast by the BBC). In 1938, Edna was committed to Calderstones Mental Hospital, aged 15, for having a sexual relationship with an older man. Her grandfather reported them to the police, attended the juvenile court and signed the papers for her committal: 'I was stood on the stand between two policewomen. My grandfather said, "Shut her away. I never wanted her at home and I don't want her now".'

24 Donzelot, *Policing of Families*, p. 7.
25 *Ibid.*, p. 98.
26 MPM, Women Police AR 1950.
27 For studies that focus on young people's experiences, see Abrams, *Orphan Country*, and Cox, *Gender, Justice and Welfare*.
28 J. Lewis, 'Gender, the family and women's agency in the building of "welfare states": the British case', *Social History*, 19 (1994), 37–55.
29 Wyles, *Woman at Scotland Yard*, p. 86.
30 NA, MEPO 2/5889, Welfare work and after-care.
31 L. A. Jackson, 'Care or control? The Metropolitan Women Police and child welfare, 1919–1969', *The Historical Journal* 46:3 (2003), 623–48.
32 NA, MEPO 2/7619, Social study course for probationers.
33 PSNI Museum, Women Police, early papers: minutes of the deputation on women police, April 1942; Cameron, *Women in Green*, pp. 7–19.
34 Report on the Protection and Welfare of the Young and the Treatment of the Young Offender (Northern Ireland) (NIPP 1948), Cmd 264. A copy of Macmillan's original report, which included a more lengthy analysis of the data, is available at the MPM, Hill Papers, envelope 5.
35 GMPM, No. 2 District Policewomen's Conference, minutes, 31 July 1947.
36 MPM, Hill Papers, envelope 2: First Conference of Provincial Policewomen, 5–6 March 1937, Lecture on 'The Children and Young Persons Act 1933 in relation to the work of women police'.
37 GMPM, No. 6 District Policewomen's Conference, minutes, 30 January 1948.
38 *Ibid.*
39 GMPM, No. 4 District Policewomen's Conference, minutes, 30 June 1948.
40 GMPM, No. 5 District Policewomen's Conference, minutes, 1 September 1948.
41 Henriques, *Indiscretions*, p. 74.
42 Kent Police Museum, Chatham, Policewomen's diaries for Dartford, 30 September 1946–28 November 1954.
43 Cox, *Gender, Justice and Welfare*, p. 53.
44 Henriques, *Indiscretions*, p. 74.
45 MPM, Women Police ARs 1937–50.
46 GMPM, No. 1 District Policewomen's Conference, minutes, 26 October 1961. Manchester City Police had dealt with 97 cases of care or protection, the Education Authority with 85, the NSPCC with 70 and the local authority (presumably the Children's Department) with 1.
47 MPM, Women Police AR 1950. See also PSNI Museum, Women Police, Annual Report for 'G' Division, 1972.
48 GMPM, No. 1 District Policewomen's Conference, minutes, 14 May 1960.
49 Jackson, 'Care or Control'.
50 T. H. Ferguson, 'Protecting children in time: a historical sociological study of the abused child and child protection in Cleveland from 1880 to the "Cleveland affair" of 1987', Ph.D. thesis, Cambridge, 1992.
51 WPT, Ivy.
52 WPT, Irene.
53 WPT, Kathleen; Peggy: 'we thought they were condoning cruelty to children . . . they let all sorts of things go by'.

54 WPT, Gina.
55 WPT, Kathleen; Joyce.
56 NA, MEPO 2/6632: Children and young persons in need of care or protection.
57 *Yorkshire Evening News*, 8 July 1944: Miss Bullock left Leeds City's Policewomen's Department to become a probation officer in 1944. NA, HO 287/822 HMI Annual Inspection Reports, Liverpool, 1942–58: Miss Bushell, formerly Deputy Director of the Women's Patrols in Liverpool, later worked in the probation service.
58 GMPM, No. 4 District Policewomen's Conference, minutes, 30 June 1948.
59 NA, MEPO 2/8634: Metropolitan Women Police Branch, meetings of women inspectors and sergeants.
60 WPT, Peggy.
61 WPT, Moira.
62 GMPM, No. 6 District Policewomen's Conference, minutes, 10 April 1964.
63 GMPM, National Conference of Senior Policewomen, minutes, 13 May 1964.
64 GMPM, No. 5 District Policewomen's Conference, minutes, 5 March 1964; No. 6 District Conference, minutes, 10 April 1964; No. 1 District Conference, minutes, 23 April 1964; No. 2 District Conference, minutes, 13 October 1964.
65 PSNI Museum, Inspector General's circular no. 94, 18 April 1969.
66 WPT, Christine.
67 Concerns about the involvement of juveniles in political crime were to emerge during the Troubles of the early 1970s. See D. M. M. Fowler, *Patterns of Juvenile and Youth Crime in Northern Ireland c. 1945–2000: A Report for the Northern Ireland Office* (Belfast: NIO, 2000), p. 102.
68 MPM, Hill Papers, envelope 5, copy of 'Home conditions and background of juveniles convicted of crime', covering letter from Woman Head Constable Marion Macmillan, 3 January 1949.
69 Fowler, *Juvenile and Youth Crime*, p. 40.
70 *Ibid.*, pp. 53, 93.
71 Cameron, *Women in Green*, p. 24.
72 Assistant Director of Social Services, R. J. Bunting, recorded in 1993 that there had been 'differences in approach at times', which were 'understandable given the different philosophies underpinning social work and police work'; for the most part, however, 'the Women Police are perceived as emphasising the social care element in policing'. See Cameron, *Women in Green*, p. 153.
73 Report on the Protection of the Young, 1948.
74 Cox, *Gender, Justice and Welfare*, p. 7.
75 GMPM, Bohanna papers: notes for National Conference of Senior Policewomen, 28 September 1970.
76 GMPM, Bohanna papers: 'Psychology in the service of the court'.
77 P. Starkey, 'The feckless mother: women, poverty and social workers in wartime and post-war England', *Women's History Review*, 9 (2000), 539–58.
78 GMPM, Bohanna papers: notes for talk on juvenile delinquency, c. 1960.
79 GMPM, Bohanna papers: Police College, directing staff notes on 'juveniles and the law'.
80 WPT, Edna.
81 WPT, Irene.
82 WPT, Moira.

83 J. Davis, 'A poor man's system of justice: the London police courts in the second half of the nineteenth century', *The Historical Journal*, 27:2 (1984), 309–35.
84 Hunt Report, p. 26: 'Policewomen have not only a high professional value but can play an invaluable part in enhancing the relationship of the force [the RUC] with the public.'
85 GMPM, No. 1 District Policewomen's Conference, minutes, 14 May 1963 and 7 November 1963; No. 5 District Conference, minutes, 5 March 1964.
86 W. Webster, *Imagining Home: Gender, Race and National Identity 1945–64* (London: UCL Press, 1998), p. 48.
87 *Ibid.*, p. 51. See also P. Cox , 'Race, delinquency and difference in twentieth-century Britain', in P. Cox and H. Shore (eds), *Becoming Delinquent: British and European Youth, 1650–1950* (Aldershot: Ashgate, 2002).
88 Wyles, *Woman at Scotland Yard*, p. 57.
89 WPT, Joy.
90 Interview with Jean Law.
91 WPT, Helen.
92 Interview with Pauline Wren.
93 WPT, Marion.
94 WPT, Alice.
95 Donzelot, *Policing of Families*.
96 N. James, 'Emotional labour: skill and work in the social regulation of feelings', *Sociological Review*, 37 (1989), 15–42, defines emotional labour as 'the work carried out in the management of emotions'. As well as their duties with parents and children, policewomen were detailed to break news of sudden deaths and, in the Second World War in particular, to escort the bereaved in the identification of bodies.
97 WPT, Carol.
98 WPT, Christine.
99 WPT, Joyce.
100 WPT, Joan.
101 WPT, Maureen.
102 WPT, Gina.
103 WPT, Joyce.
104 WPT, Joan.
105 Report of the Committee on Children and Young Persons (Ingleby Committee) (BPP 1960) Cmnd 1191; Report of the Committee on Children and Young Persons. Scotland (Kilbrandon Committee) (BPP 1964) Cmnd 2306; Report of the Committee on Local Authority and Allied Personal Services (Seebohm Committee) (BPP 1968) Cmnd 3703.
106 NA, HO 287/620, Juvenile Liaison Schemes.
107 Ingleby Report, pp. 49–51.
108 Ingleby Report, p. 24.
109 Kilbrandon Report, p. 60.
110 GMPM, No. 6 District Policewomen's Conference, minutes, 22 April 1966.
111 GMPM, National Conference of Senior Policewomen, minutes, 19–20 October 1966.
112 Nigel Parton, *The Politics of Child Abuse* (Basingstoke: Macmillan, 1985).
113 GMPM, National Conference of Senior Policewomen, minutes, 30 September–1 October 1970.
114 *Ibid.*

115 GMPM, Bohanna Papers: memo from Inspector Kathleen Jones to Bohanna, 19 September 1970.
116 WPT, Joyce.
117 Hendrick, *Child Welfare*, pp. 231–7.
118 WPT, Susan; Gina; Jill. Jennifer Hilton, 'Juvenile delinquents: care or control?', *International Journal of Offender Therapy and Comparative Criminology* 16 (1972), 194–200.
119 WPT, Jean.
120 PSNI Museum, Women Police: co-operation between welfare services and police under the Children and Young Persons Act (Northern Ireland), 1968.
121 PSNI Museum, Women Police, ARs: report from Women Police office, RUC 'G' Division, 17 June 1972.
122 PSNI Museum, Women Police: letter from Assistant Principal Social Worker, Health and Social Services Board (eastern), 24 May 1976, to District Services Officer.
123 T. Thomas, *The Police and Social Workers* (Aldershot: Gower, 1986).
124 O. Stephenson, *Child Welfare in the United Kingdom 1948–98* (Oxford: Blackwell, 1999).
125 I. Hacking, 'The making and molding of child abuse', *Critical Inquiry* 17 (1991), 243–88.
126 Wyles, *Woman at Scotland Yard*.
127 WYAS, Tancred Papers, Box 5: Wyles to Tancred, 21 May 1949.
128 See also C. Smart, 'Reconsidering the recent history of child sexual abuse, 1910–1960', *Journal of Social Policy*, 29:1 (2000), 55–71.
129 WPT, Moira.
130 WPT, Janet.
131 WPT, Moira.
132 Ryder, *The RUC*, pp. 301–18.
133 Susan McKay, 'Rest in peace', in Bourke *et al.* (eds), *Field Day*, vol. 5, pp. 1536–8.
134 WPT, Laura.
135 WPT, Moira.
136 *Ibid.*
137 WPT, Gina.
138 WPT, Joy.
139 WPT, Gina.
140 Hendrick, *Child Welfare*, p. 284.

7

Women, sexuality and the law

THE LAW – AND ITS ADMINISTRATION through the criminal and civil courts – continued to uphold a sexual double standard in the first half of the twentieth century, despite challenges from campaigners concerned with women's rights. Although the grounds for divorce between men and women were equalised in 1923, prostitution was still regulated through a range of statutes that criminalised women who solicited, not their male clients.[1] During the First World War, the controversial Regulation 40D of the Defence of the Realm Act forced a woman to be medically examined, under threat of fine or imprisonment, if more than one servicemen alleged that he had contracted a venereal disease from her.[2] When sexual assaults came to court, female complainants rather than male defendants faced intensive interrogation about their sexuality.[3] Women's 'respectability' or status continued to hinge on sexual reputation. As Carol Smart has argued, the discourse of the law constructed them contradictorily as both 'powerful and powerless, as sexual agents but also as victims, as dangerous but in need of protection'.[4] 'Innocence' was equated with sexual propriety/purity, and 'danger'/guilt with promiscuity. While small children tended to be viewed with unquestioned sympathy, the ambiguities surrounding adult women meant that 'womanhood' was rarely treated as a homogenous category. As the previous chapter demonstrated, adolescent girls – those on the cusp of 'womanhood' – were also viewed ambivalently.

The appointment of policewomen to take statements from female victims and escort them in court was a change that was structural rather than ideological. As Heidensohn has stated, 'women in control . . . may participate in the oppressive "protection" of their own sex, in the most literal sense adding insult to injury'.[5] This chapter will focus in depth on two areas – the regulation of prostitution and the treatment of women victims of sexual assault – in order to consider the relationship between

women officers and those with whom they came into contact on a daily basis.[6] Norms of 'respectable' heterosexual femininity were upheld within the culture of the Policewomen's Departments through gossip and disciplinary process. These gendered assumptions also informed their approach to other women. Given that police duties were shaped by legislative frameworks and by institutional strategies, opportunities to transform daily practice were ultimately limited. Policewomen often drew on existing repertoires and frameworks developed within male police cultures rather than creating new ones. Most significantly, the assumption that the majority of rape allegations were false pervaded their work with rape victims in the era before integration. Yet it is also possible to identify a distinctly 'feminine' approach that was 'softer' and less aggressive in dealing with sexual assault. A critique of the sexual double standard was voiced by policewomen across the period in relation to soliciting. Anxieties about 'moral danger' were gradually replaced with concerns about the physical and psychological well-being of women working in prostitution.

The policing of prostitution

Women's police work in relation to the regulation of prostitution was based on prevention rather than the arrest of offenders. 'Moral welfare' had formed a central component of the work of the NUWW's voluntary patrols during the First World War as they patrolled railway stations, city centres and garrison towns, separating young working-class women and servicemen in the interests of order, public decency and sexual continence. Without the power to arrest, caution or 'move on', their tactics were based on advice, persuasion and the sheer persistence of their presence; they could also refer cases to the police for prosecution.[7] Guided by a continued belief in 'moral purity' for both sexes, the organisation affirmed 'its unshaken belief in an equal moral standard for men and women'.[8] The Dublin patrols were reported to 'run in men and women alike for having sexual intercourse in public'.[9] Sexuality was considered 'dangerous' in wartime because of panics about the prevalence of venereal disease among the armed troops, increases in illegitimate births and the spread of the 'social disease' of prostitution, all of which could be read as signs of national degeneracy. The cleansing of the streets and public places was part of the war effort: a civilising mission to achieve a sanitary and moral victory as well as a military one. Women's sexual morality was equated with virtuous citizenship and national strength.[10] The 'respectable' middle-class femininity of the women patrols was considered a valuable

instrument of authority: 'their own womanhood makes its silent appeal to men and girls alike'.[11]

Those women who exchanged patrol armbands for full uniforms and powers of arrest combined feminine 'virtue' with an official police authority, and an interest in 'welfare' with 'law enforcement'. Despite arguments about the need for equal moral standards, the gender-specific focus of their work meant that it was mainly women that they arrested. The UK's first attested policewoman, Edith Smith, cautioned 50 'prostitutes' and secured the conviction of 10 others in 1917 by way of warning. She also cautioned 100 'wayward girls' and referred 8 'fallen women' to rescue institutions for rehabilitation: 'there is a marked falling-off in the number of such persons in Grantham, one such stating "that the policewoman was such a nuisance she would go elsewhere".[12] If the emphasis was on 'prevention' rather than 'repression',[13] it was a 'prevention' that was informed by specific moral agendas, by the close linking of public order and welfare work within a 'tutelary complex', and by a focus on femininity. Young women under 17 could be committed to an industrial school by a magistrate if they were found to be 'in moral danger' by associating with prostitutes.

The act of prostitution was and is not illegal in the UK. However, soliciting – importuning clients – was and is an arrestable offence related to public order. In London, the Metropolitan Police Act of 1839 had specified that any 'common prostitute' could be arrested and fined 40 shillings if she was found to be 'soliciting in the street to the annoyance of passengers'.[14] The dubious issue of who deserved the derogatory label of 'common prostitute' was a question of official 'knowledge'.[15] It was standard practice in the Met that a woman who had been previously cautioned for soliciting could be identified as 'a common prostitute'.[16] In other towns and cities the Town Police Clauses Act formed the basis of prosecutions for soliciting: under this act, a 14–day prison sentence could be awarded instead of a 40-shilling fine in the first instance.[17] The regulation of prostitution in Scotland was largely determined by the austere Burgh Police (Scotland) Act 1892, which criminalised the act of 'loitering': 'Every common prostitute or street walker, who in any street . . . loiters about or importunes passengers for the purpose of prostitution commits an offence.' A fine of 40 shillings was to be imposed for a first offence, followed by 80 shillings or 30 days' imprisonment for a second.[18]

Statistics relating to prostitution tend to reflect the zealousness of police activity (or its lack) – in cautioning or making arrests – rather than actual activities of women. While a number of studies have examined legislative changes, an in-depth study of the practice and policing of

prostitution in the twentieth century is needed.[19] Rather more is currently known about the sexual economy of Metropolitan London than about the UK's other towns and cities because it tended to feature in social surveys and parliamentary enquiries. Nevertheless, placing statistics alongside personal testimony, it can be argued that women disappeared from the streets in the aftermath of the First World War, partly in response to the visible preventive presence of the women patrols. While some crept back to street prostitution as the presence of troops acted as a magnet during the Second World War, their ranks were also swelled by vast numbers of 'amateur prostitutes'. It was the latter group of young women requiring 'rescue' with whom policewomen were most centrally concerned. In the postwar years a series of moral panics about prostitution focused on London, and in particular on its West End – Soho, Piccadilly and Mayfair – an area in which prostitution had become increasingly concentrated. London was placed on display to the world during the Festival of Britain of 1951 and the Coronation of 1953. As preparations took place for these events it was felt that the 'moral cesspool created by the presence of street-walkers' did not fit with the presentation of the city as the capital of a 'civilised' nation.[20] The problem of the visibility of vice in London became the subject of the official enquiry conducted by the Wolfenden Committee, which was appointed in 1954 to examine the effectiveness of laws on both prostitution and homosexual offences.[21] The public outcry over the 'problem' of prostitution also led to a stepping up of police activity.[22]

It is important to point out that the arrest and caution of adult prostitutes was demarcated as a duty for specialist groups of policemen rather than women officers, despite Edith Smith's earlier activity. In most towns and cities policewomen rarely made arrests for soliciting. During Sergeant Goddard's corrupt regime at Vine Street in the 1920s, both he and a plain-clothes constable had 'regulated' prostitution though their own ad hoc system that involved taking bribes. According to Harry Daley's memoirs, bribery quickly disappeared after Goddard's conviction in 1929 and, to curtail the opportunities for abuse that covert surveillance had concealed, arrests were in future only made by uniform officers.[23] When the doors of the new West End Central Station opened in 1940, arrests for soliciting were placed in the hands of a 'Rowdyism Squad' of approximately 14 uniformed policemen undertaking 'tom duty' on a rotational basis (their activities were separate from the plain-clothes 'Clubs' office, which investigated brothels and licensed premises).[24] In most other cities – including Glasgow, Edinburgh, Leeds, Manchester and Newcastle – arrests for street soliciting were made by squads of

plain-clothes men in the postwar period.[25] Only in Belfast were policewomen involved in plain-clothes observations for soliciting, patrolling with a male officer until 2am in certain areas of the city. Women were to be cautioned on a first instance of soliciting and arrested for subsequent instances.[26] In Oldham and Rochdale, it was argued, soliciting was more prevalent in public houses than in streets, requiring different policing tactics.[27] Despite localised moments of tension, British magistrates upheld police prosecutions by convicting in over 90 per cent of cases between 1906 and 1955. The ability of the courts to impose prison sentences in all cities other than Manchester and London was seen as a sufficient deterrent.[28] In Leeds, the Vice Squad was involved in the conviction of 362 women for soliciting in 1949; it was argued that prostitution had been practically eradicated in the city centre.[29] The 'problem' in London was attributed to the ineffectiveness of a 40-shilling (£2) fine when the average prostitute, who earned £7 a night, viewed it in terms of 'business expenses'.[30] Elizabeth Bather of the Met's Women Police Branch argued that the situation was 'a farce indulged in by the prostitute, the police and the magistrate'.[31]

Women officers were accorded a preventive role that was based on a display of feminine authority and the searching out of vulnerable girls under the age of 17 who might be referred to the juvenile court as 'in need of care or protection'. In the Met, however, they also made arrests for soliciting as part of their general duties. Patrolling the West End in the mid-1930s, the Met's women police were instructed 'to concentrate on moving prostitutes on, and on cautioning them, only effecting such arrests as are necessary in order to maintain their authority'.[32] There is strong evidence from personal testimony that the 'Rowdyism Squad' of the West End arrested prostitutes by arrangement and on a rota basis during the 1940s and 1950s:[33]

> They'd say to her, 'Mary, half past seven next Tuesday,' and she'd say, 'Alright Bob,' and half past seven next Tuesday, she'd be in West End Central and she'd be charged with soliciting prostitution for the night and pay two quid the next day at Bow Street Court'.[34]

While this did not equate to police corruption, it can be seen as a diversionary tactic that subverted the intent of the law. Women officers in the West End refused to participate in the system: 'If I see a prostitute soliciting to the annoyance of a passer-by, irrespective of whether she was in court this morning or not due until next week, I say to her, "I have seen my evidence, I am arresting you".'[35] In the immediate postwar period women were, as a mean average, making similar numbers of arrests for

soliciting as male officers, although they were not involved in special 'tom patrols'.[36] Their activity, as for male officers, was stepped up during the Festival of Britain. In 1950 the Met's Women Police Branch made 184 arrests for soliciting during street patrols. This had quadrupled to 591 in 1951 and increased sixfold to 782 in 1952. In 1953 Bather reported that 'the work of the women in this field is proving very valuable – they are successful in keeping prostitutes on the move and reducing complaints and the public appear to appreciate their employment'.[37]

It was argued that women officers had a different effect from men, not simply because they refused to indulge in the 'rota' system but on account of competing femininities. Members of the Rowdyism Squad suggested that women caught for soliciting 'do not mind being arrested by a policeman but they just do not like being arrested by a policewoman' and that 'they will run like the dickens, more from them than from us'.[38] An explanation, based on both the culture of flirtation and on amateur psychology, was volunteered by Bather: 'They know that a woman will not respond to the charm of a feminine smile or be diverted from her intention or purpose. I feel they dislike being arrested by a woman officer because the majority of them have a guilt complex about their profession and therefore resent the presence of the WPC'.[39] According to this analysis, policewomen were more effectively 'in control' of other women than male officers because of the differences that shattered any sense of shared womanhood. Yet the situation was more complex. While women police (now drawn from a lower-middle-class/upper-working-class background) distinguished themselves from those other women who loitered on street corners, they had also come – in some situations and contexts – to empathise with their experiences.

'Vice' and 'virtue'

As Chapter 2 has shown, policewomen internalised the norms of 'respectable' heterosexuality. Awareness of difference – in terms of the identifiers of class, status and sexuality – are present in their descriptions of encounters with the other 'women of the streets'. Reflecting on an encounter with a 'tom' in the 1950s, Joan Lock wrote:

> I met Mabel in the charge room about four months after my arrival at West End Central. She was one of the ravaged kind. Her bloated, shiny-pink face with its piggy eyes, sparse eyebrows and sloppy mouth, was surrounded by yellow sausage curls and frizz ... The severe uniform with its flattering white starched collar had the effect of making a young face look younger and a pure expression purer ... 'Miss Bleeding

Purity, don't look down your nose at me! You know you're fucking trouble, you've never had it'... 'Get your bleeding hands off me, you lesbian', she screamed pushing me away.[40]

Here the 'purity' of police dress is juxtaposed with the disorderliness of 'the ravaged type'. Judgements about sexual status – reflected in the language of insult – structured these two women's evaluations of both self and each other.

Writing about policing in the earlier era of the 1920s, Lilian Wyles had depicted prostitute women as 'the most wretched of women, outcast from all decent society'. Although she was aware they had not had her opportunities in life, she saw them as a diseased 'menace', indolent and of low intelligence through hereditary defects.[41] Despite the patrols' criticisms of the sexual double standard during the First World War, they had also differentiated between categories of women: the 'hardened' mature prostitutes who preyed on servicemen, and young girls – 'amateurs' – who were in need of rescue through moral vigilance. By the 1940 and 1950s these assumptions were being challenged by an increased sense of a shared identity as women:

> I'd never met a prostitute, and I said to my friend in the training school, 'What's a prostitute look like?' I was so innocent, I really was. She said, 'I'll take you to the West End and show you.' And we went up there, and there were these ordinary girls standing... you know, I couldn't believe it,... they were just ordinary people.[42]

Rather than viewing prostitutes as one homogenous underclass, police culture categorised them into different classes, based on appearance, demeanour, earning power and education. These different categories of woman were also delineated in relation to the social geography of the city, their trajectory through it downwardly mobile:

> They started at Shepherd's Market when they were young, very good-looking, they would charge a high fee... As they got older, not so good-looking, they would go to the Bayswater Road, where they could earn less. And as they got older, if they were still on the game, they would go to the stations... Euston, Paddington. And later on some of them, all they would require is a drink at the pub, and that would be it. And you'd watch them go downhill, you know.[43]

If the dirty, jaded and dishevelled 'prostitute' encountered by Lock represented the distinct opposite of her eager and fresh-faced naivety, the pretty and attractive call-girl, who was smartly dressed and sweetly smelling, was harder to categorise in terms of difference. Women officers

recognised that she came from a similar class position. Her earnings might, however, be significantly higher than theirs:

> I remember being in a taxi with this beautifully-dressed prostitute, and she had the most lovely perfume on. I said to her, 'That's very nice perfume you've got,' and she told me what it was, 'Piquant,' I think it was. And while we were waiting, I said to her, 'Do you make a reduction if they're good-looking,' and she just looked at me, and said, 'What difference does it make?' ... She said to me, 'How much do you earn?' '£6 a week.' She said, 'I earn £200 a night. What would you do?' I said, 'Have you realised the danger you're in with some of these people? Not just the danger of venereal disease, all the other diseases, but these men can be very violent.' 'Oh,' she said, 'we can take care of ourselves'.[44]

The concern about the woman's physical well-being that was voiced here was part of a significant shift: prostitutes were increasingly being perceived by women police as potential victims rather than threats. This was partly a result of the acquaintance with male police cultures that had always been cynical about moral vigilance and had, to some extent, developed a relaxed (although often ambivalent) rapport with 'regulars'. In some respects women officers – no longer aloof from male colleagues in class terms – had come to share the non-interventionist beliefs of policemen expressed in Harry Daley's memoirs: 'both sides were blessed with character and a sense of humour, and we bumped into each other so often it was impossible to prevent a sneaking mutual interest'.[45] The use of police slang – 'toms' or 'tarts' to describe prostitutes – was absorbed by women police by the 1950s judging by its presence in the memoirs of Lock and Condor as well as oral history interviews. The shift was also a function of the building up of a body of women's experience of policing that was passed on through training.

In 1958, Dorothy Peto reflected on a change of attitude within the Metropolitan Women Police in her sketch of a typical day's patrol duty around Piccadilly, undertaken by Inspector Violet Butcher:

> When Inspector Butcher was a constable she had wanted passionately to clean up the streets, to make harsher laws, to rescue all prostitutes from a life of sin. Sometimes she had even wanted to have them shut up in registered brothels and medically examined twice a week. But for a long time now she had known that one couldn't force people into morality by Act of Parliament, and that the less the State had to do with the control of prostitution the sooner men would grasp the fact that it was they who must learn to control themselves. Meanwhile the Inspector trained her women in a scrupulous fairness in their dealings with all street walkers, while waging vigilant warfare for the protection of young

people and the frustration of pimps, procurers and all other parasites who exploit frailties of human kind.[46]

The sketch aimed to outline the beat policing of the 1940s, although it was, significantly, published just after the Wolfenden Report.[47] Peto was clearly contrasting the earlier strategy of women police – who had sought to eradicate prostitution in the early 1920s – with a developing recognition of a shared humanity. The transformation was a notable one: from moral rescue/reform to concern for physical and psychological wellbeing. The brutality of pimps was identified earlier in the article: 'Once Lally had come to the station to complain of his knocking her about, but when it came to the point, she couldn't face the witness box. The Inspector wished devoutly that she could get a case against him'.[48] Although attributed to Violet Butcher, the shift was clearly Peto's own which, she hoped, was reflected in the preventive strategies of the Women Police Branch. The law was seen as hypocritical in persecuting prostitutes and not their clients.

Although Peto's successor, Elizabeth Bather, oversaw an increase in the volume of arrests for soliciting performed by women officers, her evidence to the Wolfenden Committee was not out of kilter with Peto's line. She argued that the law discriminated unfairly against women, advocating the criminalisation of men who congregated in the streets to accost passers-by.[49] She also opposed suggestions that the law should be strengthened to such an extent that it would drive prostitution underground: the number of pimps would increase, prostitutes would be less free, and it would be harder to stop the procuring of young girls.[50] Despite public distaste, the 'visibility' of prostitution was seen as an aid to both police containment and the security of women on the streets. The decriminalisation of prostitution was the logical conclusion of their arguments. Their aim was primarily to work with young women under 17 who, for various reasons, had taken to the streets and to deter them from pursuing a life of prostitution.

Bather argued that their work was successful because there was very little juvenile prostitution on the streets of London. It is impossible to know whether this claim was correct given current awareness of the dark figure of non-reported sexual abuse. There are examples across the twentieth century of adolescent involvement in prostitution, although quantification is problematic.[51] In England and Wales the 1959 Street Offences Act followed the far from liberal recommendations of the Wolfenden Committee in introducing prison sentences for soliciting. It removed the clause concerning 'the annoyance of passengers' (present in the 1839 Metropolitan Police Act) and it seems to have cleared the streets of London

and Manchester of streetwalkers.⁵² In the Midlands, concerns were expressed that women who had been cautioned simply moved to another town, escaping close surveillance.⁵³ Social workers and lobby groups commented on an increased difficulty in identifying juveniles involved in prostitution during the 1960s because activity had gone underground, suggesting Bather's premonition – that it would be harder to 'discover' cases – was a correct one.⁵⁴

Women who were involved in prostitution were not asked to give evidence to the Wolfenden Committee. The only whisper of their voices that is available is an ethnographic survey involving 69 interviews, undertaken by social worker Rosalind Wilkinson for the British Social Biology Council and published in 1951 as *Women of the Streets*. The text is a heavily mediated one but it does provide information about perceptions of policing practices, including the belief of women soliciting in the West End that the 'rota' system was prevalent. Where mention is made of the activities of women officers, their endeavours to 'rescue' the young are viewed with approval. Prisilla, a Mayfair 'prostitute', was recorded as stating: 'No one can possibly grumble about the women police, they do a fine service in assisting the young girl who has had a row with the family and may easily get led astray. But the men police don't make any real difference to the real prostitutes . . .'⁵⁵

Elements of a libertarian approach to mature prostitutes accompanied a seemingly contradictory protectionism towards young women in the outlook of the Met's more junior officers. Woman Police Sergeant Spalton and Woman Police Constable White told the Wolfenden Committee that it was impossible to eradicate prostitution altogether. Spalton argued for decriminalisation:

> I do not think it should be a crime to be a prostitute . . . We will never be without prostitution . . . If a woman is over 25 and she wants to be a prostitute nobody can stop her, and I do not see why it should be an offence if that is what she wants to do with her life.⁵⁶

Both, too, agreed with Bather (who gave evidence after them) in calling for powers to deal with those in the 17–25 age category as in need of 'care or protection'.⁵⁷ A critique of the sexual double standard was encouraged within the Women Police Branch according to Joan, who served from 1949 to 1952: 'We used to say that the men should be dealt with as well, because they're the ones who are requiring the service.' In practice, they were often constrained by the male hierarchy. Both parties could, technically, be prosecuted for indecency if they had sexual intercourse in public. According to Joan, however, one chief superintendent ordered

that they only charge the woman for soliciting because he didn't want his female officers giving 'sordid' evidence in court: 'We said, "That's not fair, sir".'[58]

Policewomen's personal testimonies also indicate concerns for women's welfare that was not necessarily condemnatory, although a life in prostitution was seen as hard and undesirable. In Nottingham during the Second World War, policewomen aimed to 'contact them and get friendly with them', hoping to 'induce them to give up their mode of living and go to work'.[59] Both before and after the 1959 Act, women who were moved on or cautioned for prostitution were asked if they would like advice to help them quit the life. This opportunity was rarely taken up. In 1960, 31 women who had been cautioned agreed to visit a police station in the Metropolitan Police District to be interviewed by a woman police officer: of these, 10 kept the appointment, 6 agreed that their names could be forwarded to a probation officer and 2 sought help from a voluntary society.[60] Women officers recognised that the 'moral welfare' strategy did not work with adult women: 'We always tried to talk them into going for some kind of rehabilitation, always. "Are you convinced this is the way of life you want to continue? Can we give you some help? . . . Can we put you in touch with probation people who can help you?" They didn't want to know.'[61] In some cases a certain admiration is detectable, particularly when women were using prostitution to support their children:

> I said to her, 'Why are you doing this?' She said, 'I need the money.' She had a daughter who had no idea what she did for a living. She earned money to send her to a private school. She would come home to her on school holidays, she wouldn't work during school holidays, and the girl would go back to private school and have no idea whatever what her mother did for a living to earn money to keep her there . . . I was sorry that they did do that. I mean, it was against my sort of moral standing. But you could relate to them, you could certainly understand why they did it.[62]

Stella Condor's memoirs similarly refer to a woman who was saving to study at the Sorbonne: 'for every argument I could put against the life she was leading, the girl could almost invariably provide me with three or four excellent reasons why she intended to go on the way she had begun'.[63] Across the period certain women were categorised as 'hardened', 'drunken' or 'filthy'; but preconceptions about what a prostitute was were undoubtedly challenged on the streets, particularly when officers met well-dressed, well-spoken women like themselves, who had their own goals and ambitions. The mirror image was too clear a reflection to enable her to be labelled as 'other'.

If panics about the scale of street prostitution led to an expansion in arrests in 1950s London, more informal and disinterested approaches were taken elsewhere. 'Moralistic' approaches were clearly absent. Working in Essex in the early 1950s, Ivy recalled that prostitutes around the dockyards of Tilbury were only picked up if they were drunk and disorderly rather than for soliciting: 'You knew who they were and you used to say, "Watch it". . . They were the local ladies earning a little bit. It was nothing you made a fuss about. You knew who they were and it was only when they got drunk or got a bit naughty that you did anything about them . . . It was just one of those things.'[64] Although arrests in cities such as Newcastle, Manchester and Glasgow were usually made by plain-clothes policemen, women officers often searched them and questioned them at the station, developing 'a sort of rapport'. They were often a source of information in the search for runaway girls: 'I remember one night going down, I was looking for a missing from home, underage. And they said, "You'd better go round the corner, because I think she's there, she's only charging half a crown." And she was.'[65] Edna, who served in Kent Constabulary in the early 1950s, encountered girls of 14 or 15 who had run away from London to Chatham: 'if they started going on the game in Chatham, we knew pretty quickly because our prossies would tell us. People used to say, "Oh, that was good-hearted." It wasn't good-hearted: they didn't want the competition with young girls.'[66] While policewomen were involved in the surveillance of urban space, women involved in prostitution might also be keen to regulate their 'patch': partly to discourage competition, partly perhaps also out of concern for younger women. There were moments, therefore, where their interests and concerns coincided.

A number of women officers remembered the collection of money for baby clothes or the passing-on of second-hand items to adults involved in soliciting.[67] Elsie, who joined Glasgow City Police in 1944, described an occasion in which women officers were able to assist in the finding of work:

> I felt nothing but sorry for these women . . . We had one girl . . . she was boarded out at Inverness and she came down to Glasgow and she was on the streets. And, oh, she was a bonny girl, that lovely reddy gold hair, and a beautiful speaker having come from Inverness. And her sidekick was as opposite to her . . . she was quite a nice lassie, but oh, she had no presence, and she was really quite a coarse-looking girl. And one morning after the war had finished and the streets were kind of bare and there weren't many men for them to get business from . . . two of the policewomen got them in the station. They arranged to meet them and take

them to the labour exchange . . . and they got fixed up in the hospital as ward maids . . . The one with the red hair decided she would like to become a nurse. So the matron of the hospital phoned the inspector and spoke to her about this girl. Would she give her a chance? Anyway she did and apparently she made a terrific job of it. And she was very clever, passed the exams and came out top of her class, and then she disappeared. And apparently somebody had found out about her past and made it known and this was it.[68]

Elsie met the woman on one other occasion: 'She'd been found lying drunk and I think she'd been flung out of a car . . . I never heard any more about her until her body was taken out of the Clyde one day.' This poignant story is worth quoting at length because there are echoes with the accounts of other officers. Elsie categorised the appearance and demeanour of the two women in relation to the markers of class: the 'coarse' and the 'beautiful'. The red-haired woman – despite coming from a broken home – was able to achieve social mobility and enter the semi-profession of nursing, achieving equality of status with the policewomen. The profound tragedy leading to her death was not the result of a personal flaw but of a hypocritical society, of which the story is a critique. Elsie does not criticise her morality – she is seen ultimately as having little choice – but presents prostitution as a downward spiral of violence.

While policewomen's attempts to 'rescue' adolescent girls from the streets can be interpreted in relation to strategies of regulation that sought to control and delimit sexual behaviour, it can also be argued that their zealousness was shaped by their awareness of the lives of adult prostitutes, which they increasingly viewed in terms of violence rather than sexuality. Yet their scope to assist adult women was hugely limited. The values of a wider police culture as well as rules of evidence often prohibited intervention. The wartime blackout and its aftermath saw a series of murders of prostitutes, culminating in the trial of John Christie in 1953 for concealing the bodies of his victims – three of whom were prostitutes – at his home in Rillington Place, Notting Dale. Mary, who was serving in the Met at the time, commented: 'You didn't look much for prostitutes in those days, because they were like flotsam, they roamed so much from one area to another that the men were very reluctant to accept them as missing persons as a whole.'[69] Gina found a similar attitude was prevalent when she had to deal with a brutal rape on a young woman in the mid-1960s: 'There was this sort of barrier: "Well, she's a prostitute, she's got 19 convictions, she can't be raped." But she was in a dreadful state . . . She was only about 23, 24, a little bit older than I was.' The CID finally agreed to press charges: 'She'd been left at the bottom of some railings, she had a

broken jaw ... that one shocked me more than almost anything that I dealt with.'[70]

Domestic violence – disputes between adult men and women within the private sphere – was not viewed as a police matter: 'We were told not to meddle; it was a family affair and we weren't allowed to meddle in it.'[71] Reports of wife-beating were not recorded as assaults and the CID often refused involvement in the 1950s and 1960s. In Leeds and Birmingham, policewomen aimed to advise and assist but were unable to prosecute. Women complainants were told to pursue their own action: 'If a woman came to the Women Police counter to tell us about her husband and what he had done, we'd say, "Well, come here at 10 o'clock tomorrow morning and I'll come with you and we'll go to the courts and I'll show you how to apply for a summons".'[72] Women police in the RUC voiced similar frustration because rules of evidence made it impossible for the police to proceed if a woman withdrew a complaint: 'The unfortunate thing by the cool grey light of dawn, she was back in again to say, "Look, I don't really want to do anything about this, he's not bad".'[73] Those trapped in abusive relationships were unsupported by the law. Similar issues affected the ability of women engaged in prostitution to escape those who lived in luxury on their earnings. While plain-clothes officers were keen to use their evidence in the regulation of vice, women often felt unable to speak to a law enforcement agency that might be seen as part of the problem rather than part of the solution: 'they would have to build up a rapport with these girls over months and months, maybe two or three tom patrols, and it might take a year before one of them would actually trust the PC enough to turn their pimps in'.[74]

During the nineteenth century, condemnations of the 'social evil' of older women were co-existent with concerns about the procuration of 'innocent' young girls.[75] The ambivalent positioning of the 'prostitute' – as victim and/or threat – continued into the twentieth century and was reflected in the attitudes of male and female officers (although responses were negotiated in different gendered ways). The tension was a function of the marginal rather than criminal status of prostitution itself. For most policemen, the regulation of morals fell outside of the policing remit. For women officers, however, moral scrutiny remained a central aspect of their remit as a result of the Children and Young Persons Act. While they argued that many prostitutes were attentive and loving mothers, a woman's 'immorality' could be seen as a possible indicator of 'unfit' parenthood if there were other indications of negligence. In 1954 Bather argued that 'the human and moral point of view' was indistinguishable from 'the police point of view' in relation to the prevention of prostitu-

tion. The moral protection of the young was the central priority for women officers, shaping their strategies in the policing of both street and family. No longer the specific target of rescue and reform, women working in prostitution were still caught within the regulatory gaze of penal-welfarism in their capacity as parents and guardians.

Sexual violence

In 1982 a BBC television documentary about the Thames Valley Police showed male detectives conducting an interview with an alleged rape victim, in which she was bullied, intimidated and insulted.[76] The footage shocked the public and angered older policewomen who had joined before integration as 'specialists' in offences against women and children. Jill had served for 18 years in the Portsmouth area when she saw the documentary:

> Doing it on a TV programme was even more horrendous ... I really didn't think there was any of our CID that would have behaved like that. I just found it appalling. But I mean, I took rape statements for Thames Valley [Police] from two girls [on a previous occasion] and heard back from them how pleased they were with the rape statements and how full they were. So they knew what was required. But did they think I had brow-beaten these girls into giving these statements? Did they wonder how I got these statements from these girls? But it was just the meticulous way of taking a statement. You have to take it in chronological order and you have to take it in detail. But there he was haranguing ... very extraordinary.[77]

When Jill joined Portsmouth City Police in 1964, women officers took all indecency and sexual assault statements from women or child victims and were responsible for investigating a large number of them. She saw her methods as thorough and intensive but non-combatant and lacking in aggression. The documentary on Thames Valley Police – as well as Home Office pressure and the campaigns of organisations such as Women's Aid – led to extensive discussion of police provision for victims of assault. The introduction of rape suites (safe environments for interviewing and examination), as well as specialist teams such as those based in Northern Ireland's Care Units and in Manchester's Sexual Assault Referral Centre, were part of an orchestrated response that aimed to treat reports of sexual violence in a more sensitive way.[78] Legislative changes in the rules of evidence began to tackle the sexual double standard and to offset some of the tensions experienced by those in abusive relationships.[79] Many women officers felt that the situation in 1982 – exposed at its

worse on TV – was a result of a decline in specialist knowledges and responsibilities since the collapse of the Policewomen's Departments. In this final section of the chapter I shall examine the development of women's specialist work with adult victims of sexual violence, asking to what extent their approach differed from that of male colleagues in the era before integration. An analysis of the lectures and writings of women involved in training – Lilian Wyles, Dorothy Peto and Mildred White – is indicative of methods and approaches used by women police in the inter-war period. Oral history interviews with those who joined in the postwar period allow comparisons to be made across time.

During the first half of the twentieth century, statement-taking in cases of sexual assault was delineated, initially, as the 'specialist' work of women welfare workers (during the First World War), then as the 'specialist' work of CID women (in the inter-war period) and, finally, as the 'specialist' duty of rank-and-file policewomen (in the postwar era). Work in statement-taking was initially prioritised in relation to children and juveniles; adult women were added to the remit as a later development. The first women statement-takers – Emily Miller in Glasgow and Eilladh Macdougall in the Metropolitan London – served during the First World War as 'lady assistants' rather than attested policewomen, while statement-taking itself was positioned as a continuation of moral welfare work. In the Met, Lilian Wyles cajoled a reluctant head of the CID into a recognition that statement-taking was in fact police work, since detailed knowledge of the rules of evidence was required for a statement to be both useful and admissible. In 1922 Wyles was given responsibility for the taking of statements in all cases involving children and young girls that arose north of the Thames, while Macdougall retained responsibility for the area south of the river. The high-profile Savidge Inquiry of 1928 – which investigated claims that Wyles' male boss had asked inappropriate questions of Miss Irene Savidge in relation to an indecency case that also involved Sir Leo Chiozzo Money – forced the issue regarding the testimony of adult women.[80] The Metropolitan Police Orders subsequently stipulated that male officers should only ask adult women 'questions of an intimate character' if there was a policewoman or matron present; policemen could, however, conduct the interview.[81] For the rest of her police career, Wyles and a small group of women based in CID took the majority of sexual assault statements, although all women police received specialist training from Wyles in this line of duty. When she left in 1949, uniform officers became more involved. A similar procedure took place in Birmingham. Initially the responsibility of 'lady enquiry officers' to the CID – Dorothy Peto was succeeded by Mildred White and Doris Bushnell

– it became a duty of uniform women in 1944.[82] When provincial policewomen met for their second annual conference in 1938, it was recorded that policewomen took statements from female victims of indecency 'in the majority of cases'.[83] In forces where policewomen had not yet been appointed, statements from children and juveniles were allegedly taken by male officers in the presence of police wives, matrons, female probation officers or rescue workers.[84]

There were situations in which women officers were involved in transforming case law. In 1930 Glasgow businessman Samuel Moorov was convicted of a series of assaults and indecent assaults on women whom he had employed as assistants in his drapery firm. Glasgow policewomen were involved in the investigation of the case, which led to the ruling that single witnesses in individual crimes could be used as mutual corroboration if there was sufficient interrelationship in time, place and circumstances between incidents.[85] For the most part, as women ventured into statement-taking, they combined masculine precedents – gleaned from standard legal texts – with what they considered to be a woman's approach. Lilian Wyles followed traditions of jurisprudence – dating back to the seventeenth century – in arguing that 'taken as a whole there are not a large number of cases of genuine rape, although there are many spurious and doubtful complainants alleging that offence'.[86] Mildred White – who had worked in Bath, Salisbury and then Birmingham – was asked to give a lecture on statement-taking at the first Conference of Provincial Policewomen in 1937, an important training event for women across England and Wales. She told the assembled audience that the rape of adult women was 'very much rarer than is sometimes supposed; in twenty years I have only known three cases in which a conviction was secured'.[87] While the sexual assault of children was the subject of considerable anxiety in the inter-war period, the rape of adults was assumed to be the product of fantasy. White argued that 'great tact' and 'understanding treatment' should be used in dealing with 'neurotic women who may be subject to delusions' as well as with those 'passing through a difficult period in middle life' (menopause); 'the accusations made by such women are not frequently withdrawn after a sympathetic talk with another woman'. White's lecture pathologised adult rape victims, constructing them in terms of psychiatric disorder.

Wyles complained of the women trainees – older women from social work backgrounds – who were recruited straight into the Met's CID in the inter-war period and who 'could only see the welfare side of the case, and completely lost the police angle'. They were, she said, unable to understand why the police could not take action if there was no corroboration:

'These trainees would pour out pity on the head of the complainant, and show their contemptuous distrust of police who were so hardhearted that they could ignore the sufferings of such outraged women or girls, completely ignoring the fact that the tale the girl told held not one shred of corroboration.'[88] For Wyles, concerns about law enforcement and women's welfare had to be neatly balanced within a professional framework of policing; unlike her trainees, she did not perceive a tension between the two. She positioned their reaction as amateurish, emotional and inappropriately 'feminine'. Wyles felt that she was 'neither callous nor hardened': 'but I did not become hysterical when dealing with a woman who had been nearly murdered; it would not have helped her if I had done so'. She used her own self-control as a strategy to encourage emotional restraint in the victim. Pioneering a role for policewomen in this line of work, she did not consider it her role or duty to challenge entrenched legal traditions. She had had to fight for admittance to the CID and to demonstrate that she was good at her job on male terms. As a police officer, she was primarily there to enforce the law. A 'genuine' case of rape was, to her, one that could be proven in the eyes of the court. It was her job to ascertain the strength of the evidence and to prepare women and children for the grilling that they would receive at a later stage. Mildred White's approach was similar. She indicated a series of 'main points' that policewomen had to ensure were covered:

1. Any previous acquaintance?
2. If not, place and circumstances of meeting? Any drinks?
3. Did the woman consent to go into a dark or lonely place?
4. If the man was, hitherto, a stranger, did she accept kissing and fondling without protest?
5. What preliminary conversation?
6. What other liberties were taken? What reaction?
7. At the time of alleged rape, what protest? Any determined struggle? Any screams? Any building near?
8. Bruising? Injury done to man? Injury to woman's body?
9. Signs of scuffle on the grass?
10. Clothes torn, muddy, tumbled? Underclothing stained?
11. First complaint? How soon after?
12. Any offer of money payment?
13. Previous sex experience? General reputation of woman?[89]

The previous sexual history of the victim was a key line of enquiry. She was expected to prove substantial physical resistance, by demonstrating evidence of physical injury and torn clothing. Earlier signs of encourage-

ment – 'kissing and fondling without protest' – might be seen as an inducement or a sign that she was a woman of 'easy virtue'. 'Loose character' was seen as an indication that a woman might have encouraged her assailant's advances.[90] The structure of questioning duplicated and pre-empted that of the court interrogation.

In 1930 only 1,960 sexual assaults were recorded as crimes in Britain; this rose gradually to 6,992 in 1960 and 12,723 in 1980.[91] It is extremely unlikely that these figures indicate a sixfold increase in actual assaults. Rather, they suggest that women (as well as children) have been extremely reluctant to report sexual assault in the past (as, indeed, many still are today).[92] For adults, this was undoubtedly a result of the cultural stigma attached to rape, the invasion of personal privacy that would be caused by a trial and the knowledge of the gruelling cross-examination that this would entail. It is also possible that a significant number of reported assaults – particularly those involving adult women – were not taken seriously by the police. As the previous chapter has demonstrated, understandings of the prevalence of child sexual abuse only emerged in the 1980s. It is likely, however, that adult rape received even less recognition. Manchester's woman police surgeon, Nesta Wells, examined 2,000 alleged victims of sexual assault between 1927 and 1954: 83 per cent were under 16 years of age.[93] Between 1946 and 1954, policewomen in Dartford, Kent, took statements in 122 cases of indecent assault involving children or young people but only 4 cases of rape/attempted rape involving adult women (only 1 was pursued as serious).[94] Adult women may have been prepared to report assaults on their children in the inter-war period, but were less likely to make complaints about their own experiences of brutality. The prevalence of child over adult victims is suggested by Dorothy Peto's writings on statement-taking in sexual offences, which deal only with children and young girls; throughout she warns of the dangers of dismissing children's testimony as lies.[95]

Both White and Wyles divided alleged victims into different categories, based on age. Wyles, like Peto, emphasised the inherent truthfulness of children: 'Whilst the young child makes as a rule, in my opinion, a superlatively good witness, her older sister generally does not.' In 1937, White gave her audience special instruction on dealing with adolescent girls over 13, who were technically 'young persons':

> It is wiser I am sure, not to receive Lily with a pleasant smile. Place her in a standing position and facing the light. This is a grave matter. Sternness may be called for. In any case Lily must immediately get the impression that she is dealing with someone who can see through her. After a few minutes of silence and close scrutiny of the girl's face, Lily

may be told to sit down. You will then explain exactly who you are and that the business in hand is to get an entirely true account of what has happened. If you have a good reason of suspecting fabrication, mention the risk of prosecution for Public Mischief.[96]

Women officers were warned not to 'scold' nor to show surprise or horror; they were to maintain their position of authority by remaining collected and calm throughout. They were warned not to accept melodramatic narratives as explanations of under-age pregnancy: 'I have been a policewoman for nearly 20 years and have worked in three different cities, but not once, in all that time, have I met with a case in which the victim of an assault was either DRAGGED or DRUGGED!'[97]

In the postwar years it became established policy throughout the UK for women officers (now a presence in all forces) to take all statements from adult women victims as well as children. The traditions of jurisprudence that informed the work of Wyles and White were cited as standard on women's specialist training courses and internalised by the next generation of policewomen. Jean Law argued, 'it is the easiest thing in the world for a woman to make an allegation and it can be very difficult to disprove it if it is only a man and a woman. There's quite a few false complaints made, many false complaints made.'[98] Joyce, who served in the Met in the 1960s, drew on canteen terminology to explain responses to women's allegations of rape: 'a lot of rape cases in my early years, I think, were what we term "a touch of the seconds", where a woman had . . . been late home and thought, "How am I going to get out of this one?" and they cry wolf. The CID would say, "Oh, it's a touch of the seconds. . ."'[99]

Nevertheless, a significant number of those interviewed – across police forces – distinguished their approach from that of male officers. If women were wary of 'false allegations', they still felt that they had acknowledged the possibility of rape; male colleagues were viewed as reluctant to believe a woman although they were usually shocked by allegations involving children:

> CID men . . . nine times out of ten they would not believe the woman was genuinely raped. Either she'd agreed to it or whatever reason . . . You really had to prove to them that it was a genuine rape.[100]

> There still were a lot of men that, you know, didn't think that you could rape a woman. Yes, there was a lot of that. I don't think they were quite so sympathetic.[101]

> The women had a better appreciation than the men. I mean, as far as rape was concerned, there was a very prevalent attitude, 'Oh, she must have bloody asked for it.' And that used to make me so mad.[102]

Reluctance to accept an allegation might also stem from the desire to avoid complicated cases or to maintain appearances through statistics: 'If this CID man couldn't get a confession from the father and he had nothing else but an allegation from a not very bright girl, he didn't want a crime, so he had it written off as "no crime" and left the father free to start on the younger one. It used to make me furious when I thought somebody had slipped up like that.'[103] The recording of all complaints not pursued as 'no crime' could be distortional, creating an impression that the majority of cases were 'false' since it failed to distinguish between lack of evidence, women's unwillingness to go to court and false allegations. Prosecution was hugely dependent on the effectiveness of the working relationship and level of consensus between women officers (who took the statements) and CID men (who investigated). Not all male officers were obstructive. Working in the CID at Notting Hill in 1968, Carol Bristow was extremely impressed by the sensitive and sympathetic approach of her detective sergeant, since other policemen subjected women to 'a severe grilling', suggesting 'either that they had made it all up or had asked for it'.[104]

Both male and female officers started off with the assumption that 'a complaint hadn't been a genuine rape' and that it needed to be tested through interview. Arguably, a reversal of this emphasis – to initial belief rather than disbelief – began in the mid-1980s as a result of the transformations that occurred in response to the Thames Valley documentary.[105] Policewomen did, however, feel that they offered a different style to male colleagues, a style that was discreet, sensitive and caring. All women interviewed were involved in taking statements from women and child victims and indicated that this was force policy in the 1940s to 1960s. They also escorted victims to the police surgeon's house or surgery for a medical examination, accompanied her if there was an identity parade, and were involved in the emotional work of consoling.[106] In rural areas, however, policemen might have dealt with a complainant in the first instance if a woman officer was not immediately available, particularly at night. Vera served in Lincolnshire: 'It was shocking sometimes how they used to get at these poor women who were obviously in a heck of a distressed state ... Usually it happened at night and we were at home in bed. By the time you got up and got there, they'd had their ten penn'orth.' The woman officer would then have to 'be the comforter, the nice person, trying to get them onto a bit of an even keel so you could discuss it properly'.[107] Interviews were conducted in the Women Police Office or at the victim's home.

Rather than adopting a haranguing or bullying style, the questioning was calm but firm, according to Zena, who served in Bournemouth Borough:

> You have to be patient. And sometimes if you get a girl who had perhaps alleged rape and you couldn't get anywhere with her, another policewoman came in and would say, 'Was she a bit hard on you, dear?' and then it would come out perhaps very often that a girl had made it up because she was late home and was frightened what mum would say . . . You had to be very careful because it could have been true and you'd say things like, 'Do you realise what you're saying, my dear? You're alleging that this happened. This young man could be in terrible trouble.'[108]

The approach described by Zena resonates in many ways with White's training lecture of 1937. In both accounts, false allegations were normalised and complainants infantilised through a rather matronly line of enquiry. There is also a notable shift. White's lecture had positioned adult rape complainants as pathological. As divorce and sex outside of marriage was regarded as more commonplace in the 1950s and 1960s, rape was more likely to be dismissed as 'unwanted sex'.[109] While there was an attempt, therefore, to adopt an ethos of care, it was not necessarily experienced as such by women victims.

It is clearly the case that the reporting of sexual offences involving women and children increased notably between 1930 and 1960. The returns produced by Women Police Branches reflect both this increase in reporting and women's replacement of men in statement-taking. Birmingham's 2 lady enquiry officers had taken 41 statements in relation to indecent assaults and exposures in 1927; in 1960, the city's 72 policewomen took 4,686 statements in relation to all sexual offences cases.[110] An analysis of statistics produced by the Met's Women Police Branch suggests that the period after the Second World War saw the most significant increase. In 1933, women CID officers dealt with 508 sexual offences cases; this dwindled to 450 in 1945. In 1957, however, they handled 2,005 sexual offences cases (involving 3,266 statements), including 826 cases of indecent assault, 84 cases of rape, 278 cases of unlawful sexual intercourse (in which young woman was under the age of consent) and 52 cases of incest. It is certainly possible that women's visibility as police officers – and the knowledge that they conducted the interviews – was a significant factor in encouraging an increase in the incidence of reporting. Notions of after-care were comparatively underdeveloped but the treatment that was offered was probably a considerable improvement from the methods of the male CID. However, despite odd moments of dissent in the years before integration, policewomen had developed a feminine style of policing rather than offering a feminist challenge to the assumptions that underpinned the law.

The 1982 documentary on Thames Valley Police exposed the worst effects of the 'loss' of this feminine approach as well as the expertise of

women officers. In Northern Ireland, where the process of integration had been far more gradual, statements from women and children continued to be taken by women officers throughout the 1970s and 1980s. Janet served in Glasgow City Police and then in the RUC. She found herself increasingly working with representatives of the voluntary lobby and support group, Women's Aid:

> My male colleagues were very anti-Women's Aid because they saw it as women who made a lot of trouble for husbands who had done nothing wrong. We had to fight to have Women's Aid accepted ... We could never have prosecuted without complaint from the abused wife. Women's Aid were always saying, 'But that's nonsense, she's too frightened,' and so on. We didn't listen to them for a long time. Some of us did. But it's only now that we've persuaded our male colleagues or a lot of our male colleagues ... that in actual fact we should proceed with those prosecutions. There's a whole different thinking on it.[111]

Women officers who retired in the 1990s identified a paradigmatic shift that had shaped the last years of their service: 'a whole different way of thinking' or 'a different set of assumptions'. A woman's well-being could be prioritised even within police work. Both the law and rules of evidence could be challenged and transformed. In relation to sexual assault, a culture of belief could replace the atmosphere of disbelief. The extent of this shift remains unclear and it is likely that the police still overestimate levels of false allegation.[112]

This chapter has demonstrated the existence of a set of tensions and contradictions in policewomen's negotiation of gender, sexuality and the law in the first half of the twentieth century. While adamantly opposing the sexual double standard that underpinned the prosecution of soliciting, they reinforced a culture of disbelief around the rape victim that has only been challenged since the 1980s. The softer touch in the interview room was an issue of style over substance, although it was undoubtedly preferable to the dismissive approach of most male officers. Although they demonstrated sympathy for 'women of the streets', their 'immorality' was, nevertheless, held against them on other occasions. Arguably, these tensions were shaped by ambiguities within the culture of the Policewomen's Department, which aimed towards a professionalism that was both 'tough' and 'feminine'. An emphasis on respectability and a 'higher standard of conduct' was offset by an assumption that those who experienced sexual harassment within the force should deal with it firmly themselves; those who failed had possibly 'asked for it'. Similarly, it was assumed that most complaints of rape were 'a touch of the seconds'. Nevertheless, as a result of daily experiences, women officers like other

welfare workers moved away from social purity frameworks; their concerns about adult prostitutes increasingly centred on health and personal danger. Moments of mutual recognition – of shared humanity and shared womanhood – meant that black and white assumptions were increasingly replaced with shades of grade. Ultimately, however, their central focus was on the 'welfare' or protection of childhood and youth, which meant that adult women were rarely a priority. The changes that resulted from the process of integration and the demolition of Policewomen's Departments will be outlined in the concluding chapter.

Notes

1 The Matrimonial Causes Act of 1857 permitted a husband to divorce his wife for adultery; a wife, however, had to prove both adultery and an additional offence. The 1923 Matrimonial Causes Act made adultery alone grounds for divorce for both parties. See L. A. Hall, *Sex, Gender and Social Change in Britain since 1880* (Basingstoke: Macmillan, 2000).
2 Regulation 33B, passed in 1942, required the examination and treatment of infected men too, but in practice was used to regulate women rather than men. See Rose, *Which People's War?*
3 D'Cruze, 'Crime'; S. Lees, *Carnal Knowledge: Rape on Trial* (London: Penguin, 1996).
4 C. Smart, 'Disruptive bodies and unruly sex', in Smart (ed.), *Regulating Womanhood* (London: Routledge, 1992), p. 8.
5 Heidensohn, *Women in Control?*, p. 26.
6 I use the terms 'prostitute' rather than 'sex worker' and 'victim' rather than 'survivor', although they are emotive categories, to reflect usage in the first half of the twentieth century.
7 Peto, *Memoirs*, p. 11.
8 IWM, Women's Work Collection, Emp 42.1/5, NUWW Annual Meeting, 1917.
9 IWM, Women's Work Collection, Emp 42.3, NUWW Women's Patrol Committee, reports 1917.
10 Rose, *Which People's War?*, pp. 73–92.
11 Liverpool City Archive, Liverpool Women Police Patrols, AR, 1923, p. 5.
12 IWM, Women's Work Collection, Emp 43.7, Policewomen's Work in Grantham, First Annual Report, January 1917.
13 Peto, *Memoirs*, p. 2, contrasts the 'preventive' work in which she was engaged with the 'repressive' effects of the nineteenth-century Contagious Diseases Acts. She fails to mention the role of women police in the enforcement of curfews under DORA.
14 A prison sentence of not more than one month could arise if the fine was not paid. Arrests might also be made under the Vagrancy Act of 1824: 'every common prostitute wandering in the public streets or public highways or any place of public resort and behaving in a riotous or indecent manner shall be deemed as an idle or disorderly person'.
15 The AMSH campaigned for civil rights for women involved in prostitution, including the removal of the term 'common prostitute' from statutory law.

16 Report of the Committee on Homosexual Offences and Prostitution (Wolfenden Committee) (BPP 1956–57), Cmnd 247, clause 275.
17 NA, MEPO 2/10236, Evidence to the Wolfenden Committee: police procedure in England and Wales, memo, 6 Feb 1958.
18 Wolfenden Report, p. 84. In Edinburgh and Aberdeen local by-laws allowed a fine of £10 or sixty days' imprisonment on a first offence.
19 For a broad overview of legislation, see Hall, *Sex, Gender and Social Change*. Other relevant studies include P. Bartley, 'Prostitution', in Zweiniger-Bargielowska (ed.), *Women in Twentieth-Century Britain*; A. Brown and D. Barrett, *Knowledge of Evil: Child Prostitution and Child Sexual Abuse in Twentieth-Century England* (Cullompton: Willan, 2002); H. Self, *Prostitute Women and the Misuse of the Law: the Fallen Daughters of Eve* (London: Frank Cass, 2003).
20 *Daily Graphic*, 12 October 1952.
21 Mort, 'Mapping sexual London'.
22 Wolfenden Report, Appendix 2, table XXII. From approximately 10,000 a year before the First World War, prosecutions for soliciting in England and Wales fell to 5,288 in 1918 and 1,303 in 1931. They reached 10,000 again in 1952, suggesting an orchestrated response to the public panic. Aggregation distorts the concentration of both prostitution and police activity: over two-thirds of all arrests in England and Wales in 1953 (6,829 out of 10,269) took place in London's West End (see Wolfenden Report, p. 91).
23 Daley, *This Small Cloud*, p. 149.
24 NA, MEPO 2/10236: Q. 499, PC Scarborough and PC Anderson.
25 NA, MEPO 2/10236: procedure for England and Wales. Birmingham and Southampton, like the Met, used uniformed male officers.
26 GMPM, No. 1 District Policewomen's Conference, minutes, 10 June 1948; Cameron, *Women in Green*, p. 37; WPT, Audrey; Laura.
27 GMPM, No. 1 District Policewomen's Conference, minutes, 10 June 1948.
28 Wolfenden Report, Appendix 2, tables XII and XVI.
29 Clay, *Leeds Police*, p. 102.
30 Wolfenden Report, p. 148.
31 NA, MEPO 2/10236: Q. 349, Elizabeth Bather.
32 MPM, Women Police, AR 1936.
33 Members of the Squad (PCs Scarborough and Anderson) denied there was a pattern to arrests (see, for example, NA, MEPO 2/10236, Q. 466), claiming it was imagined by prostitutes. WPS Spalton and WPC White believed that male officers were operating a rota system, as did women interviewed for this book who worked in the West End in the early 1950s.
34 WPT, Mary.
35 NA, MEPO 2/10236: Q. 386, WPS Spalton. See also WPT, Mary; Joan; Gina.
36 MPM, Women Police, AR 1948. In 1948 they effected 126 arrests – just over two per cent of the total of 5,353 across the Metropolitan Police District – which was proportionate to the size of the female establishment. The Met's statistics for arrests for soliciting can be found in Rolph, *Women of the Streets*, p. 205.
37 MPM, Women Police, AR 1953.
38 NA, MEPO 2/10236: Q. 478, PCs Anderson and Scarborough.
39 NA, MEPO 2/10236: Bather to Commander 'A', 25 November 1957.
40 Lock, *Lady Policeman*, p. 13.

41 Wyles, *Woman at Scotland Yard*, p. 68.
42 WPT, Violet.
43 WPT, Joan.
44 *Ibid.*
45 Daley, *This Small Cloud*, p. 148, argued that male officers treated assaults on prostitutes with seriousness.
46 Peto, *Memoirs*, p. 98.
47 Peto, now retired from the Met, had developed her links with the AMSH, described as 'the most feminist and libertarian of the social purity organisations' (Hall, *Sex, Gender and Social Change*, p. 101). While promoting 'high moral standards', the AMSH argued that it was wrong to criminalise sexual acts in private between consenting adults and called for gender equality in the laws surrounding soliciting. Peto made a written representation to the Wolfenden Committee on behalf of the AMSH and participated in a deputation in January 1958 to protest against the report's heavy-handed recommendations; see Self, *Prostitute Women*, pp. 166–7. The AMSH is now the Josephine Butler Society.
48 Peto, *Memoirs*, p. 97.
49 NA, MEPO 2/10236: Q. 347, Bather.
50 *Ibid.*: Q. 356, Bather.
51 Brown and Barrett, *Knowledge of Evil*, p. 137.
52 GMPM, No. 1 District Policewomen's Conference, minutes, 23 April 1964.
53 GMPM, No. 4 District Policewomen's Conference, minutes, 5 March 1964. Senior policewomen decided it would be inappropriate to introduce a national register of cautions that might prevent mobility, because 'every women's organisation would be against them'.
54 Brown and Barrett, *Knowledge of Evil*, pp. 147–8.
55 Rolph, *Women of the Streets*, p. 36.
56 NA, MEPO 2/10236: Q. 425, Woman Police Sergeant Spalton.
57 NA, MEPO 2/10236: Q. 406, Woman Police Constable White; Q. 421, Woman Police Sergeant Spalton.
58 WPT, Joan. There was some scope for the prosecution of men under the Metropolitan Police Act 1839, s. 54 (13). In some forces in England and Wales, s. 32 of the 1956 Sexual Offences Act had also been used to convict male clients. This was judged inappropriate by the Court of Criminal appeal in the case of Crook v. Edmondson. See GMPM, Senior Policewomen's Conference, minutes, 19–20 October 1966.
59 GMPM, No. 3 District Policewomen's Conference, minutes, 6 April 1948.
60 MPM, Women Police, AR 1960.
61 WPT, Joan.
62 WPT, Joyce.
63 Condor, *Woman on the Beat*, p. 48.
64 WPT, Ivy.
65 WPT, Maureen.
66 WPT, Edna.
67 WPT, Audrey; Joy.
68 WPT, Elsie.
69 WPT, Mary.
70 WPT, Gina.

71 Interview with Pauline Wren. For the inadequacy of police response, see G. Hague *et al.*, 'Women's Aid: Policing male violence in the home', in C. Dunhill (ed.), *The Boys in Blue: Women's Challenge to the Police* (London: Virago, 1989).
72 Interview with Pauline Wren.
73 WPT, Moira.
74 WPT, Gina. Police tactics changed as prostitution moved off the streets. In the West End the plain-clothes 'Clubs' office concentrated on the undercover investigation of brothels and vice rings; women officers were admitted as aides for short periods of time.
75 Walkowitz, *Prostitution*.
76 'Police', 18 January 1982.
77 WPT, Jill.
78 Lees, *Carnal Knowledge*, pp. 23–6; S. Scott and A. Dickens, 'Police and the professionalization of rape', in Dunhill (ed.), *Boys in Blue*.
79 Thomas, *Police and Social Workers*, pp. 81–94. Rape in marriage was criminalised in 1992. The Police and Criminal Evidence Act 1984 made it compulsory for spouses to give evidence against each other if it was in the public interest; the Criminal Justice Act 1988 allowed police to produce written statements in court if an individual refused to testify because of fear.
80 Lock, *British Policewoman*, pp. 57–72.
81 MPM, Police Orders, 1 August 1928.
82 Interview with Jean Law.
83 GMPM, Walkden Papers, minutes of the Conference of Provincial Policewomen, 1938.
84 WYAS, Acc no. 1187, Tancred Papers Box 6: Lee Commission, minutes of evidence, Q. 593, Major General Sir Llewellyn W. Atcherley, HMI Constabularies.
85 *Daily Record and Mail*, 8 May 1930. Moorov's conviction was upheld after appeal; see *Justiciary Court*, 18 July 1930, *Moorov v. HM Advocate*, pp. 68–94.
86 Wyles, *Woman at Scotland Yard*, p. 121. The seventeenth-century judge Sir Matthew Hale argued that, although rape is 'a most detestable crime', it 'is an accusation easily to be made and hard to be proved, and harder to be defended by the party accused, though never so innocent'; see V. A. C. Gatrell, *The Hanging Tree: Execution and the English People 1770–1868* (Oxford: Oxford University Press, 1994), p. 471.
87 MPM, Hill Papers, envelope 2: First Conference of Provincial Policewomen, Leicester, 5–6 March 1937: Inspector Mildred White, Birmingham City Police, 'Lecture notes on the taking of statements'.
88 Wyles, *Woman at Scotland Yard*, p. 127.
89 MPM, Hill Papers, envelope 2: White, 'Lecture notes'.
90 GMPM, No. 7 District Policewomen's Conference, minutes, 4 June 1948.
91 British Criminal Statistics, cited in D'Cruze, 'Crime', p. 209.
92 L. Kelly, *Surviving Sexual Violence* (Cambridge: Polity, 1988).
93 Greater Manchester Record Office, Medical Women's Federation scrapbook, p. 235: N. Wells, 'The need for women police surgeons', *Journal of the Medical Women's Federation* (1967), cutting.
94 Kent Police Museum, Chatham, Policewomen's Diaries.
95 D. O. G. Peto, 'The taking of statements in victims and witnesses of sexual offences', *Criminal Law Review* (1960), pp. 86–9; Peto, *Memoirs*, pp. 46–8.
96 MPM, Hill Papers, envelope 2: White, 'Lecture notes'. Unlike Wyles, White did not

argue that all children were truthful: rather, she made reference to the 'sharp-witted vindictive child' and the 'pathological liar'.
97 Ibid.
98 Interview with Jean Law; see also note 86. Similar statements, using Hale's phraseology, were made in WPT, Maureen; June.
99 WPT, Joyce.
100 WPT, Vera.
101 WPT, Jill.
102 WPT, Joy; see also Joan.
103 Interview with Jean Law.
104 Bristow, *Central 822*, p. 66.
105 WPT, Vera.
106 The first woman police surgeon, Nesta Wells, was appointed in Manchester in 1927. The Met used a panel of general practitioners, which included a number of women, from 1934 onwards: see Wyles, *Woman at Scotland Yard*, p. 166; Peto, *Memoirs*, p. 47. From 1953 onwards the RUC's policewomen used GP Dr Elizabeth McClatchey to examine female victims of physical and sexual assault (Cameron, *Women in Green*, p. 149). Despite the high-profile campaigns of women's organisations such as the NCW and the Medical Women's Federation (in 1938 and 1942), many forces remained reluctant to employ a woman doctor.
107 WPT, Vera.
108 WPT, Zena.
109 Scott and Dickens, 'Police and the professionalization of rape', p. 85.
110 NA, HO 45/112821. Evelyn Miles, Report to C. H. Rafter, 15 January 1927; HO 287/1192, Birmingham HMI Reports 1959–64: Chief Constable's Report 1959.
111 WPT, Janet. Attempts to construct a women's coalition in Northern Ireland in the 1980s to campaign on issues such as domestic violence are outlined in Bourke, *Field Day*, vol. 5.
112 L. Kelly, J. Lovett and L. Regan, 'A gap or a chasm? Attrition in reported rape cases', Home Office Research Study 293 (London: Home Office, 2005). Only 5.6 per cent of all reported rape cases ended in conviction in 2002. The authors draw attention to a continued 'culture of scepticism' in policing and call for the wider availability of women officers to take statements from female complainants, echoing the voices of early twentieth-century feminists.

8

Beyond integration?

> When I joined the force 28 years ago there was Police Work and Women Police Work. The women were a force within a force... At this point in time we are at a halfway stage. Women are involved in practically every type of policing... Yet still the feeling persists in the minds of some that it is inappropriate to put women in charge of any operation involving men.[1]

This book has considered the relationship between gender, welfare and surveillance in the twentieth century by analysing the involvement of women police in the regulation of the family, sexuality and city space. It has outlined the structures, cultural frameworks and mentalities that shaped the field of 'Women Police Work' and positioned women as 'a force within a force'. It has also examined the way in which policewomen negotiated these frameworks through the practice of everyday life: encounters with male colleagues, other professionals, and the women and children whom they policed. Women officers played a key role in enforcing child protection legislation in the years before integration as they carved out a role at the intersection of policing and social work. As statement-takers, they were aware of the impact of child sexual abuse and they developed a more sympathetic approach than many male officers in dealing with adult complainants of sexual assault, although it is likely that they, too, overestimated levels of false accusation. The field of 'penal welfare' was not as homogenous as is sometimes suggested in studies of official policy and strategy. Tensions and disagreements – between different groups of practitioners who sought to define their own distinctive roles within the modern welfare state – were played out at a local level. Arguably the culture of penal welfarism can only be fully understood through a study of its grassroots implementation. The relationships between those who were implicated in the gaze of authority (the police, social workers and investigators) and those who were its objects (women,

children and family groups) were unequal but complex. Policewomen's interventions might be resisted, welcomed or, indeed, invited within the dynamic of 'protection' and 'control'. Stereotyped assumptions about gender, sexuality, ethnicity, social class and status were challenged and negotiated as well as firmly reinforced on a daily basis.

There was considerable regional variation and the content of policewomen's work was always far broader than its denotation as 'specialist' suggests. In rural and county areas, women carried out ordinary 'police work' across the period. Nevertheless, policing as an occupation was structured through gender. This book has argued that in large city forces a particular ethos, based on a confident feminine professionalism in relation to child care and protection, permeated the work of central Policewomen's Departments and Women Police Branches in the first half of the century. Senior policewomen – both within individual forces and, after 1945, at the Home Office – sought to create a strong occupational identity for women officers that was distinct from other forms of social work. Furthermore, 'femininity' was itself a resource or performative device that was drawn upon within the tactics of physical surveillance. The uniform enabled women to step into the shadows and, hence, facilitated female spectatorship 'on the beat'. Women officers appropriated the gaze by using and sometimes subverting predominant assumptions about gender. Successful undercover surveillance was based on the ability to pass as 'other' through the manipulation of appearance. According to the popular press and accounts of former officers, 'femininity' was the ultimate cover, since the public were less knowledgeable of the activities and bodily demeanours of policewomen.

As the sociologist Anne Witz has demonstrated, women adopted a range of professionalisation strategies as they moved into new occupations in the late nineteenth and early twentieth centuries.[2] Strategies based on gender difference were double-edged in that they reinforced conventional stereotypes while creating distinct spaces and opportunities for women. However, arguments that were grounded in an equality of 'sameness' did not necessarily challenge the hegemony of cultures shaped by masculine values and could serve to naturalise and, therefore, reinforce them. For Joan Scott, this is a 'paradox' that has been faced by feminists across time: 'in order to protest women's exclusion, they had to act on behalf of women and so invoked the very difference they sought to deny'.[3] The concept of social maternalism, which emphasised women's innate qualities as carers and nurturers, was used to justify their involvement in a broad range of social/welfare-oriented work after the First World War. In relation to medicine, social work and, as demonstrated here, policing,

it was often argued that women practitioners were required to work specifically with women and children. In some occupations women chose to form their own separate networks that cut across workplaces in order to campaign around women's issues (for example, the Medical Women's Federation and the National Union of Women Teachers).[4] Women lawyers preferred to seek absorption into established networks even though such traditions valued attributes that were distinctly masculine.[5]

Among women's occupations, it was only in policing (and, after 1949 in the military) that arguments about gender difference – which were crucial in gaining initial recognition and admittance – were institutionalised internally through a separate career structure: the 'force within the force'.[6] Attempts to standardise policewomen's work and to create a network of regional and national conferences created a sense of a shared community and culture that cut across the tradition of local autonomy. Although policing recruited a significant proportion of female graduates in the inter-war period, particularly as statement-takers attached to the CID, it failed in the long term to attract the daughters of the middle classes. While it did not attain semi-professional status, rank-and-file women officers nevertheless viewed themselves as specialist practitioners. Moreover, the specificity of 'Women Police Work' had a significant impact on those who were the objects of this female gaze: the women and children who formed the focal point of their activities in the years before integration.

Arguably, the demise of 'Women Police Work' by 1969 was a function of its success. Women officers had demonstrated their utility in relation to 'specialist' or 'welfare' work; this confidence had enabled them to argue for a place in CID and Special Branch work as well as an active and visible presence in all stations. During the 1960s, the work of Policewomen's Departments was increasingly decentralised as women were posted out to all divisions. In terms of structure, the British Policewomen's Department, as a central office and hub of operations, had ceased to exist by 1969. Jean Law, then Assistant HMI, commented that 'departments of women at Head Quarters . . . with the senior women officer in absolute command, are now almost unknown'.[7] The daily management of female staff was passed on to station inspectors. The senior woman officer, who in small forces still only held the rank of inspector herself, acted largely as an adviser to ensure that women officers were properly deployed. The demise of 'Women Police Work' in terms of content can also be viewed in relation to the crisis of confidence in penal welfarism, as social workers (albeit temporarily) reclaimed the 'care or protection' of child 'victims' as their own. This usurpation of their 'specialist' work by other professional

groups and also by male officers, who were increasingly engaged in preventive work with potential young offenders through Juvenile Liaison Schemes and Juvenile Bureaux, forced the argument for integration. Clearly, too, the concept of separate women's departments was out of kilter with equal opportunities frameworks, which were a requirement of membership of the European Economic Community in the 1970s.[8] Shirley Becke, who had headed the Met Women Police Branch since 1966, increasingly saw the separate structure as a 'strait-jacket' and the branch was effectively absorbed into the force, undertaking the same types of work as men, in 1969.[9] The final dissolution of the Met Women Police Branch and the formal integration of male and female officers within promotions systems and line-management structures took place in 1973.[10] Becke and the Met Commissioner Sir Robert Mark were pre-empting the Equal Pay Act of 1970 and the Sex Discrimination Act of 1975, which made formal equality a legal requirement. In other British forces, Policewomen's Departments were dissolved overnight when the Sex Discrimination Act came into operation in December 1975.[11]

Gender politics in a divided society

In Northern Ireland the impact of the Troubles created a different situation in the early 1970s. If the First and Second World Wars had both disrupted and in some ways reinforced gender roles, the 'double helix' was also at work within the conflict zone of a divided society.[12] Women officers had been strongly associated with a 'community policing role' prior to 1968/69. However, their association with the 'Women Police Work' of child care or protection was soon dissipated as they were drawn into communications duties (to free up able-bodied policemen for operations), crowd control and, subsequently, vehicle patrol. The police response to the Troubles involved a disruption of women's specialist work as their remit, like that of their male colleagues, focused on security and the prevention of 'political crime'. Some of the work was, nevertheless, gender-specific, as in the Second World War. The influx of British troops between 1969 and 1976 led to renewed concerns about sexual relations between soldiers and adolescent girls, who, if under 17, were below the age of consent and required protection.[13] Just as the Met women had been seconded to Rushen internment camp on the Isle of Man in 1940, so RUC women were detailed to carry out searches at Long Kesh with the introduction of internment in the province in 1971. Yet the Met women had been relocated to work as 'outsiders', in relation to both the local Manx community and the German, Austrian, Czech and Italian communities of

the camps. If RUC women felt that they had been, to a degree, accepted by Catholic communities because of their association with the 'soft' policing of child welfare, internment duties eroded the possibility of trust. The concept of 'community policing' was hard to sustain when they were very visibly linked with Crown forces: 'it certainly wasn't a good thing for community relations at the time... it leaves you in a very awkward position'.[14] While representing themselves as non-sectarian and impartial, they recognised that they were perceived as partisan by others. Although technically 'unarmed', they were representatives of the Union, which was viewed by nationalist campaigners as a brutal imperial regime.[15] Because of their commitment to law enforcement, RUC officers defined all those involved in political protest involving forms of violence as criminal, whether nationalist or loyalist. RUC men and women effectively inhabited a third and quite distinct position as a 'force under fire'.[16] In a small number of country areas, RUC women continued to perform a 'welfare' role across the period of the Troubles.[17] Overall, however, a substantial reduction in 'welfare' cases must be linked to an increased reluctance to report 'missing children' or children in danger to the police as well as to an orientation of women's work away from 'welfare'.

While serving policewomen were increasingly moving towards a male policing model, the Troubles raised a fundamental choice for others: whether to stay in the RUC altogether, given security fears; or whether to concentrate on their roles as wives and mothers (despite the recent lifting of the marriage bar). Those with families left the constabulary, viewing domestic support as a basic duty and necessity within the conflict situation. As for other women, both Catholic and Protestant, feelings of fear and anxiety were almost overwhelming in this period: 'every day was ... oh, your husband's way out and you'd listen to every news bulletin ... You just lived from hour to hour, hoping and then thinking, and your mind never eased ... you were the target, always in buildings you were the target'.[18] Association with the RUC made it practically impossible for police wives to work again because of fears of disclosing their previous identity (a security threat) to any prospective employer. For other police wives, the Troubles acted as an incentive to return to police work, albeit temporarily, as part of the RUC Reserve.[19]

While the content of their work began to shift in the early 1970s, the RUC's Women Police Headquarters at Castlereagh continued to exist until 1982. Although the Chief Constable had failed in his attempt to gain total exemption from the Sex Discrimination (Northern Ireland) Order 1976, the Northern Ireland Office agreed to support a more gradual process so that security interests could be taken into account.[20] Effectively,

a 'modified role' was developed between 1976 and 1982, which allowed women to perform 'all duties carried out by men except those of a security nature involving the carrying of firearms'.[21] Full firearms training became available for women in 1987 after a complaint – made by a woman member of the Reserve – was upheld in relation to European law. In her book *Women in Green*, Margaret Cameron, who was serving at the time as a superintendent, suggested that senior policewomen distanced themselves from the request to bear arms: 'proud of being hitherto regarded as the "gentle arm of the law" they regretted the questions of firearms being raised'.[22] Absolute 'equality' was seen as undesirable.

Responses to integration

In other parts of Britain, where integration was much more sudden, there was no one response but, rather, sets of shared responses that can loosely be typified in relation to generation and rank. Recent young women recruits tended to support integration while older women constables were more likely to want to preserve their identity as women. Senior policewomen in all age groups tended to support a greater level of integration.[23] Ivy had objected to the 'narrow' focus of the Policewomen's Department when she joined Essex Police in 1948 and had insisted on undertaking a broad range of police duties in addition to her 'specialist' work, rising to the position of Chief Inspector in charge of a Women Police Department.[24] Some senior women opposed a broad-brush approach because they felt it was unfair on the older age group, who would find that 'the goalposts' had been suddenly moved.[25] There were, nevertheless, young recruits as well as older peers who felt that their work as women involved more expertise and less monotony than that of the average policeman: 'I used to say, "Well, I don't want equality; I'm not coming down to your level".'[26] RUC women similarly contrasted their experience of section duty with the freedom and autonomy of the Women Police Department: 'You were stuck in the back of a Land Rover, stuck doing one thing and I'd got so used to having a variety of work that I didn't really enjoy the other.'[27] The principle of 'equality' was a highly controversial one.

All women experienced periods of considerable anxiety that resulted from the actual process of integration. Lack of preparation and fear of the unknown were identified as key factors by women of rank. Maureen returned from a training course to find that 'they'd moved my office and my desk. I'd nothing, everything had gone.'[28] Pat was serving as an inspector in Coventry: 'Before I actually moved out they were coming and

taking furniture out of my office. Terribly demoralising really . . . you didn't know where you stood and didn't know what was going to happen.'[29] June's experiences in Bournemouth were similar: 'I think it was sort of "everybody out"... and then gradually they realised they'd thrown the baby out with the bath water. . . I think it was probably inevitable but it came too quickly, it was sort of thrust upon us.'[30] The loss of knowledge, information and expertise in relation to care or protection cases was identified by all women as an area of intense concern: 'It was a traumatic period for the women and people who really wanted to safeguard the past, all the duties you'd done, the rapport you'd built up, it was gone overnight.'[31] In almost all forces policewomen's specialist indexes disappeared: 'One of the girls asked about all the books and was told "ditch them" and so she did; she just put them in a black plastic bag and that's what happened to all our records, which was horrendous really. . . all these families weren't going to suddenly disappear.'[32] Women's anxieties were endorsed by the Edmund Davies Report of 1977, which found that integration 'had resulted in a serious loss of expertise in dealing with juveniles, women, missing persons and certain types of offences such as rape'.[33] Arguably the creation of Social Services and the erosion of the police role in relation to child welfare had already rendered these records dispensable. On the other hand, if relationships between police and social workers was at an all-time low, the continued presence of specialist officers in this area was all the more necessary if an effective multi-agency response was to be coordinated. Observing the effects of integration in Britain, RUC women were wary of making similar mistakes in the province: 'there was a lot of very valid reasons why we were opposed to integration . . . to us it was really a retrograde step'.[34]

Women in some forces became concerned as their workloads increased. As well as carrying out shift work on Divisions, they were also expected to interview women complainants or to advise on children's cases because male colleagues had received no formal training in this area. While women were assimilated into men's work, there had been no discussion about training men in women's specialist duties: 'We said, "Look, integration, it works two ways"'.[35] It took a full ten years before serious attempts were made to compensate for the loss of women's expertise. This was mainly shaped by external factors, particularly the public outcry that followed the 1982 television documentary on Thames Valley Police.

'Equality' was not a panacea but a paradox, and women's experiences were mixed. For some the process of demoralisation continued until they left the force.[36] Others who weathered the storm often found a sense of satisfaction in their subsequent work. Jill initially found little enjoyment

in vehicle patrol but returned to a welfare-oriented role as a community beat officer towards the end of her career.[37] In some forces senior policewomen found themselves sidelined into 'softer' personnel work when their departments were disbanded; in others they found interesting challenges.[38] Despite concerns about taking over a male unit, senior policewomen found that they were accepted for their commitment: 'I used to hear men saying, "I'll never work for a woman." And yet they were fine. I did it for four years ... and it was some of the best years of my service in actual fact.'[39] Margaret found that, despite her reluctance, 'after a while ... I enjoyed it, and I think it was the best thing that could have happened'.[40] Younger women in particular welcomed the opportunity to participate in what they saw as a full range of work, although they soon realised that recognition had to be fought for because of an endemic sexism in police culture which meant that they had to prove themselves to be better than male colleagues.[41]

Despite positive and approbatory statements from women officers regarding integration, women as a whole were far less likely to be promoted than male colleagues in the 1970s and 1980s. Sandra Jones's ground-breaking study, published in 1986, showed that the proportion of women officers in England and Wales who held the rank of sergeant fell from 11.2 per cent in 1971 to 6.1 per cent in 1976, and to 4.3 per cent in 1982. This trend for women was duplicated through all senior ranks, while the proportion of male promotions remained constant.[42] The discrimination experienced by women officers was in fact intensified rather than countered by integration; 'equality' was a sham. Pat was based in the personnel department: 'You could tell, with some of the remarks that you heard sometimes, that senior officers really didn't want too many women in key positions.'[43] Sian felt that 'they weren't going to give one place to a woman that they could to a man ... Once integration came it stopped the women in their tracks.'[44] Women were easily pigeonholed as less strong or agile, as emotional, as less committed because of marriage or family commitments, and as 'risky' in difficult situations.[45] Single women who were clearly physically robust might, on the other hand, be adversely judged against a gender stereotyping, in which successful women were expected to be slim, feminine and deferential.[46] As Heidensohn and Brown have argued, 'certain organizational discourses control women through denigrating or praising social constructions'.[47] Arguably, it was the experience of integration that forced women officers to adopt one of two behavioural models – the 'hard' or 'macho' police officer or the 'softer' and more feminine policewoman – as a coping strategy. Although the 'feminine' had provided an important reference point within the culture of the

Policewomen's Departments, it had been negotiated in different ways by different policewomen: 'when we joined you could have the nice sweet little one who really wanted to look after the kiddies ... and she could survive'.[48] Women's ability to be flexible, tough *and* feminine was now constantly tested as women in a man's world.

Writing in 1975, Jennifer Hilton (then a Metropolitan Chief Inspector) predicted that it would take another quarter of a century before a woman would be appointed at the helm of a UK police force. Assumptions about gender difference would take a whole lifecycle to dispel: 'she will have entered the service as a fully integrated officer and thereby, although not necessarily more capable than women serving now, will be able to command credibility with her male subordinates'.[49] While Alison Halford turned to litigation to press her claim for advancement,[50] other senior policewomen waited for the wheels to turn more slowly. Pauline Wren advanced as far as the position of commander, before encountering the glass ceiling: 'I got as far as I could get and I had to recognise the fact and leave.'[51] Hilton's prediction was fairly accurate: the first woman Chief Constable, Pauline Clare, was appointed in Lancashire in 1996. By 2004, there was a total of five women 'chiefs' in the UK; it has been argued that 'recognition of emotional intelligence and other so-called "soft" skills" means women don't have to act like men to get on'.[52] Nevertheless, women constituted only 20 per cent of the police service overall in 2003.[53] Reports compiled in the late 1990s indicated high levels of sexual harassment in the police service in England, Wales and Northern Ireland, although, significantly, not in Scotland.[54] Summarising recent research in the field, Heidensohn and Brown have concluded that cultures and structures have been slow to change.[55] As the media concentrates its attention on racism in policing, 'gender issues' may well be 'slipping'.[56] The 'halfway stage' – in which changes in structure had yet to lead to changes in culture – was remarkably persistent.

The need for cultural diversity in recruitment to the police service has been a central concern of the late twentieth and early twenty-first centuries.[57] As this book has demonstrated, an alternative to the homogeneity of a working-class, masculine police culture was developed after 1915 within the feminine space of the Women Police Branch. While male officers were traditionally hostile to the university-educated, early 'pioneer' policewomen sought to define themselves as 'experts', liaising carefully with university social work departments. Their work was associated with 'social' and 'welfare' roles, positioned as a 'soft' alternative to the 'hard' policing of thief-taking. Women stopped short of creating a distinctly feminist 'ethic of care'. Working within legal and professional

tramlines, differences tended to involve style or approach over substance and content. Nevertheless, a specifically 'feminine' model of policing was sustained throughout the inter-war and postwar period. Yet policing remained a white male bastion and there was little 'feminisation' of male culture. The separate structure of the Women Police Branch not only protected women from the worst effects of sexism, but preserved masculine police cultures intact. It was not until the integration of the 1970s, when women began to work alongside men on the same terms, that some male officers began to demonstrate their fear of heterogeneity and diversity. While the experiences of 'women' and 'ethnic minorities' are clearly not the same, both have provided a challenge to the uniformity of the UK's police service over the last 30 years. The problem of discrimination – relating to both gender and ethnicity – is still awaiting final resolution. Clearly at least part of the answer lies in the development of a cultural pluralism within policing that is based on a celebration of difference.

Notes

1. S. Becke, 'The first 50 years', *Police Review*, 3 October 1969.
2. Witz, *Professions and Patriarchy*.
3. Scott, *Only Paradoxes to Offer*.
4. K. Michaelsen, '"Union is strength": the Medical Women's Federation and the politics of professionalism, 1917–30', in K. Cowman and L. A. Jackson (eds), *Women and Work Culture: Britain c. 1850–1950* (Aldershot: Ashgate, 2005); Oram, *Women Teachers*.
5. Sommerlad and Sanderson, *Gender, Choice and Commitment*.
6. Women's military services were constituted separately as support roles during the First and Second World Wars, but for the duration only. The Women's Royal Army Corps (WRAC) was formed in 1949 as a permanent but separatist structure. See L. Noakes, *War and the British: Gender and National Identity 1939–1991* (London: I. B. Tauris, 1998).
7. GMPM, National Conference of Senior Policewomen, minutes, 1–2 October 1969.
8. H. L. Smith (ed.), *British Feminism in the Twentieth Century* (Aldershot: Edward Elgar, 1990).
9. Lock, *British Policewoman*, p. 200; S. Becke, 'Metropolitan uni-sex', *Police Journal*, July–September 1973. Whilst Becke argued forcefully that integration would lead to equal opportunities for promotion, other senior policewomen were 'most sceptical about this'. GMPM, Senior Policewomen's Conference, 27 September 1972, handwritten notes.
10. MPM Metropolitan Police Orders, 22 September 1972.
11. See, for example, M. Scollan, *Sworn to Serve: Police in Essex 1840–1990* (Chichester: Phillimore, 1993), p. 88; and Livingstone, 'History of Glasgow Policewomen'. Women in Glasgow City Police wore divisional numbers from 1972. In 1975 Glasgow City was amalgamated with surrounding forces to form Strathclyde Police; women were designated 'police officers' rather than policewomen for the first time.

12 Higgonet and Higonnet, 'The double helix'.
13 Cameron, *Women in Green*, p. 93.
14 WPT, Moira.
15 For nationalist perceptions of the RUC, see C. McAuley, 'Nationalist women and the RUC', in Dunhier (ed.), *Boys in Blue*. McAuley describes nationalist women's experiences of physical and verbal assault during interrogation and the targeting of nationalist communities for 'unnecessary surveillance'. While she focuses mainly on male officers, she argues that policewomen 'often engage in as much sexist abuse of women as their male counterparts'.
16 Ryder, *The RUC*; Brewer with Magee, *Inside the RUC*.
17 PSNI Museum, Women Police, ARs: Report from Women Police Office, Newtownards, RUC 'G' Division, 17 June 1972.
18 WPT, Irene. See also McAuley, 'Nationalist women'.
19 WPT, Audrey.
20 Cameron, *Women in Green*, p. 9. The British Army had been exempted and the WRAC did not begin weapons training until 1981; women were integrated into the regular army in 1992. See Noakes, *War and the British*.
21 Cameron, *Women in Green*, p. 109.
22 *Ibid.*, p. 112.
23 See Cheshire Record Office, Cheshire Constabulary Records, personal files of Woman Superintendent Joan Hunt, CPJ/21/3/1 Anti Discrimination, for the range of views aired by senior policewomen in 1973. Some spoke of gradual integration without disbanding separate women's departments and called for an evolutionary process rather than a legislative one. As M. Silvestri, *Women in Charge: Policing, Gender and Leadership* (Cullompton: Willan, 2003) p. 151, has demonstrated, senior policewomen tended to avoid or reject the label of 'feminist' or 'women's libber' although they were clearly involved in setting the agenda for women's progression.
24 WPT, Ivy.
25 WPT, Maureen.
26 WPT, Susan.
27 WPT, Laura.
28 WPT, Maureen.
29 WPT, Pat.
30 WPT, June.
31 WPT, Maureen.
32 WPT, Jill.
33 Edmund Davies Report, cited in Cameron, *Women in Green*, p. 100.
34 WPT, Moira.
35 WPT, Cynthia.
36 WPT, Joy; Jean.
37 WPT, Jill.
38 Interview with Pauline Wren.
39 WPT, Pat.
40 WPT, Vera.
41 WPT, Jennifer; Sian.
42 Jones, *Policewomen and Equality*, p. 101.
43 WPT, Pat.

44 WPT, Sian.
45 Jones, *Policewomen and Equality*, pp. 129–62.
46 WPT, Jennifer; Sian.
47 Brown and Heidensohn, *Gender and Policing*, p. 76.
48 WPT, Sian.
49 Jennifer Hilton, 'Women in the police service' (Queen's Police Gold Medal Essay), *Police Review*, 17 September 1976, pp. 1166–71.
50 Halford, *No Way Up*.
51 Interview with Pauline Wren.
52 *Observer* magazine, 9 November 2003, quotes an interview with the Met's Deputy Assistant Commissioner Carol Howlett.
53 *Police Review*, 31 January 2003.
54 Heidensohn and Brown, *Gender and Policing*, pp. 82–4; Brewer, 'Hercules, Hippolyte and the Amazons'. In 1998 Dee Mazurkiewicz successfully pursued sexual harassment claims against Thames Valley Police CID; see *Police Review*, 22 May 1998.
55 Heidensohn and Brown, *Gender and Policing*, pp. 76–104.
56 The existence of racist attitudes among a small number of training school recruits was 'exposed' in the BBC television documentary, *The Secret Policeman*, broadcast in October 2003. On gender, see *Police Review*, 6 April 2001, pp. 10–11.
57 Macpherson Report.

Select bibliography

Archive Collections

BURY CENTRAL LIBRARY
Edith Sharples (née Hoyle) 'My Life's Work', unpublished typescript, A52 (P) Hoyle.

CHESHIRE RECORD OFFICE
Cheshire Constabulary Records, personal files of Woman Superintendent Joan Hunt.

GREATER MANCHESTER POLICE MUSEUM
Clara Walkden papers.
Nellie Bohanna papers.
Policewomen's conferences (pre-1950 papers and post-1950 papers).
Women Police Department, box file on clubs.

GREATER MANCHESTER RECORD OFFICE
Medical Women's Federation scrapbook.

IMPERIAL WAR MUSEUM
Women's Work Collection.
Department of Documents, diaries of Gabrielle West.

KENT POLICE MUSEUM, CHATHAM
Policewomen's diaries for Dartford, 1946–54.

LIVERPOOL CITY ARCHIVE
Liverpool Women Police Patrols, Annual Reports.

METROPOLITAN POLICE MUSEUM, LONDON
Miss P. M. Lovell, 'The Call Stick', unpublished typescript.
Metropolitan (Women Patrol) enrolment forms.
Metropolitan Women Police, Annual Reports.
Papers of Miss K. M. Hill.
Women Police scrapbook.
Women Police newspaper cuttings.

POLICE SERVICE OF NORTHERN IRELAND
Papers of Women Police Branch.
Personnel records.
Women Police Annual Reports.

SELECT BIBLIOGRAPHY

NATIONAL ARCHIVES, KEW
Home Office papers (HO).
Metropolitan Police papers (MEPO).
War Office papers (WO).

NATIONAL ARCHIVES OF SCOTLAND, EDINBURGH
Home and Health papers, Scottish Office (HH).

WEST MIDLANDS POLICE MUSEUM
Birmingham City Police, personnel files for policewomen.

WEST YORKSHIRE ARCHIVES SERVICE
Tancred Papers.
Records of Leeds City Police, West Riding Constabulary and Huddersfield Borough Police.

Film

BRITISH FILM INSTITUTE
Looking on the Bright Side (1931). Dir. Graham Cutts and Basil Dean.
Street Corner (1953). Dir. Muriel Box.

Parliamentary papers and official publications

Report of the Committee on the Employment of Women on Police Duties (Baird Committee) (BPP 1920), Cmd 877.
Report of the Departmental Committee on the Employment of Policewomen (Bridgeman Committee) (BPP 1924), Cmd 2224.
Report of the Departmental Committee on Sexual Offences Against Young Persons (BPP 1924–25), Cmd 2651.
Report of the Committee on Street Offences (BPP 1928), Cmd 3231.
Report of the Royal Commission on Police Powers and Procedures (Lee Commission), (BPP 1928–29), Cmd 3297.
Report on the Protection and Welfare of the Young and the Treatment of the Young Offender, Northern Ireland (NIPP 1948), Cmd 264.
Report of the Committee on Homosexual Offences and Prostitution (Wolfenden Committee) (BPP 1956–57), Cmnd 247.
Report of the Committee on Children and Young Persons (Ingleby Committee) (BPP 1960), Cmnd 1191.
Report of the Committee on Children and Young Persons, Scotland (Kilbrandon Committee) (BPP 1964), Cmnd 2306.
Report of the Committee on Local Authority and Allied Personal Services (Seebohm Committee) (BPP 1968), Cmnd 3703.

SELECT BIBLIOGRAPHY

Report of the Advisory Committee on Police in Northern Ireland (Hunt Report) (NIPP 1969), Cmnd 535.
Report of the Stephen Lawrence inquiry (Macpherson Report), (BPP 1999) Cm 4262.

Other reference series

HANSARD
Northern Ireland House of Commons Debates.
Statutory Rules and Orders.

Select primary published sources

Allen, M. S., *The Pioneer Policewoman*, (London: Chatto and Windus, 1925).
Allen, M. S., *Lady in Blue*, (London: Stanley Paul, 1936).
Allen, M. S., and J. H. Heyneman, *Woman at the Cross Roads*, (London: Unicorn, 1934).
Baxter, V., *Elizabeth: Young Policewoman*, (London: Bodley Head, 1955).
Bristow, C., *Central 822*, (London: Bantam, 1998).
Condor, S., *Woman on the Beat*, (London: Robert Hale, 1960).
Halford, A., *No Way Up the Greasy Pole*, (London: Constable, 1993).
Hilton, J., *The Gentle Arm of the Law*, (Reading: Educational Explorers, 1967).
Lock, J., *Lady Policeman*, (London: Michael Joseph, 1968).
Peto, D. O. G., *The Memoirs of Miss Dorothy Olivia Georgiana Peto OBE*, (Bramshill: Organising Committee for the European Conference on Equal Opportunities in Policing, 1992).
Tancred, E., *Women Police 1914–1950*, (London: NCW, 1951).
Wyles, L., *A Woman at Scotland Yard*, (London: Faber and Faber, 1952).

Select secondary sources

Bland, L., 'In the name of protection: the policing of women in the First World War', in J. Brophy and C. Smart (eds), *Women in Law*, (London: Routledge, 1985).
Brewer, J. D. 'Hercules, Hippolyte and the Amazons – or policewomen in the RUC', *British Journal of Sociology*, 42 (1981), 231–247.
Brown, J. and F. Heidensohn, *Gender and Policing: Comparative Perspectives*, (Basingstoke: Macmillan, 2000).
Cameron, M., *The Women in Green: A History of the Royal Ulster Constabulary's Policewomen*, (Belfast: RUC Historical Society, 1993).
Carrier, J., *The Campaign for the Employment of Women as Police Officers*, (Aldershot: Avebury,1988).
Cox, Pam, *Gender, Justice and Welfare: Bad Girls in Britain, 1900–1950*, (Basingstoke: Palgrave, 2003).

Doan, Laura, *Fashioning Sapphism: The Origins of Modern English Lesbian Culture*, (New York: Columbia University Press, 2001).

Douglas, R. M., *Feminist Freikorps: The British Voluntary Women Police 1914–1940*, (Westport: Praeger, 1999).

Heidensohn, F., *Women in Control? The Role of Women in Law Enforcement*, (Oxford: Oxford University Press, 1992).

Jones, S., *Policewomen and Equality*, (Basingstoke: Macmillan, 1986).

Levine, P., 'Walking the streets in a way no decent woman should', *Journal of Modern History*, 66 (1994), 34–78.

Lock, J., *The British Policewoman*, (London: Robert Hale, 1979).

Weinberger, B., *The Best Police in the World: An Oral History of English Policing from the 1930s to the 1960s*, (Aldershot: Scolar Press, 1995).

Woodeson, A., 'The first women police: a force for equality or infringement', *Women's History Review* 2 (1993), 217–32.

Young, M., *An Inside Job: Policing and Police Culture in Britain*, (Oxford: Clarendon, 1991).

Index

Aberdeen 28
Abergavenny 40
age of consent 142, 146
aliens 25
Allen, Lily 22, 28, 33
Allen, Mary 5–6, 9, 10–11, 21–2, 24, 49
Allen, Sislin Fay 64
'amateur prostitutes' 92, 97, 100, 142, 174, 176
AMSH *see* Association for Moral and Social Hygiene
Anglesey 28
approved school 92, 99, 142, 143
Association for Moral and Social Hygiene 19
Astor, Nancy 19
Ayrburgh 28
Ayrshire 28

Ball, Emma Jane 29, 142
Banff 28
Bangor, County Down 161
Barker, Lilian 33
Bather, Elizabeth 24, 51, 62, 92, 147, 175, 176, 179–80, 184
Becke, Shirley 202
Belfast
 care or protection 154, 161
 delinquency 145, 151–2
 interwar policing 20, 24
 Kincora boys' home 163
 plainclothes 117, 127
 prostitution 93, 175
 RIC policewomen 62–3
 uniform patrol 86
Belfast Council of Social Welfare 145
Belfast Welfare Authority 163
Bell, Jane 63
betting 93, 110, 116, 121
Beveridge, Peter 111–12, 118

Birkenhead 9, 57, 118
Birmingham 23, 41, 47, 58–60, 62, 65, 97–8, 108, 184, 186
Bland, Lucy 5, 98
Bohanna, Nellie 29, 70, 151, 152–3
Bournemouth 39, 65, 117, 191
Box, Muriel 52
Boyle, Nina 17
Bradford 30
Brewer, John 6
Bristol 18, 21, 23
Bristow, Carol 10, 84, 86, 87, 126, 130, 191
British Social Hygiene Council 145
Brogden, Mike 85, 89, 97
Brown, Jennifer 206, 207
Buckinghamshire 28
Burt, Cyril 145, 151, 152
Bushnell, Doris 59, 186

Caernarvonshire 28
Cameron, Janet 55
Cameron, Margaret 5, 204
canteen culture 38, 41, 102
Cardiff 28, 30
career novels 53–4
Carmarthenshire 28
Carrier, John 5
Carton, Mary Catherine 63
Catholic Women's League 19
Charity Organisation Society 145
children
 care or protection 7, 24, 92–3, 138–65, 175, 205
 cruelty 138, 140, 141, 145–7, 156, 162
 neglect 138, 141, 145–8, 154–5, 157, 162–3, 165
 sexual abuse 140, 162–5, 178, 188
Children's Department 145, 149–50, 158, 160

INDEX

Children and Young Persons Acts 7, 93, 99, 140–3, 144, 145, 159, 161, 162, 184
Childs, Sir Wyndham 108, 110
Child Welfare Panels 159
Church of Ireland Moral Welfare League 145
CID *see* Criminal Investigations Department
Clare, Pauline 207
class 57–60, 75, 98, 112, 133, 153–4, 176, 201
Condor, Stella 9–10, 112, 120, 181
conferences 8, 33–4, 54, 146–7, 187
Contagious Diseases Acts 17
Cornwall 28, 30
corruption 124
Coventry 63, 68, 90
Cox, Pamela 142, 147, 152
Criminal Investigations Department
 dress 113, 116–17,
 Lancashire 110
 Metropolitan Police 111, 124
 performance 119
 rape and sexual assault 183–4, 186–92
 relationships with policemen 35
 segregation 107–8
 as 'specialist' 7
 training 31, 32, 33
 women in 128–33
Crown Prosecution Service 7

Daley, Harry 107–8, 178
Damer Dawson, Margaret 22–3
Danby, Mary 26
Dean, Jessie 29, 91
de Certeau, Michel 82
decoy work 117, 125
Defence of the Realm Acts (DORA) 115, 171
delinquency 24, 101, 145, 151–3
de Vitré, Barbara Denis 22, 26–34, 41, 47, 146

Doan, Laura 6
domestic violence 184
Donzelot, Jacques 143
Douglas, R. M. 6, 22
Downpatrick 161
drugs
 Dangerous Drugs Act 115
 Drugs Squad 130, 132
 raid 126
 trafficking 110
Dundee 141
Durham 146

Edinburgh 28, 174
education 61
equal opportunities 26
Equal Pay Acts (1970) 2, 202
Ettridge, Amy 128
Evergreens 10, 11, 74

Fabian, Robert 118, 126, 128
Fallon, Mary 63
family 67, 68, 120, 131–2, 138–65, 203
fascist sympathies 22
Fearnley, Percy 48
feminism 5, 17–23, 36
Fields, Gracie 48–9
Fifeshire 28
film
 The Blue Lamp (1949) 51–3, 65
 Carry on Constable (1960) 55
 Looking on the Bright Side (1931) 48–9, 53
 Street Corner (1953) 52–4
First World War
 blackout 100
 duties 120
 gender 5
 patrols 2–3, 18, 28, 30, 80, 97, 172–4
 recruitment and social class 57
 social change 17–18, 83
Forsyth Wright, Jean (also known as Mrs Thomson) 141
fortune-telling 115–16, 118

INDEX

Foucault, Michel 82–3
Fowler, David 152

Garland, David 138
Geraghty, Christine 53, 54
Glaister, John 33
Glamorgan 28
Glasgow 21, 22, 27, 28, 29, 41, 69, 73, 128, 141, 174, 182–3, 187, 193
Glasgow Police Heritage Society 10
Goddard, George 109, 124, 174
Grantham 18, 173
Gray, Janet 27
Gray, Norah 59
Gwent 65

Halford, Alison 3, 10, 11, 207
Halifax 28
Hall, Radclyffe 49
Hartnell, Norman 55
Heidensohn, Frances 6, 48, 171, 206, 207
Hendrick, Harry 140
Henriques, Sir Basil 1, 138, 147
Henry, Jack 111, 128
Her/His Majesty's Inspectors of Constabularies 7, 19
 assistant 10, 16, 26–33, 61
Higgs, Edward 81
Higonnet, M. R. and P. L. R. 17–18
Hill, Kathleen M. 27, 32
Hilton, Jennifer 10, 207
HMI of Constabularies *see* Her/His Majesty's Inspectors of Constabularies
Hobbs, Dick 113
Holtby, Winifred 19
Home Office 7, 10, 24, 26–33, 34
Horwood, Sir William 108, 110
Hoyle, Edith 9, 23, 28, 35, 109, 117–20
Huddersfield 9, 22, 23, 28, 30
Hull 29

incest 154, 163, 164

integration 162, 202, 204–7
internment 25
Isle of Man 25, 202

Jones, Sandra 6, 64, 206
Juvenile Bureaux 162, 202
juvenile court 1, 140, 141, 143, 146, 153, 157–8
Juvenile Liaison Schemes 158–9, 161, 165, 202

Kent 27, 51, 147, 182, 189
Kent, Susan Kingsley 20
Kirkcaldy 28
Krays 131–2

Lambert, John 64
Lambourne, Maud 52
Lanarkshire 28
Lancashire 28, 109, 128, 207
Law, Jean, OBE QPM 10, 27, 31–2, 35, 40, 61, 70, 100, 190
lawyers 4, 19, 201
Leeds, 29, 31, 41, 61, 62, 69, 129, 148, 174, 175, 184
Leicester 27, 33, 55
lesbianism 39, 72–3
Levine, Philippa 5, 80, 97
licensing 109, 110, 115, 120–3
Lincolnshire 39, 71, 72, 131, 191
Liverpool 21, 28, 30
Lloyd George, Megan 19
Lock, Joan 5, 10, 11, 120–1, 176
London *see* Metropolitan Police
Londonderry/Derry 86, 161
Long Kesh 32, 202
Lovell, Phyllis 9, 35, 57, 118–20

Macdougall, Eilladh 141, 144, 186
MacInnes, Colin 113
Macmillan, Marion 8, 24, 26, 33, 35, 92, 145, 151–2
MacMordie, Julia 20
Macready, Sir Neville 21

Manchester
 beat patrol 90
 care or protection 147
 delinquency 152–3
 duties 29
 ethos 70
 prostitution 174–5, 182
 sexual assault 189
Mark, Sir Robert 55, 202
marriage 54, 68, 70, 73–4, 131–2, 192
 bar 26, 54, 72–3
Martin, Susan 6
Medical Women's Federation 201
Members of Parliament 19–21
Merthyr Tydfil 28
Metropolitan Police (the Met)
 beat patrol 80, 90, 93–5
 care or protection 141, 144, 147
 CID 107–8, 110, 116–17
 culture 69–70
 integration 202
 memoirs 9–10
 plainclothes observations 123
 prostitution 175–6
 publicity 49–53
 recruitment 57, 59, 62, 64–5
 sexual assault 186–7, 192
 specialist role 6–7, 23–4, 26, 41
 uniform 50, 55, 87
Metropolitan Women Police Association 10–11, 74
Meyrick, Kate 108–9
Midlothian 28
Miles, Evelyn 58, 97–8
Miller, Emily 141, 186
Monmouthshire 28
Montgomeryshire 28
Moorov, Samuel 187
moral danger 93, 138, 142–3, 172, 173
moral welfare work 109, 144, 172, 186
More Nisbett, Iveigh 21–2
Motherwell 28

MPs *see* Members of Parliament
MWPA *see* Metropolitan Women Police Association

National Council of Women 18, 19, 21–2, 23, 30, 172
National Society for the Prevention of Cruelty to Children 17, 141, 143, 145–9, 158, 159–60
National Union of Societies for Equal Citizenship 19
National Union of Women Teachers 19, 201
National Union of Women Workers *see* National Council of Women
NCW *see* National Council of Women
Neath 28
Newcastle 65, 90, 130, 174, 182
Newport, Gwent 28
Newtownards 161
Northern Ireland *see* Royal Ulster Constabulary
North Riding 28
NSPCC *see* National Society for the Prevention of Cruelty to Children
nursing 21, 47, 53, 54, 58, 65, 183

Oldham 24, 34, 116, 175

Paisley 28
Panopticon 82, 89, 133
Pembrokeshire 28
Perth 28
Peto, Dorothy Olivia Georgiana 5–6, 9, 23–4, 26, 41, 47, 49–50, 59, 80, 96, 116, 144, 178–9, 186, 189
Picton-Turbervill, Edith 19
plain-clothes observations 107–27, 132
Police Federation 22, 34, 73
Police Service of Northern Ireland 66

INDEX

police surgeon 17, 189, 191
political crime 126–8, 151
probation officers 5, 143, 146, 149, 152
prostitution 17, 25, 45, 92–3, 94, 109, 118, 124, 140, 165, 171, 172–85
Procurator Fiscal 7, 141
professionalisation 200
professionalism 5, 150–2, 164
PSNI *see* Police Service of Northern Ireland

race 63–4, 99–100, 154–5
Rafter, Charles 108
rape and sexual assault 3, 17, 35, 36, 130, 141, 144, 162–3, 171, 172, 185–93
Rathbone, Eleanor 19–20, 74
Read, Jan 52–3
recruitment 60–5
Reiner, Rob 67, 68
religious belief 62–3, 151
Renfrewshire 28
Rhondda, Margaret 19
RIC *see* Royal Irish Constabulary
Rillington Place 183
Rose, Sonya 26, 27
Royal Irish Constabulary 62–3
Royal Scottish Society for the Prevention of Cruelty to Children 141
Royal Ulster Constabulary
 child neglect 148
 delinquency 145, 151–2
 divided society 7–8, 62–3, 66, 86–7, 88, 202–4
 employment of women 5, 24, 26, 40, 41
 identity 6, 66, 74
 inspection 27, 32
 marriage bar 60
 other police forces 33, 55
 plainclothes observations 117
 recruitment 60–3, 86–7

training 31, 129
uniform 50, 55, 86–7
RUC *see* Royal Ulster Constabulary

Sales, Rosemary 66
Salvation Army 1, 97
Savidge, Irene 186
Scott, Sir Harold 48
Scott, Joan 200
Scottish Office 7, 17
Second World War
 blackout 100
 citizenship 4
 duties 25–6, 28
 (armed) forces 6, 50
 protective clothing 38
 social change 17–18
 uniform 50
Sex Discrimination Acts (1975/6) 2, 202, 203
Sex Disqualification (Removal) Act (1919) 4, 19
sexual assault *see* rape and sexual assault
sexual discrimination 3, 206
sexual double standard 70, 171, 172, 180–1, 185
sexual harassment 3, 36, 39, 40, 207
Sharples, Edith *see* Hoyle, Edith
Sheffield 27
Sillitoe, Sir Percy 51
Smart, Carol 171
Smith, Edith 18, 173, 174
Social Biology Council 142, 180
social workers 1, 5, 143, 150, 158–62, 164
Special Branch 41, 127–8, 132
Stanley, Liz 11
Stormont 7
suffrage 17, 18, 19, 21, 22, 23
Sussex 65
Swansea 28, 30

Tancred, Edith 21–2, 28, 33

219

INDEX

television police series 56–7
 Dixon of Dock Green 56–7, 65
 Prime Suspect 57
 Softly Softly 57
 Z Cars 56–7
Thames Valley Police
 BBC documentary 3, 185, 191, 192, 205
Thorpe, Arthur 128
training 21, 29, 30–1, 32, 37, 73, 84–5, 86, 129, 150
Troubles, the 7, 66, 127, 163, 202

undercover observations 5, 107–28
uniform 5, 50–1, 55, 71, 74, 80–1, 84–9, 102

vagrancy 100–1
voluntary societies 109, 143–4, 181

Walkden, Clara 24, 116
Walkowitz, Daniel 15
WAPC *see* Women's Auxiliary Police Corps
WAS *see* Women's Auxiliary Service
Watson, Edith 17
Welfare Authorities 145, 150
Wells, Nesta 189

West Riding (of Yorkshire) 26, 27, 28, 61
WFL *see* Women's Freedom League
White, Jerry 121
White, Mildred 33, 52, 186, 187, 188–9
Wilkinson, Ellen 19–20
Wintringham, Margaret 19
Witz, Anne 200
Wolfenden Committee 174, 179–80
Women Police Service *see* Women's Auxiliary Service
Women Police Volunteers *see* Women's Auxiliary Service
Women's Aid 193
Women's Auxiliary Police Corps 25–6, 27, 28, 49
Women's Auxiliary Service 5, 18, 21–2, 24
Women's Co-operative Guild 19
Women's Freedom League 17, 19
Women's Institute 19
Woodeson, Alison 5
Woollacott, Angela 5
Woollcombe, Joan 49–50
WPS *see* Women Police Service
Wren, Pauline, MBE 10, 32, 207
Wyles, Lilian 9, 10, 35, 36, 87, 144, 155, 163, 177, 186–90